AS ALWAYS

As Always

Memoir of a Life in Writing

MADELEINE GAGNON

Translated by Phyllis Aronoff and Howard Scott

Talonbooks

Original title: *Depuis toujours*
© Les Éditions du Boréal et Madeleine Gagnon, 2013
Translation © Phyllis Aronoff and Howard Scott, 2015

Talonbooks
278 East First Avenue, Vancouver, B.C. v5T 1A6
www.talonbooks.com

Typeset in Arno and printed and bound in Canada
Printed on 100% post-consumer recycled paper
Cover and interior design by Typesmith

First printing: 2015

The publisher gratefully acknowledges the financial support of the Canada Council for the Arts; the Government of Canada through the Book Publishing Industry Development Program; and the Province of British Columbia through the British Columbia Arts Council for our publishing activities.

Depuis toujours by Madeleine Gagnon was first published in French by Les Éditions du Boréal in Montreal, Quebec, in 2013. We acknowledge the financial support of the Government of Canada through the National Translation Program for Book Publishing for our publishing activities.

All photos reproduced permission of Madeleine Gagnon.

LIBRARY AND ARCHIVES CANADA CATALOGUING IN PUBLICATION

Gagnon, Madeleine, 1938–
[Depuis toujours. English]
 As always : memoir of a life in writing / Madeleine Gagnon ; translated by Phyllis Aronoff and Howard Scott ; with an afterword by Maïr Verthuy.

Translation of: Depuis toujours.
Issued in print and electronic formats.
ISBN 978-0-88922-896-2 (PBK.).—ISBN 978-0-88922-897-9 (EPUB)

 1. Gagnon, Madeleine, 1938–. 2. Québec (Province)—Social conditions—20th century. 3. Authors, Canadian (French)—20th century—Biography. 4. Authors, Canadian (French)—Québec (Province)—Biography. 5. Feminists—Québec (Province)—Biography. I. Aronoff, Phyllis, 1945–, translator II. Scott, Howard, 1952–, translator III. Verthuy, Maïr, 1931–, writer of afterword IV. Title. V. Title: Depuis toujours. English.

PS8576.A46Z4713 2015 C848'.5403 C2014-907203-1
 C2014-907204-X

Patience and still patience,
Patience beneath the blue!
Each atom of the silence
Knows what it ripens to.

– Paul Valéry

Contents

VILLAGE

Stars of stone fallen in the forest,
protect those we love.

– Christian Hubin
Le sens des perdants

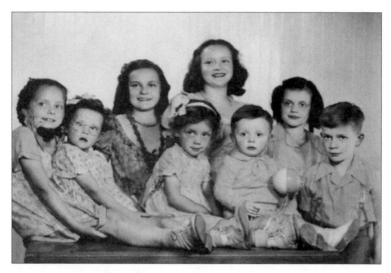

At Amqui, 1946. Numbers indicate birth order in the family. The four eldest are standing, from left to right: Céline, with necklace (2), Janine (1), Raymonde (3), and Paul-André (4). The youngest are seated on the table, from left to right: Madeleine (5), Pauline (6), Françoise (7), and Jean-Marc (8). Not present in the photo are Bernard (born 1947) and Bertrand (born 1948)

The Field of Carrots

In my child's eyes, Uncle Auguste was the best man on earth. When I tried to imagine heaven, his house and the outbuildings were always front and centre. The barn with its animals and hay, but also the wooded area where we used to picnic, where the temperature was cool in the heat of summer and warm in the cold of winter; the fields that extended all the way to the lake with its trout and the forest with its moose; to me, all this was the scenery of heaven, like a prayer spoken as far as the celestial vault in the great silence punctuated by flights of angels in the form of birds.

Between the two of them, Uncle Auguste and Aunt Adéla were able, with the grains and fruits from his land, the meat from the animals he raised or hunted, the fish, the eggs from the chickens or other poultry, the milk and cream from the cows, and the butter she made in the creamery next to the house, to feed the whole family, which grew to twenty children.

In whatever season I was taken there, sometimes in a horse-drawn cart, by one of the adults of my extended family, grandparents, father and mother, or aunts and uncles, I was filled with joy anticipating arrival at my heaven on earth. My own personal heaven, which I kept secret for reasons I sensed but could not explain in the language of logic, as if I knew from some ancient wisdom what would be confirmed for me as an adult: it is often risky to trumpet your happiness. Before even knowing the word *happiness* or imagining its geography and its contours, but after being punished for expressing it, you learned to be cautious. You might say it, murmur it, whisper it in the ear of someone dear.

So I would go up there to the lake already in a state of wonderment. Adéla and Auguste lived on the crest of a mountain called Saint-Alexandre, on a plateau where there was a lake of the same name. Adéla, Auguste,

and Alexandre were three names with the same sacred first letter, the beginning of the alphabet, the key that opened the door of heaven to me.

To keep my heaven for myself, I lavished my exultation on anything in motion, the piercing call of a bird in the shadows of the underbrush, the leaves rustling in the breeze, or, in winter, the muted sound of the frozen scree falling on the snow. Or the drumming of partridge wings in the branches, or the tracks of animals large and small on the smooth carpet. I would sing.

When I arrived at the bustling household, there was suddenly nothing to remind me of my village down below. I was unfaithful to the big house I came from, its church, its river, and its bed, and I felt no guilt for it. I was in my paradise, fully immersed in the human symphony of shouts and laughter and squabbles and babies crying and the roaring of the fire in the stove, the simmering of soup and the aromas of different stocks, the smells from the full troughs in the creamery where, in the summer, the milk was curdling to be made into cheese.

My paradise was generous. While in other places I found flies and wasps intolerable, here, their buzzing and humming did not frighten me, nor did the rough manners of the big dog outside. They were all part of heaven. All of them like God's little angels. All witnesses to the great Creator of all things animate and inanimate. All miracles, I thought, even before I knew the word *miracle*. And when I learned it, I was told that there was nothing in it to understand – that was its very definition.

In the large house by the lake, there were get-togethers on Saturday night. Everyone in the district came, couples young and less young, boys and girls of an age for falling in love. Since there was no parlour or dining room, the party was held in the single big room, the kitchen, where the furniture was pushed against the walls to make a dance floor in the centre for slow dances and waltzes, set dances and square dances. There was always a caller, as well as a fiddler, an accordionist, a harmonica player, and a jaw harp player, and sometimes a singer. Generally, these were all men. The women would see to the food and the coffee for themselves and the teetotallers. The men would bring their own drink, beer, moonshine, or jenever, which was known as *gros gin*.

Down in the valley, I had learned classical music, old French and French-Canadian folk music, and songs from church in Latin or French. Up here, these festive Saturday nights, I learned popular and country songs, which we called *musique western*. My love for all the different kinds of music of the world was born during these evenings.

One morning, in the kitchen, after sleeping in a big bed with two cousins my age, I witnessed a scene I'll never forget. I was alone with Aunt Adéla, we were chatting over coffee, the older children were outside, the little ones in their beds babbling. Before going out to the barn and the fields, Uncle Auguste had carried out his morning ritual: kneeling and saying his prayers in front of the crucifix, making coffee and a huge pot of porridge for the whole family, changing the baby's diaper and putting it back in white swaddling, and finally, taking the "little bundle" or "little doll" to Aunt Adéla – and we would hear it from the kitchen, sucking greedily.

That morning, like every other morning, Aunt Adéla had gotten up and washed while the baby was still asleep, and then she had come and sat at her place to eat porridge and thick slices of bread toasted on the stove, with salt butter and strawberry, raspberry, or blueberry jam made from the fruit the children had gathered all summer. Suddenly, the door opened and a devastated Uncle Auguste burst in. He was crying. Through his sobs, he told us his field of carrots was "finished." The carrots finished! They had frozen during the night. No carrots for the winter. All the seed planted for nothing. The beautiful field that only yesterday was being admired had died of the cold. No reserves for the fall, the winter, and the next summer. Auguste slumped into his chair at the table. Head in hands, he wept bitter tears, blaming himself for not having harvested the carrots the day before.

I didn't understand his sorrow. In my fourteen-year-old head, I wondered how a field of frozen carrots could be as valuable as something like a gold mine. And I had never seen a man cry.

Aunt Adéla comforted him. She brought him a good hot cup of coffee and rubbed the back of his head and his neck. Told him not to cry. Said they had so many other vegetables put away. She listed potatoes, turnips, parsnips, and cabbage. She talked to him of God, who had taken

everything away from Job and, because of his faith, had given it all back to him. Auguste was comforted. He went back to work. Adéla began her day. And I had seen a man cry for a field of carrots. I had witnessed a person I considered a saint weeping and sobbing. Since that morning, tears have been blessed to me, drops of the sacred from on high.

Auguste and Adéla lived to old age. After Auguste died, Adéla wore his best white shirt and black tie as mourning dress on important occasions for a full year, as they used to do then.

Adèle's Twin Brother

I had two Aunt Adèles: Adéla, my father's sister, Auguste's wife, and Adèle, my mother's sister, who wasn't married. Adèle was first a schoolteacher and, later, in her fifties, a housekeeper for her brother, my uncle, Father Léopold Beaulieu. The two of them lived together for years like a loving old couple. They were as thick as thieves. Adèle was part of all his moves from parish to parish. They travelled a lot and had a good time, as she liked to recall. They made several pilgrimages to Europe to places where the Virgin had appeared, Lourdes, Garabandal, and a few others, and always brought back rosaries, statuettes, and medals, which they gave us with joy like so many indulgences. We children were touched, until, having grown up and lost faith in these relics, we received them more coolly. But without ever telling them of our disenchantment. They were good and we loved them.

One of the talismans they brought back from Rome, which had been blessed by "the Pope in person," was a huge statue of the Virgin, which, they declared proudly, they had managed to transport in the baggage hold. It now stands in the cemetery near the family gravestone. They told me it would be lighted up at night. I've never checked.

In the final years of their lives, it happened that we lived in the same city, where they had both retired. "The seat of the archdiocese isn't just anywhere," they said happily, as if the ecclesiastical honour reflected on them and represented a kind of apotheosis of their lives on earth.

The last time I saw Adèle, she was in a hospital bed, where her dying went on for several weeks. In fact, she spent forty days and forty nights in agony. She had headaches that could make the white walls of her room tremble, having refused all painkillers "so as to do her purgatory on earth," her brother the priest said, and thus spare herself the ordeal of post-mortem purgation. Léopold added later, "She did her forty days.

It takes a long time to give birth to a whole life. And what a life! Your aunt was a saint, I tell you. You have to suffer a lot to deserve to be close to Our Lord on high."

That last time, unlike the others, she was smiling, her gaze was radiant, and she could speak real words. She took both my hands in hers and stroked my fingers and my nails, which seemed to delight her. And she made me understand through words and murmurs and by showing me her own hands, which were beautiful and pale but whose nails were too long, ragged, and dirty, that she would like to have a manicure like mine. In her face, I saw that her request, so simple for me, was of vital importance to her. Since I didn't live very far away, I told her I would come back within the hour and that she could take a little nap while she waited.

When she saw me return with my manicure kit, the expression on her face was ecstatic. Just as in the best beauty salons, I put a towel down, with a little bowl of warm water in which she could soak her hands, one after the other. I carried out the delicate work to the best of my ability. The result was fabulous. Adèle's nails were perfect. She examined them admiringly. And she smiled.

Then, having regained the words she possessed before her ordeal, she told me she would see Gérard again in heaven. Gérard was her twin brother, whom she had lost at the age of ten months. She had not seen him all that time. He had gone directly to heaven because of his infant innocence, and Adèle had lived. All her life, she had wished to see him again. Now, like her, he was eighty-six years old. And he was waiting for her. He had been waiting so long for her!

"I'm really anxious to see him," she said. "You know, he must look younger and better than I do. He hasn't suffered, he's been in heaven. Can you imagine? He grew up in heaven! He must not have any wrinkles." And she continued recounting her dream of finally being reunited with him after a lifetime of separation.

She told me how she yearned to look nice for the occasion. She wanted to have her hair done, and I promised to ask the nurse to see to that. She would wear her best clothes, the beautiful forest-green suit Léopold had given her for her last birthday. The gold jewellery he had bought her on their trip to Jerusalem, where, after Bethlehem and

Nazareth, they had finally seen the grave of "Our Lord." She explained, "You understand, I have to be dressed as well as Gérard." She imagined that he would be wearing shiny black shoes, an impeccably pressed white shirt, and a suit and tie such as she had never seen here below. "He'll be better dressed than all the bishops in the world," she added in the delightful mischievous way I knew so well.

In the dim winter light of late afternoon, while staff came and went, she turned her head slightly toward the window. The reflection of the sunset on the frost gave her face a soft pink tinge, and she still had a slight smile, which was waning with the day. She fell asleep, alone, as we die alone. I left the hospital.

The next morning, the telephone rang. It was Léopold, telling me what deep down I already knew. "She passed away during the night." He added, "By this time, she has already met her Creator."

And her twin brother, Gérard, I said to myself.

The
Christmas
Window

The year before the Christmas window
incident, I had lost much of my faith in God when Santa Claus came to
our house, with his red suit, his white beard, his big belly, his resounding
laugh, and his bag of presents. I was four. He sat me on his lap, and while
he spoke to the grown-ups without my understanding a single sentence,
I felt his breathing, like that of a huge bull charging down the slope of the
pasture, and I observed his attire. Suddenly, my impulsive hand shot up
to his beard, and I had the idea of pulling it – I'm not even sure it was an
idea, the movement seemed to happen very fast, all by itself. The beard
came off in one piece. Seeing his real face, I recognized a man from the
village who sometimes passed our house. There was no Santa Claus,
it was just that man! I howled the way angry children do at that age. Not
only was the party spoiled, but I had my first metaphysical experience of
total confusion and solitude – which, when you think about it, is what
always happens when faith in love is shaken.

The next year, when I was five, I was standing bundled up in my
snowsuit admiring the Christmas window of a little gift shop. It was
the first one in the village! Aside from the decorated Christmas trees in
our houses and the large Nativity scene in the church, I had never seen
anything like it. The window was filled with gifts. Toys and nothing else.
Of course, today's profusion of gifts was not the style then; each child
only received one gift, or sometimes, in better-off families, two.

Staring at this abundance, I was dreaming, no longer aware of the
time or the biting cold of late afternoon. There were all kinds of toys,
and I wanted all of them: dolls such as I had never seen, dressed as
princesses or as peasants with little cows; there was a little farm, with
its residents, its fields and barnyard; there were all the animals of the

world, a bear, a lion, an African giraffe, a peacock with a sparkling tail open like a fan, and dogs of breeds we had never seen in the valley, cats of all kinds and colours, including a pure white one that looked at me with its yellow-green eyes and wanted me to hold it in my arms, I could have sworn it was meowing; and little cars, garages, men dressed as mechanics, trucks, tractors climbing up hills; birds in a shiny purple cage; carriages and sleighs drawn by black, brown, or beige horses, with their drivers dressed like our fathers, with pipes in their mouths and whips ready to strike in their right hands. All kinds of toy buildings, too, with lights inside: from church to castle to mansion to houses that looked like ours to a little cottage alone at the edge of a winter forest on its white carpet of snow. There were even sprigs of spruce and pine in the ground. Featured in the centre of the window was a train! Like a real train, it travelled through the countryside on rails, and there was a plume of grey smoke coming from its engine. It was beautiful, it was too much, I was lost in enchantment.

Suddenly, I heard a voice right beside me. I turned; it was a man I had never seen before. He said, "Do you want to have all these toys?" I answered, "Yes," as if in a dream. He added, "Do you want me to give them to you right now?" Of course I did. Then his smile turned into a sarcastic sneer and he said nastily that I would get nothing, nothing at all, and he ran off toward the train station, I heard the train whistle, and he was gone.

I went back home, taking the footbridge across the river. I couldn't tell anyone what had happened. There were no words to express the horror. As if the meanness of the world had emptied my heart. I was as cold inside as the weather was outside. That stranger had sown the seeds of malice in a field of goodness and beauty offered for my delight. I was not only having a crisis of faith in God, of whom Santa Claus was to me the representative, but in humanity, which seemed even more terrible because it was closer. In my five-year-old's mind, I thought it might have been the devil that had appeared to me.

As with a rape of the body, I had lost my innocence. My spirit had been defiled. Much later, I understood why words to speak of the experience dry up after rape. When evil touches the place of the body's

rejoicing – pleasure, joy, delight – and what is most private and secret is the site of the wound, then evil becomes part of the body at its deepest level. Evil takes root in the very place of enjoyment and is exiled there. The body comes to possess evil, to breed its own evil. Its own unhappiness. How can you express this, especially when you're a child? I have known rape victims, little girls or boys, who have taken years to come out of the labyrinth of mutism. And others who never escaped it.

Unlike the year before with Santa Claus, I didn't howl or cry. And to comfort myself before going to sleep, I recreated the Christmas window. I saw it again and again, as later I would write.

The Marriage Proposal

My father, Jean-Baptiste, was twenty years old. He was tall and strong, and he was handsome. He worked for his father, Joseph-Auguste, who owned a sawmill. Joseph-Auguste had educated his sons so that they could help him in the mill, but also so that he could eventually start a company with them, which would expand throughout the Gaspé Peninsula and would do very well. "A thriving industry," said Joseph-Auguste, a man of remarkable vision, who liked to think big, and who, unlike the humble priests in their pulpits with their eternal refrain, "Blessed be ye poor: for yours is the kingdom of God," believed that the Lord and Master on high would bless wealth here below, recognizing it as an image of the splendours of eternity.

After studying at business schools in Quebec City and Chatham, Jean-Baptiste worked as an accountant for his father. At twenty, tall, good-looking, and educated, he was seen as a good catch in the village. There were a lot of girls who dreamed of him in their secret hearts. Everyone around felt he was ready for marriage. But he had yet to choose a girl and ask her father for her hand. Who would it be, people wondered, especially the women.

Jean-Baptiste did not go out much. He was shy. Or rather, introverted. He didn't go to parties or dances. He worked long hours, and he often went walking in the fields or woods or harnessed the horse Jos and went up into the hills, past the seigneury, all the way to Saint-Tharcisius or Saint-Vianney, stopping to dream, to contemplate the huge expanses of land not yet cleared, sometimes to imagine that he would put down roots there, establish a farm or a mill all his own, and there he would have a wife he had glimpsed in a dream or maybe even seen Sunday at church, and the two would love each other for life and have a large family.

When he wasn't at work or walking in the countryside, Jean-Baptiste would read. A lot. The Bible, of course, he knew whole passages by heart. But also, especially, books on history and geography. And he would dream. He would have liked to know the whole world. All the peoples of the earth, all the countries, and all the epochs. He would also think about the people he knew, his family and friends in the village and at the mill. He would consider them one by one and wonder why the Creator, his Creator, had planted so much imperfection, narrow-mindedness, greed, pettiness, and barbarity here below. He would think that more men than women had succumbed to evil. He found women better than men. Didn't say this to people. Kept his thoughts to himself. Found that most of his contemporaries were not worthy of such confidences.

So as not to sink into despair, and since you can't live without ever speaking, he would confide in Jos. Or imagine himself one day talking with his beloved, whose hand he would soon be asking for, he could feel it. Occasionally he saw his dreamed-of beloved at church on Sundays or at the post office, which people in those parts called *la malle*, using the old-fashioned Quebec word for it. Or on the platform of the train station, where he would sometimes walk in the evening when the *Océan limité* – as people called the Canadian National train the Ocean Limited – passed on its daily route from Montreal to Halifax, when groups of young people (and a few old ones too, sitting on the benches facing the tracks) would go to see the travellers who were leaving and those who were already in transit, most of them strangers, dressed differently, often speaking a different language – it was English, which few people in the village understood, but which they enjoyed hearing. Sometimes a passenger would come out onto the platform to stretch his legs and take deep breaths of the country air, and then, as if he'd had his fill of it, light a cigarette or refill his pipe after tapping it against the heel of his shoe.

One evening, Jean-Baptiste had seen his beloved walking on the platform with a group of girls, her friends. He knew that her name was Jeanne, knew her family, modest but highly regarded, and the little house at the edge of the village where she lived. It was a summer evening. In her light cotton dress tied at the waist with a broad sash of silk mousseline

that fluttered in the breeze, she was so charming, she had wide eyes that were a bit dreamy and smiling, a soft mouth that seemed to like to talk, and a flower in her hair like all the girls were wearing that summer. Jeanne was beautiful, and it seemed to Jean-Baptiste that she had smiled at him in passing. She must have been around sixteen, and she would be even more beautiful in five years.

"She's too young to be my fiancée, but she's old enough to be my intended. I'll have to go ask old man Napoléon for her hand soon." It was a daunting task. How should he formulate his request? What exactly should he say? He would think about it.

The night of the *Océan limité*, Jean-Baptiste had trouble getting to sleep, haunted by the sweet thought of being united with his intended. His decision was made. He would go see her father the following Saturday.

Old man Napoléon, who was a log scaler by trade, worked up above the village on Saturday in a huge field converted into a timber yard, where the owners of mills in the area would come for logs. In those days, they didn't raze the forest, clear-cutting would come later with the industrialization of the trade. The loggers would cut trees down one by one using axes. For every tree cut down, they would say, two would grow. It was a time when the forest was deep and endless, you could never see it all, you'd get lost in it. A time when trees were cut, sawed, and planed to build houses, barns, buildings of all kinds, from forges to shoemakers' shops, from mills to creameries – and churches, without churches, there was no future! "And without trees to build the country, no Canada," said old man Thomas, which people pronounced "Tomesse," from Joseph-Auguste's sawmill, "a dependable man," as they always said of him.

So that Saturday, Jean-Baptiste went to call on old man Napoléon, whom he already saw as his future father-in-law. He explained that he would like to "reserve" one of his daughters – there were four in the family, the eldest of whom was a nun and the next two, schoolteachers and, at twenty and twenty-two, already considered old maids.

"Which one are you asking for?" Napoléon had inquired.

"Your youngest," answered Jean-Baptiste. "She's around sixteen. Her name is Jeanne."

"You're choosing the most beautiful, and my sweetest. The other three, a nun and two old maids, are lost to men. I'll talk to Mother and then to Jeanne herself. If they agree, I'll keep her for you for as many years as you want."

"Four or five years would do. Have her educated during that time. I want a wife who knows how to read and talk, that will be important for our children. When she's a schoolteacher, I'll come and ask her the big question, I'll have a diamond, and I'll make her my fiancée."

"You'll be my first son-in-law," Napoléon had said. "Jean-Baptiste, I know you to be a good match, you'll make a good husband, I know you will never beat my little Jeanne. But in return, could you ask your father to send me a load of wood this week?"

"It's a deal, Monsieur Beaulieu," said Jean-Baptiste and solemnly shook hands with his future father-in-law.

And so it was done.

Jeanne and Jean-Baptiste first communicated through glances exchanged at church, then at the station and sometimes on the sidewalk in the village. Four years later, on a Saturday night, Jean-Baptiste went and asked Jeanne the big question in his future in-laws' parlour. He then placed the engagement ring on her finger. In her heart, Jeanne rejoiced and told herself she would have the most handsome husband and the best catch in the land. During the year of their engagement, they were always chaperoned by the two old-maid sisters, but they would sometimes manage to steal a kiss.

Jeanne was twenty-one and Jean-Baptiste twenty-five years old when they married. She had become a schoolteacher and had taught for three years in country schools. From then on, she raised her large family of ten children, including me. They lived, happily I would say, until eighty-six and ninety-one years of age respectively.

Ernestine
the Wise

Ernestine was Napoléon's wife and the mother of Jeanne, my mother. Many children were born of that marriage. Some, including Gérard, Adèle's twin, died very young, as was common in the late nineteenth century. Jeanne, born in 1910, was the last child, and was therefore pampered, and even, according to her siblings, spoiled.

While Napoléon was a bon vivant who liked to have a few drinks, smoke a lot, and have fun with his friends, Ernestine was serious and dreamed of a future of perfect saintliness for her offspring; one son did indeed become a priest, one daughter, a nun. As for the other children, they spent their whole lives going from partying and excess to repentance and contrition, except for Jeanne, the special one.

Ernestine was said to be strong and severe. We, her grandchildren, knew her as soft and gentle, tiny, tired, and by the end of her life, sick. Her death was sad, as any death of a loved one was for us children.

In her youth and her mature years, she held the fort of the family, often alone, and brought up her brood with a firm hand. She was educated, like her schoolteacher father, who died at thirty-two, leaving her a legacy in which a disproportional sense of responsibility compensated for the emptiness of loss, like a chest that emptied itself of its treasure. One might well wonder how a young woman managed who so early in life became older than her own father had been. Ernestine persisted; she was a woman of duty and never failed to fulfill her obligations. She was a midwife, and throughout her life, she attended at births as well as deaths. Her great asset was the understanding of life and of death.

Before the occupation of public letter writer was known, Ernestine practised it for those in the village who didn't know how to write. How many letters did she write for lovestruck lads who couldn't express their passion in words? How many of these boys were troubled, moved,

or delighted when Ernestine read them aloud what she believed to be a faithful translation of their feelings? Many of them were so grateful that they would have given her a fortune if they could. But all they could find in their threadbare pockets was a few cents, which was all that she asked. Ernestine was not rich, but they often were really poor. Her reward was seeing their happy smiles through their moustaches stained with sweat and tobacco. She also wrote letters of condolence. As her daughter Albertine, a schoolteacher, said, "Your grandmother was a creator of love and sympathy."

My memory of her is of an impeccable modest house with white-washed walls and polished floors, a silent house, where in the afternoon you'd hear the sad ticking of the clock weighted with eternity, punctuated by the clicking of knitting needles, the squeaking of the rocking chair, and the soft rubbing of the rosary beads against her big starched white apron.

But also, the memory of Grand-mère on hot summer days coming in from her vegetable, fruit, and medicinal herb garden – she was also a healer – carrying the makings of a snack she would prepare for us: a thick slice of her fresh-baked bread spread with strawberries and thick cream from her cow, generously sprinkled with her maple sugar from the spring.

One day shortly before her death at eighty-four, I saw her asleep in her big rocker, a shawl over her shoulders, her hands in her lap holding a framed picture that she seemed to have been contemplating. It was a daguerreotype of a splendid young man with long, slender hands like those you'd imagine a romantic pianist would have. A beautiful boy with a gentle gaze and a melancholy smile: her father and my great-grandfather on my mother's side, Louis Desrosiers, whom Ernestine had mourned for so long and would finally see again in paradise.

Rose's Parlour

Rose, my grandmother on my father's side, was what in those days was referred to as a strong-minded woman. She was beautiful and stout, and proud of her curves – slenderness and thinness were not yet the law of the land. Until the end of her life, her husband, Joseph-Auguste, called her "my lovely little Rose," and, despite their many lovers' quarrels, he only survived her by a month, weeping hot tears for his loss every day, imploring her by his pet name for her to come back to him, to the house where "the fire was lighted." He remained clinging to her pillow that whole long month.

The daughter of a family of Gaspé fishermen, she was brought up the hard way and had little education, but she steered the family ship with a steady hand. She had met her husband at the age of fifteen on a farm in the hills above Sainte-Luce, where, as the granddaughter of a cousin, she had been hired one summer for haying and other farm work. Those weeks were an idyllic vacation for Rose. She and Joseph-Auguste, the son of the family she was working for, made love the first time in the barn in the hay mow. Rose liked the adventure so much that she kept on doing it nearly until the end of her life. Until the fatal illness that ended her life at seventy-seven. That was in 1964. I went to the funeral in our village reluctantly, as you do when someone you love dies.

Joseph-Auguste and Rose had nineteen children. Some of them died in childhood, as happened in so many families of the time. I knew fourteen of the children. And on that side of the family, I had, if my count is correct, eighty-four first cousins. On Ernestine and Napoléon's side, I had more than forty. A clan. A tribe. A respectable community!

Their house was large and full of life. Since my father, Jean-Baptiste, was among the eldest, I knew the younger ones, my uncles and aunts, in their wild youth – their games, their songs, their rowdiness, their outings with girls and boys, their "running around" as Rose said, their carryings on,

their trials and tribulations, and their noisy pleasures. Then, each in turn, they married and left the big house. Some of them never came back; they died in accidents. These tragedies were met with operatic cries and tears. Those who came back did so for major occasions or at Christmas or New Year's, and a few aunts who left their husbands came back seeking refuge.

At each death and each separation, my grandmother Rose would find herself alone in the evening, in her chair at the end of the table in the centre of the big kitchen, and she would cry. When I slept over there as an adolescent, she would dry her tears with her big white cotton handkerchief and talk to me. About her dead sons, mostly, whom she called "my little boys," and about some of her girls, "the poor things," who had not had her luck and "had made bad matches."

Then, when she'd had enough of her sorrows, she would say, "Let's make ourselves a nice cup of tea. Get out the fudge. Let's play cards." She liked to play a game called La Politaine. The two of us would play and talk. Or when my cousin Carmen came, the three of us. Carmen and I would sleep in one of the upstairs bedrooms in a double bed with a creaky old bedstead where one of the aunts had slept. But before we went upstairs, we would play cards, drinking tea and nibbling fudge. And we'd talk. Especially Grand-mère. Until she said, in a tone that didn't allow for objections, "All right, girls, time for bed. Don't forget to kneel and say your prayers. And confess your sins." Rose wasn't excessively religious. She was of her time. In that country, God was everywhere, all the time.

Rose had a garden filled with flowers. Peonies were her favourites. I'd see her coming from the bushes, her arms full of peonies that were pink and white like her, with her redhead's colouring and tender complexion, her face radiant in the sun under a rich auburn bun that she sometimes protected with a broad straw hat. As a young girl, I once asked her what she did to keep her complexion so bursting with health, what cream she used. She answered by telling me what seemed obvious to her: "First, you wash morning and night with country soap; then, you rinse three times with hot water and four times with cold water." I never forgot her recipe. I might have dropped the soap, but the number of rinses, that I'll never forget. And each time, I think of her.

I don't think she ever wore perfume. Just her skin smelled good. With the smell of country soap, something like peonies and warm bread and soft snow, with a touch of sweet onion. Because she was often in the kitchen, her domain, at the centre of which sat the big wood-burning stove with many lids, two warmers, and two huge ovens. Rose was a great cook, and she taught her daughters and even my mother, a cordon bleu chef, who loved her mother-in-law as much as her own mother, that's what she said and I take her word for it.

At parties, when the whole family was there, the ones from the village and those who had come up from the Gaspé or down from Montreal, I remember what a beehive the kitchen was, with four tables of people, when Rose prepared a huge meat pie called a *cipâte*, as well as a turkey and a goose, both with stuffing, not to mention all the rest of the foods that came before and after these main dishes.

In her parlour, with its magnificent furniture, china vases, and the piano we had to play each time to "show our progress," Rose had an electrician install two plugs, one at each end of the sofa. She had measured everything carefully long before. This, she told us without apparent emotion, was for two candelabras, one at either end of her future coffin. She wanted to die in her house, she said, calling on us as witnesses. In her "marriage bed," as she put it. And for the viewing of her body to take place in her own parlour (it was the time when the first public funeral parlours were being established).

When she died, years later, it was in the hospital in the village, now a town. And the viewing took place at the funeral parlour. Rose Boutin, daughter of fishers who were modest but strong-willed, mother of nineteen children that she loved, had not been able to convince anyone of her final wishes.

During Rose and Joseph-Auguste's last years, it was Aunt Marguerite, their daughter, who lived with them in the big house, watched over them, and cared for them to the end. She was with Rose at the hospital when she died. Thinking she was at home, Rose said to Marguerite, whose name she pronounced "Magritte" in her accent from the southern Gaspé Peninsula, "Magritte, close the curtains and lock the door. We're going to rest." Those were her last words.

THERE

I swear, I can't go on,
the subject surpasses the teller.

– Stendhal
The Life of Henry Brulard

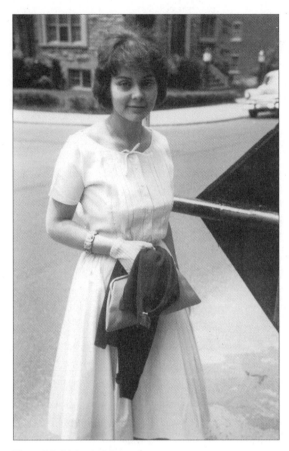

Young Madeleine in Montreal, 1957

Quebec City and
the Ursulines

I was fifteen years old. It was my first trip alone. By train. My parents couldn't come because of work, the household for my mother – there were five children after me – and the mill for my father. The four eldest were already away at their respective boarding schools.

I was going to the Ursulines in Quebec City. In those days before the Quiet Revolution and the democratization of secondary education, girls and boys who lived far from the urban centres and who wanted – and were able – to receive an education had to exile themselves in what were known as classical colleges, boarding schools run by the different religious communities, secular or cloistered.

I was going there with a heavy heart, a dulled spirit, and a body already constricted in a uniform that would not be taken off until the holidays: navy-blue pleated tunic to below the knee, light-blue blouse with long sleeves and round collar closed with a button at the neck, long heavy stockings, and brown shoes (on Sundays, the tunic, blouse, stockings, and shoes would be white).

Going with me in the baggage car, the inanimate witness to my former life, was a beautifully ordered trunk that I had enjoyed packing because everything in it was new and clean and sweet smelling and it was all mine. There were clothes, underwear, and toiletries, and of course, a missal with gilt-edged pages and a rosary of rock crystal, gifts received at my solemn communion, and other personal effects, all in neat compartments, according to a list provided by the convent. The contents would be examined on my arrival – as at customs – and they had to exactly match the list provided. All the clothes, towels, and blankets were labelled with our names. I had watched my mother patiently sewing on the labels. I had been thrilled to see my first possessions, as humble as they were, identified with my own name.

In the moving train, I became completely absorbed in the country-side so as to forget my terror at leaving my home and my two rivers, the one near the village and the one at the mill. Looking at the unfamiliar landscapes and contemplating the destiny that was already beyond my control, I thought of my little house that was so full of life. Like the country we passed through that disappeared behind us as the train advanced, what lay ahead offered no image. I was being thrown into a place made up of absences and fears.

Well aware that my only travelling companion, my trunk, was an inanimate object that could not share what I was feeling so intensely, I felt absolutely alone. I even said to myself, and I still remember this, that the loneliness would always be there, always with me. And that when I was old, I would be able to say: this loneliness is so vast and has been there for so long that one lifetime will not be enough for me to measure it; whether people I meet over the years cry their eyes out or laugh their heads off, it will always be there.

After the train trip, which ended at Lévis, and after the ferry crossing from Lévis to Quebec City, there was a taxi ordered by the monastery – as they called the site where the nuns' convent, the chapel, and the boarding school were located – which took my trunk and me to the school. I didn't exchange a single word with the taxi driver. I have no recollection of that man other than that he looked exhausted.

My introduction to life in boarding school, like that of all the other weeping girls, was brief and brutal. As soon as we crossed the threshold and went through the entry hall, a double row of metal bars, the gate to the cloister, opened and then closed again behind us. We were locked in, as I had imagined being in prison. So I was in prison. And my little house in the form of a trunk had disappeared.

Through the long corridors of polished wood, which I would find beautiful when I went back and visited the place years later, endless passages dominated by shadows and the obligatory silence, we made our way in a slow, docile herd to the large room known as the division hall, which corresponded to our level and age group. There we listened to our first words of welcome, in the form of a sermon: enumeration of the first rules, the first prohibitions, the principles to be respected,

some pitfalls to be avoided and mistakes not to be made, a detailed list of offences and punishments, timetables to be followed, from early rising to early bedtime. All at one time, we were given so many things to memorize that our brains immediately went into obedience mode and forgot everything else. Everything that had up to now driven us, excited us, enchanted or disheartened us, had to go into the shadow zones of gradual erasure. All that life would now be expelled from within the stone walls of the convent. Our spirits no longer had time to go outside. We were immersed in the norms of inside. One might just as well dream. Study. Write.

This preamble was followed by an endless prayer, which was punctuated by the smothered sobs of the girls. I had no sobs, no tears. Only the deep nest of a refusal that was beginning to dig its furrows, an underground spring of boiling water that, when the time came, would gush out in a torrent.

After this, we had to go down to the basement to get our personal effects, which we carried in piles in a slow, silent procession up to the dormitory where we had each been assigned our cell. In silence, because, except during short recreation periods, we were subject to the same rule of Great Silence as our teachers, who were "semi-contemplative mothers." In a way, in bringing us into their Great Silence, they were taking us with them into the arms of the perfect holy union they had chosen with the Almighty. Our teachers called themselves, and asked us to call them, "mother," as if we no longer had any. Any mothers. In fact, we almost didn't have. Our real mothers were far away, very far. They wrote us letters, sent us treats, and sometimes, too rarely, came to visit us on major holidays. The other nuns, the ones who weren't teachers but were assigned housekeeping tasks, were called "sisters." That was what we had to call them. With five sisters in real life, I found this a bit strange. That's the way it was, and we were not to discuss it. One more strange thing didn't make much difference.

In the dark, cold basement, I saw our trunks lined up in neat rows, like so many coffins in a huge cemetery. There were no epitaphs. Or flowers. Or the sky shining, day and night, above the graves. There I said my goodbyes.

Goodbye to the lively household filled with children's shouting, crying, squabbles, and laughter. Goodbye to my friend, wild nature in its vastness, with no metal gates, walls, or boundaries. Goodbye to summer at the mill, where we spent weeks in practically total freedom, between the clapboard cottage, the cookhouse, the timber yard, the log pond, the frog pond, the mill, Papa's office, the streams, the forest. Goodbye to the river, where we'd play for hours in the sun or the rain, fording it, swimming in it. Doing nothing but having fun in the long expanse of time. Goodbye to Jos the horse we'd sometimes mount to ride up and down the rough, dusty road between the stable and the timber yard. Goodbye to the trails in the woods, the leafy branches in summer, and in winter, snowshoeing or skiing over wooded hills and through clearings, surveying to the four points of the compass our two domains, our two valleys, that of the Matapédia River, with the family house in Amqui, and that of the Matane River, with the mill. Goodbye to going up to the mill in winter in a horse-drawn sleigh or a "snow," as we called the first Bombardier snowmobiles, which were as big as buses. With wide skis, they could hold a dozen passengers. In the summer, in a Jeep or a car, on horseback, or on a bicycle with balloon tires.

No, no sobbing or weeping accompanied my arrival at boarding school. But a state of stupor verging on catatonia, and a cold anger that slowly ate away at the heart of the wild child I was.

What was it that allowed me to keep going those two years? And above all, what made me study without any problems, and succeed? My love of learning, of course. Studying has never been a demand for me, but rather a passion and a pleasure. But there were other reasons as well. First, all our teachers in all the subjects were excellent. Despite the severity of their ways, the Ursulines were unequalled as teachers. For example, the one who taught us Latin knew the language like the back of her hand and would recite from the works of Horace or Virgil. I was dazzled. The same was true of our English teacher, who recited Shakespeare in Elizabethan English with the intonation of a tragic heroine. I remember her Macbeth. Fascinating! The same utter competence in French, in language, grammar, and literature. And in Greek. Mathematics. History. And music. My piano teacher was a true artist, and I adored her. With them, learning was an inner necessity, an exciting adventure, an art of living. Learning, reciting, ·

and writing, we would spend hours in what our teachers' magic turned from arduous work into an exhilarating game.

In addition, we were surrounded by beauty. The beauty of the place, which the imposed silence practically forced us to see clearly and to contemplate. We were surrounded by masterpieces, from the refectory to the corridors and the chapel. The furniture, paintings, religious ornaments, sacred vessels, liturgical vestments, wood carvings, silverware, embroidery – all of it there before our eyes, bearing witness to the skilled hands that were devoted to these arts, and, though it was laborious, were happy in practising them.

There I did my first two years of the classical college curriculum.

Two days before the presentation of the diplomas in Versification, I was called to the office of the mother general, who had not liked me from my very first day at the school. She had often told me of her loathing of "the backcountry of the backward people" of French Canada, "the faraway remote country" of the Abitibi or Saguenay regions, the North Shore or the Gaspé Peninsula, where I came from. She was interested only in the girls from families from the Upper Town of Quebec City. She had stated as much on the day of a grand sermon. On this day, she told me outright that if I wanted to come back to the college the following year, I would have to give up my first prizes – I had a few of them, in various subjects. She gave me twenty-four hours to think about it and come back with my answer. Not really understanding what was going on but sensing an abuse of power, I took, not twenty-four hours, but twenty-four seconds, and looking her straight in the eye, which was forbidden, because we had to show humility, I said, "I've made my decision, Mother, I'm keeping my prizes!" Unable to contain her rage, she shouted, "Get out, Mademoiselle. Out of my office, and out of the college next year. You are expelled. For insubordination!"

I left, insubordinate and unsubdued. And I had every intention of remaining that way. I've kept my promise, my life bears witness to that. And to my propensity to expose injustice in all its forms and my determination to fight it wherever I found it.

Years later, I recalled that the girl who had won the second prizes, and who would therefore have inherited mine had I given them up,

a girl I actually liked – there was mutual respect and emulation between us – came from a prominent family in the Upper Town of Quebec City. She knew nothing, at least I hope not, of the bargaining the mother general had carried on.

On the day of the presentation of diplomas, in front of my mother and my dear aunt Françoise, my father's sister, both of them dressed to the nines and radiant as always, I climbed the steps up to the stage to accept each one of my prizes, triumphant.

The seething subterranean waters sprang forth in torrents. My resistance had begun. It would last a long time.

Acadia, Life

Rebellion saved me. That, plus a mad desire to write that came from two sources. The first source was the great writing I had read, like someone parched with thirst drinking from the spring of meaning – meaning for this life that seems absurd. The second source was a simple truth I took to heart, a single sentence written at the bottom of a page by my French teacher: "I have finally discovered my poet!" I put my faith in it because, without admitting it to myself, I wanted to believe it. To write, to allow the possibility of happier endings and to ward off adversity, even death itself. That was my deep conviction, and it came from the very soil where the seeds of malevolence had touched the roots of hope.

In September of that year, when I was seventeen, I went away to another boarding school, in the Montreal region. It was a disaster. I had become hardened, and, sensing the arbitrary and unjustified nature of decisions of all kinds, I lasted three weeks. I felt adult enough to inform my parents that I was leaving the place on my own initiative and coming back to the house, and that I did not want to go to school anymore.

The details of my leaving the college, the long trip back, and my arrival at the home of my parents, who at first were not very happy to welcome the rebel I had become, are of little interest. Those emotional events were just an interlude preceding the weeks, months, and year that followed, which were sheer delight. It was by experiencing the very essence of freedom that year that I truly became an adult, or at least had the pleasure of perceiving myself as one. I wrote. I sang and played the piano – I learned to improvise, what a paradox! I went out with my friends. I discovered movies, especially the classic American westerns – we had two theatres where they were shown, the Mozart and the Figaro. I discovered another culture. I explored independence, although I sometimes covered up my excitement with nonchalance. I freed myself from all authoritarian

control, that of the Catholic Church, which was omnipresent and trium-
phant at that time, and that of the family. I lived. Fully. And I read a great
deal. How could I not read when the dream of writing remained in me
like embers beneath the ashes of my old life?

It was with my aunt Françoise that I went to the Figaro and the
Mozart and discovered American movies. We watched a phenomenal
number of westerns in those months. She introduced me to her close
friends and we all went out together. I discovered a world. All of them
younger than my parents by a generation, but old enough in my eyes for
me to feel privileged and appreciated because they treated me as an equal.
I was seventeen, Françoise, thirty-four, and the others, in their thirties.
Françoise was the most beautiful woman in the village, we all thought
so. A tall romantic blonde with blue eyes and a luxuriant head of hair,
she looked a little like Ava Gardner, whom she admired and adopted as
one of her Hollywood models.

Françoise and I went out together so much that I ended up mov-
ing in with her. That year, she was living with her parents, Rose and
Joseph-Auguste, my grandparents, with whom I felt very comfortable, as if
I were on holiday. Françoise had her six-year-old daughter, Astrid, with
her, whom everyone adored. Very charming and intelligent, Astrid was
"our little ray of sunshine," as the grandparents said. I spent weeks in
the big house, I loved its atmosphere, the memories that were not yet
heavy and sad, the freedom that reigned there. I didn't have to answer
to anyone. Other than meals, there was no program or timetable. The
hours flowed by according to each person's rhythm: six o'clock mass for
Grand-père, preparing meals for Grand-mère, with Françoise carrying
out the other household tasks in good humour. Nothing too tiring,
or at least so it appeared. My grandparents were probably resting from
the labours a household with a horde of children had once required.
Rose would spend the afternoon knitting for the Red Cross, of which
she was the regional president during the war, and when little Astrid
came home from school, she would rock her and tell her stories or sing
her "La poulette grise," her favourite song. She would often talk with
us, which she really enjoyed; "I sometimes get bored with your old
grandfather," she would say. At sundown, she would say her rosary and

pray for her "old dead," all of them in heaven, she was certain. And her
tears would fall on the rosary beads when she spoke of those who had
died more recently, such as François and Ozanam, who had been killed
in an accident in the Gaspé Peninsula in their early forties.

Grand-père Joseph-Auguste was beginning to show signs of a brain
that was aging, like the rest of his body. He imagined things that didn't
exist, but since they were happy things, it didn't bother us too much. For
example, although he was no longer working and had not owned the
mill for a long time – it belonged to his sons now – he believed he was as
rich as Croesus, and when he looked out the window at the now-empty
timber yard, he saw mountains of planks, to be shipped by truck and then
by train to Montreal, where his business associates were waiting for "the
best wood in the country." Every morning, he had me tally up his sales on
huge sheets of graph paper he'd kept from his glory days. I played the game;
he was kind, and he had taught me to calculate these strange accounts and
appointed me his secretary. I filled the sheets of graph paper with fictitious
numbers for rail cars of fictitious wood that would leave in the morning
on an invented journey to the CN station and then to Montreal, as they
had in the past. Joseph-Auguste was broke but thought he was rich. I told
myself, "He's happy, and in the end, that's what matters."

I slept in Françoise's bedroom, in the big bed with sheets printed
with pink flowers, the two of us surrounded by our movie magazines
with their stories about Hollywood actors, with whom we went to sleep
after saying our evening prayers. This was Françoise's reading, and mine
too. I shared my lovable aunt's dreams of screen goddesses. I lived in
the state of unquestioning well-being to which she seemed to have been
born and in which she gave no sign that she envisaged a different future.
I will always be grateful to her for allowing me this gentle transition
between the turbulent adolescence I had experienced until then and a
young adulthood filled with the simple joy of living.

Aunt Françoise and I talked a lot. About all kinds of things, but
especially about love. We talked, sitting on the cushions of her big bed, the
bedroom door closed and magazines all around us. She told me how good
love was: "You'll see when it happens to you, it's heaven on earth." No one
had ever described heaven or love to me this way. She was the first one to

say the word *orgasm* to me; she said, "You'll see when it happens to you, you won't want to live without it." She imagined making love with the most handsome actors. "Which one would I choose?" she would ask, looking out the window at the distant horizon. She would open the magazines and we would study them and choose our favourites. Hers was Cary Grant, or else Gary Cooper or Humphrey Bogart, and mine was either Gregory Peck or Burt Lancaster or Richard Burton. Those images of handsome men were the stuff of our dreams. We didn't know much about film. Watched the American movies for their stories and characters. Whether they were written and directed by Howard Hawks, Alfred Hitchcock, John Ford, or Elia Kazan mattered little to us. At any rate, only the current movies came to the valley, and no criticism or interpretations. It was later, through the film club at the college, that I became acquainted with a certain film culture.

Years later, I understood the aesthetic and social meaning of the masterpieces we had seen in Amqui. I imagine the same was true for Aunt Françoise. I had to travel on all the continents of planet Cinema in order to understand the filmed images that formed me. Sometimes when I happen to see movies from the year I was seventeen, which are now known as repertory films, with the appreciation I have of them today, my emotions of that time come back to me, as if the action were taking place on two parallel screens, the one that captivated me then and the one that touches me still. This doubles their power, and I am often moved to the depths of my soul.

Aunt Françoise and I also loved the Hollywood actresses. We had our models that we tried to look like, hers, Ava Gardner, and mine, Audrey Hepburn. Against this fictional backdrop, I learned to use makeup and dress in black velvet with a pixie haircut. This life of freedom was good and we enjoyed it.

Grand-père Joseph-Auguste began to worry about our frivolity and our "unwholesome magazines." He started waking me up in the night to go down to the kitchen and read him passages from the Bible that he had carefully chosen, each one harsher than the one before. While he sat rocking and sipping his little glass of brandy, I would sit on a stool reading long, boring passages. Grand-père would have his eyes half-closed in bliss, while I, exhausted, would fall asleep with my forehead on the sacred book.

Grand-mère observed all this "foolishness" of her "blathering old man with his religiosity," but at the same time did not approve of Françoise and me reading about these Americans who were surely all in a state of mortal sin. She must have spoken to my parents about it. One day, Jean-Baptiste came to get me, silent and authoritarian. On the road to our house, all he said was: "Your home is our house. Your mother needs you." In those days, a parent's word was law. I returned home. It was as if a page had been turned for me. I crossed the bridge at my father's side, and as Maupassant might have said, I walked in life as in a poem.

With the distance of years, this slight madness Françoise and I had experienced can be easily understood. Françoise, at thirty-four, just separated from her husband, Léo – they would be reunited the following year, move to Montreal with their two children, and love each other to the end of their lives – allowed herself to experience the youth that the harsh ways of the time had robbed her of. As for me, recently released from the prison of the Ursulines in Quebec City, with its share of passions held in check, I was in the midst of a transformation toward free flight, and the chrysalis was giving way. Françoise had reverted to her seventeen-year-old self, while I became mine with a vengeance. In a sense, we were the same age during those weeks, an age made for dreams.

We had both come a long way. And we were both coming back from a low point. We had grown up in one of the harshest places in French Canada of the time: the archdiocese of Rimouski, run with an iron hand but no velvet glove by Archbishop Courchesne, a brilliant man – they're the worst – aligned body and soul with the equally rigid, erudite Pope Pius XII, with his repressive political and sexual morality. It was a time of the Church dominant and triumphant, when our village, Amqui, was subject to the law and order of the boss and priest, Nazaire Caron, who ruled for some forty years over his obedient flock. Today, these men would be called fundamentalists. They laid down the law. Applied the dogmas decreed in Rome. Reigned over their people of sheep and ewes, great shepherds for the Lord.

And girls had the fewest freedoms of all. Had no right to learn to swim. Nor to play tennis or any other sport. The boys in the classical colleges would come back every summer with tales of their athletic

feats, which we poor girls could only admire and envy. There was a Boy Scout troop but no Girl Guide troop, despite the journey my friends and I made to the archdiocese of Rimouski to plead for one to be established, a request that was refused without any discussion, with the peremptory authority typical of the time. We had come back to the village determined to secretly form our own troop, with the support of our mothers and of the provincial commissioner, Blandine Neault, to whom I had written. As she requested, we sent the money for our dues, and she mailed us a huge parcel containing the uniforms we had dreamed of, in which we paraded down the main street every week: regulation hat, short skirt, belt with a dagger (a dagger that gave you strength and power!), whistle, and neckerchief, everything needed to impress and defy the adults, and frighten some of them. I became the leader of the troop of girls aged between twelve and fourteen. Of course, we had no chaplain. But it was decided that I would fill that role, and I did so willingly.

At that time, in that archdiocese, dance had been proclaimed a mortal sin from every pulpit. We danced, of course, at Camp Cartier on Saturday night, but our hearts were divided, half in heaven, half in hell.

I remember a story that was often recounted by the adults: Papa's younger sister Gisèle was happily riding a bicycle belonging to one of her brothers and she met Father Caron walking, as always, with his cane and wearing his big black felt hat. He was coming toward her as she went down a hill at full speed, her hair and her skirt flying in the wind, and she heard him shout "Shameless hussy" and felt a blow on her legs from his cane. He shouted, "Go home, you're not allowed to use that machine, it's reserved for the stronger sex. You will come to confession on Saturday." Gisèle went home in tears, enraged. Rose, her mother, did not know what to say to her. "You have to obey the priest, he's the representative of Our Lord on earth." So said the adults in my country.

Françoise and I came from that purgatory on earth. We wanted to get out of it. To escape from it. We didn't have the words to express this desire to get away. Not yet. Had someone suggested we climb Everest, we would have done it. Or crossed the Arabian Desert, so thirsty were we for the oasis on the horizon. We were given the Figaro and Mozart movie theatres. We quenched our thirst with the westerns,

with their handsome males and voluptuous females. They were our companions in hard times. They seemed so happy. So much happier than the illusory images of our childhood.

In the following weeks, while carrying out light household tasks to help my mother – and to learn the art of being a real woman, as they all said – I discovered the literature of Quebec, which we then called "French-Canadian," and which was absolutely unknown at the convent school I had gone to. It was in my mother's library that I found books by Laure Conan, Gabrielle Roy, and Félix Leclerc. I even wrote to Leclerc after reading his *Adagio*, slipping in a poem of mine and asking if he thought I had talent. He answered with a poem that ended with the words, "Yes, talent. But never forget love, nature, and God."

In March, my mother, who found my presence in the house rather pleasant – I only learned this some years later – began to worry about what would become of me and shared her concern with my father so that he would do something. Since he spent his weeks at the mill on the Matane River and was only at the house in Amqui on weekends, he was unaware of the daily events of our shared life.

One Tuesday, without warning, I was summoned to a meeting with him at his office at the mill – which we called by the English word *office*, pronouncing it "affice." Midas, his trusted assistant, came to pick me up in a Jeep. I can still see the scene as if it happened yesterday. Polite, as always, my father greeted me with a cup of strong black tea and then came right to the point. He said something like "This is all well and good" – I had talked to him about freedom the previous Sunday – "but what are you planning to do with your life? You're intelligent, you have talents, you have to put them to good use. Do you have any idea of what you want to do next year?"

In fact, I'd hardly given it a thought, I was so happy during these days that went by with no constraints and no real obligations. Without thinking too much, I answered in all seriousness, "I want to go to Montreal and become a nightclub singer." He could have gotten angry, shouted at me, told me I was an idiot. I saw that he was considering the question. Slowly, he began to speak. He drew a picture of the life of a "nightclub singer in Montreal" as a kind of prelude to a life of prostitution. If I were

to take that path, I would need a man to protect me, if not a pimp. So he would be my protector, and he would come to Montreal with me to find me an apartment. In a good neighbourhood. Would pay for the apartment at the beginning and help me until I could earn my own living. And so on and so forth.

He stood up, put out his hand, and said solemnly, "I'm offering you a contract. If you find another college, come back and see me after you've done your second year, and if you still want to be a nightclub singer, I give you my word of honour that I'll help you settle in Montreal." I shook his hand and said, "Okay. It's a contract. I'll find a college. I'll come back and discuss my plans with you after I've done another year of college." I stopped thinking about my dream of being a singer and became totally involved in finding a college for September.

The one I found was the formidable College Notre-Dame-d'Acadie in Moncton, run by a young religious community of Acadian women, the Religieuses Notre-Dame-du-Sacré-Coeur. All the good things friends had told me about it proved true upon my arrival – including the fact that some students who had been kicked out of their convents in Quebec for being "rebellious" and "insubordinate" were happily studying there alongside the Acadian students.

I couldn't believe it when I got there. It was a relatively new college, solidly built in beautiful grey stone, with a pleasant, bright, well-appointed interior. No rule of Great Silence, no uniforms, no visible sadness in the place – even the chapel seemed joyful – no dormitories filled with sorrows, but beautiful large double rooms as pleasant and comfortable as those in our homes (undoubtedly more so for the less fortunate among us). I shared mine with my cousin Carmen. The nuns, as good teachers, had seen to it that sisters, cousins, or friends from the same village were put together. As soon as I arrived, I heard talk and laughter everywhere, and hugs and stories being exchanged by the returning students. And the whispering of secrets being shared. And songs filling the stairways and corridors. The eager tribe of students was settling in for the year, getting reacquainted with the place and enjoying it.

I couldn't believe it! In pain and thirst, I had wandered an academic desert. Now I had reached a huge oasis. That proved true in the three

years I spent there. I finally saw that you could learn without suffering, work while playing, and be studious without being miserable.

I am extremely grateful for the years I spent there, and for the teachers, our companions in that great adventure of living. Realizing today the full danger of the hopelessness from which they quietly pulled me, almost without my knowing it, my gratitude is even greater now than it was at the time.

In addition to the school subjects I walked happily among, I spent hours in piano practice and theatre rehearsals. I no longer counted the passing hours as if I were in prison. The time we had was infinite, and the hours spent with the teachers were no less pleasant than those spent with friends. I read a great deal. There was not yet, strictly speaking, an Acadian literature, and Quebec literature, as an institution that existed in the networks of teaching and distribution, was about to take off with the coming Quiet Revolution. We read the great authors of nineteenth- and twentieth-century French literature, a few other European writers, and some North and South Americans. Without broadcasting it or rebelling openly, our teachers got around the law of the Index, which banned books deemed immoral or seditious by the Roman Catholic Church, so that we had access to Baudelaire, Rimbaud, Lautréamont, as well as Gide, Montherlant, Sartre, Camus, and others. I read, did theatre, and played the piano a lot. I began to write. Creating stories or even poems gave me paths of expression that allowed me to begin to think differently about the world and life, and within it, death.

In theatre, I acted in the very first plays by our teacher Antonine Maillet. A great teacher in her literature classes, she already showed signs of the wonderful stylist she would become. She helped me to understand the best writers of the time, and I will always be grateful to her for it. The same is true of Father Maurice Chamard, an extraordinary intellectual and artist. He had founded a theatre group at the boys' college Saint-Joseph de Memramcook, which, together with the girls' college, later became the embryo of the Université de Moncton. Father Chamard was my adviser in adolescence and he became a friend until his death. He was a lover of art, a scholar of poetry, a teacher and director of theatre, founder of the Faculty of Arts at the Université de Moncton, Quebecer by birth

and Acadian by adoption. Alas, he has not received enough recognition! Will somebody one day write the story of these pioneers of the soul and the imagination in Acadia?

I loved my college. And I loved Acadia, which is the most generous, welcoming, festive place I've ever known, where you discover the simple truth that anyone who doesn't have a sense of celebration, with joys, songs, and revelry, does not really know how to live, or even how to think. I made friendships there that will remain alive until my death. I've continued to go back there, and when I do, it's always a celebration.

I even loved the city of Moncton, which is not particularly famous for its beauty, but I found in it a charm and an appeal that were emblematic of what I experienced there – a passion for life. And I loved the language of Acadia, the same as my own but spoken differently, with maritime accents and a mixing of elements that opened new horizons. I didn't understand the inferiority complex some people had about their language; they even thought the Québécois spoke better than they did. Fortunately, thanks to their poets, their singer-songwriters, their novelists, and their intellectuals, the image of their language has changed for even the most timid of them, and that's all to the good.

I found it very hard to leave Notre-Dame-d'Acadie and Moncton and all of Acadia, but that was softened by the hope it had given me. New horizons were opening up before me. The future was mine. Choices were offered that put the wind in my sails. What would I do with my life? as my father had asked me three years earlier. I was hesitating, yes, but in exultation. I might go toward music. After taking part in the Maritime provinces section of the national piano competition in Halifax, I was offered four years of training at the London Conservatory of Music by the chair of the jury, who was a teacher there, if my parents paid the cost of my voyage across the Atlantic by ship. I thought about it. In theatre, George Bloomfield, who had chaired a jury, invited me to join his troupe in Montreal. I thought about it.

After an inner struggle, I chose writing. I had no idea where this choice came from. Nor did I know how to go about it, what direction to take to make my desire a reality. After all these years of doing it, is it any clearer to me now?

Montreal,
Freedom

I had only been to Montreal once, in 1957, on an "official trip" if I can call it that, and I had hated the experience from start to finish. My college, Notre-Dame-d'Acadie, had taken part in a Canada-wide essay contest on the subject of Marguerite d'Youville. Even the name was unfamiliar to me before I was given the assignment. Ten finalists had been chosen from among students in classical colleges from Vancouver to Halifax. And I was among them.

I remember the long, dreary train trip. I was probably nervous at the idea of going to the unfamiliar metropolis and having to take part in an interview in front of a jury that would select two winners, a girl and a boy – the lucky ones who would get a trip to France. I don't remember which students snatched the first prize. I only recall that they were from Montreal, from two of the major colleges, but I forget all four of the names – those of both the winners and their colleges. I took note of very little when I was eighteen. All I remember is my discontent during those long days. For the first time in my life, I was treated like a foreigner. I came from far away, and I was made to feel it. Nobody talked to me, as if I spoke a different language. Come to think of it, perhaps I did speak a different language, one from different horizons, forged by different landscapes or crafted by different jewellers, who came from the woods and the rivers.

I was met at Central Station by some nuns, whose names, faces, and words I've forgotten. The same amnesia with regard to the members of the jury, priests and nuns who froze my blood and my brain with questions I found inane. We slept in dormitories, in a convent for the girls and I don't know where for the boys. In a group, in a chartered bus, we visited an incredible number of monasteries, churches, chapels, cemeteries, and graves. We had a meeting with Canon Lionel Groulx in person, who received us in his huge library and gave us a signed copy

of one of his books. (Did I read it? I've forgotten.) I remember a very little old man with thin hair, old-fashioned round glasses, and delicate white hands, who gave us what I considered a sermon on race and the elite that we were, which bored me.

That was my first visit to Montreal. Luckily, there were more. Many more. Montreal is where I live now, and it is in a sense my base camp. I've lived here for half a century.

Is it possible to feel young and write the previous sentence?

That's the paradox of writing. Through the power of memory, it grants the writer two lives, that of the past and that of the present. The life of the past, in being written, becomes just as present and alive as the life of today – this is the simple truth.

I got to know Montreal and its freedom several years later, when I came here first to study, and then to live. Although I've spent time in many capitals, metropolises, towns, and villages in the world, I never found as much freedom as in Montreal. The freedom of Montreal, perhaps simply because I had chosen it, and free choice – of a person or place – is the cornerstone of happiness. Also, probably, because Acadia and its joie de vivre had given me the impetus to undertake, on my own initiative, a series of journeys across the world, to places I'd been dreaming of since childhood. But also because, coming from the more modest human geography of villages and small towns, without denying the grandeur of the countryside surrounding them, I craved, without really saying it to myself at the time, large populations and their habitats, the way of life of a concentrated human group. I found there the openness to others that arises from multiplicity and diversity – of colours, languages, dress – and at the same time, the solitude and anonymity that only big cities provide.

Oh, the freedom of a big city, how keenly I felt it the first times I walked in the streets, knowing nobody and not being known to anybody, not seeing faces half-hidden behind a curtain watching my comings and goings, as I had experienced so many times! Oh, that solitude I savoured on street after street when I walked an area alone according to my own plans, discoveries, or reveries! Oh, the pleasure of hearing so many unknown languages that opened so many paths to the world! And people moving in every direction along major thoroughfares and crowded streets,

appearing to be going nowhere while their faces expressed precise goals, exact destinations that were theirs alone. The happy face of some lucky person whose program of activities no one knew or cared to find out, or who may not have had any program at all, what joy! Was the person going to the post office? Or to mass? Or to work? Or to meet a lover? Or to one of the many hospitals? Was the person sick or dying, and was he or she aware of it? Nobody could have guessed. Lucky passersby who could be alone and free to decide their fate! And lucky me to discover Montreal: huge, colourful, open to other cultures. The city with no one centre, but many, the city inhabited not by a single people but by dozens.

I had, however, been told that the centre of Montreal was exactly at the intersection of Sherbrooke Street and St. Lawrence Boulevard. St. Lawrence, "the Main," which divided the city in two: the west of "the English" and the east of "the French," as we said in those days. St. Lawrence, which crosses the city from south to north, from the St. Lawrence River to the Rivière des Prairies. That's where the numbering of addresses starts in the west or the east, from 1 to infinity. And Sherbrooke Street, so long that it goes all the way to the country in both directions without you noticing, all the way to villages in the anglophone west and the francophone east, to meet the great festive waters of the St. Lawrence and its lakes.

To understand the city that had quickly become mine, I went to the central intersection with a map. For a good month, I took the 55 bus north and south on St. Lawrence Boulevard, and the 24 bus east and west on Sherbrooke Street, stopping to visit different neighbourhoods and taking the bus back the other way to my starting point. Some drivers began to recognize me. One day, noticing a driver's skeptical look, I said, to dissipate any doubt, that I was a writer working on a book about the streets of Montreal. I hadn't thought about it before. I said it quite naturally, the way you might say "I'm a surveyor." And the driver smiled at me. In fact, I *had* begun to write. It was in Montreal that I started to write in my head while walking or riding the bus.

I was registered in the department of philosophy at the Université de Montréal, in a master's program. Since our classes were given in the morning, five days a week, from eight thirty to twelve thirty, I had all

the afternoons and all the evenings to study and enjoy my new freedom. It was a celebration. I walked in the streets of Montreal the way one tours a museum. I went to all the museums too. I should say, I studied them. Aside from religious paintings and sculptures in churches, I had never seen works of art except in books. Real paintings, I said to myself. At twenty-one, I saw an exhibition of the Automatistes for the first time. I was astounded, and I still am. I was insatiable. I visited the galleries of Montreal, especially those on Sherbrooke Street. I took notes, I wrote in my head what I hoped one day would be commensurate with my discoveries, my daily illuminations. I went to the movies a lot. Less to the theatre or concerts, as I was still too aware of having so recently put them aside. I was not finished mourning my double loss. Will I ever really be? In any case, my budget would not have allowed me so many outings. And I did not want to play Lot's wife turning back to the places I had just left behind – music and theatre, scenes and lives still too alluring for me to go anywhere near them.

I also discovered the alleys of the city. I walked in them constantly, never at night, unfortunately, it was too dangerous for a woman alone, and even today, I often miss that freedom. In this respect, things haven't changed that much. When will we know that the first sovereignty is over one's own body? That fundamental independence is to be found there, in the freedom of movement of all adult bodies, regardless of their sex?

So in the daytime, I discovered Montreal, the city of back alleys, such as I had never seen anywhere else, and still haven't to this day. The alleys of Montreal, a city within a city, like a sea catching its breath between wave and backwash, between streets and alleys that belong to the same great waters, the streets visible and audible in their noisy swell, the alleys in their quiet ebbing. With their amphibious creatures, they wash up on shore, merging from crest to foam, making the same music, which comes from elsewhere, which comes from everywhere and speaks all languages. Anyone who doesn't know the alleys of Montreal and the music they lend to the streets, their great twins, does not know this city. In a few short months, Montreal had become my own, and it has remained mine.

But I was also attending all my philosophy classes. There were about thirty of us in the class, men and women. We stayed in the same

room, and the professors came to us. They were all men, which didn't surprise me, although till then I had only had women teachers. It was presumed that philosophy, on its imaginary promontory, was a male preserve. Forty years later, has this really changed? (In the world of thought, it could take centuries.) Almost all the teachers were excellent. Most were Dominicans, and most Thomists, it went without saying. That year, there were also two lay professors, who were equally remarkable, one of whom introduced us to Plato, the other to Descartes, as well as Locke, Hume, and Berkeley.

I often see the image of Father Régis wearing his beautiful long beige robes, his body thin like that of an ascetic, his dark eyes bright, and his smile sphinx-like, you'd think he was hearing Mozart in his head. He would come without books or papers, greet us, and write a single word on the board, *being* or *essence* or *substance* or *existence*, always just one word. We would spend the hour-and-a-half-long class in talk based on that one word. He used the Socratic method to teach us the basis of Thomism. He was a midwife of thought. A male midwife, who translated thought into words (and vice versa). With him, we didn't take notes or study books. We didn't memorize lessons to regurgitate in our assignments. We learned to think. We learned to translate this thought, these thoughts, into the action of words. In Father Régis's classes, I got in touch with the source of writing without knowing it.

That year, my awareness of injustice was put to the test once again. One of the professors warned us in the very first class that he would never give a girl a mark over 70 per cent, whatever the value of her work. There was a silence. Then someone dared, in a timid voice, to ask why. The professor seemed surprised and he took some time before answering. "Because everyone knows that girls don't go into philosophy at university to study, but to find a husband," he said in the authoritative tone of someone stating a self-evident truth. We didn't say anything. We were stunned. A part of our brains was still in the alienated, sexist, macho state that surrounded us all, men and women. And indeed, the best assignments of the girls received a mark of 70 per cent, while the boys' best ones received between 80 and 90 per cent. We got our marks and didn't say anything. That was the way it was. That was the way it was

when the earth was square and not round. That was the way it was, and we said no more about it. Period. I believe the earliest beginnings of my feminist thinking were born there. In 1960, in Quebec. On the verge of the Quiet Revolution.

In those classes where I experienced the wonder of learning philosophy, I also experienced the sense of strangeness I had felt three years earlier during my stay with the finalists in the contest on Marguerite d'Youville. All these young people who had come from the colleges in and around Montreal talked with each other if as they had known each other forever. Few of them spoke to me. They had established a solidarity based on their common background, probably unconsciously, but it was a fact. It didn't take me long to identify the only other stranger in the group, Paul B., who came from Philadelphia, where his family lived and where he'd gone to school. We quickly recognized each other. A friendship was born of that recognition, woven from the feeling of shared strangeness. That feeling seems to give rise to intimacy more quickly, because we very soon became lovers. I'd had a few flirtations and three or four passing romances, but with Paul, love, the real thing, serious love that dares to plan for the future, was born. Confronted with our colleagues' seemingly natural solidarity based on their common background, Paul and I established our own solidarity based on our common strangeness.

When we were preparing for our exams, we would spend delightful hours in the library studying furiously, and we would change libraries, going from the tower at the Université de Montréal – a mysterious, secret haven – to the Bibliothèque Saint-Sulpice, on St. Denis Street – a real masterpiece, with its tables and lamps and the reflections of the light from the stained glass windows on our books and our hands – to the main branch of the Montreal municipal library on Sherbrooke Street. We travelled to the books without fully grasping their significance until later, often years later. Going across the city to them allowed us to anticipate the journeys of our lives, which we hoped would be distant and many. Every day, or almost every day, Montreal, its libraries, and its books welcomed two young people from far away who loved learning and loved this city, and who were slowly falling in love with each other.

Then Paul Ricoeur came. It was at the beginning of the second semester, in January, that we were introduced to this professor from Paris, who would spend the term teaching us Immanuel Kant and his *Critique of Pure Reason*. His teaching would have a decisive influence on me for the rest of my life. Nothing had prepared us for his approach, so studious and rigorous, and so far from our ordinary understanding of things that many students were tearing their hair out trying to understand it. Ricoeur, a great educator, modest, not arrogant or condescending, would read entire passages of the *Critique* the way we would have recited Baudelaire's *La Beauté*. He gave us these passages in German and translated them into French for us (comparing his translation with others as he went along), creating a way of theorizing the translation of the Kantian concepts – with which he would play in parenthetical comments, relating them to the basic concepts of other philosophers from Aristotle to Hegel.

We were fascinated. Silent, merely scribbling notes on the fly. Some students were so disconcerted that they became discouraged. As for me, I discovered that I liked being disconcerted. I liked not understanding. I liked being thrown into spheres of abstraction, and besides, I got poems out of it, making something resembling my dreams of poetry from the thoughts I was tinkering with.

One of those thoughts was this: the basic thesis of the *Critique* is that there is a bridge (Ricoeur stressed the word *bridge*) between "pure understanding" and "pure sensibility," and this bridge is "transcendental imagination." I gave a presentation on this bridge. Later, I did my master's thesis on it. Above all, I made it the cornerstone of my subsequent choices. I realized that I could become a writer. That I was glimpsing the philosophical foundations of writing. That the bridge or passage of transcendental imagination was the very link of writing – its roots, its raison d'être, its purpose its fertile ground for the seed that would come.

In going to the Université de Montréal and in choosing philosophy, quite intuitively, I had sensed that I would reach that bridge. It was the chance encounter with Paul Ricoeur that enabled me to get there. It remained for me to step onto it, cross it, and see what lay on the other side. I'm still there. On that bridge.

When I left Acadia, I had decided I would finish my master's quickly. My ultimate goal was to go to France to do a doctorate. And I wanted to work to do it, determined from now on to pay my own school fees, living costs, and travel expenses. How would I manage all that? That would be a tall order, as my mother would have said.

For the time being, I had found what was essential. I knew what I wanted to study and where. I would study philosophy. And I would write. From Paul Ricoeur's course and a few others, another option had quietly arisen: psychoanalysis. I didn't yet know quite where this option had come from to water the soil. I would find out over there.

Paul B. was already about to cross the ocean. We promised each other that we would meet in a year. He told me we would be "pre-engaged." Gave me a ring from his family that had been used for pre-engagements, gold with a ruby, which he placed on the ring finger of my left hand that summer of 1960 at my parents' house. Which made my mother dream and imagine she was in one of her novels.

Return to Acadia

It smelled of hay, clover blossoms, and dried elm buds. A slight breeze made the strings of the air vibrate and brought the scents in through the half-open window of the train. My exams over, I was going back to my village in the valley for the summer. I would write my thesis and prepare for the year I was to spend in Moncton teaching at College Notre-Dame-d'Acadie, replacing a teacher who was going to be away for the year – none other than Antonine Maillet.

During the trip, I was reading an account of walks in Rome by Stendhal, my favourite novelist. I adopted his words and recited them to myself, and I still do sometimes: "I want to be understood only by people born for music, I would like to be able to write in a sacred language."

Yes, I really want that solitude of writing, and I want music, I said to myself, but why should I write this master's thesis, and on Kant, to boot, and why do I want to earn money teaching so that I can finally fulfill the dream of crossing the ocean and going to France, the land of my beloved writers, and why do I want to enrol for a doctorate, to study more and more and work so hard and with such fervour? I couldn't answer all my questions and I returned to my reverie, my contemplation of the landscape, every corner of which I felt I knew, I had been through it so many times, discovering it anew at every turn. I let the music of the train and the rails slowly produce somnolence and create sparks of understanding that, far from providing answers, raised more questions.

Like the words of our philosophy teacher at the college, Sister Dorothée, who made us delight in what she taught us, including some demanding writings by Thomas Aquinas, whom we called St. Thomas: "If you want to write literature, it would be good for you to do a master's in philosophy and get something solid into your head first. That way, you'll

build the foundations of your house. Later, with your books, you'll add storeys as you wish." I said, "Storeys, dormer windows, backyard, and front garden." She answered, "If you like!"

Like the words of my father when I must have been about ten – he probably said this to all his children: "If you want to study, you should study, the Lord gave you intelligence that it's your duty to put to good use." And he supported his words with quotes from the Bible. He also said, "You have to go to the end of the road of knowledge you choose, not halfway, not even nine-tenths of the way, all the way, and that end is a doctorate." He had named some of those roads – medicine, law, business, theology – adding with wonderment, "There are even doctors in the study of God, can you imagine?" and, raising his eyes to the heavens, "Doctors in the study of God!"

In the train taking me to the first studious summer of my life – I finished my thesis by the end of August – I didn't realize that I was fulfilling a desire of my father's, a desire marked by the law, in this case the divine law, nor that later, in becoming a writer, I would be fulfilling a desire of my mother's, she who had dreamed of books and the lives of writers, she whose life was often like a marvellous work of fiction, which she would recount, her words flowing easily. Until her dying, when she no longer spoke. She fell asleep then with a thick book on her belly that she didn't even have the strength to open, *Enchantment and Sorrow*, by Gabrielle Roy, a woman she greatly admired, who did not have any children but produced a brood of books, which my mother read when her own brood allowed her to get away from her daily chores. Then she would journey through books, far from us though physically present. We would see her in her armchair near the bookshelves, with an ecstatic air that she didn't have even when in church praying. I'd glance at her and see her drifting away holding her book, and I would look at the title. One day it was *Children of My Heart*, a little masterpiece by Gabrielle Roy that I read much later, and I knew then that those children were the students she had taught with such fervour in Manitoba when she was young. My mother had also been a schoolteacher in a little country schoolhouse before her marriage. They both belonged to a time when a woman couldn't have three "families" in her life, that of the marital home, that of the school, and that of books.

I belonged to the generation that, thanks to the Quiet Revolution and feminism, was able to combine all three: motherhood, teaching, and writing. Against our wishes sometimes, occasionally paying a heavy price for it in heartache or feeling torn inside.

I was taking the train back to my origins. I had in me a need to write, like a thirst, coupled with a wish to earn my livelihood teaching and a mad desire to go to faraway places, a desire for the unknown, for new and strange places, which would take me to the deepest and the closest places within me, as I was later to learn.

The summer I was twenty-two was a happy interlude. It was the last summer I spent living in the family home. Not yet knowing this, I experienced none of the heavy nostalgia of leave-taking. I wrote my thesis without thinking of the nagging question of the writing to come. Like an athlete who no longer thinks in the heat of action, I lined up sentence after sentence with the sole aim of reaching the finish line and starting another race, another chapter, in a rush to be done with it and get on with the future I imagined in the distance. Just as the Kantian transcendental imagination I was writing about served as a bridge between "pure understanding" and "pure sensibility," this experience served as the basis for the writing I would do when the time came.

So in September, I went back to Moncton and my Acadia. The year lived up to my plans and dreams. In accordance with my contract, I taught contemporary French literature and Latin to girls who were only two or three years younger, who were in fact my old friends, which made it like a celebration for them. Rigorously following the compulsory curriculum for this level, I stressed my favourite works and authors: Virgil's Aeneid, which I still knew by heart in both languages, the original and the French translation, and Camus, whom I remember the best, because his writing, both non-fiction and fiction, allowed me to build my own scaffolding, which involved deconstructing, stone by stone, the huge edifice of Aquinas's five proofs of the existence of God.

We had fun playing this game, writing all sorts of inflammatory fragments, contributing in our innocent way to laying the groundwork of an intellectual transformation that would later be known as the Quiet Revolution. Unfortunately, however, our games did not please

the religious authorities of the college. Without having to do penance, I had to retreat. After all, my goal was to teach there in passing, so to speak, and to save a good part of my earnings – the first in my life – for my journey to come. And that's what I very sensibly did.

That year, with my friends and roommates Réjane and Rose-Marie, and John, Réjane's future husband, I was part of a quartet – piano, violin, and tenor and soprano flutes – which filled a large part of my leisure time. For me, this was a way to avoid abruptly giving up music, which was essential to the breath and rhythm of my entire life.

The pre-engagement ring was returned to Paul B., who was doing a doctorate in Switzerland. It wasn't a breakup. It was by mutual agreement, both of us totally taken up with our respective hopes, dreams, and utopias. In this separation without suffering, this absence where our letters simply stopped, this unavoidable lack, writing began to create its crucible.

FAR

I miss the people I love,
even when they're there.

– Christian Bobin
interview with Laure Adler

Student card from the Cité Universitaire de Paris, 1961–1962

The Atlantic
on the *Homeric*

The horn announced our departure. We heard the rusty sounds of the anchor being weighed and the moorings being cast off, and then the creaking of the gangway as it separated from the dock, like the crying of a baby when the cord is cut.

We were setting sail. The steamship *Homeric* was going to take me toward an odyssey of my own. I saw my friends among the crowd on the dock waving white handkerchiefs just like in the movies. I swung my arm in a wave of goodbye. We would not see each other for a good two years – that was the length I had planned for my trip and that's how long it turned out to be. It was a time when crowds of tourists didn't pour daily into all the cities of the world, when crossing the ocean took as many days as there were hours of time difference, when travel in a way respected the curve of time.

September 1961, I had just turned twenty-three and I was headed to the port of Le Havre to meet my destiny. The future was my only concern. Already, my brief past seemed far away, while the people on the dock were becoming smaller and smaller as the ship moved through the waters of the St. Lawrence. I was already nostalgic leaving Montreal, even though I rushed to the bow to get a better sense of where I would soon be: in the middle of the ocean, going toward the centre of my life. I remained on the highest deck until darkness fell, until I could see only a few tiny lights on either shore blinking under the canopy of stars, blurring together as a result of both the ship's pitching and my half-asleep state, which led me up the stairways of iron and rope to the little cabin that would be my home for six days and six nights.

I had felt the ocean was my place of writing. Here, it was the silence of my writing. I didn't read either. Didn't open books or notebooks. Aside from the hours of sleep, meals, and conversations with a

few friends who were also going to study in France, I spent my time on deck gazing at the expanses of moving water that were always the same, always different. How to write when you've lost all your landmarks? No landforms, mountains, lakes, rivers, forests, or roads. Only the limitless space of sky and water. With a horizon line that constantly carried you beyond your gaze. You inevitably became all hearing and all smell, open to what the skies and the tides offered. I was taken. Enthralled. In the arms of the gigantic elements.

I saw no fish or boats during the crossing. There were only waves and more waves, whose height and force varied with the tides and the currents, waves I sometimes imagined to be as deep as the highest mountains are tall. I'd try to glimpse those marine Rockies or Alps and I'd get dizzy, feeling myself reduced to a tiny point on this choppy surface of a liquid planet. Suddenly I would be filled with fear and a feeling of the pointlessness of writing and a desire to throw into the sea anything signed by my hand, to be scattered by the winds like ashes or dust.

Moving back from the rail, I would see within myself the time of my passage through this world shrunken and coagulated, and I would stop thinking, carried away by the limitless beauty before my eyes and all around me. It comforted me, especially at night when I was enchanted by the stars and the moon, the emptiness and the light coming from the blackness itself. Absorbed in wordless contemplation, I felt it was indeed possible that if one day I wrote, it would be to bear witness to the magnificence of the elements. For that reason alone, that enormous reason, I would write. This certainty, without any evidence, reconciled me with the universe, with all of life and its finitude, with all the excesses and follies of humanity, and with myself, as if after childbirth, as I would later confirm.

On the ocean liner, I no longer thought about writing and I no longer thought about love. I had left my lovers, one by one, without bitterness and without blame. I didn't hate any of them, and even today, if I were to meet one of them, I can easily imagine what a pleasure it would be to talk, to tell each other about our lives – for those who are still living, of course. I've already lost four or five, now gone to the other slope of life, into nothingness, or somewhere my thoughts cannot reach.

I no longer thought about the torture and guilt related to the inevitable loss of a stifling religion. The ocean swallowed the burdens of my short past, in which the words *engagement* and *marriage* rang like knells, mingling with the great marine orchestra, blending into it, the better to disappear, I thought, delighted. I had undoubtedly felt my body and my spirit fettered. I put all my energy into casting off my moorings, and I moved forward over the water. I saw marriage as a banal jail, a prison of normality, which demanded so many sacrifices, including studies and creative work, and more broadly, freedom. I was escaping its bars and shackles.

On the water, I let my reveries of the world drift in the wake of the ship, just as I had done with my thoughts on land. It was a time when youth could not make love without the blessing of the Church, that is, without the sacrament of marriage. The law that governed our young desiring lives etched on our flesh the double tattoo of forbidden and sacred. It was a time when sexual prohibitions were very strong, and when we contravened the law, boys and girls alike were ruled by the guilt-inducing ideology that the girl had to be a virgin until the threshold of the altar. Of course, we permitted ourselves lots of sexual play. However, there was no contraception, and when it did become available, the Roman Catholic Church maintained its prohibition. The shame heaped on unmarried mothers was absolute and their dishonour was great. Young girls paid the price for one of the great taboos of the time, and they paid dearly. Social condemnation of unwed mothers was like a huge black star that would long shine in our collective dark night of the senses.

In my early twenties, I saw marriage merely as a religious and legal authorization to make love. My rebellion was fuelled by all the books defying the blacklist of the Roman Index. I rejected what I considered false, the lies in which we were all immersed. As for religion and my torments of the past two years, I simply didn't think of them anymore. I left it to the land I would soon be entering to bring me back to what I had left behind, the transcendent faith shared by the vast majority of my fellow citizens, the triad I had tried to better understand and perhaps free myself from, which I ranked in the following order: God, Jesus Christ, and the Church.

While I was on the ship waiting, major events demanded my observation. Witness to sky and water, my retina registered the changes and cadences, the movements and rhythms of sun and moon when the cardinal points become lost to the naked eye in the immeasurable distance and the stars and then the constellations drew another map of the heavens, which I was learning to read.

When we crossed the great unfathomably deep basin south of Cape Farewell in Greenland after lurching through the tides of Newfoundland, a storm that had arisen from the churning of those ocean basins shook everything up to the sky, unleashing torrential rains, and the ship, on which the tables and chairs and other furniture had been fastened to the walls with ropes, suddenly seemed like a tiny cork tossed by wind and waves. With the pitching and rolling, we all returned to our cabins to the sound of sirens and loudspeakers barking orders.

The fury of the storm outside had penetrated deep into our bodies, whose rivers and streams in their turn underwent the revolution of the humours known as seasickness. Stretched out on my bunk in a state of nausea and vague somnolence with my ear pressed to the thin mattress, I seemed to hear, beyond the howling of the waters, the tearing of the earth's belly beneath, millennial moaning echoing to the underground entrails, the secret galleries and corridors piled with bones, treasures, and raw songs aborted, nipped in the bud during ancient crossings. I seemed to hear the echoes resounding all the way to the continental shelf below, to the long mid-ocean ridge, and to all the epicontinental seas, the Mediterranean, the North Sea, and the Baltic, transmitting throughout their waters the news of our Atlantic tremor. I fell asleep that night with the image of the lights in the sky and on the land left behind on the shores of the St. Lawrence, clouds of sparks strewn by a giant hand like that of a God of night anonymous and silent, hidden with the shadows, and with no religion.

When calm returned, I went back to my normal life, if being on a ship can be described as normal. After all, aren't rules, codes, and conventions needed for the smooth functioning of these overpopulated little islands that open to infinity? I understood quite soon that this openness had within it the conditions for its being closed. No one could

escape from this cloister surrounded by the impregnable wall of the waves. No path, no trail by which to get away and go who knows where? Elsewhere, over there, a village or a forest, a desert, a road, or an oasis or a peaceful lake to lie down beside, to rest and cool off. I felt like getting off the ship to take a walk and I found myself a prisoner of the infinite spaces surrounding me.

For the first time on this trip, I had a desire to write. To write about this impossible freedom in the extreme latitude I'd given myself in order to achieve it. I had allowed myself an extraordinary free space, in which, in the end, I was trapped. I said to myself that later I would even write about this. But when? I didn't really care anymore. It was as if, without realizing it, while preparing to change the point of view from which I perceived the world, I no longer thought about it. The ocean had in a few days opened the way for me to a state of latency where reveries of people and things became the basis for understanding them.

In conversations or walks with shipboard friends in this floating town at once open and closed, I heard the call of the sea and went to meet it. I climbed the stairways to the upper deck and, clinging to the handrail, I listened to its song, its age-old lament, and its exultation. There opened up within me so many memories that I returned, wave after wave, to my own birth. I had come into the world from the aquatic maternal womb. I'd been born here. I was now crossing the huge basin of my origins. I was born of this passage. I recognized myself in it. Reconciled, I went forth, soothed, toward the unknown.

One day, before even glimpsing the line of land on the horizon, I felt the land, its animal warmth permeated with vegetable and mineral smells. As we moved forward, we saw more and more birds coming in flocks to greet us. Soon the coast of Ireland, and then of England, emerged from behind fleecy mountains of cloud. Above our heads, seagulls wheeled and shrieked in a single ballet and a single language that seemed impenetrable, a language in the form of cries and songs like those of our shores of the New World, no doubt a universal language found on the shores of the entire world. They were accompanied by the snickering of terns, those swallows of the sea, joyful as their sisters on land, coming in great multitudes in frantic spirals, moving together

toward the swells offshore. At times, I could follow the beating of wings on the little coloured paths traced by the blinking rays of the sun. From the rocks scattered along the coastline came those strong flyers, the gannets, whose flight, made heavy by their webbed feet, lets the wind pass like an organ, the music rising from the mineral valleys of the water that dies murmuring with the backwash on the stones and pebbles of the shore.

We were in the Irish Sea, travelling along the coast of England to Liverpool, where the *Homeric* would stop for a few hours to unload part of its cargo of humans and merchandise before going down to the Celtic Sea, crossing the Channel, and landing in Le Havre, France.

I saw people milling around in the port of Liverpool, those getting off the ship and those meeting them. I heard the shouts of the dock workers mingling with those of the sailors. There was the same hustle and bustle at the port in Le Havre. And on the platform of the train that would take us to the Gare Saint-Lazare in Paris. I was swept away by a shouting, clamouring human swell. I had arrived in Europe.

Wherever I went, I saw noisy, energetic people jostling, harried, or boisterous. The ground pitched beneath my feet like water. I was landsick. In the train taking us to Paris, the music of the waves and the backwash melted into the rhythm of the rails. I was no longer in the dreamlike anticipation of the journey. I was in it. I had arrived. My head leaning on the shoulder of my destiny finally reached, I slept all the way to Paris.

Paris

"Athens was never white," wrote André Malraux in *The Voices of Silence*. This was the first sentence that came to my mind when I walked out of the Gare Saint-Lazare and saw Paris all dark and dilapidated, drenched in sweat, stained with smoke under an overcast sky grey with rain. I had dreamed of this dazzling city. How disappointed I was seeing it for the first time! After so many books and films, my imagination had created a city of light, and now, at the end of September 1961, I found before me a city of shadows.

The great cleanup of Paris would begin a few years later. The scrubbing of streets, avenues, and boulevards, sandblasting of stone buildings and monuments, polishing of marble, scouring of facades, and restoration of sculptures would give Paris back its former glow. The French state, whatever the party in power, would invest the funds needed. After several decades, Paris would become that beauty of a city the entire world would flock to and admire.

The young North American woman I was could not find beauty in this dirty, turbulent city that flaunted its torn, foul-smelling guts. Could not yet understand that the wounds of war were still fresh. Was unable to see the beauty for the scars, or sense the grace behind the poverty she had never seen before. Was not able to experience the charm of the urban body beyond the repugnant odours of urine, animal feces, and old tobacco on fetid breath. And the smell of coffee as strong as an abrasive fumarole, the like of which she hadn't tasted in her country.

So Paris was at first a disappointment. Darkness. Dilapidation. Bad smells. Postwar discomforts. And wounds of war that I was unable to read.

I was spat out of the station into one of the arrival areas with my baggage, basically a big trunk containing everything I'd need to live for two years – I'd given away to friends a good half of my modest possessions, books, records, clothes, and other impedimenta. I took a taxi to a

dreary building on Boulevard du Montparnasse, where the driver said I could find an attic room. He even helped me get my trunk up six flights of stairs after I had agreed to the rental conditions with a sinister-looking concierge with a vacant gaze. I wanted to add a small tip to the cost of the taxi, despite my limited means, but the driver refused, on the verge of tears, saying, "No, Mademoiselle, I owe it to the Canadians who came and saved us in Normandy." He continued with some comments on that awful war and wished me good luck and a pleasant stay. I've rarely felt such distress, such loneliness as I felt after the taxi left.

I made a quick examination of my home, with its closed horizon, and assessed where my desire for freedom and independence had brought me. A single small window that looked out on a crumbling old stone wall, with no view of sky. A rickety bed with a broken bedspring and dingy sheets and blankets. A tiny sink with no hot water; "W.C. and bathtub on the fifth floor," the concierge had said, stuffing my week's rent in the big pocket of her apron.

I stood in the middle of the dismal room in a state of shock. No more music of the waves or birds. No more outdoors or a horizon to breathe, to see elsewhere, to see farther. To the sound of the rain on the neighbouring roofs and that of the incessant dripping of cold water in the rust-stained sink, I decided, even before I opened my trunk or my bag to take out, who knows what, a book that would provide help, to stretch out on the bed and think and rest. "You didn't want help from anybody," I told myself, "not from your father, not from the government, which could have provided a fellowship, not even from the Cité Internationale Universitaire de Paris international students' residence, where most of your companions from the *Homeric* were merrily heading. Too bad for you! What were you trying to prove – how strong you are, how resourceful, how brave?" I fell asleep castigating myself and in severe but tearless pain.

After a narcotic sleep of a good twelve hours, I was awakened by hunger. And what hunger! I could have eaten an ox! Still fully dressed, I didn't spend much time getting ready. I washed quickly and glanced out the blind window to check the weather, but saw only dim light. At least the rain had stopped, maybe it was nice outside. I dashed out,

rushing down six floors, catching a quick glimpse of the deeply vacant gaze of the concierge, who was perhaps wondering about that strange bird from the north that hadn't budged since the night before and was now moving like the wind. I must have said hello to her. All I remember is being outdoors.

And what an outdoors! On the sidewalk, in bright sunshine, I found myself in a crowd that was racing in all directions, with voices and shouts in many registers, like an orchestra tuning its instruments in a nervous yet cheerful cacophony. Like the overture of a modern opera greeting this beautiful morning. Paris speaks louder than Montreal, I thought to myself. In the evening, its residents must be more tired.

I kept walking quickly, on the lookout for a restaurant. With hunger gnawing at me, I didn't have time to study menus or slates and I found myself in what seemed like a palace, with gleaming copper pots and pans and sparkling glassware, flamboyant red velvet banquettes, and immaculate white tablecloths. A waiter in a smart uniform, also white, quickly seated me at one of the tables. I read the menu without understanding all of it, although the words were in my own language. And in my own words, the only ones my hunger knew, I ordered "two eggs sunny side up, bacon (pronouncing *bacon* as we do in Quebec), toast with jam, and coffee." I added, "And half a grapefruit, please." With a slight smile that struck me as ironic, the waiter replied, "If I understand correctly, Mademoiselle would like . . ." and repeated my order, translating it into French from France. We agreed on the type of bread and coffee. My meal, which was both late supper and breakfast, arrived on fine china, with crystal and silver cutlery. Famished, I emptied every plate.

The bill was so steep, I couldn't believe it. I had with me, in a shoulder bag I was wearing with the strap across my chest, my whole fortune, my entire savings, which would last me two years, I had thought, if I was lucky. And now in a single breakfast, I had gobbled up my budget for a whole week!

I understood much later that at that hour of the morning in Paris, you don't order that menu. I learned, too, to distinguish the fashionable, the ordinary, and the poor, and I realized that I'd found myself, without knowing its significance, at the luxurious Café de la Rotonde – where

these days I occasionally return in the evening, and each time I do, I say a silent hello to that young girl, alone and a bit lost on her first morning in Paris.

Dejected, I went back to my broom closet. In a flash, I understood that I had to leave that hole. I had come here to study, and I was going to give myself the material conditions I needed in order to do it. An hour later, I found myself at the Porte d'Orléans metro station. I walked along Boulevard Jourdan to the Cité Internationale.

At the Canadian students' residence, I asked to see the director, Eugène Cloutier. He was friendly, but he showed me the pile of applications from students waiting for places. I had never submitted an application. He opened a file for me, noted my contact information on a large sheet of white paper, and placed the file at the bottom of the pile, saying in a kindly tone that my wait could be long, "very long." Then he asked me to talk to him. To tell him why I had undertaken this long journey, what my plans were for my studies, and why I was there in his office that day.

I don't remember what I said. I must have talked for a good hour. I talked, he listened. I told him of my desire for psychoanalysis, philosophy, writing. From time to time, he asked short questions. I also told him where I came from. My village, my parents, my family, my studies, from the Ursulines' school in Quebec City to Acadia to my master's thesis on Immanuel Kant at the Université de Montréal. As well as the writers I liked and the huge windows they had opened to the world for me, and also Paul Ricoeur and the "bridge" of transcendental imagination. I liked talking to this man, who urged me to continue. Suddenly, he took out my file and put it on the top of the pile. In words filled with esteem and affection, he told me he'd make my application a priority. That he'd find me a room in one of the houses of the Cité Internationale and would send me a message by pneumatic post in two or three days.

I left there on wings and went for a walk in the beauty of Montsouris Park across the street. Sitting on a bench near the lake, I felt both at home and elsewhere, in that place between near and far that I would constantly seek, that gentle state where the strange meets the personal in a kind of marriage, always dreamed of and never fully achieved, between what will forever be an enigma and what seems always to have been familiar.

The blue of the sky was the same as at home, and so were the wingbeats of the birds, but at the same time something of their light or their form escaped me and would lead me to active contemplation and an ever-renewed desire to study their differences. The display of vegetation, the trees, shrubs, and flowers, the delicate forest that seemed to have been smoothed, combed, designed, and retouched over centuries, while it was not like the wildness of the woods of my country, brought me back to those natural cathedrals fallen from the sky between rocks and rivers or planted there at random in the huge spaces and the harshness or softness of the northern seasons.

I still remember the precise place where on impulse I went to touch and smell the bark of a very old tree – it was a plane tree and not a more familiar maple, poplar, or elm. I felt its smooth, polished bark and its long, thick leaves; if I had been alone in the park, I would have hugged it. I remember its intoxicating scent, which was new to me. I would be living across the street from it. I said out loud to myself, "Yes, it's possible. I've arrived. Paris is opening its doors to me. I will dwell in its house. I will discover it."

The next day, a driver came in a truck from the Cité Internationale Universitaire to pick me up and take me to the Fondation des États-Unis, where Eugène Cloutier, my good Samaritan, had found a room for me. Did I thank him enough? Sometimes I doubt it. Youth is often ungrateful. The feeling of gratitude and the satisfactions that come with it, like ripe fruits, take time to develop. When I saw his death notice years later in the newspaper, I promised myself that one day, as a writer of public words, I would pay tribute to him.

I'd like to get straight to the point about what I experienced during my two years in Paris. In retrospect, it seems to me that those two years became a touchstone through which, during subsequent events in my life, I would be restored to myself from infinite divisions like so many thin layers of flint. Each time, I would be fundamentally reconciled with myself. The number of events that came to be attached to this kernel

might suggest that I rushed madly through Paris, the rest of France, and the adjacent countries of Europe. However, in terms of the impact of new friendships, courses at the Sorbonne, repertory films, theatre, and museums – in France, Italy, Belgium, Holland, Germany – it seems to me, looking back, that a musical score was written that was dedicated to time taken slowly, to the rhythm of a thought that pays tribute to its former turbulence, its unresolved dilemmas, its burning enigmas.

I was a daughter of the Catholic Church and the Grande Noirceur, the Great Darkness of pre-1960s Quebec, and despite everything I did to replace my childhood icons with the greatest paintings of Western art, from the Renaissance to the Impressionists – which I discovered with as much excitement as I had the Automatistes of Quebec – the repressed returns, as they say, and I knew very well, without putting it into words, that I would have to bring it to justice eventually. The quest ahead, though still implicit, was nevertheless apparent in the musical score, written in a minor key.

It would be an understatement to say that I had a less-than-perfect attendance record in my classes those two years. Since my material needs cost me little – I was housed, fed, and laundered at modest cost at the Cité Internationale Universitaire – my savings were spent on travel, always in a group or with friends, and cultural activities, the cost of which was adjusted to a student's means. I didn't feel I was jeopardizing my academic plans; I even saw sitting at the movies, in a theatre, or at a concert, or looking at paintings in a museum as working to understand essential aspects of humanity, its complex thoughts, its astonishing creations. Nevertheless, I had gone through all the administrative procedures to obtain equivalences that would lead to doctoral studies. It was a real obstacle course, travelling hither and yon in a city that was extremely bureaucratic and poorly organized, between the administrative services of the university, the prefecture of police, and the embassy, with long waits in inhospitable offices, rude and often abusive remarks from tired and surly employees – the whole ordeal just to obtain a simple academic authorization, yet I remember submitting to it almost willingly. I observed the workings of a decrepit machine. I noted harsh, unwelcoming comments. Occasionally, I would

be thanked for "the Canadian soldiers who saved France," though usually I was given to understand that I was an intruder. The human beings seemed as broken down as their buildings. I saw in this the still-open wounds of the recent war that had cut the fabric of France in two, as Louis Aragon said. If the reconstruction of buildings and landscapes was still unfinished, just imagine how it must have been for minds and hearts. Beyond the hateful and venomous words I heard while waiting in line or sitting on rickety benches, I sometimes seemed to hear a muted chorus of wounded people. I recorded this lament within me. (In the France I love and visit regularly, it still happens that I pick up bits of it in people's cynical words and hear those fragments rustling as if they had remained stuck deep in my inner ear all these years.)

Once I had obtained the administrative talisman, I enrolled in several courses. Although I was weary of classrooms, I wanted to hear the professors whose books I had read during my studies. Almost all of them disappointed me. I preferred their books and did not go back again after seeing them once. I should point out that it was a time when courses were given in huge auditoriums, when the great professors pronounced their teachings from on high. Those dismal, dusty amphitheatres were nothing like the gardens of higher learning I had imagined from the descriptions given me by my father when I was small. He had urged me to "go to the end of the road of knowledge," and I had envisioned broad avenues far from our home, our mill, and our river. His eyes raised to the heavens and his hand on an encyclopedia, he had pronounced the magic word *doctorate* and had said, "You can choose the field you want, there are *doctors* in every area of knowledge."

One of the professors, Ferdinand Alquié, invited us one day to make an appointment after the class to see him at his home. I couldn't believe it, his attitude was the complete opposite of the usual authoritarian, distant, cold manner of our teachers. So I made an appointment with him. He lived in the Latin Quarter. I remember the entry gate and a charming little garden with the autumnal smells of dried flowers that were unfamiliar to me, a massive door opened by a lady – a concierge? his wife? – her polite manner when she ushered me into a library-cum-living room, where I waited for the professor, contemplating the books ordered

like a huge city with its streets and its alleys, its cathedrals, and its houses, a megalopolis that would take more than a single lifetime to explore. And Professor Alquié entered. A sober, affable man who seemed rather shy, he invited me to take a seat and speak. I presented my plan to become a philosopher and psychoanalyst. And a writer. I must have spent two hours with him. What did we talk about? I don't know anymore. I only know that I liked him and that our conversation did me a lot of good.

All I remember, and the memory is so strong that it has stayed with me: leaving his home, I felt sure that I finally knew Paris, if only a little. I was no longer alone in a strange city. Through words, but also meaningful silences, my solitude had been shared. I became aware of this at the intersection of Boulevard du Montparnasse and Rue Campagne-Première. Under a slanting ray of sunshine. It was late afternoon. In October. In that light, precisely, I suddenly had the impression that I recognized Paris, as if an archaic understanding of the city was revealing itself to me, emerging from the layers it had been buried under since my ancestors' departure for the New World. It came about through smell, finally reconciled. As on my first day in Paris, I smelled the abrasive fumarole of coffee, chewed tobacco, and fetid breath, the compost of urine on old stone and animal excrement, all warmed and lighted by the sun, but now the olfactory mosaic was good and invigorating, even intoxicating, I would say, as a mother's belly must be for an unborn child when the uterus is rocking and roiling like a pot of soup.

That afternoon, I recognized Paris. And for the first time, I was able to see beyond its scars. For the first time, I saw the lines of its architecture beneath its dust. I loved this city that had been tattooed on me so long ago. And forever.

I had many friends those two years. First, my companions at the Fondation des États-Unis, all of them Americans on Fulbright postdoctoral scholarships, which enabled the most brilliant students to study in Europe while they gave classes in English and lectured on American literature and history – young people in their early twenties, lively,

talkative, always laughing, they were athletic, with clean hair, great complexions, and white teeth, all of them tall, rushing toward a happy destiny, exhibiting self-satisfied smiles, probably as a result of their recent victory on European soil.

A few times, the Americans and I pooled our spending money, rented a vehicle, drove to one of the destinations of our dreams, slept in a dismal inn, and saw paintings we had been eager to admire firsthand. Or we went skiing in the Austrian Alps, where I nearly dislocated my shoulder, accustomed as I was to the gentle hills of the Matapédia Valley with no trails or instructors or professional equipment. On one of these trips, shortly after the erection of the Berlin Wall and the division of the world in two, with the Reds on one side and us, the capitalists, on the other, we drove across Germany in a little Renault, with a twelve-hour visa for the other side of the wall. Just to see, we said. We were all so ill-informed, we wanted to understand something that was beyond our grasp. Exactly what, we didn't know. What is beyond you arouses curiosity. What is forbidden creates an enigma. We wanted to solve the enigma of the crossing to the East. None of us took notes or read. What did we do during those long drives? We looked at the landscape, we talked, we sang.

Such is youth that, in a time of crisis, young people are often absorbed in other things. Unless they are prisoners, like Anne Frank or Hélène Berr, whose diaries recount the period of the Shoah, or my character Bosnia, who lives through the war in Bosnia-Herzegovina, young people cannot directly confront the wall of atrocities and absurdities of this world. For them, enigmas slip through one by one by way of minute openings, until, slowly, an awareness of their own history is formed, although gaps remain.

I still have vivid images of Berlin, West and East. No one took notes. Or pictures. I have always preferred to write from images within me. As for the others, they're gone from my life, vanished into the oblivion of the world, their destinies likely corresponding to my lack of interest. I remember the very modern city of West Berlin, newly built, flashy, and so opulent that it could have been a modern city in the United States. I particularly recall a striking image that brought together two periods

of German history, the war of yesterday and the reconstruction of today. It was the Gedächtniskirche, a cathedral in which the extremely modern cylindrical construction of the nave was on the same ground as its sister from another time, the Gothic arrow that had fallen in one piece during the bombing. A page from history in a single monument, where the new architecture incorporated the beauty of a former time, bore its vestiges, sublimated its wounds.

Early one morning, we reported to the U.S. Army headquarters carrying our twelve-hour visas and crossed to the East at Checkpoint Charlie. We expected to encounter a squad of Soviet soldiers on the other side, but only a single uniformed guard with a pleasant manner checked our papers. We went across uneventfully. Everything was calm. No weapons or infantry on the horizon. There was a watchtower nearby. No sentry in it. Without much thought, I decided to climb up to get a view of the two cities, West and East. What a mistake! I had hardly gotten to the top when angry screaming and shouting in Russian reached me from below, where there was now a pack milling around, while a soldier armed with a rifle charged up after me, swearing at me in his language, flipped me over like a pancake, and flung me down the stairs before I even had time to get my bearings. I wasn't afraid. I was stunned.

Down below, my companions were looking at me disapprovingly. I was the only girl in the group and I was causing problems, their eyes seemed to be saying, half-frightened and half-angry. An interpreter came to assist with the discussion. We were searched and the car was gone over with a fine-tooth comb. The soldiers put everything back in order – car, tires, steering wheel, hood, dashboard, trunk, seats, and our bags – scrutinized all our papers, including the missal belonging to one very devout person, and then let us go through after a litany of admonitions on what we could do and when we had to return.

During those twelve hours in East Berlin, I experienced one of the greatest upheavals of my life. We were followed the entire day by two men dressed in grey with black hats, who, at each intersection, would hide behind a building, just as I later saw in so many spy movies of the Cold War. We paid attention to them at first, but then we forgot them. After all, we weren't there to see spies.

Just by passing through a gate in a wall, we had gone from one world and one time to another. Not only was there no reconstruction in East Berlin, but you would have thought the bombings of 1945 had just happened. Sixteen years had passed and the decay and poverty were already tolling the death knell of Communism. Walls of brick and stone fallen in heaps of rubble and dust, silence and terror on people's faces, old carts of debris pulled by old people in rags, no cars aside from a few carrying officers or men in grey with black hats. Nor did we see any public transit vehicles. And we met so few people.

(Were there still wholesale rapes by the "Ivans" – the name given to the Russian occupiers of East Berlin – rapes of thousands of women who were alone, their men having been killed or taken prisoner after the surrender of Nazi Germany and the suicide of Hitler and Goebbels?)

Everybody had gone to ground. And there was a great silence. I will never forget the vast, dense silence of East Berlin.

We visited the university with a guide assigned by the police, a pleasant, reserved young man who spoke English. We saw the silent corridors, the shabby classrooms, the pallor of the students, the general dilapidation. As we were leaving, a whole class was going to the cafeteria, as the guide told us, when a mournful-looking, emaciated young girl left the group and ran toward us. I remember her grabbing the sleeve of my jacket, asking us on the verge of tears to take her with us to France – she must have heard us talking among ourselves. In less time than it would take to snuff out a candle, a man appeared and, with a punch to the temple, knocked her to the ground, shouting orders at her to show her student card, and at us, standing frozen in place, to get out. I tried to look back to see what happened to the poor student, but she was surrounded by a human wall and we were hurriedly pushed outside by our guide, who was not at all nice anymore. For a long time, I was haunted by the image of that panic-stricken young girl whom we, powerless and upset, had left to her terrible fate.

After a sad lunch gulped down standing at a rustic counter in a restaurant in a grey alley – it was the only one we could find – we went to the National Gallery, which, according to the propaganda, was filled with contemporary paintings, masterpieces. What we saw was appalling.

We were speechless. We were alone; there were no other visitors. Alone and silent. On walls ripped open by the wartime bombing, between patches of dull sky, there were a few Old Masters, all fakes – the real ones must have gone to the Hermitage, and we had also seen some in France and Belgium and in Amsterdam, but I had neither the expertise, the time, nor the heart to take inventory. While I was standing in horror contemplating the breaches in the walls, empty spaces revealing the grey-ness outside, I saw a receptionist I had scarcely noticed when entering. An old lady, with wrinkled, waxen skin and a thin, straggly bun. She began to cry. When I went to the counter, which dated from another era, she asked me in French for chocolate. I had no chocolate. I gave her all my small change, and she took my hand and smiled at me. I had never seen such a sad smile. She handed me some postcards of the museum that I could see had been faked – they represented the National Gallery as an architect imagined it after an eventual renovation, not what I saw there. I couldn't believe it. I didn't have the words to describe this distorted representation. My mind faltered. The old lady and I looked at each other. Each of us knew that the other knew. We both smiled sadly.

I walked out of there with my mind in revolution and my heart swimming in tears. (Later, in Paris, I sent the postcards to friends at home, explaining the lie. Nobody ever mentioned them. It made me feel that the Berlin Wall circled the entire West.)

The day in East Berlin ended with a long walk on Karl-Marx-Allee, which was described as Berlin's Champs-Élysées. The shop windows displayed the riches of the West: haute couture, perfumes, jewellery, candy. I forget how we were informed, but they were all fake. Behind the windows lived the officers of the Soviet army. This time, I felt nauseated. I wanted to leave. My wish was granted. It was time to cross back into the West.

After our return to Paris, one night when we were telling some other friends about our visit to Germany, I started to talk about what we had seen in East Berlin, from the spies to the young girl at the university to the fake National Gallery and the equally fake Karl-Marx-Allee. A travelling companion I'll call Jim interrupted me, saying, "What she's saying is totally untrue. She's telling you complete lies." There was silence around the table. I was dumbfounded. Of some twenty people who were present,

not one said a word. The sidereal silence made my blood run cold. Was it because I was a girl? In those days, women's words had no basis in authority or prestige. Women, and especially girls, were expected to be seductive, to offer charm and lightness. The blunt silence of the group was enough to say that Jim was right.

Without being able to really understand what had happened, I remained mute, and I learned two or three good lessons that are still of use today. I had to debate the true and the false, to find truth and challenge lies within myself, as many pre-Socratic Greek philosophers did – such as Empedocles, who, in the face of anger, injustice, lies, and all the ills of life, decided one day to pick up his cithara and sing. Likewise, I would opt for poetry and fiction, which contain their truth in sometimes sibylline words. Not everyone grasps them immediately. For the writer who creates them, they calm and console and reconcile with the world, opening the way to impossible heavens. More true than real.

I never spent time with Jim again. I occasionally bumped into him. Had I been a sociologist or a writer of crime novels, I would have tried to examine his motivations. I have sometimes had certain intuitions, which I didn't pursue for lack of interest or time.

I made a new friend that year, a close one. Her name was Lucienne Topor, and she was exactly my age. She was from Manosque, in Provence, and she lived in the Cité Universitaire d'Antony, on the outskirts of Paris. Lucienne opened up horizons such as I had never imagined, and my friendship with her had a depth that none before had. I said she came from Manosque, and that's true, that was her home and that of the Dickenses, who had adopted her during the war from an orphanage for abandoned Jewish children in Normandy. She was ten at the time and had lost her biological parents at four – when they were twenty-seven and twenty-eight. They had been forced out of their home in the raid of July 1942 in Paris and taken to the Vélodrome d'Hiver.

Lucienne told me her story many times and I never tired of hearing it, so strong was the impression it gave me each time of getting to the heart

of History writ large through the Holocaust. It was surely the fact that I was a foreigner, as well as my innocence about war, which I knew almost nothing about, that allowed Lucienne to share her confidences. In 1961, in France, people were beginning to break the silence. But not in front of just anyone. The evil geniuses, fascists or former Nazi collaborators, might repeat the dirty deeds of the war, who could know? With me, Lucienne spoke in complete trust, trying to reconstruct her history from scraps that her child's memory had retained deep within like a painful treasure. She said, "When I talk about it, it seems to hurt less."

Her parents, a young couple from Poland, had managed to flee their invaded country and the misery of the ghetto with their little girl born in 1938. Lucienne had vague memories, mixed up as in a nightmare, of escaping and fleeing in the night, travelling through the forest, feeling so hungry her stomach ached yet not being able to shout or cry because of the risk of getting caught. She vaguely recalled a hand over her mouth, her father's or mother's, stifling her moans. They were afraid. Bundled up against her father's or her mother's stomach, she felt the trembling with cold and fear, she heard the gurgling of hunger. They ate snow, she remembered. And frozen berries torn from the bushes. And one time, her mother sang, she recalled.

And finally, the apartment in Paris. She was too small to know whether it was large and comfortable. She didn't know what neighbourhood they were in. She had a vague recollection that for a long time they slept in the same bed and that it was warm, that there was always something to eat on the kitchen table. She remembered drinking milk.

A final memory that still felt like a kick in the stomach and made her heart stop: she heard men charging up the stairs in heavy boots. She remembered her mother pushing her behind a sideboard and putting her hand over her mouth while the door was broken down. She heard men shouting and her mother saying "No" and crying. Lucienne was lying on the floor, and from under the sideboard she saw black boots. They went back down the stairs making a terrifying racket. And then, nothing. Silence. Cold. Absence.

Lucienne didn't remember how long she remained in the apartment. Hours? Days? Certainly a day and a night, because the night came with its

darkness and ghosts, and she cried until sleep took her into its arms. She ate everything there was to eat in the apartment. Then, on a sunny day, there was nothing left to eat or drink, and she went down into the alley. Saw a cat. Looked for food in the garbage cans. It was there that she was found by a woman. From social services, she later learned.

She went on a train with the woman. They travelled a long time. She slept. She ate. She searched for her parents down to the depths of her dreams. She scanned the countryside they crossed. Maybe they would come to the train. How many times did she imagine she saw them emerging from a clearing or standing in a field of wheat where they had been taking a nap? But nothing, ever, and the train rolled on.

The woman took her to Normandy, to a big house full of orphans, most of whom were crying. She lived there six years. The Dickenses came and got her when she was ten years old. They had a nice house in Manosque, which I would see the following year when I moved to Aix-en-Provence. They loved her. They pampered her. Since she had become a ward of the state, they were able to give her the best education in whatever she chose.

Lucienne eventually became a lawyer in international law, in Paris. She criss-crossed Eastern Europe and went to Israel and the United States, looking for any trace of her parents. She went to the labour camps and then the extermination camps, but she never found anything.

One day years later, she took me to the memorial for the French Jews who had been deported and murdered, a masterpiece of restraint situated at the tip of the Île de la Cité near Notre-Dame Cathedral, like a ship on the Seine, with black bars on the outside that let in the light and let out the shadows inhabited by poems of resistance and the names of the absent ones, which shone brightly. In the moving silence of the huge crypt, among the thousands of lights representing anonymous Jews who died, Lucienne showed me a shimmering star, saying simply, "Here are my parents."

Although her adoptive parents had loved her very much, they had never been able "to put out the fire that was eating away at her heart," in the words of her mother Madame Dickens, whom I loved like my own mother. Lucienne helped me to go from innocence to awareness

of the world. I went there through the door of the Shoah. I have often said I was a Jew. Or at least, I have written it.

Lucienne came to Montreal after I returned to Quebec. I remember her playing over and over the new song by Barbara, "Dis, quand reviendras-tu?" [Tell me, when will you come back to me?] She was sitting on the carpet in the living room, her sad eyes gazing far, far away. I don't see Lucienne anymore. Why? I don't know.

I had another good friend in Paris, Pierre Blanchette. He was training for psychoanalysis, the profession he had always wanted to practise. He was therefore in analysis, for himself at first, and later in a training analysis. He was also studying philosophy, history, and literature. A Québécois my age who had arrived in France a few years earlier, he had established a rhythm of weekly get-togethers with me in the lounge of the Fondation des États-Unis, coming there from the Latin Quarter, where he lived. Get-togethers where we would talk. Untiringly. Pierre was the first guy with whom there were none of the games of desire. I found him good-looking, I found him charming, and he felt the same about me. I finally had a male friend with whom I could converse freely without passion confusing things. I couldn't get over it. I finally had a male friend. Not a future lover or a would-be fiancé, and even less a potential husband.

We talked about our discovery of the world. Of the world of thought. Of the psychological universe whose every hidden corner and subterranean passageway we, as budding archeologists, wanted to explore. We talked about the books that had marked us. About those we wanted to read, suggesting titles to each other. We talked about the faith that aroused many doubts in us, the religion of prohibitions we came from (people did not speak of fundamentalism in those days), the fictions surrounding the figures of our Catholic divinity (we didn't yet know the fictive figures of the two other monotheistic religions, Judaism and Islam). We told each other of the paths we had taken to try to untangle the paradoxes, the enigmas, and the imbroglios of our Christian mythology from the

Old Testament to the New, through the Church Fathers – Fathers, but no Mothers or Wives – which left us skeptical and uneasy. To reassure ourselves, we had, for me, the "voice of the cithara," which I wanted to use in writing, and for Pierre, the "voice of the other" in the living word of psychoanalysis.

I remember talking to him about what had made me want to travel, with Kant and his transcendental imagination, in which, at twenty, I glimpsed a possible bridge – which I might one day cross – between "pure understanding" and "pure sensibility." And Pierre understood. No intellectual cowardice, no flirting or seductive words, no attempts to use words to take power. Pierre knew how to listen. The dialogue between us flowed freely, like a river. He talked to me about Husserl, Hegel, and Freud, whom he knew better than I. Based on his experience of the Paris intellectual scene, we outlined together the path my own university education might take.

I even consulted the psychoanalyst Favez-Boutonier (I called her Madame Favez-Boutonier, and in *Les cathédrales sauvages* [Wild cathedrals], Madame Fa, and I never knew her first name). I remember a warm exchange when, unlike the inhibited French women of the time, she sat on the edge of her desk swinging her legs (she was wearing a suit with a short skirt) like a college student. I remember talking to her of my desire to become a psychoanalyst and writer, of the disturbing dizziness related to the loss of faith, as we said, but also to the mad, passionate love unto death I was experiencing, having recently fallen head over heels.

I remember talking to her of the land I came from, my large family, the tribe, the clan, the village, the water, the forests, and the hills. Of my desire to write. And telling her, I'm not sure why, that I had come to France, the country of my origins, to understand my ancestors on both my mother's and my father's side, who had torn themselves from the land of their birth, but why? And to understand their encounters with the Aboriginal peoples, which were just as much a part of my origins, I felt then. To grasp my own strangeness, but how? Did I have these words then? Probably not. But I'm trying, with my words of today, to translate the ones I was groping for then.

I remember clearly the end of that first session of psychoanalysis. Madame Fa saw me to the door. With a smile, she said, "I'd like to work with you. Come back when you're ready." The word *work* surprised me. And pleased me. I was ready some years later. In Montreal, where I would meet the man I called "the god of dreams." I worked with him for years.

While walking to the door, Madame Fa asked about the man I'd fallen in love with, "And has that young man ever considered psycho-analysis?" I was puzzled by this, and later, I was astounded: not only did he too consider it at some point, but he was the one who became a psychoanalyst, while I stuck with my cithara.

EVERYWHERE

*To say less of yourself than is true
is stupidity, not modesty.*

– Montaigne, *Essays*

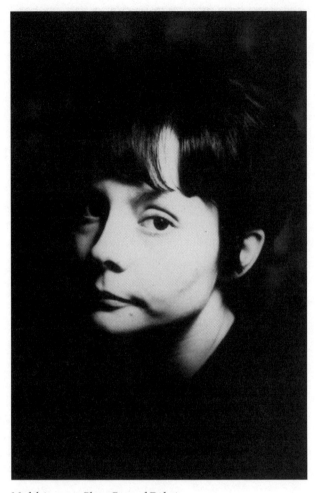

Madeleine, 1975. Photo Bernard Dubois

Marriage in
Notre-Dame

My falling madly in love bore fruit. In 1962, I was pregnant, and Patrick and I were going to get married. It was the time of unwed mothers, children born "out of wedlock," and orphanages. Since we were both raised in deep-rooted Catholic cultures, in his case, Irish, and in mine, French-Canadian, there was no question for either of us of jettisoning this child among nameless orphans, and the word *abortion* did not exist in our vocabulary or even in our minds. So we had to get married, as quickly as possible. And have a proper wedding, because the parents would come. Nothing must show. My parents therefore came to Paris, delighted at this unexpected journey. And nothing showed. My belly was as smooth and flat as at my first communion.

In hindsight, I can see that neither of us was ready to start a family. With no time to stop to analyze and understand things, we put our heads down and blindly accepted what appeared to be our fate. A throw of the dice had set us on a path heralding radiant happiness, while there lurked in the shadows its inevitable companions, the conflicts and sometimes the sorrows that such a commitment far away from our families and our land of origin would sooner or later give rise to.

For the moment, we threw ourselves wholeheartedly into the celebration. A happy celebration, but wrapped in a veil of contradictions that it would take me years to unravel. Through the great happiness of loving and carrying a child, I don't recall a single instant when I didn't cherish the small creature within me – but secret turbulences affected me, and my mind was filled with burning questions. Why was none of the three monotheistic religions able (or willing) to include femininity in its conception of the divinity? How was it that in all the history of humanity, women had been excluded from theologies and philosophies? Why, in all the countries of the world – including, until very recently, the so-called

developed countries – had women been prevented from studying? Why had they been forbidden access to universities and major schools?

In the Catholic religion, which had educated me and permitted me to be here in France and to study here, there were many dogmas and mysteries I found repugnant, the most glaring being the conception of the son of God by a spirit, however holy it may have been, and a young woman who was immaculate in her own conception. Mary is thus supposed to have become pregnant by divine intervention. Since the real Father was in heaven, they could have imagined a divine Mother, but no, the divine was reserved for males. How bizarre! Her husband on earth, the humble carpenter Joseph, was only there to play a supporting role. Nothing is written of Mary's pregnancy. Nothing about the labour of birthing either, when we know that this labour has something in it that is great, even sublime. But not a word of the Scriptures on this, total silence! How did that Jesus of Nazareth get inside her belly, and how did he come out? Nothing, total silence! Moreover, it was an angel, Gabriel, who announced to her that she was pregnant. A male angel, of course.

In the mythologies of all three monotheistic religions, the figure of the angel is always masculine. In the Catholic tradition, angels have been represented as beautiful, often effeminate young men, and century after century, the members of the clergy have been moved by them. Among Jews and Muslims, there is no representation. Images are forbidden. They substitute. They sublimate. It is numbers, algebraic formulas, and geometric patterns that serve as intermediaries between human beings and the divine. As with Christians, men are always the ones in control of the myths of the divine and the religious. It is Moses, Abraham, Jacob, David, John the Baptist, Jesus, the Apostles, the Evangelists, the Church Fathers, Muhammad, and their ilk who conduct the orchestra of the sacred.

I had just turned twenty-four, I was carrying a child in my belly, I was going to marry the man I loved, and, in the excitement of the preparations, I was waiting for my parents to make the journey across the Atlantic – in my father's case, for the first time. I was about to be married and I was asking myself all these questions about my religion and the religions I was just beginning to study. But nothing was expressed, that was precisely the

problem, as I would see later, in 1967, when I knocked on the door of psychoanalysis. It was much later that I would start to understand the unique history of a life – my own – and I am still gaining understanding today.

As a girl born in 1938, I very early felt the effects of complex historical changes taking place in Quebec: the end of the Grande Noirceur, the Duplessis era, when the Roman Catholic Church was all-powerful, and the beginning of the Quiet Revolution. Feminism would come a decade later, but all young women who were the least bit aware with regard to the universe of seduction, the general politics of masculinity, and the religions and philosophies that had abandoned us were accumulating within them, often without knowing it, the twigs that would serve as kindling for the fires to come and the scouring powders for the great housecleaning. Women would need our own revolution to finally become part of the history of humanity.

Meanwhile, happy, loved, and loving, I prepared to enter married life. I put aside plans for studies or writing for the time being, knowing intuitively that life would take care of them. For now, I was totally absorbed in my happiness. I was dreaming a great deal. I was having waking dreams that religions would one day no longer be represented and written only by men. That the angels announcing news and delivering heavenly messages would also be women. That Mary would no longer be a virgin. That she would one day give us her own gospel, would tell us what pregnancy, love, and childbirth are when you believe with every fibre of your body in the miracle that will spring from your womb. When the words of everyday give way to internal dialogue and contemplation – poetry – and you believe that, through this sublime action, you touch the divine. I dreamed of a Song of Songs written in the feminine, in which the beloved would be a young man, and the fruit of my womb, the child I was carrying.

I didn't share all these thoughts and dreams with my companion and soon-to-be-husband. Patrick was profoundly religious. He was an Irish Catholic, and his religion, rooted in a history of (Protestant) domination and struggles for independence and survival, was like a talisman for him. Moreover, how could I find the words to say clearly and accurately what was still essentially in an embryonic state within me,

words shut away as if in a secret chest? Besides, as I said, I was madly in love. And so was he. The two of us were in a state of obsessive love, love unto death. And his faith connected with what had fuelled my days, my thoughts, and my life in my family, at college, and in my friendships, since my birth.

My parents came to Paris. We were married, first at the town hall of the fourteenth arrondissement and then, to my parents' delight, at Notre-Dame Cathedral.

While I was unweaving within me the fabric of religious beliefs that excluded women from their stories and their fables, I was pursuing my patient trial of our Christian God in three persons: Father, Son, and Holy Spirit. It was the Protestant Karl Jaspers, a philosopher of ethics and an existentialist, whose works gave me the tools I needed to unweave the rational fabric of an uncompromising and infallible faith, the fabric that had straitjacketed the minds of so many Christian intellectuals among my contemporaries and their predecessors. The thinkers of Quebec's Quiet Revolution had been formed by the weavers of that inexorable logic.

Once the proof had been established in my trial of my religion, I gained freedom of thought. I could breathe. Following Nietzsche and Kierkegaard, Jaspers gave me the possibility of believing, perhaps, but of believing without reasons. Of believing through a kind of leap, a rapturous leap to transcendence. Faith became irrational, and I could finally reconcile human purpose and poetry.

After years of apprenticeship (there's a reason I spoke of weaving), years of rote learning, in Latin if you please – two years of philosophy in classical college and a full year of nothing but philosophy for my master's in the Thomist faculty at the Université de Montréal – after endless discussions and dissertations on each and all of the five proofs, I was able to fly on my own, to think differently, or not to think at all if I so desired. I was free. I could create.

So it was that, along the way, I fell in love with a great intellectual, a second-generation Irish American, as he said, born in New York City in the South Bronx, holder of a Ph.D. from New York University. A postdoctoral fellow in Paris on a Fulbright, the scholarship granted to the most brilliant students of the postwar generation, those destined

for great success, Patrick, my future husband and father of my two sons, was a scholar of English literature, a specialist on the metaphysical poets, such as John Donne, and on Shakespeare, with his marvellous sonnets.

So it was that, without being aware of it, along with my great private trials on the reefs of the unnameable, I was brought back to literature. And to writing. No more question of psychoanalysis or philosophy. I returned to the soil of my origins, poetry and its mad desire to rush ahead and fly toward the unknown. To find something new, as Arthur Rimbaud said. And my mind and my body were filled with the new.

From philosophy to love and literature, I came back quite naturally to passions from my college days, especially Paul Claudel – a literary genius now in purgatory, snubbed by readers for his extreme Catholicism. I came back to his dramatic works and his poetry, to which I had been introduced by that exceptional teacher and creator of free minds, Father Maurice Chamard, my adviser in adolescence and the "spiritual director" for many of us at College Notre-Dame-d'Acadie. Our teacher of literature and theatre director, Antonine Maillet, was also a great admirer of the playwright Claudel. She directed me in a show in which I recited Violaine's famous monologue. I will never forget those moments of pure aesthetic joy and dramatic exaltation.

(Much later, in the 1990s, I invited Thierry Hentsch – the great author of *Truth or Death*, whose early death left all his friends at UQAM, the Université du Quebec à Montréal, inconsolable – to a performance of Claudel's play *L'annonce faite à Marie* directed by Alice Ronfard in the former chapel of the Grand Séminaire de Montréal. What a setting and what a sublime experience! Thierry, who was of Swiss Protestant background – another one! – was in tears. He said, "I am discovering a great dramatist. I'm discovering Catholic theatre!" He got all Claudel's books, and he said he wanted to talk about him in the second volume of *Truth or Death*, but I don't know what came of that.)

So, in the spring of 1962, during the patient trial that would lead me to non-belief, there's no better word for it, I went back to reading Paul Claudel. His work, but also a biography, in which I learned of his conversion from Protestantism (the culture) to Catholicism, a faith that would become dazzling and mystical for him. His reading of Rimbaud,

whom he saw as a mystic in the wild, led Claudel to nothing less than an "illumination," which occurred in the form of a dramatic conversion at Notre-Dame on December 25, 1886, Christmas night, the night of the Nativity. Near the column facing the statue of the Virgin Mary, at the altar of the right nave, not far from the transept and its eastern rose window. A young man of eighteen, alone in this place of a religion that was strange to him, he underwent a sudden conversion to Catholicism and it became the central theme of his future work.

So here I am, back at Notre-Dame in Paris – which I haven't forgotten – where I was soon to be married. It's as if I had remained outside the church, hesitant to enter. Because I needed this long detour, this slow process of reflection, to explain the choice of Notre-Dame, which, after all, was my choice. It was because of Claudel, of course. It was in the place of his conversion that I wanted our marriage to be celebrated. I went to meet the priest of the cathedral and presented my request to him. To me, the reasons were obvious. I cited Claudel and spoke of love and writing. He couldn't get over it – nor could my parents, for that matter, nor anyone else except the engaged couple – and he said something I've never forgotten: "I cannot but acquiesce to a request made with such conviction and such candour." Patrick and I were crazy with joy.

The request was made to the priest in July. We had to act quickly. The belly must not have time to grow big. And the marriage took place on August 22, 1962. Charles Patrick was born on April 12, 1963, Good Friday, in the afternoon.

Quite a tissue of contradictions, wasn't it? You could see it as pure alienation. And you wouldn't be completely wrong. There were many, in a Quebec that was wall-to-wall francophone and Catholic, who experienced this division, one foot in a past that was still so present and their heads in a future whose outlines were not yet clear, only hinted at. The real alienation would be in totally obliterating the past, making it invisible. Many are still at that point. There is no one more alienated than the person who is unaware of the conditions of his or her unconsciousness. For such people, the return of the repressed can be terrifying, like an unexpected groundswell out of the calm of low tide. After generations

of submission, it would take many more before the full achievement of a true quiet revolution – if it came, because undoing alienation is something that is not accomplished once and for all. Thus did I justify my own alienation and arrive at an agreement with myself. My reconciled self even became, as our forefather Montaigne said, the subject of my work, which has been in progress since my first writings. In other words, the recounting of this wedding is the epiphany of a piece of writing, mine: an autobiography.

Let's get to the nuptials. My parents came. We were eight for the ceremony, apart from the priest, who was very nice: my parents, my sister Raymonde and her husband, Rémi (who was in Paris doing his doctorate), Patrick and I, and two witnesses (whose names and faces I've forgotten). The weather was good. The dazzling sun lavished its light on us through the blue and red of the rose windows. The eight of us were all dressed up and joyful in front of the altar of the Virgin Mary. All of us were moved, not weeping but happy. The ceremony cost nothing. "It's free in the church," the priest had told my father, who just before the mass had asked, "How much is this going to cost?" and who couldn't believe it, accustomed as he was to the fees asked by the churches at home. "It's free," he repeated to my astounded mother.

I was wearing a little Chanel-style suit in eggshell, made for the occasion by a dressmaker Raymonde had found. I hadn't wanted a long dress or white veil. However, I wore a white lace mantilla, it being impossible in those days for a woman to enter a church without a head covering. I had dressed to my own taste, but accepted the compromise of the veil. As I said, I was then between two worlds. The one of before, which I rejected. And the one of after, which I couldn't yet see clearly.

Except for Patrick, who was a believer through and through, the young people there were, like me, making a compromise. We even listened to the epistle of St. Paul (that misogynist!) admonishing husbands and wives and declaring from his Middle Eastern fundamentalist pedestal that the wife must promise obedience to her husband. We allowed it to be said, and we said nothing. That would come a little later. For now, we were storing it up. The young women, at any rate – and even Maman would come around to this – were preparing for war.

Patrick and I were beautiful. We were radiant. We were surrounded by millions of flashes and clicks. Many tourists thought it must be a celebrity wedding. After all, a wedding at Notre-Dame is quite something. Rémi took real professional photographs, which I still have. Maman was jubilant. She was living a fairy tale. With her beloved Jean-Baptiste, "the most handsome man and the best catch" in the village of Amqui, she was attending the wedding of her daughter in Notre-Dame Cathedral in Paris, she couldn't have been more joyful, and it seemed as if she might take flight. She couldn't believe her eyes before such splendour, and she thanked the good Lord for such generosity. Back home, she would tell her many friends, "We married our daughter Madeleine at Notre-Dame de Paris!" She might sound like a snob. She was not. A great reader, she was living a novel. She was even one of the main characters. The action was not merely taking place before her eyes. She was in it. She wanted her novel to be read. By the largest public possible.

My father was impressed by the pomp and circumstance. He regularly looked at his watch, which was still on "mill time," as he had decided for this long journey across the ocean to the land of his ancestors. He liked this point of view. The time difference didn't bother him. He was simultaneously in two time zones, Paris time, near but so foreign, and the familiar mill time on his watch, which had become so distant. Throughout the day, and for his entire stay of ten long days, he would regularly look at his watch and say, "They've just changed the Catherine" or "Now they must be adjusting the edger," referring by name to two of his saws at the mill, each of which he recognized by the sound, like the conductor of an orchestra with his instruments. I suspect he heard the sounds of his orchestra of saws, which he had stored up within him, like a choir there at Notre-Dame de Paris.

My father was somewhat intimidated, but I could see that at the same time, he was very proud. He had wanted his children to be educated, that might be his only legacy, he had said during one Sunday dinner, where he often gave his little sermon of the week, following up on the priest's big sermon at church. That time, in front of my delighted mother and the children, who were expected to keep quiet and listen during these solemn moments, he had added – as I've already written elsewhere, but

I enjoy repeating it – "And if I don't have enough money to educate all ten of my children, I'll educate the girls first!" "Why?" we had dared to ask. His answer was simple: "Because women are better, more intelligent, and more moral. And because they transmit values from one generation to the next. Guys can always earn a living with their muscles." He had always said he would pay for our studies all the way to a doctorate, whatever field or profession we chose. If we had good marks. He wanted to see our report cards. Until university, he wanted to check our marks. And he wanted to read our books, so that at the end of our studies, he would be the best educated of us all. I was enrolled in a doctoral program in literature at the Sorbonne, and Papa was visibly proud of me. He didn't say it. He was a father who loved us "very quietly," as Éric Fottorino wrote of his own father.

He was quite a man, my father. A colossus of Herculean strength, an unrivalled boxer who had to stop fighting, at my mother's request and under a court order after he knocked out several opponents. Having dropped out of business school at seventeen to work with his father and brothers in the lumber company, he had gone on to found his own business in 1938, at the age of thirty-two. I – my parents' fifth child, and fourth girl – had just been born.

Quite a character, who started out as a woodsman, which he remained to the end – he died at the age of ninety-one – and became a wise man and, I would say, an intellectual. He built up a library in his office at the mill. He read the La Pléiade series on the history of religions, he subscribed to *Le Monde diplomatique* and *Le Nouvel Observateur*, and he read many books on history, geography, and economics, and biographies of "great men." My parents also subscribed to the daily newspaper *Le Devoir*, and they even went to Montreal in 1944 to hear a famous speech by the newspaper's founder, Henri Bourassa, and told us about it with excitement.

I owe my passion for history and geography and exploring the world to my parents' discussions in the evenings in the central room we called the library, before the advent of television, when, while I was supposed to be asleep, I would listen to them through the heating grate in the floor of the hallway outside my room, which was directly above

the library. Hearing parents converse as if it were a wonderful, captivating game was sufficient to spark a child's desire for knowledge.

Quite a man, then, this father who, in his time, was unusual among men in believing in the education of girls, the education of *his* girls – along with my mother, of course. A man who went from a fighter to a wise man and a scholar, who made the money, because he had a surprising business sense, to have us all educated. And who found himself, that beautiful August morning, at the wedding ceremony of one of his six daughters, a ritual that was taking place to the sound of his saws according to two very specific timetables, that of the mill and that of Notre-Dame.

The day before, when we had the civil ceremony at the town hall of the fourteenth arrondissement, he had expressed some qualms. Why have a civil marriage first, since only the religious marriage counted? That was the law, I had answered, that was the way it had been in France since the Revolution, the state came first. Anticipating the situation, he had rented a two-bedroom suite at their hotel, and he calmly put his foot down: "You won't be married yet tonight. You'll come sleep with your mother and me. Tomorrow you'll be able to sleep with your husband."

Okay! I understood, and so did Patrick, the good Catholic. Lovers for several months, we were separated for one night, which only fanned the flames. Both virgins when we met, when the religious prohibitions had given way, we had fallen into each other's arms like ripe fruit. I have no recollection of the rumoured pain of the first penetration – no tears or blood or tearing. We flew away all warm on the wings of desire and its fulfillment.

That night of separation between the two weddings was only a little pause in our lovemaking, and for me, an opportunity to thank my parents by briefly returning to the fold of the family that was temporarily reunited in a hotel suite. Papa had nevertheless retorted, "A civil marriage that takes precedence over religious marriage? That will be the ruin of France!" Which did not prevent him from slipping a hundred-franc banknote into the mayor's hand – although there too, it was free – as he would do with the priest at the cathedral. And he had said, "With their generosity, perhaps the Lord will forgive them their atheism."

He kept on repeating the same message when we were all in a car he had rented, a couple of days after the weddings. We were going to Chartres, which my parents were eager to see. In the car, there were Rémi at the wheel, Maman, and Papa, holding two-and-a-half-year-old Christine, the daughter of Raymonde and Rémi and my goddaughter, and Raymonde and Patrick and I. It was Sunday. The peasants were working in the sun-drenched fields of wheat. My father was outraged. About every twenty minutes, he would declare, "The French work on Sunday? You'll see, that will be the ruin of France!" Luckily, little Christine was there, and his radiant Jeanne and his happy children, and the laughing beauty of nature to bring him back to more tender feelings.

How could I be angry with my father? He had been so good to us, and he was being so generous with me now. In those not-so-distant days, but looking back at them today they seem like ancient history, the father of the bride had to pay the cost of the wedding, the ceremony, the bridal gown, the reception. He also had to provide for his daughter's material needs by giving her what was called a trousseau: linens, dishes, pots and pans, and other things for the home. The previous summer, I had attended the weddings of my three elder sisters. I didn't want a long dress and all the frills, or the obligations and invitations involved in such an event. So I was delighted to be far away and to escape all that. I sensed that my parents were, too.

Having calculated what the previous weddings had cost him, my father had concluded that their trip to France and a nice gift of money for my dress and my trousseau, plus a veritable banquet at a restaurant for the wedding party of eight, would not cost any more, all things considered, than a wedding in a hotel in the village with dozens of guests. I was thrilled to receive the money, two weeks before the wedding, by postal money order. Through my mother – that was always easier for me – I made an agreement with him that Patrick and I could use the money to fulfill a dream: to honeymoon in Italy and Greece. To see Rome and Athens! I told them there would always be other opportunities for a trousseau on our return, when we would settle down. That Rome and Athens would not always be near. The agreement was sealed, much to our delight!

The next week was spent in mini-honeymoon trips, with all of us together. Chartres, Les Invalides – my parents' excitement at the tomb of Napoleon and those of his family and his generals – the Panthéon – a place of "atheists in hell," said my father, and we didn't stay there long – the bateau-mouche, the Eiffel Tower, the Tuileries, the Champs-Élysées, it was one big celebration. And then Versailles – that was too much, we felt so small! When there was just too much magnificence, we would let the waters of our rivers, the Matapédia and the Matane, flow within us. We would tell each other our own stories of the wild beauty and baroque grandeur of our vast land. Which we did twice a day, at the restaurants where we feasted, choosing dishes for our father, who had a hard time deciphering the huge menus and, especially, felt uncomfortable ordering in his language. He always paid the bill. As for our mother, a gourmet cook, she travelled through the menus that were already familiar to her, wanted to taste everything, and talked with the maîtres d'hôtel and waiters as if they belonged to the family of gastronomes she had long been part of.

Our visit to the Louvre will always be one of my best memories of that holiday. According to our individual tastes, we had divided the periods and schools among us. My mother chose the Impressionists. We went with her, while Jean-Baptiste seemed to want to withdraw into his own world. At one point, I turned around and saw him with his ear pressed against the exterior wall of the museum, and then he seemed to be measuring the thickness of the wall with his arms on a window ledge. Later, he kneeled on a majestic wood staircase, put his ear against a step, and gave it little taps with his knuckles. He said he wanted to figure out the kind of wood and its thickness from the sound. A guard wearing a cap and uniform appeared at the top of the stairs and observed the strange activity, looking suspicious and ready to take action. My father turned red with confusion. I rushed up the stairs and told the guard that Papa was an expert on wood and owner of a sawmill in French Canada, as we called it in those days, and merely wanted to determine the type (or types) of wood used in the construction of the Louvre. From the height of his importance, the guard looked us up and down and ordered us coldly to move along. This was not the first time, nor the last, that we

were greeted with contempt in this country where it seemed to come naturally to people to think they were superior. My father's only words, spoken while glancing at his watch, were: "The French are not only good at lace and the minuet, they also know how to build."

After these days of festivities and excursions, my parents went back home to the land of rivers and valleys and the great St. Lawrence broad as the sea, and wide-open spaces so big that you can't see where they end. "Where everything is yet to be built," said my mother, and my father added, "Where there won't be a war." The others returned to their lives. There were no outbursts or rifts.

Aix-en-Provence

There was so much light that
one saw the world as it really is.

– Jean Giono
Joy of Man's Desiring

So we arrived in Aix-en-Provence, dazzled by the light, but not blinded by it. As in Van Gogh's paintings in which the air vibrates with brightness, I felt a flickering that would never leave me. It was late September. The golds and ochres, oranges, yellows, and blues were at their peak. With my sensitivity heightened by pregnancy, I saw the world as I had never seen it before.

The upheaval caused by the cohabitation of two beings in me, the unborn child and myself, coincided with another that was equally amazing, that of the meeting between my customary northern light and the new southern luminosity. I experienced this revolution as soon as I got off the train at Aix-en-Provence. Later, much later, I understood, through the paintings of Nicolas de Staël and others, that this tumult caused by the contact of two states of light can give rise to immobility in a painting, and eventually to silence. This is also the way the light is in Fernand Leduc's Tuscan *Microchromies*.

For the time being, I was in this double ecstasy. This rapture. We were going to live in Aix for a year. Patrick would be a lecturer at the Université d'Aix, as was expected of holders of Fulbright scholarships in French universities. I had had my academic records transferred from the Sorbonne to the same university. Having gotten married under the auspices of Paul Claudel, I would remain with him. Rooted in poetry

this time. Very far from my first loves, philosophy and psychoanalysis. I registered to do a thesis on "the structural analysis of *Five Great Odes.*"

By a lucky coincidence, my thesis director, Marcel A. Ruff, who was an expert on the Symbolists, lived in the same building on Boulevard du Roi-René where we had rented an "attic converted into a student studio," as the classified ad in the local paper described it. I only needed to go down the large staircase from the attic to the second floor to find myself at Monsieur Ruff's residence.

Between Paris and Provence, we had been on our honeymoon in Rome and Greece. We had gone by train from Paris to Rome, where we spent ten days. That was too long, and not long enough. Too long for the heat, which was punishing, and for my nauseated state. Too long for what our minds, our hearts, and our bodies could absorb. Of the dazzling light, the profusion of golds and marbles, the immeasurable riches, the vast scope and intelligence. And not long enough for the time it would have required to take in even a thousandth of what we saw.

Our budget was very limited. Our room in the little hotel was infested with fleas. A pharmacist advised us to apply a powder everywhere, including on the sheets. I was young, I slept, but I slept badly. A few difficulties arose between us. The reality principle did its work. We were no longer in the love of dreams and the dreams of love.

In Rome we had seen as much beauty as we could take in. We experienced the Sistine Chapel, with its ceiling by Michelangelo, in stunned silence and, for my part, on the verge of tears, now that cracks had begun to form between us, revealing beneath the surface signs of the inevitable break. We didn't know yet when it would happen. We didn't want to know. Love, mad love, demands a certain blindness.

Luckily, there were ruins – of palaces, statues, fountains, and the Coliseum. Ruins that told us to what depths the two of us could sink if we did not get back on the path where joy rejoices and happiness smiles. So we returned to living life. We feasted in the little restaurants and prayed in the churches, and we even saw the good Pope John XXIII go by in his white limousine. He gave his blessing to the crowd that, like us, had come to St. Peter's Square. We felt it was for us. We kissed.

After Rome, we took a boat from Naples to Greece. It crossed the Mediterranean to Piraeus. We were in second class, crammed in like sardines on the third deck, which got all the greasy, peppery cooking smells. So as not to feel seasick, we would climb up to the highest deck and spend our days there. The pure air and the two blues of sky and sea restored our desire to live and admire. We had seen plenty of museums, sculptures, and paintings. We both loved art that gives the world back its destiny magnified through contours, colours, light and shadow, in other words by the genius of its multiple transpositions. Here, on the Mediterranean Sea of our enchanted nursery rhymes and memories of childhood, we found ourselves in a huge *tableau vivant* that advanced to the musical rhythm of the sky criss-crossed by birds and the water over which we moved.

One of the most powerful aesthetic experiences of my life was going through the Corinth Canal. A slow journey between walls of ochres and pinks, gigantic blocks of stone cut vertically, exposing the strata, with very little space for the boat to pass. The passengers all held their breath. The spectacle was sublime and the trip was risky. We could no longer see the sea that carried us, the hull of the boat filling the entire space like a bed that extended from one wall to the other and that you could only get out of by going above or below. Between the sculpted walls of the canal, there were only the passengers. The only landscape, vast and stretching to infinity, was the blue sky, a blue of a rare plenitude offered bare, a jewel for our contemplation.

And then Athens! The modern one, poor, congested, polluted, was far from the one we knew in books – of linguistics, philosophy, literature – but something in us persisted in trying to break through the rough, opaque walls, wanting with every fibre to find the contemporary enigma in order to retrieve the ancient glimmers that had fed our imagination and formed our thought. As in Rome, where I had not seen any trace of the *Aeneid*, I sought in vain the fossilized impressions of a huge library containing everything from Homer to Sophocles, from Herodotus to Plato. But I saw nothing. I felt blind and deaf, exiled from myself in a land that was far away though it had in large part formed my vision and my understanding of the world.

As foreigners often are, we were tourists. In the mountains or on the seashores, in the village squares where we danced, through the streets of the towns or on the anonymous roads, we were the travellers who record or photograph everything but don't understand much, saying to themselves at night before going to sleep, perhaps one day we will know where we have been.

It was in this rather vague, almost absent state of mind that we nevertheless resolved to go to the most mythic sites, the Agora and the Acropolis. A bit tired because of my pregnancy, walking under a dazzling sun that consumed the entire landscape, I saw nothing but the hundreds of scrawny cats of all colours slinking among the dry stones looking for some non-existent sustenance. They were all going to die in the Agora, and I wanted to go back and sleep.

Suddenly, there was light! We were sitting on two huge blocks of stone from a temple demolished by time, looking at the Parthenon before us, when I suddenly grasped the lightness of this mass suspended between sky and earth that seemed about to lift off the base of its columns and take flight into the pure blue of the infinite sky. That was indeed the effect sought by the architects of those ancient times. It seemed like pure magic to us, while for them, it was the precise mathematical and geometric calculations that created this effect of taking off toward Olympus, a sacred place believed to be the home of their gods. In these dazzling moments, my reading of Malraux's *The Voices of Silence* or René Huyghe's *Art and Mankind* came back to me. I began to understand, to perceive, behind its modern, often ugly screen, the vast panorama of Ancient Greece as centuries and centuries of works had depicted it in philosophical thought, artistic expression, and religion.

In the country that also invented democracy and the rule of law, it is easy today to see why the various Greek symbolic representations such as the Acropolis and the Agora, places of offerings and public debates, could have been considered a threat to the Persian Empire and were partially destroyed by the assaults of Persepolis, the capital of the great autocratic kings, 2,500 years ago.

Upon arrival in our converted attic in Aix-en-Provence with my recent visions and knowledge and my new maternal fatigue, I visited

the classrooms of the university where I was to enroll and realized that I would not go back there. I had been attending school assiduously since early childhood, in Amqui, Rimouski, Quebec City, Moncton, Montreal, and Paris. I wanted nothing more to do with these breeding grounds of knowledge filled with noise and competition. I wanted the solitude of our little abode. I desired the calm of my reading, my music, and my dreaming walks. I needed to be alone, brooding my baby in the nest of love the two of us had joyfully created.

I only had to go down one floor to request a meeting with my thesis director. Monsieur Ruff never came up to the attic, which was normal, he was my thesis director and my superior and the hierarchical rules of the time were quite clear. He immediately agreed to my request and a program was established. I would meet with him one afternoon a week. He would direct my reading, establishing a list made up essentially of the Symbolists, especially Baudelaire and Rimbaud – and Mallarmé, he said, although his affection was reserved for the first two. Claudel's entire body of work, with emphasis on *Five Great Odes*, and the critical literature on Claudel.

Eventually, when I had started to write my thesis, I would submit the chapters to him and he would assess them as we went along. But there was no rush. We had all the time in the world. And there was "this child to be born, who will undoubtedly interrupt your academic progress."

I liked Monsieur Ruff immediately at our first meeting. He was a short man, but of high intellectual stature. Every week, we would spend delightful moments together in his huge library. Each time, his wife, who was pleasant and self-effacing, as wives were in those days, opened the door and led me down a long, dark corridor to the sanctuary of the library, where Monsieur Ruff, getting up from his majestic plush armchair from another era, would shake hands to greet me and indicate my little chair, always the same one. Madame Ruff would leave and come back with a tray holding a teapot and two cups, which she would place on a charming little marble-top table between us, which would also be used for papers and books after Madame Ruff appeared one last time, excusing herself, to take away the tray.

When he officially approved my request to be dispensed from classes, Monsieur Ruff said, "You know, my dear, we need to innovate

in French universities. In prestigious American universities, they're already teaching through tutorials." And so we met every week until my delivery, in April, and even after that, from the end of May to our departure for North America in July. He did this demanding work for free. Although Patrick and I weren't rich – we were living on his small salary as a lecturer – I still offered to pay him a weekly fee for his tutoring, and he said those words I heard often in those days: "You don't owe me anything, believe me, we're the ones who are indebted to the Canadians for saving us at the end of that terrible war."

Apart from our serious sessions of study, Monsieur Ruff, "as a sign of trust" at our very first meeting, had me go to the middle of the room and, speaking in a very soft voice as if we were in a funeral parlour, said, "Look there, in the centre." On a green velvet mat enshrined in a glass case, he pointed to something I didn't make out right away. Then I saw what looked like a spider's thread. He said, as if still in wonderment, "It's a hair of Baudelaire's!" I knew then what kind of man was going to supervise my work: a meticulous, eccentric, even devout collector. I rather liked this. Looking at the object of his devotion, a single hair that had got there in a way I've forgotten, and seeing for the first time in my life a private library as big as a cathedral, with a sliding ladder to reach the higher shelves and his collections of hundreds of books, which he presented to me in one long lesson, I felt transported to an earlier time that I couldn't fully appreciate, and I liked the unsettling feeling. That was what I'd left my little corner of the world for.

When I think back to our little attic apartment, I see a scene filled with light. It was a place of such perfect calm – no noise came through the stone walls at that height – so we could read and study as much as we wanted. There were only two rooms, the bedroom and one that served as living room and office. In the bedroom, a single window almost at the ceiling outlined a rectangle of sky whose blues ran the full gamut of shades, depending on the hour of the day or the night, which there, at that time of year, was never black. There was also a kitchenette, which was minuscule to us, accustomed as we were to large North American kitchens. It had everything needed to prepare meals. Over the months, its walls became dotted with slips of paper – grocery lists,

recipes, measurements, and cooking times. I was learning to cook, and I devoted myself to it with passion, although until then I could hardly boil an egg. I bought myself an illustrated cookbook and copied several menus in their entirety, and I applied the recipes with a perfectionism that amazed and delighted me.

The apartment was filled with laughing light. The floor was covered in ochre tiles that shone with wax. The walls were yellow, white, and orange. We didn't go out to restaurants or bistros or movies or the theatre. We had neither the means nor the desire to do so. We loved each other. I nested and gestated. And we studied.

That year, with a supplementary scholarship of $1,000 from the Canada Council for the Arts for candidates who were writing a thesis, I bought the complete works of Claudel, Proust, and Dostoevsky, as well as Shakespeare's plays in André Gide's translations, in the Bibliothèque de la Pléiade editions. I started slowly to study English. I read everything. Beginning in January 1963, we read while listening to Richard Wagner. It was the hundred and fiftieth anniversary of his birth, and one of his works was played on the radio each day. We had a Telefunken radio we were proud of, which was our link to the world outside and on which we eventually listened to Wagner's complete works. I will always associate the light of Provence with those writers and that music.

Every day, I did my shopping on Rue des Italiens. I knew all the merchants, who enjoyed talking to "the Canadian woman who's expecting." When Charles was born, I was entitled to a slice of veal liver once a week, on Thursday, as prescribed by my gynecologist. Many meats were still being rationed after the war, including veal liver. I was entitled to it in order to regain my strength, as the doctor and the butcher said, but also "to thank the Canadian soldiers." I was charmed by this honour. Charles, too, seemed pleased. I would bring him with me in his stroller. People would compliment me. They would greet the "new French citizen." They would welcome him, stroking his cheek or his "tiny hands" and singing nursery rhymes to him. He was in heaven. During our walk, I would stop at the fountain of the Four Dolphins. I would rest and he would gurgle.

Friends would sometimes come to visit us. Most of them were American students. There was Brigit, from Michigan, Charles's

godmother, who took photographs and brought us "goodies," little chocolate or orange cakes that we would eat with tea. An English friend whose name I've forgotten taught me to make "real tea." There was a visit from Pierre Blanchette, with whom we spent hours in discussions over pizza and red wine. And my friend Lucienne Topor, who came to see her parents, the Dickenses, in Manosque, where we were later invited to visit.

Through Lucienne's personal history, her tragedy, her two families, and the Final Solution, I left behind my internal religious debate and moved toward politics. I'm still there.

I became attached to Monsieur and Madame Dickens. He was a subprefect in Haute-Provence. He had a living awareness of history. His library was vast. He spoke little. Kept to himself. Withdrawn and sad. Madame Dickens was the very embodiment of vivacity, warmth, and affection. We spent Christmas with them in Manosque, and ate on the patio in the sun, wearing only light sweaters. I found it amazing when I thought of our snowbanks at home, the midnight mass, the stuffed turkey, and the singing of Christmas carols. I ate devilled eggs with anchovies and capers, a bird stuffed with three fruits, and there were no songs or decorated tree and no mass (the Dickenses were republicans, socialists, former members of the Resistance, atheists). I was elsewhere. Uprooted. Out of my element. But I didn't feel foreign. Or, rather, I felt quite at home in this foreignness. It was what I had always wanted without really knowing it. I knew it now. I let the December sun turn me golden brown. I loved Provence.

It was Madame Dickens who taught me to make "real Provençal ratatouille. Not the kind from Marseille, with peppers. And certainly not the kind from Paris, with who-knows-what. No, the only real kind, from Manosque or from Aix. With eggplant, zucchini, onion, garlic, parsley. And good tomatoes. Fresh. And good oil. From Provence. Nothing else." One day, wanting to return a bit of her culinary generosity, I invited her for a meal at our house in Aix. She said, "I gladly accept, but don't prepare anything, I'll make my ratatouille for you, you'll see, you won't forget it." She arrived with everything she needed. All the vegetables and the oil in a big wicker basket. And in front of me in my minuscule kitchen in the sunny attic, she made her ratatouille and showed me how.

Every time I make my ratatouille, I see that scene again. I think of Madame Dickens. And then of Monsieur Dickens. Of Lucienne, their daughter and my friend. And I love them.

Despite all the delights, my year in Aix-en-Provence was not pure heaven. The seclusion was sometimes oppressive. I was not of an age for asceticism or retirement – and I never will be. The born-and-bred country girl I was felt the call of the North, of the wild forests, the rugged roads, and the rocky rivers. I was totally absorbed in motherhood. I could have returned to the path of writing to calm my spirit, send my shouts to the four winds to echo from mountains and hills and come back to me in a multitonal symphony, far from the hemmed-in human beings, as I did in childhood. But I wasn't writing. I had shelved that project. I had put aside even the idea of writing. Something was being written within me. That's what I'm translating today.

Sometimes big black clouds passed above us. We entered into a time of turbulence and storms. I felt the love between us teetering and cracks forming in our marriage. I would suddenly become afraid, I didn't know of what, and I would have nightmares. Those nights called forth ghosts and I didn't know how to chase them away – or tame them. As the days – and the nights – passed, a groundswell would strand us and then the backwash of desire would carry us away again. And I would forget the storm and would be afraid to think of what might happen. The danger would be over, I would believe, and I'd bury my head in the sand. It was a common flaw, I learned later. A flaw that is cured in the forge of repeated tests with showers of sparks. With the patient hammer that must strike the anvil so many times to create something new.

In the course of a calm, uneventful night, I felt the first contractions, and then the rush of my water breaking. The labour of birth began. We were so ill-prepared and uninformed about this fundamental event that mothers and fathers had experienced since the dawn of time, including our own parents. Total silence had been the rule with regard to pregnancy and childbirth. Births had taken place in the secrecy of the marital bedroom, with a doctor and a midwife officiating behind closed doors.

My own mother gave birth to her ten children in her marriage bed. I remember those nights hearing her stifled cries and then the crying

of a baby I didn't recognize. To our questions in the still-sleepy early morning, the midwife would answer, "The Micmacs came in the night with a wicker basket filled with babies. Your mother chose the most beautiful of all of them." We knew very well it was a lie. We had seen our mother's belly growing. Essentially, since the truth was not told in true words, we knew nothing, as Françoise Dolto wrote.

Our mothers, with rare exceptions, remained silent. After all, their confidants, the parish priests, experts on the Immaculate Conception, would not allow those mothers, who had given birth repeatedly in the solitude of their bedrooms, to speak freely. It was feminists who would, soon, in writing and speech, break the seal of the treasure chest of all the silenced words on birthing from centuries and centuries. Blessed be they!

Meanwhile, in the ambulance speeding to the birthing clinic, Patrick and I felt as if we were all alone on a desert island. Far from the shores of life. Meanwhile, I was suffering torture. And Patrick sympathized. The labour, which went on for thirteen hours, was carnage, there's no other word for it.

I've written about that painful day elsewhere, in various forms. I'll only give a summary here. All I was given for the intolerable pain of the contractions was sadism and cruelty. The old saying, "You had your pleasure, now suffer!" was uttered by a brusque midwife, who screamed in my ears to push while a sister, bracing herself against my shoulders with her full skirts preventing me from breathing, pushed on my belly with her strong hands and breathed as if she herself were giving birth.

Patrick flew into an Irishman's rage. He made the sister get off me and threw the midwife out, shouting, "Leave us alone. Don't come back in here." Unable to bear seeing me in such a heart-rending state, he fainted and collapsed on the ground. He was revived with a glass of cognac and taken to rest in another room.

Alone with my torture, I continued to moan and even bellow. I must have said something, because another midwife, who had just come in, asked in a disapproving way, "Would you mind telling me what language you're speaking?" Robbed even of the right to suffer in my own language, I remember answering her with an enraged shout, "I'm speaking Huron. Leave me alone." My words were greeted by a wall of silence all around

me. I was alone, as in an endless desert. In immeasurable pain. But finally free. Free to suffer in all the languages of the world. I felt I had been given the gift of tongues of fire.

When the worst had passed, the gynecologist was called. And he came. During these dramatic moments, my feet were in stirrups. He was seated on a stool with his back against the wall. Facing the gaping hole of the beast I had become, he lit a cigarette, and he too began to shout, "Push." I couldn't anymore.

I thought I had died when the baby finally emerged. Soon, with the shouts and the flow of the placenta and the blood, I heard my baby cry. He was put on my belly, all sticky and beautiful. I was not in pain anymore. I was in an ecstasy of dreaming. It was Charles, that unknown person I immediately recognized. And immediately loved. The spring of love that had its source in that moment of grace has never run dry.

I returned home after ten days at the clinic – that was considered normal at the time, and it was a good thing for me. Born on French soil, Charles had French nationality, with all its privileges. I was entitled to the same advantages as French new mothers: a twice-weekly diaper laundry service, by a woman from the neighbouring countryside who would come with a cart to pick up the diapers and bring back the clean ones; a woman who would come every morning and bathe the baby and hold him and take care of the thousand little tasks involved in his care, while I rested, which was a great help to me. The woman was lovely and good. She herself was a mother of five, and without making a fuss about it, she showed this "poor child who doesn't have her mother with her in Provence" how to be a loving mother in practice. I can't begin to say how much she did for me. Governments should give this kind of help to all new mothers without family nearby. It is as important as school. Otherwise, there is a danger of minor or major depression.

Philosophers and educators have spoken little of this basic concern for others, for the simple reason that women could not exercise these professions. Taking care of babies – and mothers – was considered unskilled work, which was condescending to the "third world" of humanity made up of women and their offspring. As if the great thinkers about humanity had all forgotten where they came from when they took the path of higher learning.

This woman also had the wisdom of long experience as a mother. As she herself said, "I'm a midwife for after childbirth." One day when I was telling her how difficult I found caring for the baby properly and how tired I was, she answered, "Small children, small worries. Big children, big worries." She didn't sugar-coat the truth. And that helped me.

Because of Charles's birth, I also received another invaluable gift: the right to spend my afternoons with him in our landlords' garden, an oasis whose existence I hadn't even been aware of. One day when I was coming back from my walk with the stroller, Madame N., who until then had not been pleasant or friendly, complimented me on my "beautiful child" and told me in a low voice, as if it were a secret confidence, that she would open the back door to their Eden for me. She took me to it and even gave me a key. I had never noticed the little iron door at the end of the corridor on the ground floor, which led to a private garden hidden from the neighbours, surrounded by massive walls of big tall old stones, with the sunlight creeping in between the soft shadows among trees, shrubs, and flowers such as I'd never seen at a single house. A dream! A dream that had been created over centuries, you could see it and feel it. Charles and I spent hours there. He in his stroller or in my arms, drinking from his bottle, and I on a majestic bench of stones softened by time, simply revelling in this paradise.

(When I went back to Aix, I saw the house again, its facade, its steps, and its wrought-iron shutters. But never the garden. I tried walking all the way around the building, but there were no lanes in the city, and I couldn't find it. The garden was completely enclosed. It remained secret, true to what had always been its vocation.)

We left Aix-en-Provence in the sweltering heat of July. Before our departure, I had hardly done any reading, much less writing. I was involved in a different learning process. We would arrive in the oven of New York, a city I had never visited. I would meet my in-laws, whom I didn't know. We would spend two months with them before going to Montreal, where Patrick had a position lined up in the English department of the Université de Montréal.

I was going to see my parents again, and my whole family, and my friends. I had put my studies on hold along with my plans and dreams

of writing. I would introduce my son to everyone; that was better than a diploma and better than a book, I felt. I had given birth to a new human being. I was proud and happy.

On the ocean liner *Leonardo da Vinci*, where the three of us spent ten days travelling from Italy to the United States, I experienced the voyage, on waters that were calmer than those in the north, as a real vacation. I enjoyed crossing the western Mediterranean, and then Gibraltar, and then the encounter with the Atlantic.

New York

We lived in New York for two months. With my parents-in-law and one of my brothers-in-law. In the North Bronx, where second-generation immigrants, most of them Irish, had bought little red-brick cottages or duplexes. With a small backyard where we could keep cool under a tree when the sun had gone to the other side of the house. Tenants lived on the first floor, and we lived on the second in a nice little brand-new apartment with three bedrooms. Patrick, Charles, and I were in the biggest bedroom, the master bedroom, my brother-in-law said, delighted.

It was so hot in New York! A real oven. I had never experienced that. To cool off, often I'd go down to the basement where I could do the washing and ironing while watching the baby with his new family in the backyard. There was a little window looking out onto it, through which I could even talk to my in-laws. They adored Charles, their first grandson – and first grandchild. They would rock him, sing songs to him in Gaelic, and talk in whispers when he was asleep. My father-in-law was crazy about him. My mother-in-law was usually working. She was a cook for "some rich people in Manhattan" and would sometimes bring us back a leg of lamb of the highest quality or a prime rib of beef, which she would cook like a master chef. She had little education, had only gone to school for a few years, but her intelligence was so quick that she often dazzled me. With her Irish accent, she could recite Shakespeare's sonnets, which she had known since childhood and had declaimed while watching the cows in Ireland at the age of fourteen.

My mother-in-law, my father-in-law, and my brother-in-law were all very kind and generous to me. Because I came from "Canada, up north," as my mother-in-law said, and I was "French," they treated me like a foreign princess, "so beautiful and so exotic." I never knew why my mother-in-law took me for an aristocrat. She would say, "Marie comes

from high class," and no matter how many times I told her my father earned his living working in a mill, she persisted in giving me an air of grandeur. And she called me Marie, as they all did, because it was easier, more common, more plausible for Anglos than Madeleine, which they found really foreign. I was from far away, and they wanted to repatriate the mother of their grandson. And I liked it.

It was as if I were seeing myself in an unfamiliar mirror, and I entered into the new image that was reflected back at me. In a way, I was experiencing myself as other. Really a stranger, distant, elsewhere. More different than in France. I felt unknown. An immigrant. An expatriate. I liked seeing myself through their eyes and in their words as they tried to understand me. We were a completely novel experience for each other.

Luckily, there were celebrations – and what celebrations I enjoyed with them! And pure affection that never waned. What delicious meals I ate there, at the table in the dining room that opened onto a fully equipped, well-stocked little kitchen, a central room between the living room and the master bedroom. My mother-in-law was a gourmet cook, although very different from my own mother, whom I had till then considered unbeatable. I took one more step in my education as a cook. Watching her without getting in her way – I was her assistant – I acquired other ways of doing things that gave equally excellent results.

And the celebrations were always well supplied with drink. There was whisky, which was a discovery for me. And beer. And for the French princess, red wine, I don't remember where it was from. There was singing at these celebrations, and lots of stories. In Gaelic and in English. I learned English from the laments and ballads sung, the poems recited, the stories borrowed from legends or from the saga of the Irish from Ireland, who had known the potato famine, poverty, domination by the British Empire, exile in America, and the suffering and the greatness of their people, their struggles and joys – and a life that brings love and happy children and a little grandson, who was as happy as a messiah of the New World.

Friends came to visit the family, most of them Irish ("Irish Americans," as they said). They came to greet the exotic character I was, born

elsewhere but not so far away, "up north in Canada, so close, but French, just married in France, isn't it marvellous?" They called me "Marie dear," and Charles, "Charlie my love." We were content. I learned their language with these people who had exiled themselves in English in order to survive, and who spoke with an eloquence, an ease, and a musicality never heard in my own language, not in French Canada or even in France, where content always took precedence over melody.

We visited the neighbourhoods of New York. Especially Manhattan, where our friends were, at New York University and Columbia. We went to museums, and sometimes the jazz clubs in SoHo. I experienced vertigo just looking upward to admire the lines of the skyscrapers that hid the sky and closed you in, with no horizon to cast your gaze on and then to let it drift, and then to dream.

I felt much more of a foreigner than in Paris. Some days, I would say to myself that we had all left the same old countries of Europe. We had all crossed the same ocean to arrive in the New World. We all lived on the same soil, that of New York or Montreal, an hour away by airplane or a short trip by car. But, God, Manosque was far away!

Was it language that separated us? Or our different histories in America? Was it that our next-door neighbours had succeeded in throwing out their masters of the British Empire and obtaining their independence from the Imperial Crown, while we, both Canadian peoples, anglophone and francophone, had not achieved – or even desired – that sovereignty? Was it our different ways of dealing with the First Nations? Or the economy of the Americans, especially in the South, based on bringing in millions of Blacks from Africa as slaves, which enabled the country to develop at little cost for a good century?

And the music, blues and jazz, that came from those same slaves, and that would transform music all over the world right up to today? And the proximity of the Spanish-speaking people of Mexico and the rest of Latin America, whereas near us, in the north, it was the polar ice that greeted us?

Was it their numbers, the incredible melting pot that had over time built a superpower that maintained the precarious balance of the Cold War, ready for a hot war, a real one, armed to the teeth?

We were from two different worlds. Fascinated, I watched and listened. I read in their language, and mine seemed lost beyond the horizon, as if in the background.

How could I write then? I didn't even think about it anymore. Deep within me, I felt another writing, call it the writing of the unthought, clearing a path for itself. Like a subterranean river. I realized this later, in Montreal, when the spring emerged from the depths, in a torrent at first. As with my big sister Anne Hébert, whom I enjoyed reading years after, and for whom I felt genuine affection and friendship whenever we met, in France or Quebec.

(One day, I will describe more explicitly what I mean by this *torrential writing* when I first began to write, a little before 1970 and throughout the following decade. I will speak of its obscurity, which was necessary then because the paths my words would explore came precisely from an obscure place, from strange lands within. You could say that what I was writing then had its roots in the soil of strangeness. As if from an extraordinary, unexplored country whose language had to go through mine, through my unique way of writing and speaking French. Otherwise, it would have been mutism. Or possibly, music alone. The piano, which I had studied for twenty years and had to give up. To give up for lack of financial means. Of space. Of a place to play. But at the same time, wouldn't I find music in words themselves? Music, the only practice – along with painting and its silence – that could sustain the outpourings of emotion and the journey along the still-obscure tree-covered path of words that would finally give the world its light. I see the happy young woman I was in this first American summer. I love her for not giving in to the blissful happiness, knowing, even in an inept way, that this happiness would not do without "the words to say it," to borrow the title of Marie Cardinal's book, nor without the search for truth they would make possible.)

Anyway, in New York in the summer of 1963, I was totally absorbed in the beautiful love of family and in new friendships, and I no longer dreamed of writing or psychoanalysis. I would be changed by discoveries of strangeness that opened the way, almost imperceptibly, to what these two practices would become in my life – and much sooner than I would

have thought, when, on my return to my country, real life plunged me almost brutally into the no less unfamiliar reality of a home that I no longer recognized.

I was eager to see my family and friends again. I had spoken on the phone with Maman, who was looking forward to seeing Patrick and me and meeting this Charles she imagined to be a wonder. She dreamed of all her children and grandchildren as the most beautiful, and she would say so without embarrassment, living, as I have said, in the family romance she had created over the years. So she was waiting for us with joy on the September day when we would finally come down the river to the valley, to the house, her "manor," as she always called it, embellishing it. She would welcome us with open arms. She would tell me how I was adding years to her life, which was already wonderful, by coming home after such a long absence.

I sensed that returning to my country would end the romance Patrick and I were living. That it would be hard for the three of us to adjust. Material and financial problems. The concrete, difficult, fast-paced life we would have to live. Patrick had a position at the Université de Montréal, but where was I with my dreams of studies and writing? I hardly dared think about it. At any rate, I was busy with the baby and with getting to know the people around us and learning an English that fascinated me with its Gaelic musicality.

In the meantime, I really didn't worry. We would cross that bridge when we came to it. Like an animal, I sensed that our next land would hold surprises and dangers for me. I smelled them on the wind, let's say. There's one good thing about burying your head in the sand: you rest while you're waiting. As long as you pull your head out of the sand and check for danger from time to time. To see what's coming. To prepare yourself. Although there are some people who keep their heads in the sand to the end of their days. Who don't want to see. And when things fall apart on them, it's a shock: absolute lack of understanding, outrage, a ton of bricks. It's so strong, so sudden, that the body can give way. Or the mind. I've known some people like that. I still know some. Poor things!

So I took things easy until our departure for Montreal. By airplane this time. I enjoyed the Americans' friendliness – I must have met scores

of them, family, friends, friends of friends, or just people I came into contact with, doctors, professors, various merchants, and all kinds of officials, from the priest to the Canadian consul. It was the good nature, the humour, the spontaneous affection that struck me in this composite people. Whatever their ethnic origins. I delighted in their joie de vivre and charm, their seemingly unconditional acceptance. Despite the great friends I had left behind in France, I, like so many others, had experienced the hardness of this people that had gone through such sad, disastrous events, whose unhealed wounds had given rise to melancholy, bitterness, or rages, especially with strangers. Smiles and lightheartedness were not common. Suspicion of foreigners seemed to be a vital necessity for some people.

I had managed quite well in France with regard to these questions. I left there more lucid, more attentive. And tougher. In contrast, in the United States, I was in a country of victors. Here, it was soldiers who had fought the latest wars. Civilians had been practically untouched. They had even welcomed civilians from the world's most suffering nations with open arms. They were proud of having contributed to the well-being of the whole world. And weren't embarrassed to say so. Sometimes said so with bravado. I could understand it, but deep down I thought these people should cultivate the humility of a conquering people – not the same humility as that of a conquered people, which I would say is inherent in their condition. And still less the humility, the greatest of all, of a people that was practically wiped out by genocide. Of course, I am referring to the Jews, many of whom I met in New York. I also understood the Shoah better, I believe, as a result of my New York encounters.

Some days, I would wonder, though fleetingly, if I would ever really write, I mean whole poems, novels, short stories – in other words, books. The answer was very simple. Yes, I would write books, stories – something as yet undefined. I knew instinctively, without clearly admitting it to myself, that I would write books. I wasn't too sure why, or when. My problem, which was not enough of a problem to cause me distress, so casually did I think of it that I had barely articulated it, could be summed up as follows: what language was I going to write in? My literary language – my reading, my sources – was French, but would my own writing be different, and where would it come from, and what would it

be called? The concept of Quebec literature hadn't yet been born, the term wouldn't exist until a few years later. To my knowledge, there had never been any courses on Quebec literature. Nobody had ever, during the whole long curriculum, talked to us of this question. (There were a few courses on "French-Canadian" literature, but I hadn't taken any of them.) I could have been discouraged by this absence, but in fact, I thought about it so little that I was able to focus on other things.

Something vague was carrying me toward an accessible ideal. I would find the words to say what I had not yet read anywhere. I would create books, because until now, it had been books – the great ones, the true ones – that had taught me the essential truths of life. I would find the words never written elsewhere to tell my story, mine and my people's.

My people didn't yet have a name, its own name and not just a fraction of the name of another people. That would come at the same time as the name of its literature, with many other revolutions. Quebec would be baptized not long after that summer. I was far from home, and it was as if, intuitively, I, like so many of my compatriots, was laying the foundations for a project. My project of writing, of finding new words, coincided with their project of laying the foundations for a new country. I was present at the moment of this historic emergence.

Not very aware, and hardly capable of formulating the project, I nevertheless had wings. Something was going to come into the world, and all possibilities – politics, culture, friendships – were inviting to us. Something was going to happen and I would be involved in it. One of its architects. My passion for writing would bear witness to these social and individual changes.

In New York, during that summer of 1963, I was beginning, from a distance, to get a sense of this people that was mine and with whom I was going to live. For a long time, I had a feeling this was coming. As if having the same soil of North America under my feet and learning the English of the conquerors allowed me finally to discover my own identity! (In retrospect, I know that English, which is also the language of the Americans who became independent and the Irish who were conquered and expatriated, contributed to my understanding of the precarious state of my own language – and of my own people.)

Also, I must admit I allowed myself to be pampered by my in-laws, who were filled with affection and solicitude for me. I rested and slowly recovered from my injuries related to the birth. France was not wholly responsible for this. On our arrival in New York, both Charles and I had the horrible experience of undergoing surgery without sedation. Charles was found to have a malformation of his legs. With a total lack of sensitivity, they broke his bones, straightened his legs, and put them in casts. Which he had to wear for a full month, in the heat. He had just succeeded in performing the exploit of turning over in bed by himself when he was hit with this sudden imposed paralysis.

I remember his look when he woke up – they had given him a mild sedative afterward – as if he were searching everywhere, begging an invisible angel. He tried in vain to wriggle, but the casts fell back heavily. He had to lie still for many long weeks. I tried to find the words to tell him how this ordeal had come about. I must have found them. They must have come with the gestures of love, and those came without searching. It took years for Charles to regain his natural strength and agility. Something sudden and very painful had arisen to block his physical development. This trauma was imprinted on the core of his being and impeded the simple pleasure of living. With no preparation by his parents – and with no alternative medicine afterward to help him return to normal development, discoveries, and learning. The three of us were left on our own throughout this ordeal. And we parents, otherwise so well educated, were ignorant in these matters of physical health.

As for me, already anemic after the carnage and loss of blood of the birth, I had to undergo an operation about which the gynecologist said only, "it's nothing." I was informed firmly that American medicine was the best in the world and that I had nothing to fear, that it would go well. The procedure was a cauterization of an infection of the cervix, something that occurs frequently after botched deliveries. It was literally torture. Reduced to an animal, with my feet in stirrups, with no anaesthesia, I saw the doctor approach holding a long metal rod. He brusquely inserted it in my vagina and turned on an electric current. An indescribable violent pain, and I fainted after a cry that ripped through the hell of this

murderous universe. Afterward? I called the doctor a barbarian. And a liar. "It will go well," he had said.

After the days of weakness and healing had passed, I was filled with a great anger. How could they treat the bodies of women – and of children, as I had seen with Charles – like this? How and why? Why hadn't anyone, mothers, aunts, grandmothers, or friends, talked to us of these horrors? How many women have been told they were frigid or sexually frustrated when mere vaginal penetration was torture before you had healed? How can you make love under such circumstances? Nobody, ever – not doctors, not friends, not spiritual guides – had taught us about these unspeakable ordeals. I believe I became a feminist ahead of my time because of these murderous experiences.

I didn't say this then. Like other women, and there were many of us, I did not yet have the words to say it. For the moment, we were experiencing these dramas in isolation and silence. As for me, I scrounged crumbs of love and friendship wherever I could, in search of comfort. I could feel the cup of rebellious words slowly filling up.

It was the summer of 1963, the weather was warm, and there came to our New York ears the cries and laments of southern compatriots, the Black Americans whom racist whites wanted to keep in servitude. There was ongoing social unrest. We read reports and analysis of the situation in our daily papers and in magazines such as *Time*, which my friends encouraged me to read as it was easier for a beginner in English. I began to understand what I thought of as this new racism, since I knew little of the long and painful history of slavery, and my understanding of racism was based on what had existed in Europe with Nazism. I suddenly remembered what I had, for all sorts of reasons, put aside without realizing it – you can't do everything or think about everything at the same time – my concern for all injustice, wherever in the world it existed, all violence exercised against those who were subjugated and dominated. I saw that in the great American democracy, from which the world could take many lessons, there had been domination and violence against anyone who did not

submit to the privileged majority. Slowly, I reconnected with my earliest struggles, finding the substratum of my private rebellions and my quest for justice. And I remembered.

There had been riots in the United States of America in the 1950s. At College Notre-Dame-d'Acadie in Moncton, we had followed the racial crisis in the South in shocked disbelief. The drama of the high school in Little Rock had given rise to many questions and thoughts for us. Someone recently gave me some articles I had written in 1959 in the college newspaper, of which I was the editor. Rereading them, I realized that the historical injustices toward Black people were the crucible of my political awareness. My sensitivity to the patriarchal domination of the world and the exclusion of women from all power of any kind has its source there.

On August 28, 1963, when Martin Luther King gave his famous speech, "I Have a Dream," at a march on Washington by some 250,000 people, I found myself, without being there physically, mesmerized by the new hope of freedom for all the subjugated people in the world. And by the strategy of non-violence, as well. As if those saving words had finally awakened me from a sleep of two full years, in France, during which I had dreamed a dream of my own – which wasn't so bad, when you come to think of it.

I had pretty much ignored the war in Algeria during my stay in France. Cut off from my roots and trying to understand where I had come from, where I was, and where I was going, I had been almost oblivious to the anti-colonialist struggle of the peoples of the Maghreb against the conquerors from Europe, and what I knew of it was essentially from reading Camus, conversations with my friends in Paris, or the newspaper *Le Monde*, which I read daily, but many of whose analytical articles were beyond my understanding because I didn't know enough about the issues. After the "I Have a Dream" speech, the theologian Bruno Chenu had said that love is not a private feeling, but a force in history.

With my return to politics, I could feel that something was going to be reconciled within me. What? I didn't know yet. But a wind of hope was rising. It was in this state of mind that I took the plane for Montreal, with Patrick at my side and the baby in my arms.

AN
UNPRECEDENTED
TIME

That love can only be shed a little more.

– Monique Durand, *Eaux*

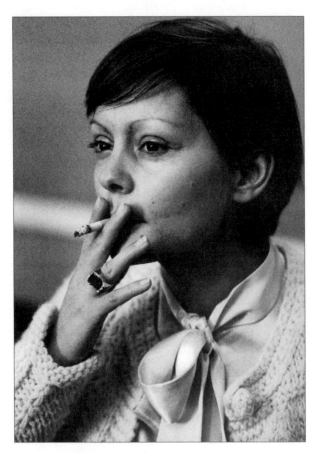

Madeleine, 1976. Photo Claire Lejeune

The New
Quebec

I had left French Canada two years earlier. I returned to Quebec. What a strange feeling!

When I arrived in Montreal at the beginning of September 1963, despite the joy of seeing my friends and family again and the peculiar power that comes from being three people together and not one alone, as when I had left, I especially remember feeling like a foreigner in my own country. I had changed, that was obvious, but the land and the people I had left two years earlier also seemed changed, they were practically unrecognizable. In fact, what I came back to seemed so much like a different land, I had a feeling of being without a country. And how can you recognize what you no longer know? I looked for signposts. I found them, luckily, in the thousand and one little tasks and the thousand and one little things in everyday material life.

I should say that in those days, the geographic distance from home ground was a real separation, a purely physical exile that was nonetheless real. There were none of the links that today connect people to their home base when they go away. No Internet or webcams, or so-called smart phones, hardly even the telephone. There were only letters. In the ones I received, very little had been said about the social upheavals that were occurring at a rapid rate in those years. I fell into the turmoil of the beginning of the Quiet Revolution, and I hadn't known anything about it. Neither personal letters nor the French or American newspapers had uttered a word about it.

Slowly, I was realizing how little importance my country had in the eyes of the great powers of the world. And I found the silence of my circle so puzzling that, little by little, I began to leave the enigma to them. In a "notebook on returning," I wrote convoluted sentences to try to penetrate the mysteries of public affairs. This was the starting point for

my first poems and stories. To tell the truth about my coming to writing, it was there at that confusing crossroads, in that place of my temporary inability to recognize my people – and as a result, myself – that writing found its source. Scribbling my first notes in that notebook of confusion, that was what I was doing without being aware of it at the time.

I also didn't know why I was thinking so much about Stendhal in the early days after my return. Stendhal, my Stendhal, who had become what for a long time I called my indirect ancestor – since my thesis director Monsieur Ruff, a great admirer of Stendhal, had told me that the author's mother, Henriette Gagnon, and his grandfather, Henri Gagnon, a doctor and encyclopedia editor, were "without doubt" my ancestors. In sowing these bits of personal history in me, he had, without my knowing it, traced the sinuous maze of a life lived in writing. Greeted with the enigmas of my country that was becoming one, I began to read the novels of Stendhal and utterly neglected my thesis on Claudel. I wasn't in the mood for it anymore.

The love of Patrick and Charles, my thousand and one everyday tasks, and reading Stendhal prevented me from sinking into the inevitable depression of a person who no longer recognizes the land of her birth and no longer sees herself in it.

Today, as I write this autobiography, my indirect ancestor is very close to me. I have been rereading fragments of his *Life of Henry Brulard* and better understand how making a life into a work through the act of writing can illuminate many an event that is nebulous and hard to explain. With the distance created by the transposition of his life into writing, Stendhal, before leaving that life – he had been gravely ill and he felt, he knew, he would soon die – allowed himself to go quietly back to the detested name of his equally detested father, or I should say, to the almost-name of his father, to that Henry Brulard that was so close to the paternal name given him at birth, Henri Beyle, but abandoned with the publication of his first book. At least, the venerated first names of the maternal line, Henriette and Henri, have been kept. Thus writing, the capacity to dream his life, would be saved and protected. Preserved. The maternal side of him that had its source in Italy – where, incidentally, he would spend a large part of his life, and where, in Rome,

he would begin writing his *Life* – that side, the side of the Gagnoni of old, of whom Roland Barthes spoke when he began the last text of his own life when he was to go to Italy to give a talk on Stendhal and wanted to tell his contemporaries of his desire to finally write fiction, the "Stendhalian maternal side" neglected until then, eliminated in favour of the theoretical essays that Barthes considered masculine while feeling they had a castrating effect on writing. (This was the text found in Barthes's typewriter on the day of his accidental death in 1980.) Stendhal would have liked to take his mother's name, Gagnon, for his pseudonym, he wrote in his *Journal*, but the time did not allow it.

At the beginning of his *Life of Henry Brulard*, he is sitting on a bench on the Janiculum Hill, in Rome, contemplating the beauties of antiquity. He writes, "It was marvellously sunny." He took care to indicate the date, October 16, 1832. "A light, barely perceptible sirocco nudged a few little white clouds over Mount Albano, there was a delicious warmth in the air, I was glad to be alive."

A little further, a nostalgic Stendhal writes: "Ah! In three months, I will be fifty, can it be possible! 1783, 1793, 1803, I count out the decades on my fingers, to 1833. Fifty. Can it be possible! Fifty! I'm going to be fifty."

Today, October 6, 2010, I reread those pages and I understand why, at twenty-five years old, on my arrival in Montreal, the fiction of Stendhal was more accessible to me, and why it was at the beginning of my own fifties, without seriously planning it, that I embarked on my own novelistic "personal writing." Now, at seventy-two years of age, I am beginning to understand why it has taken me all these years to put my life into writing. When one wants to shed light on a life in the shadow of words, which are all light for the writer, time becomes the great blacksmith of the work. And why the indispensable ray of light shines when I recall the darkest period of my life, the 1960s.

Today, October 6, 2010, to the sound of the waves in the strong winds and blazing sun of Indian summer on the Gaspé Peninsula, I can say, like my indirect ancestor: two months ago, I turned seventy-two, can it be possible! 1938, '48, '58, '68, '78, '88, '98, 2008, plus two years, I count out the decades on my fingers, to 2010, seventy-two. Can it be possible! Seventy-two!

I can't believe it myself, my heart seems to be in springtime. My heart and my mind. I just can't believe it. But I must think about it. Autobiography is only a way to better think about this stunning test of time passing. It may be public, as books are, but those who fear autobiography lack humility.

On our return from New York in the late summer of 1963, we stayed with one of my sisters. We were free to roam the city while she babysat Charles. First, we had to find an apartment, not too far from the Université de Montréal, where Patrick would be teaching, and furnished, if possible, since all we had were our clothes, our books, and a few things mainly bought in Provence. We finally found a furnished semi-basement with two bedrooms, a small one for the baby and a big one, the "master bedroom," as the landlord called it, which would also be my office. In Côte-des-Neiges, a drab neighbourhood of poor people and immigrants, which didn't displease me, since I felt like an immigrant myself.

Walking in the streets of Montreal, I was struck by a major change that had taken place during my absence. There were almost no more cassocks or long habits and veils walking along the sidewalks. I had left a city filled with tall black birds, and I didn't see them anymore. What had happened? I kept asking people. They explained to me. The churches were emptying, so were the convents and monasteries, people were losing faith or it was being dissipated elsewhere, melting into civil society. The men and women who remained in the religious communities quietly slipped into lay garb and were no longer recognizable. Even the hospitals and schools had been largely drained of their sacred personnel.

What was the explanation for this sudden change? Reunited with friends, I asked questions. We discussed. We spent endless evenings with a glass in our hand and new kinds of music in our ears – Miles Davis, Leonard Cohen, Pete Seeger, Joan Baez, Bob Dylan, Gordon Lightfoot, and Donovan, and Barbara – trying to understand these upheavals that were happening to all of us. I say "were happening to us," conscious that we were involved in the changes. Through books and records, the sexual revolution, largely from California, was knocking on our doors. And a burgeoning feminism was finding its way into our minds and hearts through books and magazines from the United States, France, Spain, Portugal, and the countries of northern Europe.

AN UNPRECEDENTED TIME

With our friends in their twenties or early thirties, we broke open the locks of incredible prohibitions. We talked for hours. We had the feeling that we were living in a marvellous period of history. We felt we were the players in an extraordinary game that was going to change our entire society.

Everything seemed possible to us now that the dust of centuries of condemnation, prohibition, and guilty silence was being swept away before our very eyes. We were certain we were part of a revolution that didn't yet have a name. We would name it. We would write it. We were in an unprecedented time.

During lunches or suppers with plenty of alcohol, we girls, we women, spoke up, talked about our oppressed sex lives, our relationships with men that were based on seduction. Our submission. Our alienation. Our lovers, our companions, our brothers listened. I remember one evening when we raised the question of orgasm, vaginal or clitoral. The men listened to us. Couldn't get over it. We couldn't get over it either. Coming from the emotional darkness of patriarchal and religious machismo, we tried to invent the words to express our rebirth, words that would come from the lights we lit with feverish excitement.

Usually, when the debating and the words were done, the parties would end with dancing. There, too, we wanted to innovate. We had grown up with the waltz, the tango, steps learned and counted, and now we took the path of rock and roll. Now, with movements that each one invented in his or her own way, we went out into the night spellbound and in love.

I gradually went back to my thesis. Idleness has never been my forte, and anyway, probably because of the discipline of growing up in a large household and going to boarding school, I had learned to finish what I started. Did the sayings I'd heard so often – "Never put off to tomorrow what you can do today," "A rolling stone gathers no moss," and others – end up finally becoming part of the very fibre of my will?

Realizing that I wouldn't really be able to study or write in the house otherwise, I – like all the women of my generation and background who wanted to study or work, with no daycare centres – had to hire someone to do childcare. We called her a nanny, which seemed more respectful than maid and much more so than servant. She had come from Romania, and she asked us to call her Nana. She was marvellous. So warm and so loving. She would sing Romanian songs when she rocked Charles and tell him stories in German. "That language is beautiful," she would say. "It will open a lot of doors for him when he grows up." Two years later, when we moved into a spacious apartment and I could finally see trees from the windows and bring in a piano, Nana would play what she called "little pieces for children." I still remember hearing the notes when I would walk back through the bucolic little wood – which today is the grounds of the fashionable Sanctuaire apartment complex – and climb the stairs to the second floor, where a happy child, Charles, would be waiting to throw himself into my arms.

I wish Nana were still alive. I would hug her and tell her how much we loved her. Because she left us a bit later when everything began to go awry in our lives. The vessel of our love had run aground on the reefs of everyday life and was taking on water. I was having one miscarriage after another. I was anemic and felt I was at the end of my rope. The social violence that was emerging in Quebec was threatening to divide us, and every discussion revealed our divergences and antagonisms. I recall one time getting angry at Nana. I criticized her unfairly, for something trivial. And she left. The unhappiness in our house must have become intolerable to her. Her departure is still one of the greatest regrets of my life.

Social violence was also part of this Quebec I didn't recognize anymore. Hateful words, inflammatory speeches, provocative demonstrations, bombs exploding. Deaths. Not a great many, but still, deaths. Close friends would mention in the course of conversation that there was a secret organization called the FLQ that was divided into clandestine cells and that advocated political revolution through the use of arms. I knew our people had been defeated on the Plains of Abraham by the British conquerors in 1759. I knew about the deportation of the Acadians in 1755. And the Patriotes movement destroyed by fire and blood in the

mid-nineteenth century. I agreed in part with the budding independence movement, the RIN (Rassemblement pour l'indépendance nationale) [assembly for national independence]. I say "in part," because I have always been wary of nationalism, which has been responsible for so many wars and so much oppression, including the Nazism that soaked the soil of Europe with blood. I knew then, as I do today, that the nationalism of empires and conquerors is not the same as that of peoples who have been conquered and subjugated, such as ours. We had to have our country, recognized by Canada and internationally, I've never doubted it. I saw a socialist and secular current of thought beginning to emerge, in the magazine *Parti pris*, for example. And in the new Socialist Party of Quebec, with which I felt an affinity. Union struggles were being organized, and I would take part in them during the coming decade. I agreed with these actions in favour of freedom and autonomy, but, then as now, I didn't belong to any party.

I was against violence of every kind: murder, rape, destruction. I was opposed to violence, I would say viscerally, and I still am. My political heroes were not the members of the FLQ or Che Guevara or Malcolm X. They were the first philosophers of Ancient Greece, who had developed the concept of democracy and tried to put it into practice. They were Gandhi and Martin Luther King and Albert Camus. Closer to home, they were Lester B. Pearson and René Lévesque. And the poets who did not spew out their hatreds in the public arena. Who were not always shooting their mouths off and did not brandish guns, the weapons of the weak. I began to really read those who had sharpened their "nuptial tools" (René Char) and desired-thought-dreamed the world differently: Émile Nelligan and Saint-Denys Garneau; Alain Grandbois and Anne Hébert; Gabrielle Roy; and sociologists such as Marcel Rioux, Guy Rocher, and Fernand Dumont.

My tastes were unorthodox. That's still the case. And already, I felt that poetry was broader than poems. That writers of poems did not have the monopoly on poetry. It was, and still is, the preserve of all true writers, whether they express themselves in prose or in poems. Before I read Elias Canetti's *The Conscience of Words*, I agreed with his view on this, as I would discover when I read it twenty years later. The life of a poet is full of these happy coincidences.

I began to read a great deal, writers from here, in order to begin to understand my people. It worked out well, because I was asked to teach two courses that would require this self-taught learning. In the meantime, one thing was clear to me, and still remains my most deeply held conviction: you don't build a country through violence, or a democracy through clandestine activity. It's like physical violence. Of course, there are children born of rape. I would acknowledge the kids, who aren't responsible. But never would I associate with rapists.

During this unsettled time in society and at home, there were many things that gave me comfort. The piano, which – before I got one of my own – I went and played at Eaton's, where they had big Steinways in the music department (what a wonderful time that was, when you could practise scales, chords, arpeggios, and so on without anyone minding!), spending two or three hours a week there. Studying, reading, and starting to write my thesis in the tower at the Université de Montréal, which held a fabulous library. Friendships old and new – oh, the joy of friendship, whose merits we don't praise enough, with love, or at least thinking about love, demanding so much of our attention! And a few encounters, in speech or writing; I'm thinking particularly of Fathers Benoît Lacroix and Ernest Gagnon, with whom I discussed this time of historical transition that was both unnerving and exciting. We talked, what freedom!

I haven't spoken of the incalculable joy of loving a child – Charles – and watching him grow. This may be because this maternal love still speaks within me, as does my love for my second son, Christophe.

Nor have I spoken of the joy of seeing my parents, Jeanne and Jean-Baptiste, which goes without saying.

The Death
of Régis

Régis killed himself in April 1964. With a rifle bullet in his mouth, in his bedroom in the family apartment, one night at around one thirty in the morning. He had left us, Patrick, Charles, and me, at about eleven. It was his sister, my cousin Pierrette, who found him in the morning. Poor little Pierrette, the sixth and youngest child in her family, the one who was alone in the car with her father, François, my father's brother, when it swerved on an icy December road in the Gaspé. A few hours later, François died. He was handsome as a prince and had a lively intelligence and a keen sense of humour. He was in his early forties. We loved him. His death was a long tear in the fabric of the family, which had until then seemed indestructible. The pain we all felt seemed to me then, at twelve years old, like a tattered shroud covering the earth.

Pierrette had been five at the time of the accident. She had seen it. Now on the threshold of adulthood, she was seeing her brother dead. The body of her father lying on the frozen snow. The body of her brother fallen on a rifle, his brain shattered. How was she able to endure it? It took unshakeable strength to go on living after these trials.

I didn't see her again after the tragedy. I still imagine her, dignified through the ordeal. And beautiful, as she was when she was little. Many of the members of the large Gagnon family did not see each other again afterward. A young man who takes his own life raises a lot of pressing questions for his family and friends, some of which will never be answered. It challenges them to elucidate their own enigmas and find their own clarity. Or for some, the fatal act will open the path to a dark abyss from which they will never be able to free themselves.

It was never easy for me to think of that suicide, and it isn't easy for me to speak of it now. It happened forty-six years ago. It's not logical

to still be upset about it. Although I don't think about it often, it still seems to me that, while the wound is essentially healed, I will never finish writing about it. Writing alone holds the secret of transforming traumatic experiences into living memories.

I discovered that in suicide, along with unfathomable distress, there is an immeasurable murderous rage that leads to the annihilation of the self. Rage against the inaccessible object of his love – myself – whom Régis accused of killing him, as he stated in his last letter, which he scrawled before the click of the trigger. His ravings were interpreted literally and some cousins in turn accused me of killing Régis. Great tragedies always revive the dormant wounds in families. It was during psychoanalysis that I experienced, underneath the pain, the mad rage that allowed me to simply begin to live again – to love and to work.

When Uncle François died, on December 20, 1950, Régis was eleven years old. My brother Paul-André was thirteen. I was twelve. I am giving our ages to describe the soil in which the friendship among the three of us took root. Régis and all the children in his family were devastated by their father's death. Their mother, Aunt Marie-Anna, whom I also loved very much, left Montreal, where she had gone to live alone for a while, as the adults said, and returned to them in the Gaspé Peninsula. We had suspected that there were disagreements between them. The adults whispered. The terrible drama of François's death overshadowed the other drama of the separation of the couple, and no one ever spoke of it again.

Marie-Anna went back to her brood, heartbroken, and didn't leave them again until her death. Her six children adored her. She went back in pain and poverty. François, like his father and brothers, had a sawmill, but he hadn't had time to build up his business. The whole extended family helped his widow and fatherless children. My parents were Régis's godfather and godmother. They took him to live with us in the house in Amqui for a while and provided him with a classical college education along with their four sons and six daughters.

Régis, Paul-André, and I were the best of friends. A friendship based on mutual esteem, emulation, and affection. We shared our intellectual discoveries, talked about the books we were reading, the languages we

were learning, and our dreams for the future. We were sometimes joined by my little sister Pauline for walks in the forest or along the river and physical competitions – wrestling, running, jumping – we were strong and fit. Pauline was the same age as Régis and loved him to the point of adulation. She was devastated by his death.

We wrote to each other often from our respective boarding schools. My correspondence with each of them was copious. The older we were, the more intelligent our conversations were when we saw each other again in the summer. When I came to study in Montreal in my early twenties, Régis was there – his mother had moved there for her children to go to school – and we saw each other a lot. Régis was also studying philosophy, and he shared his new knowledge with excitement. He had learned German and was reading Nietzsche and Heidegger and quoting them to us, and he had become an atheist and told us so, which my father, his godfather, didn't like at all. Before long, my father decided to stop paying for his studies. But Régis still loved him and loved Maman, until the end.

(I recently reread the last letter he wrote to my parents – Christmas and New Year's greetings for 1964 – a letter that was in Maman's "little honeymoon travel bag," where she kept her most precious letters, and which I inherited after her death in 1996. I hadn't dared to open it since.)

In the two years before I went to France, when I was studying at the Université de Montréal and then teaching back in Acadia, Régis and I saw each other regularly. Either I saw him at his mother's place or he would come visit me, especially the last summer, when I was sharing an apartment in Outremont with my friends from the college, Josette, Charlotte, and Micheline. I remember evenings at the apartment and going out together in a group. Régis was with us. We were crazy kids full of discoveries – folk music clubs, movies, books, discussions, and dances. If I was going out with a new boyfriend, Régis would want to meet him. And to give his blessing, he would say. He was falling seriously in love with me, and told me so. I thought he would get over it, that he'd fall in love with another girl.

He came to the ship with my friends when I left for France. He cried. Spoke of his love for me. I felt sad for him. I didn't realize the extent of his attachment. I went away to my future, while he was stuck in a passionate

past of lost loves, from the death of his father to this impossible "life and death" bond with me. And I didn't know he was foundering.

It was on my return to Montreal two years later that I learned of the terrible events that had followed. The day of my marriage to Patrick, in August 1962, Régis had crashed his motorcycle into a car on Laurier Street. He spent several months in a coma. When he came to, he told his mother, and then other members of his family, what had happened, at first in barely audible snatches. In place of the car, he had seen me in a wedding dress and had thrown himself toward me (he had just learned of my marriage from some cousins he had been visiting). It took him weeks to understand that he had not thrown himself toward me, but toward a car. He spent further weeks in the hospital and saw all kinds of doctors, including psychiatrists, but he never recovered completely from his fractured skull or from the delirium that had caused him to drive into an oncoming car on the day of my wedding in Paris.

When I saw Régis at the house in Amqui, where we were spending Christmas, we didn't say a lot to each other. He had come because he knew I would be there. He was greatly diminished physically and intellectually, and I no longer knew him when he tried to start a conversation. It was heartbreaking.

I had no more news of him until a fateful phone call the night of his death, when he told me he had just bought a rifle. With two bullets, one for me and one for him. "If you don't want to die with me, I'll kill myself right away. I'm holding the loaded gun to my temple now." He added that he loved me. I told him to wait on the line, that I had to talk to Patrick and would come back. Patrick, Charles, and I were alone at home that night, as we often were. We had just eaten. Charles was already in bed, falling asleep with his bottle. He would soon be one year old. I spoke quickly to Patrick. I was beside myself. He was amazing. Without thinking about it for long or talking much, he just said, "Tell him to come here. To take a cab, we'll pay for it. Tell him to come and talk to us." Régis accepted right away. Asked me for our address and simply said, "I'm coming, I'll be there in fifteen minutes."

In the meantime, Patrick and I called a friend and asked him to come to our place with his car. And then at the end of the evening, to offer

Régis a ride, and on the way, to convince him to stop at the emergency room of a hospital with a psychiatry department. I did not want Régis to commit suicide. I did not want, absolutely did not want, to be killed. I wanted to live.

Régis arrived. So did the friend. We talked. Régis cried. In the course of the evening, he asked if I would talk to him alone. In the kitchen. The other two would stay in the living room. I was afraid, but I agreed. He proposed once again that we die together. I tried to reason with him. He said we would be like Romeo and Juliet. I answered that I wanted to live. That I loved Patrick. And that I loved Charles. And that I didn't want to leave them. And that I loved life.

Charles started to cry in his room. He was crying softly as if he felt that something unusual and upsetting was happening. I rushed to his crib and picked him up, kissed him, and told him everything would be okay. He stopped crying. I took him to the living room and held him close and rocked him. Régis had come back and sat down. He lit a cigarette. Talked about this and that. He had understood that I did not want to die with him. He looked at us. He had understood. Then he asked me if he could hold Charles. I passed the baby to him. I saw Régis's face, tender and radiant, like the faces of all the Gagnon men when they were holding a baby. I believed Régis was saved. And my fear of seeing my baby in the arms of a dead man dissipated. Régis left with our friend at about eleven o'clock, I think.

Then the telephone rang. The wife of our friend told me that the friend had taken Régis back home. That he hadn't left him at the hospital. That the whole story of love and suicide was nonsense. That I was "poeticizing" the whole thing. That I was imagining that a man would die for me, for my beauty, or something to that effect.

I hung up. Talked with Patrick. I was devastated. We knew that Régis was going to take his life that night.

The next morning after breakfast, and Charles's bath and bottle, the two of us went out, he in his stroller and I in my pain. I remember, when we were coming back from our errands, I had a flash of realization in a ray of sunshine, while Charles, mesmerized by some birds flying across a cloud in the blue of the sky, smiled and babbled his first syllables.

I stopped and I knew that Régis was dead. My body suddenly sensed with total clarity that he was dead.

When we were back in the house, the phone rang, and the family specialist in passing along bad news told me he was dead. All I said was that I knew.

"How can you know?" she retorted, angry. "This isn't about poetry." Yes, this is about poetry, I said to myself. Yes, it is also about a bereavement that will last a lifetime. Poetry has no boundaries.

I remember the funeral home and the ceremony in the church. Down to the last detail. But I didn't feel anything. I dressed carefully – I still remember the little black velvet suit with an ivory satin collar – but I didn't feel anything.

People came from far and wide, from all the cities, towns, and villages where our large family was now dispersed. Everyone shed a lot of tears, and I was as cold as marble. I remember that my parents were there. I remember my father's words. He was afraid that Régis was in hell. He said that the sin of pride was the worst of the mortal sins, because only God, who had given life, had the right to take life. My mother was crying. I tried to reassure my father, saying that there was no hell for Régis, that he had been very sick, that it was a sickness to be suffering to the point of wanting never to suffer anymore. I told Papa and Maman, long before I had read Marguerite Duras, that it was "the malady of death."

At the cemetery, they gave me Régis's last letter, which was addressed to me. He accused me of killing him. I read the letter sitting in the black car and asked Patrick, who was beside me, to tear it up. Which he did, and I thank him for it.

They decided not to give me all the letters that were on his desk when they found the body. Somebody, another one of the family experts, this one on psychological matters, took it upon herself to keep them, despite the fact that he had written them all to me. How ghastly!

Three years later, I was in psychoanalysis. It had taken all that time for the tears to find their way into my life. Finally, after hardly giving it a thought since my meeting with Madame Favez-Boutonier in Paris, I had come to psychoanalysis.

Having written the preceding pages, I am aware today, decades after those dark events, that the love that is declared or wept or shouted is not necessarily what I understand by that word. Love. The massive libidinal and fantasmic investment of my dear cousin Régis in a single object – myself – was in reality a symptom of a deprivation or deficiency that was not mine to understand, either then or now. However, it was my duty, my responsibility, to analyze how I had, unconsciously, of course, received those disproportionate declarations of love with a certain pleasure – before things went wrong, I mean, when we were in a sort of garden of delights, still innocent children, before our flirtatious games turned into tragedy for Régis. Later on, in the antechamber of his death, I took no pleasure, far from it, in this role of the heroine in a tragic opera that seemed to have been assigned to me by some mysterious director. This was a lesson for the rest of my life. It was the end of my romanticism. There.

What is love, I was asked one day by a French friend who was shattered by the decline of her desire for the person she had once loved so passionately. I replied that love can exist when desire or passion diminishes. "So what is love, then?" she had said in a bitter, despairing tone of voice. I heard myself answer – is it possible? – that love is wanting the best for the other person. Simply that. In that salon of cynical intellectuals, in their eyes, I was an imbecile, a fool. I couldn't care less – not then, not now.

In my youth, without claiming to have any precocious wisdom, I already felt, as the passing years would confirm, that love was made up of two components: passionate desire and friendship. If one of the two was absent, you couldn't speak of love. Without desire, love would never even happen. And without friendship, the waning of desire would mark the end of love. Régis's death helped me to better understand these things.

Into Writing

Some people, perhaps even many, think psychoanalysis was created for those who are seriously ill or insane. They make pronouncements without knowing much about it. People also say that psychoanalysis is an intellectual experience. In Quebec, where anti-intellectualism is rampant, these preconceived notions are favourite topics for chatter at cocktail parties, trendy bistros, and pretentious salons.

After years of half-listening to this drivel, I wanted to go back and immerse myself in the 1960s, when I was in my twenties, which were both happy and tumultuous, when at times death beckoned to me like vertigo, and analysis seemed to be an open door to the understanding of intimate things, an encounter between the unconscious of two individuals – across deserts of silence – and not a repetition of commonplace or conventional words through which antiquated prejudices and false certainties were rehashed, like dusty furniture being moved around in an old attic.

In Quebec, being a woman and an intellectual, and what's more, one who talks about psychoanalysis, is the supreme affront to the prevailing orthodoxy. If there were a gulag here, they'd surely send me to it. Our gulags are scattered all over, and censorship is devious. You have to find your oxygen elsewhere than in the marketplace of dominant ideas.

Freud is no longer in fashion, nor is Jacques Lacan. Nor Serge Leclaire or some others who brought into the world the true emotions of the hidden body. It is to them that we owe the concept of intersubjectivity. We owe to them the terms for describing this very special relationship between two subjects endowed with an unconscious, as Lacan said.

One bleak day after I had had a second miscarriage and my love seemed to be disappearing into a forest with no way out, when I wanted to die and a minute later no longer wanted to, I cried to a psychiatrist friend and told him of my despair at not yet having done anything with my life – apart from having my child, whom I loved dearly – not yet having

created anything, and having nothing to do. I had a hard time finding the words to express the great emptiness within me. My friend said, "You're intelligent. You're talented. Why don't you consider psychoanalysis?"

Psychoanalysis! In this way, it came back to me by a different path than that of university studies, which I had envisaged a few years earlier. It came to me by its usual path, that of pain, loss, and the difficulty of living. What does it take to want to embark on the psychoanalytic adventure? It takes a capacity for introspection combined with a desire to resolve the enigmas of a life; it takes a love of time that is long and slow, because these enigmas require limitless time on the horizon, as they have been eternities in the creation. One can easily count eight generations for the configuration of a single enigma. The psychoanalyst Julien Bigras wrote that, but nobody reads him anymore. Our centuries have lasted only five years in recent times. We don't know these truths with the certainty of hard science. We feel them, we sense them. In psychoanalysis, truths are individual and subjective, interwoven with fiction. Between an enigma that obsessed a grandparent who, let's say, went crazy from not understanding it and another enigma that I'm beset by, there are layers of imaginary concretions marked by collective or individual stories.

That was how I saw things at twenty-six or twenty-seven years of age, and it helped me climb out of the pit that had swallowed me up and allowed me to begin the work I so much wanted to do, the nature of which was unclear to me, although I knew it involved writing.

Of all the books on the subject, I recall one I read at that time, a very simple and practical book by the American psychoanalyst Karl Menninger. (I no longer have the book, but I remember it as if I'd read it yesterday.) He saw the analytic adventure essentially as a contract between two individuals, setting the terms of emotional presence between the two, duration of treatment, frequency of the sessions, and cost. He spoke of his long years of practice and the most interesting cases he had seen. He insisted that there was no need to be an intellectual to succeed in this inner journey – prejudices about the intellectualism of this adventure were also persistent – and cited the example of a woman who had the greatest capacity for insight of anyone he had ever met.

An extraordinary woman of great integrity, and totally devoted to her quest for knowledge and healing – and she worked as a cleaner.

I began that long psychological journey, which lasted years at the rate of three sessions a week – I couldn't afford more. My personal income was meagre. Help came from three sources: the Université de Montréal health insurance, which covered the spouses of professors; my pay as a lecturer and my fees from *Châtelaine* magazine for two of my short stories it published (its policy was to "discover and encourage young voices," and it paid $500 for a story of ten pages); and my analyst, who adjusted his fees to my means throughout the treatment. I almost forgot a television drama broadcast one Sunday night on Radio-Canada, which brought me $3,000, a fortune in those days. The producer Jean-Paul Fugère had seen and liked a short story of mine called "La laide" [The ugly woman] in *Les écrits du Canada français* and had asked me to adapt it for television.

The necessary slowness of the psychoanalytic adventure, in addition to the fact that one continues to live and travel while it is taking place, contrasted with the extraordinary speed of my beginning to write, something I had ardently longed to do. I also learned that the time of the session could in a sense be bracketed off as if it had its own rhythm, its own specific process, and its own goals, somewhat the way it is said in contemporary physics that time passes more quickly at the top of a mountain than down in a valley. As if I could easily disconnect from the slower time of the unconscious during the sessions and enter fully into the speed required for the normal activities of my life.

Very early in this journey, thanks to Nana, who took care of Charles in the daytime – he was growing more and more handsome and intelligent – I was able to devote myself to teaching and go back to writing my thesis, for which I received another grant from the Canada Council for the Arts. Also, something that seemed like a miracle at the time, I began to write seriously. For writing, I entered another temporal register, which I saw as stealing time from normal time – and I still understand it this way. This stealing of time for writing resulted in my not having any physical memory of the place or places where I wrote my first book, *Les morts-vivants* [The living dead], which was published in 1969.

In an office at the university? At the library, but which one? At home, but in which room, on which table? I don't know now and I never did.

I have physical memories for all my other writing, thesis, books, and articles, but that one is a blank. I can't understand this with the tools of linear logic alone. I believe that once the floodgates of the unconscious had opened, under the supervision of the experienced guide who was accompanying me on that other journey in long time, there was such a profusion of accumulated stories upstream that some waters flowed freely and passionately in little paths of writing with no boundaries, outside of conventional time and space, and spread out so quickly in the byways of life, as if in a no-woman's-land hidden behind the usual horizon lines, that normal memory was unable to find its landmarks.

During the same period, as if in another cognitive sphere, I also went back to writing my thesis. I naturally took refuge in the library I had loved while studying for my master's in philosophy, the one in the tower at the Université de Montréal. I had made the leap from Kant to Claudel. While Claudel was a contemporary, I had the feeling I was taking a step backward in relation to the very high conceptual level of Kant. I didn't dwell on my reasons, which would probably have muzzled me. I persevered, read a lot, took notes, and made index cards. I was so proud of my index cards: on *Five Great Odes*, on Claudel scholarship, on literary and anthropological symbolism, on the structural analyses of literary (or pictorial) works done at that time, and so on. Of course, I knew *Five Great Odes* practically by heart, as well as the role of the nine Greek muses in poetic writing, since I have the gift of an exceptional memory, which I get from both my mother and my father, I'm so fortunate! I borrowed books from the university library. The cards ended up filling the entire drawer of a filing cabinet, and one day, after my thesis defence was behind me, a young professor bought them from me and published the material under his name. Other times, other techniques, but the same work.

My thesis defence took place in June 1968, at the Centre Universitaire de Nice. All the universities of France, including that of Aix-en-Provence, were still closed because of the events of May 1968. My thesis director had moved his files to Nice. In addition to the chair, Monsieur Ruff, the jury comprised the charming and sensitive Guy Michaud and the odious

Jean Onimus, who attacked me for my "awkward" way of expressing ideas, in other words, my Québécois way of speaking and my accent. I defended myself badly. I should point out that I was at the beginning of my pregnancy with Christophe, I was squeezed into a dress that was too tight at the waist, I was experiencing waves of nausea, and all I wanted to do was nest, not debate. Because of that nasty man, my defence was an ordeal. Although Patrick and several supportive friends were with me, I remember having only one desire, not to be there anymore, to be in my bed, to dream with my baby, with a bowl nearby for the nausea and a little glass of water with lemon juice. But I was there, facing the enemy, who I wished would collapse before our eyes or simply disappear as if by magic.

Fortunately, the two other members of the jury supported me, although they looked distressed. I passed, but I didn't get the highest mark. Monsieur Ruff told me later that when the jury members were deliberating, Onimus continued to deploy his arsenal of hatred. The two other members had to back down from granting first-class honours or he threatened that he would create a scandal. The "first-class" was thus crossed out and my degree was only granted "with honours."

After this ordeal, Monsieur Ruff cancelled the party he had organized at the university. He had been humiliated, and he said he would never, absolutely never again celebrate with such a boor. I saw him crying, and he came and said, "I would like to invite you and your husband to a restaurant with my wife and me." We had a wonderful dinner, during which Monsieur Ruff, who was dean of the faculty, announced that he was going to retire in a few weeks. I was his last doctoral student. Jean Onimus, he said, had taken revenge for "something that went back to the war."

So something very serious had happened between them. What? We never knew. He said that in choosing Onimus as a reader and member of his last jury before leaving the university, he had wanted to show him that he was forgiven. "But he is growing old in his anger and bitterness," he added, sounding demoralized. He reiterated his confidence in me and his friendship.

What a strange evening that was! I remember the beauty of the meal and the fine wines. I didn't feel up to drinking – I was never able to drink alcohol when I was pregnant – and I barely managed to eat.

Back in Paris, walking one afternoon in the streets where we had fallen in love, Patrick and I were suddenly caught up in a panic-stricken crowd fleeing in all directions, with the riot police behind them lobbing volleys of tear gas. It was the end of a demonstration and we had no idea where it had started. As we walked along Boulevard Saint-Germain, some of the gas reached us and I was frightened. Very frightened, especially for my baby. We ran, racing down the stairs of the nearest metro station. The train came, the doors opened, we rushed in with the panicked crowd, and the doors closed very quickly. The train started.

I held my belly to protect the baby, and the tears came all by themselves. Patrick was also weeping. And so were all the passengers in the car. I realized that it was the effect of the gas. It's strange to experience a thing like that, with dozens of people, men and women, who don't even know each other weeping together and, for the time of a short journey, forming an odd community. Among our chance companions in misfortune, there might have been some who were enraged and others who were full of joy within themselves. How could we know? The fact that we were all shedding uncontrollable tears created a sudden solidarity.

We got off in a neighbourhood far from the centre of the city and picked a different hotel from the one in the Latin Quarter, now inaccessible, where we had been supposed to stay for several days and where our personal effects were.

That night, before falling asleep, hoping that the child would suffer no ill effects from the chemical spray and the terrified race of the afternoon, I wondered why I had wanted to do my doctorate, to write my thesis and defend it here where life seemed so difficult and filled with pitfalls.

Then there was teaching. My first invitation to teach at university brought me back to my original, formative teaching experience when I was seventeen years old, rebelling against boarding school following my unjust expulsion by the Ursulines in Quebec City, and taking things easy for the first time in my life at the house in Amqui, when the school

inspector, Monsieur Guité, had come to ask my mother for a favour: would she be able to "loan Madeleine" to them to replace a schoolteacher who was going to give birth? It involved taking charge of the seven primary grades in a country school in Saint-Léon-le-Grand. I had just finished my course in Versification, I was "well educated," as Monsieur Guité said. My mother, probably unable to deal with the young rebel I had become and the idleness I was cultivating to perfection, leaped at the offer, but she still consulted me. I saw how delighted she was. I accepted the contract, initially seeing only advantages in it: I would earn money; I would go to the middle of nowhere, as in the westerns I enjoyed watching that year; finally, although it wasn't far from Amqui, only about twenty kilometres, I would travel. I would be somewhere else and see something new!

On the appointed day, in the country school, a little wooden building with one big classroom, a wood stove, a clothesline above it to dry the children's winter clothing, rows of wooden desks, and a big blackboard, I greeted a flock of children between six and fourteen years of age, from first to seventh grade, with the smaller ones in front and the bigger ones in back. They all knew where to sit, and they stood up without too much fuss and chanted in a chorus, "Good morning, Mademoiselle." I told them to sit down and I talked to them, saying mainly that we were going to be working together.

I had prepared. A few days studying their curriculum, dividing the time according to the work for each grade. It was a matter of know-ing when to teach which students, whom to assign work to do while I was teaching the others, what things should be taught to all the grades together, and above all, how to keep the attention of all the pupils and how to amuse them from time to time.

The principal had pointed out the worse and the better students, the dumb ones and the bright ones, as he described them. The worst of all was a boy he named, saying I shouldn't let him get away with anything and when I couldn't take any more of his bad behaviour, I should send him to his office. That would happen at least once a day, he said, and he would give him "the strap." I didn't like this principal and I never sent anyone to him, especially not the "devil" in question, whom I immediately identified

from his strange, fearful manner like a wary little animal. He must have been ten or eleven years old, he had bright eyes and unruly hair, and he reminded me of a beautiful, frisky wolf cub. He turned out to be a nice polite boy, and when I spoke to him, he responded with a heart-rending smile, a touch mischievous but totally charming. While the children were working in silence, I had him come up to my desk and told him I was appointing him monitor. At boarding school, the monitors had been chosen from among the best, most disciplined students. Their job was to see that the students obeyed the rules when the teacher wasn't there. I explained to him briefly what his title meant. Told him that during recess outside, I would give him my watch so that he could see that all the students came back in when I rang the bell. I'll never forget the astounded look of that wild youngster the first time I slipped my delicate watch on his wrist.

That child was a wonder. The others all respected him. He became their leader. I never saw him arguing with or hitting a child. He didn't break my little watch and would return it to me proudly after every recess. He had probably never had a watch in his life. His marks improved. This boy who had lagged behind since his first year of school became one of the top students. When I left my job after the old teacher gave birth and came back, the principal asked about his "troublemaker": "How did you do it?" I answered, "I trusted him."

When I remember those weeks I spent all alone in the little country school, far from everything and everyone (a man from the village would bring my groceries and laundry and light the stove every morning), I feel a certain nostalgia for that retreat in the forest, filled at night with the sometimes frightening sounds of animals, and with the stars shining so brightly on the snow that I could see a future, uncertain yet full of promise, taking shape in the distance. I also remember when the children's eager little faces would look up laughing from their books or slates for stories or call-and-response songs, and their excitement outdoors at recess.

That said, I understood quite quickly that being a schoolteacher was not my calling. I was not prepared for such self-sacrifice – to the great disappointment of my mother, who would have loved to have me spend

my whole life in the village practising her own occupation, "because today you can marry and have children *and* have a profession," and even one day become her support in old age, as my elder sisters said with gentle irony, because I was "Maman's favourite."

That was my first experience of teaching. I remembered it when Robert Browne, chair of the department of English studies at the Université de Montréal, invited me to teach French-Canadian literature, more specifically, the French-Canadian novel, as a lecturer in 1966–1967. I said yes immediately. I was rather ignorant on the subject. Through my entire schooling, no one had ever taught me anything about it. I would learn. My students were francophone Canadians who were studying "English literature" (today, we would say *literatures* to speak of all the literatures written in the English language, and it is understandable that this department of "English studies" was the soil in which comparative literature would grow in the course of that decade).

My students knew as little as I did of French-Canadian literature, despite the fact that they belonged to the majority in Quebec, this non-country that was in the process of becoming one. Nor had anyone ever spoken to them of it. We had a lot of catching up to do! I am very grateful to Bob Browne – a great professor who became a friend – who had understood the need for this course.

So my students and I learned together. I didn't know the literature of my own people? I didn't know my history as expressed in its novels? I took my lack of culture by the horns and decided to read everything, starting from the beginning. We began with the very first novel in our history, published in 1837, *The Influence of a Book*, by Philippe Aubert de Gaspé, Jr. Then it was a matter of following the chronological current from the mid-nineteenth century to the mid-twentieth. Frankly, I don't remember where we stopped. At André Langevin? Gabrielle Roy? Anne Hébert? No idea. We definitely didn't read the new voices of the 1960s, such as Marie-Claire Blais, Réjean Ducharme, Jacques Godbout, and others. We didn't have time. And it was history that interested us. A term

is short, and three hours a week passes quickly. And the new was not yet in fashion.

We read Tougas's history of French-Canadian literature. And probably articles, journals, and other histories. I remember how moved we were to discover the wonderful *Canadians of Old*, by Philippe Aubert de Gaspé, Sr., written when he had retired to his seigneury in Saint-Jean-Port-Joli and published in 1863, twenty years after his son's book. A wonderful epic novel against the backdrop of the battle of the Plains of Abraham, whose source was François-Xavier Garneau's history of French Canada, published between 1845 and 1848, some twenty years earlier. In order to better understand the novel, we also read Garneau. What discoveries!

After reading all these works, I became an *indépendantiste*. I'm still one today. Once you have understood the history of your people, especially its conquest by the British army, you understand it always, while continuing to refine that understanding. The details of that history, which is a classic one, and its transposition into novels, its depiction in the as-yet-untold truths of fiction, provided the backdrop against which other works would later be performed. A little as if the nineteenth century of history and novels had built a great stage on which people here would later create their thoughts and dreams.

In this perspective, we also read Laure Conan, Germaine Guèvremont, Ringuet, Félix-Antoine Savard, and many others. I had not been asked to teach poetry. But since I love that ultimate art, I would read one of our poets – Louis Fréchette, Émile Nelligan, Eudore Évanturel, Blanche Lamontagne-Beauregard, Medjé Vézina, or Saint-Denys Garneau – at the beginning of each class. We understood that the history of a people may be read as much in its poetic illuminations as in its novelistic recreations. That a people knows itself better by its writings than by its slogans. And even better than by its political programs or its ephemeral propaganda.

If I had felt like a stranger when I arrived in Montreal, I managed to recreate my country for myself by learning about its people, its history, and its works. I also realized that after six years away from Quebec, four in Acadia and two in France, it was, paradoxically, through strangers that I was finding myself again. Aside from Micheline L., who was my close

friend at this time, my former schoolmates from the college, and the members of my family – a veritable clan – my friends were the professors in the department of English studies of the Université de Montréal, most of them from the United States, and many of them conscientious objectors to the war in Vietnam. They did not want to take part in that imperialistic war. We had long discussions about just wars: wars of self-defence for peoples invaded by dictatorships or threatened with genocide. After that dirty Vietnam War, they could have gone back to the United States, but they stayed in Quebec, most of them having integrated into the francophone culture here. Many of them have died and others are still here, including some dear friends.

It was from them that I continued to learn about the culture of our neighbours to the south. Their historical, political, and literary culture, their way of life, how they raised their children, ate, and celebrated. During the 1960s, we were all young and, naturally, we did a lot of partying. We got together regularly at the home of one or another of us, often Patrick's and mine. There were big meals – I learned new recipes, mainly for buffets – huge bars, usually set up in the kitchen, where everyone would gather, and discussions until the wee hours of the morning, until we had all drunk our fill. At the parties of the Americans and anglophone Canadians, there was more discussion than at those of the francophone Canadians, where there was mainly dancing. But I did learn about their music, folk, blues, folk-rock, and jazz. Some played guitar and sang. Sometimes, at a few of the parties, joints were passed around. I immediately liked the effect of marijuana.

Later, the way life goes, with separations of some of the couples and my own move to the Université du Québec à Montréal, the group gradually dispersed, and we all went our separate ways, toward our own destinies. I'll never forget what I learned from them: Bob and Marie, and later Rebecca; John and Connie, and later John alone; Dick and Barbara, Phil and Jacqueline, Bill and Theresa, and a few others whose names and faces have become lost in the mist but whom I would recognize if the mist dissipated. I haven't forgotten my dear friends Dena and Alan Goldberg (he taught at McGill but was an integral part of the group), troubled yet radiant, both of them communists, without a party because

they were anarchists, both *indépendantistes*, for whom Quebec recalled the imagined Cuba of that time, a place they had never been but that would remain to the end their inaccessible ideal of human revolution. They died much too soon.

During those years, while writing my thesis and venturing to write my first poems and short stories, which appeared in the journals *Liberté* and *Les écrits du Canada français*, I was invited to give a course on oral French for anglophone students in the French department of Concordia University. The students were native speakers of English or other languages – at that time, we didn't really make a distinction between them. We had little awareness of ethnic particularities. For us, all that existed in Montreal were the French and the English, and the geographic line of demarcation was St. Lawrence Boulevard, with Anglos to the west and Francos to the east, with few exceptions. At my first meeting with the students, I quickly understood that none of them had crossed that line of demarcation to set foot east of St. Lawrence.

So I proposed to them that, instead of wasting time making small talk or discussing our lives, we spend every second week going to a play or a movie in French, and then, the following week, we talk about what was going on in that faraway nearby place on the other side of the famous line of separation. They were delighted. I obtained a special budget and off we went. I even took them to see paintings in art museums and galleries. Paintings don't talk, I told them, but you can talk about them all you want. The course was a real celebration, for them and for me. These students had been living in Montreal for a long time or even their whole lives. On our outings, they had the impression that they were discovering America, not the one they had learned about in books but another one, one that had been submerged like Atlantis and had suddenly surfaced.

If I could have, I would have continued to teach that course for years. But one day in the fall of 1968, I received a phone call from a man I didn't know, Pierre Grenier, who asked if I was interested in becoming a professor at UQAM, the new university that was being formed. I couldn't get over it. I hadn't applied for any of the positions that were offered. I hadn't really paid attention to what was happening with this new project. I asked him, "How do you know I might be interested in a job there?"

He answered, "People with doctorates aren't exactly breaking down our doors, you know." I was amazed. I met with the members of the curriculum committee for the humanities. And I brought my résumé.

Soon afterward, I signed an official contract. The UQAM representative who signed the contract was Louis Godefroy Cardinal. I didn't know him. Before signing, I had warned the members of the committee, my future colleagues in the department of literary studies, that I was expecting a baby and probably wouldn't be able to teach when UQAM opened – it was expected that would be in June 1969 – and they replied, at a time when no maternity leave existed, "There's no problem. We'll wait as long as necessary for you." An incredible thing from today's perspective. Those happy days when everything was possible!

And in fact, ten years later, in 1978, a journal called *Possibles* was started by some people who felt that our utopias could still be made reality: the writers Gaston Miron, Roland Giguère, Gilles Hénault, and Gérald Godin; and the sociologists Marcel Rioux, my compatriot from Amqui, now deceased, and Gabriel Gagnon, who is still alive and who deserves the greatest respect.

Pauline

*This forest at whose centre is the
stone where hearts founder.*

– Richard Millet
"Mouvement"

On October 11, 2009, during a trip to the
North Shore, I was in Baie-Comeau with my friend Monique; Guy, who
was my little sister Pauline's widower; and Hélène, Pauline and Guy's
daughter, who was born in 1963, the same year as my son Charles; as well
as Yolande, Guy's second wife, and Alain, Hélène's husband. It was raining
a hard, icy rain, it would soon be winter, we could feel it though we didn't
talk about it. We had opened the floodgates of our warm friendship.
We were there to mark Pauline's death. And to celebrate her life and our
memories of her. We were telling stories, we were even laughing, with
the dead beneath our feet.

We were at Saint-Joseph-de-Manicouagan Cemetery in Hauterive,
one of the beautiful cemeteries of the North Shore. A black wrought-iron
railing and arched gate with the name on it. Beautiful work, worthy of
Pauline's grave, I thought on entering. We were in the middle of the
forest, also black, that taiga of conifers poking their hoary heads into
the opaque sky like pious nannies in the antechamber of the beyond,
where the souls of our dead have gone. You could smell the sea, which
was not far away, and hear Route 138, which was right nearby. A pity,
I thought, there should be pure silence. But there had to be roads or we
wouldn't have been there.

Guy led us first to the grave of little Sonia, Pauline's and his second
daughter, who had died at a few months old, only two years before her
mother, whom she wouldn't have known, because she had been born

never to know life. "She's a little angel," her grandpa Jean-Baptiste had said after the funeral, his voice thick with tears and an ache in his heart that would stay with him when he got off the Godbout–Matane ferry alone with his seasickness and his heartsickness for a child gone too soon. That was something he had seen as a young man from a large family, and even on his deathbed he would speak of his little sister Louise, "the prettiest one," whom he had held in his arms and whose death at the age of four he had witnessed.

All of a sudden, I saw before me the epitaph with Pauline's name, with the dates that spoke for themselves: "on 17-07-1967, at 27." It wasn't that I had forgotten, but the memory of the loss when I was twenty-eight had forged its own black iron fence, because you have to go on living, you can't die with your loved ones. A confused memory is sometimes a protection. Those who remember everything are, in a way, mad people who don't want to feel the rest. Like amnesia, hypermnesia is a sickness.

At my little sister's grave, in front of the tombstone, it all came back to me. Sixth in the family, Pauline was between me, the fifth child, and Françoise, the seventh. The three of us were very close. Françoise and I were devastated by her death. We were the second trio of the family – there were three trios, two of girls and one of boys, plus Paul-André, a single, which made ten in all. Ten children, the second trio of which had had a member suddenly amputated. Françoise and I will always belong to a broken trio.

As I stood at the monument, the memory of the months preceding Pauline's death came back to me. Ti-Pou was the nickname we had given her. She had always been different from us. Not as pretty as her sisters, she had pronounced strabismus, unruly hair, a hoarse voice, vulgar speech, and crude manners. Poor in school, she repeated grade after grade and one year found herself in the same class as Françoise, two years behind. Françoise protected her and did not want to get marks that were too high so as not to humiliate her, because she loved her. We all loved her very much. I imagine she embodied the rebellion that lurked in all of us, that dark unexpressed and unexplored zone in the supposedly perfect children we were, with excellent marks in school, highly competitive in all things without realizing it, while at the same time wanting to be

humble and modest. We were perfect even in not wanting to shine or distinguish ourselves.

Like a character in Dostoevsky, Pauline, without meaning to, showed us all that was dark and tragic in the human condition, all that was not destined for the achievement and success we aspired to, innocently enough. And this was true of her in everything. Instead of a doll, she wanted a horse that would gallop across fields and mountains with the whip whistling on its flanks and the bit in its teeth. Instead of a watch, she wanted a stable; instead of jewellery, a pair of reins; and instead of knitting needles, a sword. When she barely knew how to talk, she swore, and instead of crying, she shouted. She pulled our hair, scratched us, and pinched us, and we loved her.

One day, on the North Shore, where she lived with her wonderful husband, Guy, their daughter Hélène, and her dreams of the wide-open spaces, she fell sick. She said it was her heart, and the doctor she saw said it was the imaginings of a "poor little rich girl" who couldn't accept being the wife of a welder. She continued to say she had heart disease; she would no longer travel and she shut herself up in the house with her generous Guy and her adorable Hélène. Before she got sick, she had lost her daughter Sonia, who was said to have smothered in her sleep. Pauline had found her lifeless body in her crib one morning. She never got over that, nor over the suicide of Régis, who was the same age as she was. She had loved Régis deeply. Suicide? She didn't understand. She never got over the death of her child or the death of Régis. The malady of death took hold of her.

Early in 1967, Maman called me in Montreal saying that Pauline had refused to take the boat across the St. Lawrence between Godbout and Matane, as she and Guy had done every year to spend Christmas with their families, both of whom lived in Amqui, because she felt too sick. Maman and Papa asked me to go to Baie-Comeau, and would pay for my airplane ticket. They wanted me to see with my own eyes how she was, to spend a few days with her and observe, judge, and tell them exactly what I thought. I agreed. I took Charles with me so that he could get to know his cousin Hélène. We took the plane. Charles was overjoyed.

Some time before, Pauline had begun to speak delusionally. No one could understand the stories she told. Everyone was worried, especially our parents. We found out later that a lack of oxygen in the brain was causing this. It seemed like paranoia. She was having delusions of grandeur, or megalomania, in which she owned the entire Gaspé Peninsula and all its villages and forests. She had mills everywhere, from Chaleur Bay to the town of Gaspé to Sainte-Flavie, and she made regular tours of the area. She was a "millionaire," extremely generous, distributed her wealth liberally, and disinherited members of the family she didn't like. She called me one day to tell me what she was leaving me as an inheritance: a large part of the upper Gaspé Peninsula, with four or five villages on its northern shore and their forests, sawmills, and lumberyards. I was happy, and I told her so. I thanked her. And we laughed. Strangely enough, although I was unfamiliar with that region at the time, I have been spending summers there for several years now.

When I arrived at their little house in Baie-Comeau, what I saw left me speechless. I just took her in my arms and then I looked at her again: her breath was short, she had circles under her eyes, her skin was like crumpled tissue paper, her lips were blue, and I could see her heart beating wildly under her cotton blouse. She was very sick. I could see it. She knew right away that I saw it. We both knew. We shed a few tears, that's all. I told her only that I was going to take care of her. That we were all going to do everything possible to make sure she got better. "Ti-Pou, it's going to be all right, you'll see," I added.

We moved on to other things. I stayed there two or three days. Took care of the meals, the children, the household chores, and told her to just rest. We talked, and I remember that each time, I could see her heart beating hard. She was not delusional during those days.

Pauline was not an especially good cook, but on my last night, she insisted on making her famous oven-baked omelette. "You'll see, it's the best omelette in the world," she said. Her omelette was good, and we savoured it. I could feel in my body that she was on the verge of tears.

My heart was heavy when I was in the air with Charles, explaining clouds, stars, and birds in answer to his constant questions. The first thing I did when I got home in Montreal was call my parents. I told Maman

the symptoms I had seen. Pauline had a heart problem. She was very sick. We would have to arrange with Guy to have her come to Montreal, to the Heart Institute. In a few days, it was all organized.

In some families, there are certain children who think they are better than the others, more entitled to take action, more competent, more capable and knowledgeable, who have come to believe in the Biblical law of primogeniture because it fell on fertile psychological ground, children in whom, for various reasons, the desire to dominate is very strong and the will to power forcefully asserted. In my family, this was manifested mainly around death, because the desire for power is intrinsically linked to the death instinct. We know this about wars of conquest. We know it less about conflicts within families. It is familiar to those who have taken the trouble, sometimes a great deal of trouble, to analyze the mysteries of power connected to the desire for death, particularly in war and dictatorship.

I wasn't allowed to see Pauline when she arrived in Montreal in the winter of 1967. Oh, no! When someone wants to control things, they don't entrust a delusional younger sister to a loving older sister, and a poet to boot. When has a poet ever been among the authorities and leaders of this world? Poets, like women, have always been shunned by right-thinking people. Just look at Plato's *Republic*.

Pauline's trip to Montreal had been organized in secret by two witches, the expert in psychological matters and the giver of bad news – from beginning to end, it was always the two of them. Pauline must have been all the more delusional for not having any allies around her. Indeed, I had already noticed a lessening of the delusions when she felt loved and understood. When she saw that you knew she was sick, physically sick with a heart condition, she was no longer delusional, as I had observed when I was in Baie-Comeau. In other words, in a hostile environment, her delusions increased.

Rather than take her right to the Heart Institute, they had her see a psychiatrist, a so-called friend, who immediately had her committed to the psychiatric hospital where he himself worked. What's more, he prescribed secure treatment for her. No visits, by husband, parents, or all those in the family she loved, for I don't know how many days. When I learned of this, I, like others who loved her, was devastated.

The supposed competent family authorities waited until everything was in place to announce the news. As usual, they were convinced that they were right. They had the law of psychiatry on their side. And no trial, if you please. No defence lawyer. No loved ones who might have been able to testify on her behalf. No! Pauline was all alone. Cut off from those who loved her. In the psychiatric darkness. Alone. Imprisoned!

How delusional she must have been when they dragged her to that specialist in delusion! From the beginning, starting with the little doctor in her little city, they hadn't believed she was physically sick, and she had suffered so much all alone that she went mad. Anyone would have. Poor Ti-Pou, poor little Pauline!

Then what had to happen happened: one night in the darkness of total isolation, Pauline's body gave out and she had a severe heart attack. Siren blaring, the ambulance raced through the night to the other hospital, the Heart Institute, where she should have been since she'd first arrived in Montreal. Poor suffering humanity!

Things happened very quickly after that. The cardiologists at the Institute asked to meet with Guy and my parents but, because of work, Guy hadn't been able to come to Montreal. I remember the meeting in the presence of Pauline, who looked so fragile in her wheelchair, her eyes wide with astonishment. They finally believed her; it was about time. My parents, my sister Raymonde, and I sat there with the two cardiologists in an uneasy silence.

Pauline didn't want to see her psychiatric bodyguards anymore, and we understood. It was not the time for arguments or recriminations. It was the time for the utmost gentleness. The doctors had informed her husband and her parents that Pauline didn't have long to live. She had been brought there too late, they said. They might be able to make a more definite diagnosis and have a clearer idea of how long she would live by examining her arteries, but the procedure was risky and could cost her life.

The four of us, my parents, Raymonde, and I, said goodbye to our Ti-Pou and hugged her gently before she went for the procedure. I'll never forget what Papa did. As he used to do on New Year's Day, he traced a little cross on Pauline's forehead and, making the sign of the cross in the air, recited the words, "In the name of Jesus Christ, our Lord, I bless you,

my daughter, in the name of the Father, the Son, and the Holy Ghost." And they took her away. None of us cried, neither Pauline nor the rest of us. We saw her go, pushed down the long, sad corridor by an orderly, and I remember a ray of sunshine that fell diagonally across that white hallway as if to mark her twenty-seventh birthday that month.

The four of us waited a long time. We didn't cry. Then the two cardiologists came back. She hadn't died. Not yet. She was sleeping. She had got there too late, they said again. There was nothing more they could do for her. All the arteries to her lungs were blocked. She had multiple embolisms. Over a long period of time. Her heart wouldn't hold out much longer. They gave her two to six months. Meanwhile, she should rest and eat lightly. She shouldn't do any work. We should be kind and attentive. Present. Loving.

And if she became delusional? "Let her rave. Her brain isn't getting enough oxygen." Should we tell her she was going to die? "If she asks, yes, gently. Deep down, she knows. She feels it, she knows. She won't ask." And she didn't ask.

When she got out of the hospital, she wanted to spend time at Raymonde's house and at mine. She wanted to be with us, to talk to us and to make up for the time when we had hardly seen each other. Because of this sickness that had taken up so much of her life, she said. She also wanted to get to know our children better. She wanted to go to Quebec City and see the four brothers she loved so much. And Françoise, in Moncton, whom she adored. But it was so far to Quebec City and Moncton.

"I'm going to rest up with the two of you. After that, I'll go back to Baie-Comeau and see Guy and my little Hélène. When I'm feeling better, the three of us will go to Quebec City and Moncton. When we go to Moncton, we'll stop in Amqui to see our four parents. Guy and I will have a fancy trailer. And we'll go everywhere."

Raymonde and I were neighbours. We prepared a calm, pretty, tidy bedroom for her in each of our houses. Those days were filled with an indescribable sweetness and solemnity.

Then Pauline went back to Baie-Comeau. One day, I received a letter from her inviting me to share the huge trailer she and Guy were going to buy. "You'll have a big bedroom, you'll see. We'll go to

Europe, I promise. In Europe, we'll go anywhere you want. We'll take the children with us."

When will people understand that we are all, at the same time, past-present-future? And that if one of the terms is missing, we become orphaned from ourselves? There are so many people orphaned from themselves in this world. "Forget it," they say. "It happened long ago." So many people are orphaned from themselves. That's why there are wars. That's why there are genocides. That's why there are murders. And femicides.

"Forget it." No!

Long live the great craft of writing, which can bring all times back to life.

On Pauline's grave in Saint-Joseph-de-Manicouagan Cemetery, in Hauterive, I placed a rose. A white rose. "Here, my lovely Ti-Pou."

1969

*One only sees the end
of the road at the last.*

– Herodotus

I had gone into psychoanalysis in 1967 because there was no longer anything going on in my life. Or because everything was going badly. I remember that at twenty-nine years of age, I felt old, older than today as I write these words. I wanted a child, but I was having repeated miscarriages – despite our difficulties, Patrick and I hoped for another child. I found myself unable to write either my thesis or poetry or stories, although I still had a strong desire to create something. The blood flowed from my body in abundance. The ink of words no longer flowed. I was both stupefied sea and dispossessed desert. I couldn't take it anymore.

On my dark road, I was lucky to encounter two or three friends who were able to point me in the right direction, to show me the star that would guide me for a long time. In the very first months of analysis, my symptoms vanished. I still had to continue the long, slow journey within in order to understand what in my past had, unknown to me, given rise to these symptoms instead of any kind of creation, be it a book or a thesis, love or a child.

A lot of people will pay for the privilege of a quick trip to a psychiatrist or psychologist and, like good tourists in the enigmatic lands within, will go back home as soon as their symptoms have gone away, believing they are healed. Until the next crisis. Psychoanalysis can heal the signs of suffering, but it is not made for that. It is made for understanding. For patiently following the labyrinthine twists and turns of a subjective story. It is made for the unique work of "rendering the enigma to the enigma." It is a never-ending story.

In 1969, two years after the beginning of my analysis, three import-
ant and wonderful things happened in my life: the birth of Christophe;
my contract as a professor of literature at UQAM, which became a reality
in June; and in the fall the publication of my first book, *Les morts-vivants*.
Not to mention that in 1968, I had defended my doctoral thesis. A child,
a teaching position, a book, and a doctorate, what an adventure! Many
adventures, and in such a short time. Now I had to stay the course.
Manage. Cope. Persist. Persevere.

Like all the women of my time, I had a double workload – despite
having household help, or else it would have been a triple or quadruple
workload. After my working day, like all mothers, I had to rush home,
so that Nana, and later Madame Leblanc, could leave. At five o'clock,
their workday ended, and like me, they probably had to start another
one at home. In a house where there are children, the hours around
suppertime are the busiest: the kids reunited with their mother, who has
been absent all day, the meal, the bath, the stories to be told or read, the
games, and later homework and assignments, and finally bedtime, with
more stories. I loved those hours that were so full of life, but after that,
I was beat. Every mother knows that state of utter exhaustion combined
with the pleasure of accomplishment.

I remember my male colleagues, who, as soon as their day at the
university ended, would go to one of the nearby bars for a drink or two
before dinner. I recall an invitation from one of them one afternoon:
"We're going for a drink while our little wives cook us a nice dinner, want
to come?" I looked him straight in the eye and said, "Sorry, but I don't
have a little husband at home." I saw from his face that he had understood
something. But what, exactly? It's hard to say. My male colleagues were
neither more nor less chauvinistic than other men. The whole world
was full of macho types at that time. With some exceptions that proved
the rule. As always.

There were few women in our department, only five or six, and of
those, only two were conscious of the inequalities between the sexes, only
two were feminists (we rarely used that word at the time), my colleague
Anne and myself. We shared the name Gagnon, but we were not related.
She had done her doctorate "with Barthes," which impressed us a great

deal. Brilliant and very attractive, she didn't stay long. She resigned almost immediately, leaving some of her colleagues devastated. She sold or gave away the books in her huge library and took off in search of adventure, with her purebred dog and a few possessions packed up neatly in her Westfalia. We never saw her again. Sad! I endured the double workload and the difficulty of being a woman in that profession, at that time, a bit longer than she did. I quit in 1982. I don't like the word *quit*, which is not like me. I'll tell that story later.

Anne and I ran our department meetings. Our male colleagues, who were most advanced in social matters and literary understanding, and were our dear friends, sometimes gave us a hard time – not nastily, but in a naive way. Some of the things they said offended our feminine ears and sensibilities. In addition to being dedicated to the study of the literary corpus, we were both, like our colleagues, union activists working to set up the first quadripartite inter-union committees on the status of women. "Quadripartite," as we said, for the four categories of employees involved: professors, lecturers, support staff, and later, lower-level administrators. That was how we spoke. That was how we wrote.

Setting up a completely new university required that the several hundred new young profs hired all at one time spend thousands of hours in meetings, during which we built thousands of castles in the air and put out thousands of ideas we thought were innovative. We wanted to invent. To rethink teaching. To rethink the world in ways we believed were revolutionary. You have to imagine that generation of people in their early thirties who had suddenly been entrusted with huge responsibilities. While all kinds of struggles for liberation and independence were going on all over the world, or at least the West, here in Quebec, we were building the Quiet Revolution, stone by stone, brick by brick, thought by thought.

At the same time, the feminist revolution was beginning. Its first writings were coming to us from the countries of America and Europe. It was "Women's Liberation, Year One," as it was called in an issue of the French journal *Change*, which Anne and I read avidly and which influenced our teaching, but also our fiery words in the department meetings. I remember the first time we dared to use the word *phallocracy*,

which we had to explain to our male colleagues, who were practically overcome, some of them livid with terror.

Weren't all my tasks too heavy for my shoulders? All the many jobs related to raising a child, to teaching, to social activism, and to writing – not to mention three sessions of psychoanalysis every week – weren't they too demanding for me to do all of them properly? I must say that I didn't have time to ask myself those questions. I had the good health of youth on my side.

In hindsight, quite frankly, I don't believe my being a mother, or a wife and lover, suffered as a result – and if there was a failure in this area, it was for another reason, or, I should say, other reasons – nor did the intense life of friendships in that blissful time when we were always partying and were discovering a new camaraderie between women and men, girls and guys, a new kind of relationship in which we sought to understand the struggles of the world far and near as much by dancing as by talking.

As for my book *Les morts-vivants*, it was as if it were written nowhere, as if it wrote itself. All I have to say about it is that it came out of necessity. I had no difficulty writing that first book. A torrent sprang onto virgin land from underground sources long imprisoned among invisible masses of iron and fire. Writing these words now, I think spontaneously of *The Torrent* by Anne Hébert.

Les morts-vivants was quite well received by the critics. I remember a very positive review by Jacques Ferron in *Le Jour*. I was pleased, but that was all. I hadn't expected anything. Being completely unfamiliar with the literary scene – which was a lot smaller and less crowded than today – I had agreed to have the book published in HMH's Arbre collection on the invitation of Jacques Hurtubise, who had read two of my short stories in *Les écrits du Canada français* (later titled *Les écrits*). I had never met him, that was how things were in those days. I sometimes wish for the return of that paradise, when the fierce rivalry and behind-the-scenes, but nonetheless relentless, disputes over literary contests and prizes

AN UNPRECEDENTED TIME

did not exist. No schools for training scriptwriters and other tinkerers with fiction for broadcast. Publishers went looking for writers. Mostly, total unknowns.

Rereading Jacques Ferron's stories in the summer of 2010, I understood why he liked *Les morts-vivants*. He and I share a geographic passion for the whole of Quebec and a love of the country of our forefathers who came in a voluntary mass exodus from the old country in the seventeenth century. What is now known as migrant writing strikes a chord in Quebec because migration has been part of our imagination since the founding of the country.

To return to what Jacques Ferron said about my first book – I mention this because he was one of the few at the time who really understood it, not because I wish to compete with him in aesthetic judgment with regard to my own writing. But a doubt he raised at the end of his article (which I no longer have) remained with me: this young writer, he said, should beware in future of a style that tends to become "convoluted." Sensitive to this criticism, I sometimes worried and wondered whether my style was indeed convoluted. The answer, often, was yes. Jacques Ferron was right. After all these years, I believe I finally understand why.

Confronting the non-country that ours has been since its beginnings, Jacques Ferron responded with cynical attacks and political antics. As for me, having a similar feeling of absurdity up against the wall of non-existence, and being allergic to impudence, I reacted by creating an internal country for myself (an "archeology of within," I said then), taking as my field for exploration the unconscious and its seemingly illogical twists and turns, even at the risk of sometimes losing my bearings, my sextant, or my compass. Persisting in the quest for an impossible writing based on what is not fully known. Hence, doubly convoluted. Boileau rightly said, "Whatever we conceive well we express clearly, and words flow with ease." Except that he was born well before Freud. And Kant. And Spinoza. And Nietzsche. And Derrida. And he didn't live in a non-country.

How about what we conceive with its necessary share of shadows and obscurities? How about what can be stated only with a certain unease, but stated nonetheless? With a certain share of shadows and enigmas, of course, or else nothing would ever be written.

1969

There is a non-place of writing that corresponds to the non-country that ours has been since its beginnings. To venture there with and through writing is to risk establishing a geography of uncertainty and half-darkness. To survey these territories, explorers must sharpen their tools differently. Those tools are "nuptial tools," wrote the poet René Char, who has always been one of my favourites. As is the Jacques Brault of the "small road" and the Maurice Blanchot of the "unavowable community." And the Paul Bélanger of "the black ink of poets." And the Paul Chanel Malenfant of "questions without answers."

I read that first review closely. Generally speaking, in the course of my life as a writer, and with the publication of each book, I have read the criticism. And I've learned from it. I do not feel that literary critics are failed writers. Very much the contrary, often. In their way, they are writers striving to find meaning, directions, and orientations, using compasses and sextants. And sometimes telescopes. Because they are also surveyors of the heavens, who will make visible in the multiplicity of a text or a book the uncharted star that opens up roads that till then were blind.

Of course, as in any field, there are critics who are treacherous, whose malice muddles later readings. That's an occupational hazard. I generally haven't worried about it.

Before the publication of *Les morts-vivants*, which seemed as if it had been written by magic, I unfortunately had to go through a battle over my name. A private war, so to speak. I simply wanted to sign it with my name, Madeleine Gagnon, and it seemed equally natural to the husband that I sign it with his. After many discussions, negotiations, and sometimes tears, I proposed a compromise. It would be, as was common at the time, a compound name. With a hyphen. The punctuation mark that unites. So it would be Gagnon-Mahony.

That caused problems for me, and it still does. You just need to go to a library to see. In taking a compound identity, I lost my own. It's not that serious, I sometimes tell myself, one day the book will be reprinted. And given back its rightful name. Not that serious after all. Except . . .

Except that my own father had told me, "If you sign a book, honour your name, honour your signature. Signing a false name to a book is like forging a cheque." He was a businessman, as I have said. He had explained

the order of language and the Name of the Father when I was ten or eleven, light-years before I read Jacques Lacan. He said he was outraged by the compound name on the cover of my very first book. I remember replying, at a time when I was just beginning to try out the arrows in my feminist quiver, that in any case, the name of the father was not my only name. That history had taken from women the other name, that of the mother. I couldn't at the time speak of Michèle Montrelay's beautiful book *L'ombre et le nom*, which I hadn't read yet, but I already knew the term *dark continent*, used to speak of the female universe and its many absences from the orders of the world. And when he heard me utter the word *phallocracy*, he nearly choked. After which the two of us talked. And my mother joined in the conversation, happy to discuss the subject.

My mother, with whom my sisters and I were sharing our feminist books, had recently declared to my father that she could "no longer stand this clerical-patriarchal-phallocratic power," and my father was dumbfounded: "What's gotten into your mother? I've been good to her. I haven't yelled at her or beaten her." And it was true. My mother was becoming a feminist at sixty years old. She didn't want to go to mass anymore. Or to see those "phallocratic" priests, those "old bachelors" who had exercised power over her and over her friends through their marriages, forcing them to "receive their rutting men even when they were in pain" and forbidding them to use contraception, even the most innocuous forms, even the rhythm method, when they could no longer tolerate carrying children and giving birth in pain.

My mother did not remain a non-believer for the rest of her life. Maman was born in 1910, and it's not easy to go without the spiritual food that has sustained you for a lifetime. And she loved her man. And her Church was falling apart. Until the end, she continued to waver. The pure faith of her childhood had been shaken. Until the end, her body and mind remembered it.

In 1969, as earlier in the decade, I was not indifferent to the wrongs in the world. I experienced the Vietnam War almost as if it were going on

in our backyard. I should say *we*, my friends and I, experienced it. Talked about it. Sometimes got discouraged by this Earth that couldn't turn without occasionally lighting fires.

Here in Quebec, too, we felt violence mounting. There had already been bombs and two or three deaths. I wondered who these people were that needed to kill in order to exist. I didn't know any of them, because they were anonymous. My dream of a country never involved weapons and murder. Such "blood weddings" were not for me.

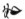

I remember that in the fall and early winter of 1968, my thoughts and my gaze often turned within. I felt my baby move in my body, I would put my hands on my belly as big as a globe of the world, I would follow the flow of the sea carrying it. When I felt it, it was as if I heard the beating of a new heart. I thought to myself, there is human rage not far away, there are disasters that frighten us, but we are two hearts living and beating and we won't die until the end of the world.

The great day came not long after the New Year. On January 28, 1969, my waters broke and the contractions of the boiling crater made themselves felt. Labour was beginning and it would last hours and hours, as unbearably painful as the preceding one, until the blessed arrival of my second son, Christophe, who was born in the very first minute of January 29.

I have many memories of the event. Unlike the birth in Aix-en-Provence, there was a large clock high up on the white wall opposite the table, which I watched constantly. That's how I saw the change from the 28th to the 29th to the minute. Amid the array of modern instruments at Sainte-Justine Hospital in Montreal was one that was placed on my belly to listen to the baby's heartbeat and the surrounding sounds, so that I felt as if I were in the middle of the ocean. I could hear the waves and the backwash and even the flotsam and jetsam the waters carried to the shore during storms – branches of trees, giant seaweeds, and even bottles smashing against a shore within me. I wondered if my child was hearing the same dazzling symphony, because very early in his development, he had ears.

AN UNPRECEDENTED TIME

I did not experience the same carnage as in the first birth. But the pain was no less intense and the lack of understanding around me, no less intolerable. Fortunately, Patrick was there and he greeted this second son with immeasurable joy. But the other people present were no better. As in Aix-en-Provence, the gynecologist arrived at the last minute, in time to administer an epidural, to see that my feet were in the stirrups of sorrow, and to catch the baby's head as it emerged. Hello, goodbye, that was the last I saw of him.

But the others! There was a nurse who did her job as if she were working in a factory, without a word, without a smile. She just waited. She seemed to have had it with working in that place where so many new human beings showed up all sticky, dirty, and bloody, and so many young mothers suffered and screamed their hearts out. She seemed exhausted. Worn out.

And then there was the other one! A midwife whose mission was to talk. Too much. She was a uterine mystic who hadn't had any children – I asked her – and kept running her hand over the "blessed uterus." She had had "a training" on painless childbirth and when I shouted "No!" during labour, because I couldn't stand to suffer anymore, she seemed horrified and said something like "No? You refuse to give life?" and the pop-psychology-granola-macramé sermon went on, a kind of moral torture that was just as appalling as that of the first birth, but under a sickly sweet coating, and I was furious. Perhaps that rage helped me to cross the unspeakable desert of the labour.

And the miracle happened! Christophe's head came out, and then his whole body slippery as a fish, and the cry after the difficult passage, a cry of both anguish and victory. Finally, the ceremony of the cord that miraculously becomes a navel. And the baby is placed on the mother's belly finally delivered of it. And those little fingers that you count, and his little toes, everything is perfect. You've brought a new human being into the world.

Those eyes, Christophe's dark shining eyes that were already gazing into mine. I couldn't get over it. There he was. None other. He already had his personality. And I already recognized it. Before sinking into sleep, I remember thinking how a child, no matter how small it is, immediately

has its own personality and temperament. Just as the gaze of the first child, Charles, wreathed in mist, had seemed to me that of a gentle dreamer, the gaze of the second one seemed to say he would be a happy conqueror.

Those two sons continued to grow in their difference. They are two men now. I have always felt that this creation of flesh, more than all the books I wrote and published, was the highest achievement of my life.

But had my life not been written, I'm convinced it would not have come into full existence.

"ME AND BOBBY MCGEE"

After all the quests and troubles of his life the passionate creature within his soul had become a pebble – beaten, polished, indestructible.

– François Cheng
Green Mountain, White Cloud
A Novel of Love in the Ming Dynasty

Madeleine at her desk by the window, Rawdon, 1972

Rawdon

In the summer of 1972, my UQAM friends and I rented two country houses north of Montreal in Rawdon, one larger and red, where the four without children stayed, the other one, forest green, where I moved in with my two boys and their nanny, Madame Lucien. The two houses were located about a hundred metres apart on a piece of land covered with deciduous and evergreen trees and were isolated from any neighbours. They were two-storey houses with enough bedrooms that we could each set up an office with bookshelves and a reading chair. The desks all faced the windows, so we could escape to the forest with its rustlings of wings, or the little branch of the river winding along the edge of the property, or the old well with its stone parapet that took us back to the peasant life of old.

In the huge yard, we created play areas for the kids. And for us, there was a wooden table with heavy chairs for picnics or work, a badminton court, a clothesline, a patch of ground for the vegetable garden we never had the time or talent to cultivate, and out of sight, a parking area for our cars.

I ate with my children in the morning and at noon. With few exceptions, my friends and I ate our evening meal together in the big red house. Every night was a party where the wine flowed freely and we enjoyed the dishes we took turns preparing. We were all good cooks.

We were five friends from various departments at UQAM – history, sociology, political science, literature – five comrades, as we said then, all in our early thirties, bound by an affection forged in union activism and political passion: Anne Gagnon, Céline Saint-Pierre, Jean-Marc Piotte, Mario Dumais, and myself. The time we were living in was one of social optimism and happy turmoil. Like many people we knew, each of us had, after a more or less tumultuous process of inner questioning, rejected

religion, the dominant Roman Catholicism that we felt had so oppressed us. We were free as birds, we thought, and none of us was interested in marriage. I was making my way through the jungle of divorce – the laws governing it were very rigid then – and another member of the group would soon take the same route. The other three were enjoying flings and free love, to use a very new expression. Some of our close or more distant friends, driven by similar feelings of revolt and rejection of the old religious and political order, had opted for communal living or experimentation with hallucinogenic drugs. We had nothing against the soft drugs, and some of us even enjoyed the magic smoke of marijuana in the form of pot or hashish.

Basically, we had chosen study and trade-union and political work without joining any of the radical groups that were then forming, such as the CPC-ML (Communist Party of Canada – Marxist-Leninist), In Struggle!, or the fledgling Trotskyist groups. Just as we had rejected the violence of the FLQ a few years earlier, we were allergic to joining the hardline leftist groups, whose rigidity in many respects reminded us of the Church, whose yoke we had recently thrown off. We felt that our revolutionary contemporaries had transferred from religion to politics without too much reflection, and that they were falling into the same traps. In fact, I knew a few who went through torments similar to those experienced by former priests and nuns after their awakening by the shrill call of freedom. Some, sadly, never awoke from the nightmare. How many suicides or cases of paranoid or catatonic madness resulted from these massive transferences that were never really understood?

The five of us wanted to study. Every afternoon, we would work in our respective offices, and then in the late afternoon, before the aperitif we so eagerly awaited, we would get together for what we called a seminar and Mario christened a *work and study group*, a term used at the CSN, the Confédération des syndicats nationaux [Confederation of national trade unions], where he also was employed.

We were working on course preparation, journal articles, or for some of us, our very first books for publication. Our university was young, and it seemed to us that it was looked down on by established academia. Among our colleagues at the Université de Montréal and

McGill University, we thought we detected the arrogance, even contempt, that old-timers sometimes show toward beginners. At UQAM, everything was young and new. There were no traditions, no proof of our competence to lend credibility to our first endeavours. What we had was the self-assurance and passion of young people who believe they are revolutionizing the world and inventing wonders, simply because everything was new to us. We were innocents, with a lot to accomplish and brains seething with excitement. Young people, who are by definition new and fresh, have always had the illusion that they are renewing the world and making amazing discoveries. So turns the wheel of history. And it's a good thing. How could we keep that wheel of creative energy turning if it was only in tune with what was despairing, decomposing, and soon to die? The renewal of the world always begins with a lot of illusions on the part of those who are the vital forces of that world, those who must be given the means to create their inventions. Crazily, sometimes. The renewal of the world, of all worlds, physical and mental, is only possible thanks to the initial illusion that everything can change. Everything will change.

Life that flows or that trickles like grains of sand will soon enough extinguish the passion of those early illusions, one by one. To age well, and to die well, however, you have to have cultivated many of them. Those people who have never felt they had within themselves the gift of invention and renewal will be the saddest, and will limp through life, drying up.

We five in Rawdon, without ever saying so to each other and without even knowing it, had the fundamental belief that we were going to change something in this world we had inherited. That we were going to bring originality and innovation to every subject through our work and our writing, but also through the way we conceived and experienced love and friendship, and even the way we raised our kids. That's what we talked about during our long evenings.

We identified with the left through our affinities with books or teachers, or by temperament. We were outraged by social injustice, inequality, and disparity. We called ourselves socialists. In my case, I still do today. One of us had worked for the journal *Parti pris* and another

had been active in trade-union organizations. And Céline wrote for and served on the editorial collective of the journal *Socialisme québécois*.

That summer I wrote an article for the journal, which I've lost all trace of. I remember racking my brain trying to reconcile my philosophical and literary knowledge with my new discoveries in political sociology. I have no idea what my ravings amounted to. It would be fun to look back at that article. There must have been a few naive ideas based on some intuitive gymnastics – quite a feat to stage a wedding between the Kantian transcendental imagination and the mystical poetics of a Paul Claudel, with none other than Karl Marx officiating. And yet, it all came together easily, smoothly, without conflict. As I said, youth.

Not to mention that I had to go to Montreal three times a week for my sessions of analysis. Fortunately, while going so quickly from one culture to the other, from fundamentalist Roman Catholicism to these radically different modes of thought I was discovering, I was experiencing the game of lucidity that is psychoanalysis. I've always wondered, and I still wonder, how those who did without it managed. It's an enigma.

Also, I could be with my kids any time of the day. Charles and Christophe were then eight and three years old respectively. I experienced the joy of conversations, stories, songs, and games with them. I was happy playing with my children.

Recently, I read something by Edgar Morin quoting someone – he had forgotten who – saying that living to old age demands a sense of humour, a positive disposition, and love (in *Manifeste féministe*, Laure Adler's book of conversations with feminist men). When I recall that wonderful summer, and other summers and other years, dotted, like every life, with conflicts and difficulties, I sometimes think that it was humour and love that kept me happy – I'll dare to use a taboo word. Love as friendship as much as desire, but the two are not opposites; sometimes they even come together.

As for a positive disposition – which did not exclude fits of rage, sometimes unjustified but usually justified – it was fed by two sources: regular exposure to works of art in every field and a sense of celebration in which unconstrained conversation, laughter, and dancing moved the lines and tilted the axis of a world that had become routine and commonplace.

There's nothing like a book, a piece of music, or a painting to take you away from a home that has become hateful or tedious, opening up other horizons, giving rise to other sensations and other thoughts. Or a party, where the table offers foods we don't make every day, the wine flows freely to sweet intoxication, and friends seen all too rarely speak with their bodies, dancing. A party, probably more than any other event, demands moderation. You have to be able to become intoxicated and stay balanced there as on the crest of a wave, without being swallowed up by the madness of the swells – which was not always easy for me because I loved wine and being intoxicated, but I didn't want to become an alcoholic (coming from a family in which there were many, including a few women, on both sides, Beaulieu and Gagnon). I sometimes went a little too far, but on the whole, I managed to pull it off. It's the same for words: unconstrained at parties, yes, as long as they remain within a certain, let's say poetic, framework in relation to the everyday norm, which would be more rational. As for music or dance, it must be part of a work of art but it must not censor words and confidences, which – I've seen it happen – can get lost and jumbled in the delirium and trance of high volume.

That summer of 1972 was a celebration, a big celebration. And during those weeks of rejoicing, we also worked, preparing our courses and pro-ducing the articles we had promised to journals. In addition, I got to work on my own writing, which I had put aside after *Les morts-vivants*. As would be the case throughout my life, without my planning or even thinking about it, I went from prose to poetry as the spirit moved my pen. Over those two or three months, in big notebooks that I always carried with me, I put together sentence after sentence until at some point I realized that I had the beginnings of two little works of poetry, which would become books a few years later, published by Herbes rouges and Aurore respectively as *Poélitique* and *Pour les femmes et tous les autres*. Written partly in *joual* – I remember feeling that I wanted to give the language of our people due recognition – filled with quotations from leftist revolutionaries, and with some poetic flights and forays into dreams, these were, as I understood quite early, drafts or, to be more generous with myself, studies that would best have remained in my personal files. Those two little books were the result of what I was experiencing at the time: a painful separation fraught

with dangers; the beginning of a long crossing of the psychoanalytic desert, where the joy of discovering a previously unknown inner geography was mingled with new terrors; the daily contact with comrades I cared deeply for. And reading, including one book that was overwhelming.

At one of our daily meetings over our aperitif, it was decided that we would all read the same book and hold a seminar on it one afternoon a week. And that book would be *Capital* by Karl Marx. Yes, okay . . . no, not in the summer . . . why not? The idea was finally accepted. So we read *Capital*, one chapter a week. Each one of us in turn was responsible for writing a summary of the chapter and leading the discussion during the weekly seminar.

At first, this "homework" interfered with my plans for writing and reading over the holiday. I saw *Capital* as a very steep mountain I would have to scale without ice axe or ropes. I saw ahead of me tedious labour, and I was afraid, as I had been afraid the week before I started primary school. My fears vanished with the first few pages. As far as I remember, we never got past the first chapter of the first volume. But what I learned, for example about the role of social or religious ideology in keeping the wheels of capitalism turning, opened my eyes. Never again would I read "blessed are the poor" in the same way, nor would I see the charity of the rich as I once had, that famous virtue that gives them an easy conscience and allows them to accept social inequalities or injustices or the whole system designed without any means for the redistribution of the wealth accumulated by the few at the expense of the exploited masses.

From this essential book that every educated person in the world would benefit from reading, I also understood the mechanisms of exploitation of the workers that produce surplus value. I don't want to give any lessons here, and I don't have the competence to. I simply want to pinpoint the *kairos*, the moment of birth of my social consciousness. The nucleus that was formed then had consequences for my poetry.

Afterwards, many literary critics labelled me a Marxist. Yes, labelled me. It was both an insult and a pretext for not really reading me. Or for saying that I had become unreadable. That reputation stuck to me for a long time. And it still does. I was also labelled a nationalist. That too was intended as an insult. In my first two little works, there were lines such as

"ME AND BOBBY MCGEE"

"Long live free Quebec!" Freedom does not make us Québécois narrow, closed-minded nationalists. I have never been a nationalist. I have always been, and still am, in favour of independence for Quebec.

Nor do I think that the little reading I've done on these things makes me what you'd call a Marxist. Here's a list of that reading: chapter one of volume one of *Capital*, as I said. *The Holy Family* and *The Origin of the Family, Private Property, and the State*, both brilliant works written with Friedrich Engels. The great French writers who inspired them: Saint-Simon, Auguste Comte, Fourier, and, especially, Flora Tristan, the extraordinary Flora Tristan. Plus a few works by their intellectual heirs, including Louis Althusser.

This long digression in my education, and its reverberations in certain of my publications, in no way hampered the poetic quest I had begun a few years earlier with the reading of the Symbolists and Paul Claudel. Nor have my subsequent reading and writing been diminished by it. The written evidence remains. And in poetry, the evidence is "nuptial tools," to use the words of René Char, one of the writers most dear to me. I went all out with my first "nuptial tools." Being young, we took risks, revelled, explored. I don't regret it. I disavow nothing. With the perspective of years, I can see how much that cost me in terms of critical reception. You don't go from Paul Claudel to Karl Marx with impunity.

With *Les morts-vivants*, I told stories that were basically in keeping with tradition. It was a normal book, if I can put it that way. One day – in the 1980s, I think – an old intellectual Quebec writer asked me directly why I hadn't continued along the lines of that first book, why I had branched off onto less readable paths, intending it as a reproach. I didn't know what to answer – the right answer always comes to me too late. Years after, or in any case now, I would say what Pasolini said in answer to a similar question: the artist should never take the expected path. The artist – and the writer is an artist – must always explore avenues of renewal. Of transformation. To see "over there, if I'm there," as the great French radio journalist Daniel Mermet said. To explore the unknown and find the new. To meet the self's other. To make friends with the Other in oneself. As Jean Cocteau said to a young poet who asked him for advice, "Surprise me!" If not, why write?

Mozart

I came back to classical music in the early 1980s. I say came back because, aside from country music, it was through so-called classical music that I had first come to the world of music and, in a sense, to the world of thought, as well. It was in 1983, after the death of Mireille, my good friend Mireille Lanctôt, when I listened, over and over, to Mozart's *Requiem*. To that music, I wrote my poem "Requiem pour une Abeille" [Requiem for a bee] – *abeille* [bee] and *soleille* [sun, but spelled with two *l*s and an *e*, a feminine ending], like the sun with two female wings, were the names she signed her writing with.

"Requiem pour une Abeille" was published in *La lettre infinie* [The Infinite Letter]. Written in grief and shock, because Mireille had died at thirty-one in a car accident, it describes in a few blocks of prose poetry the radiance and beauty of a young woman who died too soon. Like all the pieces in that book, it was considered obscure, convoluted, unreadable. I remember a meeting with Georges-André Vachon, the editor of the journal *Études françaises*, who had wanted to give the journal's eponymous prize to that book. And who no longer wanted to. The meeting took place at his home. I had gone there with my son Charles, whom I had just picked up at his school, not very far from Georges-André's place. I remember the abuse he hurled at my book, calling it all sorts of names, comparing it to "Borduas's scribbles," saying that we were painting and writing for a lost elite, far from the people and far from everyone, that we were despicable "show-offs" that were doomed to fail, "like all Surrealists." I was stunned, all the more so because he had said such nice things to me on the phone. The comparison with Borduas consoled me. My own Borduas ever since I first saw his paintings at the age of twenty-one. After I finished the drink he gave me, Charles and I left. In the car, Charles asked me, "How can you do it, Madeleine, how can you see people who

treat you like that?" We talked. Charles was fifteen. His words often shed new light on things. And people.

About that book, *La lettre infinie*, a little later, I received a letter from Bernard Noël saying he had resigned from the collection he had been editing because of a disagreement over these writings, which had been rejected by senior management at Flammarion.

To return to Mozart. All of Mozart. And the others – Bach, Schubert, Brahms, Schumann, Chopin, Liszt. And Wagner. And Mahler. And all the other composers of that unsurpassed classical music. I rebuilt my record collection, which I had lost in a separation and when I went, regretfully, from vinyl to CDs.

Mozart and the death of Mireille the Bee. Mozart and *La lettre infinie*. Mozart and the beginning of the 1980s. And the book *L'été 80* [Summer '80], by Marguerite Duras. All Duras's works, books and films. Duras and my trip to Quebec City with Yann Andréa and Henri Barras, an adventure described in two of my books, *Le deuil du soleil* [Mourning for the sun], in 1998, and *Donner ma langue au chant* [Giving my tongue to song], in 2011.

Mozart and Borduas. And writing, smooth and limpid, from the spring of childhood, beyond appearances. Smooth, limpid writing and my friendship with Annie Leclerc, and her own fluid writing. Our friendship, which lasted for decades, from 1975 to Friday, December 13, 2006, the day of her death. Of cancer. Annie and Mozart. Annie, Charles, and Christophe. Annie and Ariane, her beloved daughter. Annie and Mireille. I went to Ottawa with the two of them in 1978. Annie and I were giving a talk at the university. We were in Mireille's little car, she was driving us there. We had read over our notes and prepared our lecture on women and power, a request we often received. We were testing our ideas on Mireille. Annie was going to talk about the sharing of power between men and women, which would later lead to her book *Hommes et femmes* [Men and women]. I still have the book she signed for me: "For you, dearest Madeleine, always." As for me, I had chosen the thought of Maurice Blanchot, from whom I had long ago borrowed the idea of "un-power." Which I would summarize today as follows, applying it to women (which was not Blanchot's concern): women

never having possessed power, its positions, its stakes, or its authority, power is not women's business. Coming from the underside of power, women would emerge from the shadows and attain a name (that's from Michèle Montrelay) and the transformation of the world by speaking, and making real, what they had experienced, what they still experience on the other side of power, war, and domination – murder, ruin, rape. They would remain in un-power. Without compromise.

Hardly anyone understood anything I said. Which I realized, of course, not since I myself wasn't sure of anything. That's my nature: I make strong statements, but over a bottomless well of doubts.

In any case, that trip with Annie and Mireille was wonderful. Mireille herself was writing a master's thesis on women's words, which was based on Annie's books and which I was supervising. She was not shy about putting in her two cents' worth, wasn't afraid of us two "older women." In the course of the trip, we traded clothes. Annie was wearing a sweater I had given her. Ivory cotton, knitted by Geneviève, a friend of Mireille's, and of mine now. And I was wearing Annie's black cotton skirt, which I had found gorgeous and she had given me. Annie and Mireille are dead today. Does death exist when life is being written? The dead person no longer exists.

In Mireille's little car, we listened to Mozart. Another time, Annie and I went to Quebec City by train. Invited by another great friend also gone now, Jeanne Lapointe. To give another lecture on women and power. It was the early 1980s and there was intense interest in the subject: intellectuals, researchers, artists, cultural journalists, male and female, wanted to understand, or to better understand, women's position in relation to political, economic, and sexual power. We, the invited writers, were raising the same burning questions in front of these various audiences. We didn't have ready-made answers. Sometimes we read excerpts from our books and analyzed them with the men and women there.

During the last years of Annie's life, our friendship was in eclipse. An eclipse of the sun or the moon does not mean that those celestial bodies stop existing. That thought consoles me. Annie died during the eclipse. The grief of the final parting in such a situation is particularly difficult in that situation.

Since I'm talking about dead friends, I may as well recall my last meeting with Georges-André Vachon. It was in November 1995, at the launch of my novel *Le vent majeur* [*Against the Wind*], at the office of the publisher, VLB éditeur, which was still being run, for a few more days, by Jacques Lanctôt. Many friends had come, Annie among them. Monique and Marcel Simard had come with her. At dinner afterward, everyone was talking about the referendum that was going to be held within days. We were almost certain the Yes side would win, that we would finally gain our independence, and Quebec would finally be a country. There were a good twenty of us around the table, and with a little help from the wine, we sang country songs and songs from the French Revolution and the Resistance.

Georges-André Vachon had come to that launch. I was near the signing table, and he was a little way off with Paul-Marie Lapointe and Yves Préfontaine. They were laughing and talking in verse, they were having fun. Then Georges-André left them, looked at me, and came over. He had my book in his hand and he wanted me to sign it. He seemed sad. After I signed, he gave me an intent look and asked point-blank, "Are you afraid of death?" He wasn't joking, he wanted an answer. I said something about not being afraid of death, but being afraid of old age, its diseases, and my decline.

We didn't say much more. He left that charming little gathering and went away. Alone. With his fear of death still in his eyes and on his shoulders. Before leaving, he had murmured, "I'm afraid of it." Later, I think I understood his wanting me to sign the book and asking that question about death. It was a recognition of my writing and a veiled admission of his cruel error ten years earlier about *La lettre infinie*. And, more profoundly, a final confidence about his dread of his own end. I accepted it as a peace offering. A gift before parting. With that gift, he had asked forgiveness.

(Autobiography is a Socratic process. A kind of midwifery. In writing my life, I am giving birth to myself and my own life. May it have the same effect on my death! Also on all the dead in me who were my loves. My female loves, since the word *death* in French is feminine. Let us imagine. Let us dream.

Georges-André Vachon and I were also connected by our love of Claudel. He with his book, published by the French publisher Seuil, *Le temps et l'espace dans l'œuvre de Paul Claudel,* which I had read while working on my thesis on Claudel. He had been happy to hear that. Before writing this chapter, I never would have thought that man had been important in my life. Yes, autobiography is a Socratic process.)

Creation

It may seem that I'm far from the title of this section, "Me and Bobby McGee." But no, it's been here all along, in the background, waiting in the wings. If there's one song that's emblematic of the 1970s and even the following decades, and today, when partying is back in style, it's "Me and Bobby McGee," sung by Janis Joplin, but also by the Grateful Dead and others. "Me and Bobby McGee," which we so often danced to at the UQAM professors' union parties or those of friends, including friends in the literature department.

The songs we listened to without necessarily dancing, the songs of Léo Ferré, Brassens, Brel, Barbara, Félix Leclerc, Bob Dylan, and Leonard Cohen – I almost forgot Rezvani, and I'm sure I'm forgetting many others – and the ones we danced to – Otis Redding, Jimi Hendrix, the Moody Blues, Santana, the Stones, Lightnin' Hopkins, and still others that my memory has scattered to the four winds – will remain imprinted in our hearts to our last breath.

We transformed and taught the literature programs, replaced the chronological division of courses with what we called the basic methodological approaches to literature: sociological and historical; psychoanalytic; linguistic. Later, we would add feminist studies and creative writing. We worked for hours and hours in the classroom or in department meetings and the study committees we set up for each question, each problem. We wanted to change the world, starting with our own world in the university. We had our families, too. Our children. Our loves.

As soon as our schedules allowed us a break, we would party. We were generous in friendship. We weren't indignant, as people have to be today. We were rebellious. And iconoclastic. And celebratory. We wanted to change the world – we would change the world. We tossed out the holy writ and tattered rags of religion. And we partied. Our

pauses between bouts of hard work were punctuated by dancing. "Me and Bobby McGee" was part of it.

All around, couples were breaking up, divorcing, living together. Love affairs blossomed to the rhythm of these songs. We would overcome bourgeois and religious institutions, and marriage seemed to us the most treacherous one of all.

Our generation came mostly from large families. It has been called the lyric generation or the baby boomers, both of which are fitting. One thing is certain: we were a multitude of young people, a mass, who awakened to social consciousness when we were in our early twenties, at the time of the Quiet Revolution. Now we were thirty and we passionately wanted things to change. We girls with education didn't want to reproduce the pattern of our mothers and grandmothers, the eternal apron over the well-ironed little dress, the bodice open for the endless nursing, leg chained to the stove, as we used to say. Of course, I'm exaggerating. My own mother did not correspond to this caricature. It's more of a metaphor – in that register, if you don't exaggerate, you can lose the lamp that lets you see ahead. The men in our circle, comrades or friends or lovers, approved. In fact, they had no choice, since we were so determined.

How lucky our generation was! Everywhere in the West, feminism was being born. Writing from western Europe and the United States piled up on our desks. Conversations and discussions opened up to this new awareness of the situation of women. New demands now had repercussions on our course content as well as on union activity and certain clauses of our collective agreement. An inter-union committee on the status of women was created, which included female students. We were all amazed by what we had put in place. Professors, support workers, lecturers, and students talked together about the same burning questions. Problems came to light that we had been unaware of, related to harassment, intimidation, sexual coercion, and aggression. Like the navigators of old on the vast oceans, we were in wonderment exploring a new continent. This was our Indies, our America. We were galvanized. Excited. Uplifted. We had just begun to reap the benefits of the Quiet Revolution, and we were experiencing our young history in a state of jubilation.

We spent the 1970s reading, rereading, and rereading again. Anything and everything. We were hungry for new knowledge in our fields, and we looked to both the ancients and the moderns for it. In literature, our quests and our labours were many, according to our aptitudes: sociolinguistic analysis, structuralism (the painstakingly detailed but incredibly interesting analysis of Baudelaire's "Les Chats" by Jakobson and Lévi-Strauss – wow!), semantics, psychoanalytic interpretations of works and of the world (with a certain number of indiscretions and desecrations), many feminist studies, and a lot more. Even semiotics, which came like a tornado, carrying along many readings that were uncertain, uneasy, but necessary. With semiotics, the relationship of writing and reading was turned upside down. The empire of signs, but especially the empire of squares and rectangles, was born.

I would leave UQAM shortly after. In 1982, to be exact. Meanwhile, I withdrew to my quarters. I jumped ship at an island, the island of creative writing, and I stayed there. A few colleagues, including Noël Audet, had fought for a program in what, for want of a better term, was called creative writing. The word *fought* is not too strong. Many of the professors were against us. They didn't take us seriously. Some, including those at the Université de Montréal and McGill, laughed openly at us. We were Don Quixotes crossing the barriers of semiotic squares, defending the literary work – poem, novel, essay, or story – like two lovers who cherished literature and wanted to bring it back onto our paths of exploration and discovery. At that time, the second half of the 1970s, we found only a single ally, Joseph Bonenfant at the Université de Sherbrooke. Noël and Joseph are both dead now. I remember them both with great fondness.

I won't go into all the ins and outs of that battle, which already seems to be of another time. It is the resolution that is important to me. One day, a course was set up that was called a creative writing workshop. And then there were others. What was first a major in creative writing was established, which consisted of several undergraduate courses. Then, after long struggle and debate, a master's program in creative writing was approved. I remember the condescending jokes of the learned, serious literary scholars, whose echoes came to us from all the local universities – and even universities in France. "Wow! They're teaching

creative writing!" We kept going. We, the "pro-creatives," speculated that students who were losing their desire to read would come back to reading through the love of writing and the practice of it. That is what happened, as we have seen since.

However, we had to prove to our learned colleagues that we were serious by agreeing that the master's thesis in creative writing would have two parts: the first part would be the work itself, and the second, a critical or analytical essay on the work. I remember one student, François Charron, who rejected that dichotomy, which he found absurd and damaging. Since I was his thesis director, I supported him and had to defend his work to colleagues. The work was entitled *Qui parle dans la théorie?* [Who is speaking in theory?] and it was subsequently published by Herbes rouges.

I want to salute those who attended my seminars and published their work, and who indeed still read: Madeleine Monette, Rachel Leclerc, Élise Turcotte, Danielle Laurin, André Lamarre, Louise Desjardins, Louise Warren, Simon Harel, Anne-Marie Clément, Gaétan Soucy, Micheline Morrisset. Others did not publish, but they know how to read. For some of them, reading constitutes the writing of their lives. I am thinking of one student, who became a friend, Johanne Voyer. She was bursting with talent and showed exceptional promise. She created a different body of work, bringing four children into the world. You can't do everything in life.

"ME AND BOBBY MCGEE"

Un-power

While the destiny of many students was being decided in the department, there was union work that required time and dedication. There too, we were the first generation – the first to form a university professors' union affiliated with a union federation, in this case the CSN. "Imagine, university professors who think they're ordinary workers!" (I heard this said.) "They're crazy. Leftists. Anarchists. Revolutionaries. Dangerous provocateurs." We continued despite the insults and jokes. We were trained by Paul Doyon and Paul Thibault, the union staff assigned to us by the CSN. They patiently taught us the ABCs of union organizing. Michel Chartrand came and reprimanded us and called us selfish, privileged petit bourgeois and a lot of other names. Politely, we let him admonish us. We also met Marcel Pepin, who was exquisitely polite to us. He was a man of refinement and broad culture.

First I was a delegate of the literature department to the council of the professors' union. After that, I was a delegate to the CSN's central council of professors and the Fédération nationale des enseignants du Québec [Quebec federation of teachers], whose president was Francine Lalonde, an intelligent, sophisticated person and a good organizer and leader, but in a gentle way, with an equal capacity for having a good time. I remember the weekends of union training that were held under her gracious guidance at the Hotel Rond-Point in Lévis, where we worked hard all day and partied like crazy in the evenings. There too, "Me and Bobby McGee" was with us. I would like to pay tribute to all the friends from the professors' union with whom I worked and partied.

Around the end of the 1970s, I was elected vice-president of the union, in charge of drafting and applying our collective agreement. When we negotiated, I was the sole spokesperson from literature among some eight or ten colleagues from all departments, who helped me defend our demands. They were from political science, religion, education,

mathematics, administration, sociology, or linguistics. They supported me and briefed me. We fought for "firsts" – on workload, parental leave, equal pay for women and men. We gained acceptance for many principles and procedures that today seem self-evident.

Across from me, the administration spokesperson was none other than the current rector of UQAM, Claude Corbo. We did not treat each other as enemies. Claude Corbo was a decent, reasonable person. We were not at war. We discussed. Every article. Every clause. That time, the collective agreement was signed without a strike. The next year, there was an election for the union executive. For the first time in the history of the union, which had always been led by the left, a right-wing team, well-organized and tough, and largely from the education and administration departments, entered the fray. The election took place. In a packed hall like we had never seen before, with everyone on edge and overheated. As if the fate of the world were going to be settled that day.

The inevitable happened. The assembly, completely polarized between left and right, listened stunned to the results of the secret ballot. All the members of the right-wing team were elected, with the exception of one person on the left who was elected vice-president – me! I was delighted that I had overcome the division and been the only person elected by everyone, but at the same time, I was devastated at the thought of having to work with a team of adversaries. I remember going to celebrate that evening with "my gang," who had suffered a bitter defeat. In any case, the others, overbearing and arrogant in their victory, hadn't invited me. They had gone out with their defeated candidate for vice-president. What do these ill-mannered right-wingers know about having a good time, anyway? I said to myself.

I didn't work with that team for long. On the one hand, my colleagues on the left asked me to inform them of the nefarious policies promoted by the right in the executive, and on the other hand, I quickly realized that the meetings I attended were faked and the other members were deciding everything before (or after) those meetings. The atmosphere was awful. I resigned after a few weeks.

And the left did not take its defeat well. It never questioned the way it had previously won and exercised power. It split into a thousand

factions. It got lost in analyses that I most often found fuzzy, reductive, and heliocentric, the sun being their way of seeing things. Ultimately, regaining power seemed to be the only objective that drove them. I withdrew from all those debates. I sang to myself in my head, "Make a fire in the hearth, I'm coming home." I came home to writing.

I wrote a long article on un-power in which I quoted Blanchot, long one of my favourite writers. I also quoted Claire Lejeune and her "spirit of the workshop." I sent the article to the union, telling them I was quitting and asking them to read it and distribute it to all the members. I never received an answer or heard anything about it. Neither from the left nor the right. Blanchot and Lejeune (and perhaps Paul Valéry – I don't remember, the article is lost) and un-power? You must be joking! They probably didn't understand it. They had other fish to fry.

No. A single person did understand what it was about. That was Thierry Hentsch. The great Thierry Hentsch, who had been defeated for the presidency and who remained my friend until the end of his days, and who, within me, where silence reigns, is still my friend today. Thierry died of an aggressive cancer in the summer of 2005.

With that article on un-power, I truly came back to writing. I had crossed the barren land of drafting clauses of collective agreements and minutes of meetings. On the horizon, I glimpsed happier paths to words. It would soon be my sabbatical year, 1978, during which I would write *Lueur*, the book that began a new cycle of writing and another decade, and that was soon followed by *Au cœur de la lettre*, *Pensées du poème*, *La lettre infinie*, *Les fleurs du Catalpa*, and *Autographie*.

I wrote my essay for the union, "L'impouvoir" [Un-power], in the torments of a love that was coming undone. Everyone who knows me knows I am a loving person. Since the age of seven, I have never lived without love. The 1960s were marked by my life with Patrick, the father of my children. The 1970s, by my life with Jean-Marc, whom I left in 1980. The 1980s, by my life with Jean.

There were many separations between Jean and me before I finally managed to break up with him in 1990. After that, my love life was so complex that it would require a whole chapter. It's very well known, I'm not saying anything new, that it's never easy to separate from a person one

has loved. The hardest thing for me each time was that moment of falling out of love, a moment that can stretch over time, a moment of passage, an opening in time when it becomes clear to one's consciousness that what was loved is loved no longer. It's a break, a collapse of one's being, when one has to admit that what was once cherished has become hateful. A collapse of desire. A death foreshadowing the other death, the real one, the ultimate one at the end of the passage.

In those separations – from a love, from the union, and from a political hope – *Lueur* was written. From the outset, I described that book as "night writing." In fact, I wrote it at night, so that I could be with the children until they went to bed and when they woke up, until they left for school. All that time, the children were loving and growing up. Like all children, they had their ups and downs.

And I who loved them so much and love them still, like all mothers, sometimes guilty, I say to myself that I could perhaps have spared them unnecessary suffering. Then I don't say anything more to myself, leaving their lives to the enigma of all lives. In spite of everything, trusting.

I-ME-MY

Poets each have their own door, their own open sesame, their make-believe parents, their personal grandmother, their shadow or number of brothers, their different way to ward off death.

– Hélène Cixous

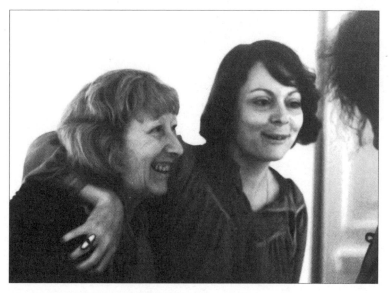

French writer and feminist Christiane Rochefort and Madeleine.
Centre culturel canadien, Paris, 1977

Meetings

I-Me-My was what we called our women's group in 1975. We would say, for example: "What time is our I-Me-My meeting next Wednesday?" Or: "I'm going to have to miss I-Me-My in two weeks, I'll be out of town." In the beginning, there were Denise Boucher, Patricia Nolin, Odette Gagnon, Marie-Francine Hébert, and myself. A little later, we were joined by Pauline Julien.

The group was formed after the annual Rencontre québécoise internationale des écrivains [Quebec international writers' meeting], which was then run by Jean-Guy Pilon and was held that year in Mont-Gabriel on the theme of "women and writing," because 1975 was International Women's Year. There were a few men present at that Rencontre: Jean-Guy Pilon, of course, but also Jacques Godbout, Fernand Ouellette, Gaston Miron, Naïm Kattan, and André Belleau. Yves Navarre was also invited. I am probably forgetting some names. After all, I am not a historian.

Of course, there were a lot of women. Given the theme, they didn't have much choice! I remember Anne Philipe, Fernande Saint-Martin, Nicole Brossard, and Madeleine Ouellette-Michalska. Spontaneously, a group formed that wanted to break up the monotony of the learned colloquium and show that women, with their newly won participation in public discourse, could conduct discussions differently, make them less stiff and static, more lively. The women who had been officially invited to speak, Marie-Francine Hébert and myself, were soon joined in secret meetings by Denise Boucher and Patricia Nolin, who were in the audience. It was the last year the public was invited to the Rencontre. That was in reaction to the events I'm about to recount. To this day, the Rencontre takes place every year behind closed doors.

The four Quebec women plotting the demise of monotonous colloquia were soon joined by Christiane Rochefort and Annie Leclerc

from France and Claire Lejeune from Belgium. The idea was simple: Marie-Francine Hébert and I would give up our official speaking time for something we couldn't quite define but that would be like improvisational theatre – a happening, as it was called then.

The day and time of our talks came. Marie-Francine and I each had two sentences to recite. I remember my two: "I no longer want my texts only. I want other speech in my words." I chanted them in a solemn tone, repeating them rhythmically while Marie-Francine softly slipped her words in and the following scene took place: Denise and Patricia came running in and positioned themselves in the big rectangle of space between the four long tables, a space that became a stage where Denise, holding a bottle of scotch (which she had lifted from the bar), sang Clémence DesRochers's "La vie de Factrie" [Fact'ry life] and Patricia Nolin, dressed as a cleaning woman, dusted the tables and the briefcases, papers, and pens on them with a feather duster. Our European allies Christiane and Annie were giggling like schoolgirls, Christiane singing "Le temps des cerises" and Annie knitting like our mothers, while Claire Lejeune was red as a beet, almost ready to collapse, but managed to calm herself and took refuge in her notes.

The next day, Claire gave one of the most beautiful talks we had ever heard. She said she was thrilled. Having been "invited and avoided" as if she were not among the authorized guests, she finally gave herself permission to join the circle of initiates and talk about her expulsion from the order of discourse from the beginning, her madness, when words abandoned her, and her return now, with the words of the "excluded third" and the spirit of the workshop that on this day breathed through her own words.

Our own spirit of the workshop – the spirit of those who were "invited and avoided" – and our improvisation, which was essentially innocent, were like a bombshell. One man stormed out yelling that we were "frustrated bitches" (which, at the time, was the supreme insult). In her little voice, Christiane said, "Frustrated, frustrated, but you, gentlemen, are the ones who have been screwing us!" Another sent his wife to tell me that if we didn't stop our madness, we would be responsible for causing his weak poet's heart to suffer a heart attack. Another shouted

at me from one end of the hallway to the other as I was on my way somewhere: "Madeleine Gagnon, you won't steal our phallus. It's ours!" I was so stunned I didn't know what to say. I think I said something like "Phallic power is symbolic. We are not attacking anyone's bodily integrity." Yves Navarre well and truly came out that day. He said how much we women had moved him. Spoke of his bisexuality, of the fact that he felt himself to be neither man nor woman, but both. He cried in front of everyone, and in the evening, he asked me to dance. In the autobiography he published shortly before his death, he recalled the Rencontre of 1975, relating the complete opposite of what happened at that event. I wrote to him about it. I wanted to set the record straight. He never answered me. Too bad for him.

Gaston Miron, who always showed solidarity and originality, stood up and, without a microphone, gave one of his hilarious speeches: "I understand you women. I'm a woman myself. I change my daughter's diapers. And I have a vagina." To which his buddies replied that he was exaggerating, as usual. That none of this was serious. And Gaston had a lot of fun with it. I've rarely met a man who had so little fear of women.

I made many lasting friendships at that Rencontre in Mont-Gabriel. With Claire Lejeune and Christiane Rochefort, but also with Annie Leclerc, who was on a mission to propose a book project to me that had been conceived by her and Hélène Cixous, in which they wanted to include a text by me. Annie and I had experienced what we called friendship at first sight – and Julien Bigras, whom I met years later, would always refer to us, at his boozy parties, as his "two dear unconscious lesbians," which really made us laugh, and maybe he was right. And the three of us wrote that book, *La venue à l'écriture* [Coming to writing], in three parts, in which, aside from our different styles, we were of one mind. It was published in 1976, in the publisher Christian Bourgois's 10/18 collection. It was rather poorly received in France. Criticized by Annie Lebrun and others. Practically ignored in Quebec. But in the United States and English Canada, it was read and much discussed in the universities' women's studies departments and the circles of women scholars formed in the 1970s on the model of the "literary salons" that flourished in France during the Enlightenment.

Hélène Cixous and Annie Leclerc both continued with their wonderful writing. Hélène first published with Antoinette Fouque's Éditions des Femmes. A major intellectual and a Joycean poet, who was also influenced by Henry James, on whom she wrote her doctoral thesis, Cixous later joined with Derrida. In her own writing, she reached as far and as high as Derrida himself, her friend, her brother, her Algerian compatriot, her double. The French (and Quebec) reading public showed little interest in her at first, finding her impenetrable, elitist, abstract, abstruse – an all-too-common refrain, unfortunately. Slowly, a few people started reading her, and discovered the genius of this "sphinge" – her feminized word for *sphinx* – and followed her verbal flights, as aficionados of Joyce follow him until they lose themselves. She is one of the great ones. Very great. She put into practice *Rêver l'autre* [Dreaming the other], by René Major, in her own writing, while dreaming herself better than anyone else.

As for Annie Leclerc, I'm happy to say I saw her regularly during the years of our young maturity, at my home in Montreal or her homes in Paris, Saint-Sulpice-Laurière, or Quinson, from one season to the next, while our children grew up together. I followed her work closely. I got to know her when her career was at its highest point, just after the publication of *Parole de femme* [Woman's word] in 1974. That book sold in the tens of thousands, with translations published worldwide (as also occurred with *Ainsi soit-elle* [So be she] by Benoîte Groult, another great founding book for the cause of women). Of Hélène, Annie, and me, it was Annie who had the limpid prose. The fluidity of her writing, which was so important to her, guaranteed her a wide readership, but at the same time it had drawbacks. Because her writing was easily understood, it gave rise to very harsh criticism. The books that followed were attacked on all fronts, including by Milan Kundera, a writer whose novels and whose study *The Art of the Novel* we admired. We never read him the same way after that, discovering macho power games in the male-female relationships in his books, where the twists and turns of desire represented a love we no longer wanted.

It's true that in *Épousailles* [Nuptuals], *Hommes et femmes,* and so many other books, Annie Leclerc, supported by her perennial model

Jean-Jacques Rousseau, didn't exactly help herself, with her unqualified praise, sometimes to the point of dogmatic orthodoxy, for heterosexuality and the intrinsic necessity for a man and a woman to make love. She was attacked from all sides. By philosophers who had long ago gone beyond rigid barriers between the sexes, as well as by radical lesbians who did not forgive her the ethical choice in favour of the primacy of heterosexual love.

Her star dimmed. People began to read her less, and publishers no longer wanted to publish her. I watched the decline. Until the day a young woman and great writer, Nancy Huston, having experienced the same "friendship at first sight" with Annie, read all her works and got her discovered or rediscovered by affectionately taking charge of the fate of her new books. Actes Sud published her last titles. After her death, Nancy Huston wrote a tribute to her for that publisher, a touching book entitled *Passions d'Annie Leclerc* [Passions of Annie Leclerc].

I-Me-My

Enough digressing. Let's get back to our I-Me-My group. I think it was Patricia who first used that name. It was spontaneously adopted by the other four. It meant, as Patricia the talker explained without any other demonstration, that we would not be doing theory or political analysis at our meetings. We had agreed to get together once a week at the homes of the members, and each of us would talk about herself and herself alone, in relation, of course, to whatever people she was close to that she cared to mention: mother, father, children, or lovers. Three of us were living with men, and two had children. During our meetings, our men were not to be present in the house, nor were the children (where were they? I don't remember). These exclusions caused the first problems and were a source of latent conflict, as one can easily imagine.

Before the Rencontre, we barely knew each other. For my part, one of them, Patricia, was my neighbour, and that was all. In the beginning, we formed a funny, light-hearted group. Affinities had brought us together, and our need to be with others was so intense that we immediately seized upon them – as was the case for thousands of women of our generation. We knew we came from a patriarchal and largely sexist civilization. Although most of us were privileged in our lives with men – fathers, brothers, lovers, and friends – we were conscious of the injustices and inequalities, as well as the violence women were subjected to. We had all seen around us, and for some, very close to us, the submission of mothers, the subservience of some women, the shame of unwed mothers and the humiliation heaped on them. We had all seen sexist violence and misogyny close up, in our private lives or at work. Unpunished rapes were something we all knew about among our friends. We also knew that our mothers had finally obtained the right to vote when they were almost forty. That women were not yet legal persons: no right to own

property without the consent of husband or father; no right to sit on a jury, no right to this, no right to that.

And we were discovering a very new freedom, in large part because of contraception. We had been able for some ten or twelve years to control our bodies and love relationships and choose whether or not to have children. We were a happy, enthusiastic group with all kinds of plans. We had all read a lot. We wanted to keep up the momentum of the social, religious, and sexual revolutions of our fresh youth, to push against the resistance, to flush out the least symptom of oppression and subjugation, we wanted to raise our consciousness of the situation of women, but without fighting and without open revolt. Our slogan, also proposed by Patricia: Justified anger and ultimate gentleness.

Our meetings were funny and lively. With the vitality of the group, they were like bonfires. We didn't drink or listen to music or dance. We talked. We must have had a great need to talk. We talked about ourselves. Each one talked about herself. There was a theme for each meeting, and they were many and chaotic, ranging from "my first experience of love," a subject that could be extremely serious, to "who does the housework in my house?" which could end in theatre – we were doing improv ahead of our time.

"Consciousness-raising groups" had been formed throughout the Western world. Ours began to give birth to others. I remember one meeting when we had invited a few friends who wanted to see how it worked and possibly start their own groups. By word of mouth, we ended up with a crowd of some eighty women. We didn't know how to manage all this. What should we say? What should we do? Since we did not allow ourselves to say anything theoretical or analytical, and since we also did not want to display our "I-me-my," if I may put it that way, we told stories. Denise and Patricia were excellent storytellers, and the evening was filled with uproarious laughter. Among the women in the room were Pauline Julien and Pol Pelletier. Pauline even joined our group the following week.

I remember ambitious plans hatched at that meeting. Some women agreed to found their own groups. Another said, "We should get out of Montreal and start groups all over Quebec." To which Denise, always the

joker, added, "Yes, let's go forth and multiply!" Since we absolutely did not want to become a political organization – leftist groups were a dime a dozen in those years – we did not follow up on the seeds we planted there. We went back to our homes.

We heard that Christiane Rochefort had started her own I-Me-My group in France. I was invited to it once when I was in Paris. It was really funny. Incapable of not theorizing, the six or seven of them, who called themselves anarchists and said they had seen it all, veered into endless learned discussions that I listened to with both astonishment and skepticism. Basically, I needed to rethink things, to find the tools for thought and knowledge that were lacking in my beloved Montreal group.

For all the learned theorizing and verbal jousting of those French women, the time would come when the partying would start: good wines were uncorked, the magic smoke perfumed the air, the table was filled with delicious things to eat, and then dancing, finally, dancing.

It was in that group that I met the young ethnologist Jeanne Favret-Saada, who wrote the magnificent book *Deadly Words: Witchcraft in the Bocage* after a stay with the sorcerers of the Bocage, where she was bewitched, then released from the spell to go back to Paris to write her doctoral thesis on sorcery. Jacques Lacan had abandoned her – she had also become a psychoanalyst – and she had received support from the Centre national de la recherche scientifique [National Centre for Scientific Research] to write and publish her work. This book is one of a few in my library that I would never give away or sell, but will keep to the end of my days.

The group had been started by Christiane Rochefort, who had returned to Paris "dazzled by the women in Quebec." What an original, vivacious person Christiane was! She made me think of Job. First very rich, from the sale of hundreds of thousands of copies of her first novel, *Warrior's Rest*, which she had written during a year of total solitude in a tiny room. She had bought a typewriter with her meagre savings and taken refuge there. She had gone to the neighbourhood bistro as she did every day, when she had a flash worthy of St. Paul on the road to Damascus: lighting her first Gitane of the morning while sipping her coffee at the counter, she knew she would not go back home to her husband, whom

she had never really loved (in fact, she never saw him again). She would set off toward her destiny. Toward the dream she had always cherished. She would write.

With *Warrior's Rest* came glory and wealth. She got herself a sports car, a red convertible, and drove down to Cannes, where the book was being made into a film. Then she bought her little dream house in Brittany, which she had to leave broken-hearted after a black tide washed onto her land. The *Amoco Cadiz* had run aground, and her maritime dream was shipwrecked on the Finistère coast one spring day in 1978. In addition to being an anarchist, but also a pacifist, Christiane was a committed environmentalist throughout her life. After the disaster, she acquired a big, charming eighteenth-century stone house on the heights of Ménilmontant, with an amazing view of the whole of Paris. It was located on a huge piece of land, which she allowed to go wild and which became a "paradise for cats," as she said. In the late 1970s, developers, through some kind of scheme, bought the land from the city. Christiane was evicted by court order. She watched the malevolent cranes tear down her house. High-rise apartment buildings were built there that she wanted never to see. She bought herself "a little place" in a working-class arrondissement in the south of Paris.

Then her books stopped selling so well. From the time her writing expressed her commitment to the cause of women – and children, because she also published *Les enfants d'abord* [Children first], in which she recounted many tragedies, including the rapes she was subjected to as a child by a well-respected uncle and a parish priest – her publisher no longer supported her. Like everything else in her life, her work declined. She became poor. But her writing was still funny. Her last book, *Mon testament* [My testament], was so funny it made you cry. She had an unflinching sense of humour. Like her, indestructible. Invincible.

The last time I saw her, she had shrunk so much I had to bend over to talk to her. Suffering from bone degeneration, she didn't have much longer to live, and she knew it. She was sad. Because the idea of her approaching death was hardly a cheerful prospect. And because she knew our Montreal I-Me-My group had disbanded amid conflicts and animosities. She had believed that we in Quebec, in the new America

with its wide-open spaces, were immune to the old quarrels and narrow-minded quibbling of the old country. I couldn't find the words to console her, caught up myself in the torments of my own goodbyes.

Yes, our group had disbanded! Enmities had sprung up from deep down to explode one evening in a theatrical burst of tears and resentment. The group split apart. I found myself with Denise. I had invited to the meeting Liliane Wouters, a brilliant Flemish poet who wrote in French, and her companion Françoise Delcarte, a Belgian philosopher, who has since died in a car accident. We ended the evening at Denise's place, trying as best we could to understand what could have happened, how on earth things had come to this.

It was difficult to understand at the time, since the group had always rejected analysis. In hindsight, it's easier to see that without the necessary analytic distance, our confidences, which were based on dreams, reveries, and fantasies and gave rise to improvisations, as intense as they were, would end up smashed, body and soul, on the rocks of everyday life. I don't regret anything of that fabulous experience, even though, as with any breakup, the end caused a lot of pain.

Denise and I quite soon decided to make a book out of it. That was *Retailles* [Scraps]. Although it is far from the masterpiece she and I dreamed of creating, the book is still interesting and instructive for anyone who wants to get a sense, from the inside, of certain dramas experienced by the committed women of those years, and some of the beauties too. We wanted to improve relations between men and women. Between women too. We thought we could replace the rivalries with new forms of solidarity. Since we had a lot of catching up to do, our trails were not always very well scouted out. I quoted Bob Dylan and I wrote, "I've been thrown down into the nights of your sorrow, from which our sonority will also speak to me now." And Denise wrote poems in which the fiery flashes of a fierce wildness ran aground on the shores of simple common sense:

– *You are there, with your women's Wednesdays, like anarchists in the dark making a bomb that's going to blow up in the guys' faces when they aren't expecting it.*

– *You haven't told each other everything, l'il girls? Let yourselves go.*

Women
United

In 1974, on the initiative of Patrick Straram,
we founded the monthly magazine *Chroniques*. The team was made
up of Straram and myself, and we soon added Philippe Haeck, Céline
Saint-Pierre, Jean-Marc Piotte, Laurent-Michel Vacher, and Thérèse
Arbic. Each of us was responsible for a column – on political, socio-
logical, or cultural events, according to our respective skills and interests.
We defined our basic objectives during long meetings in a space we rented
at our own expense, one floor of a little duplex on Wolfe Street before
the gentrification of that neighbourhood, among the "true proletarians."
We wanted to distance ourselves from our petit-bourgeois class situation,
as we said at the time.

We wanted to be "organic intellectuals," bound with lucidity to
the people we came from. We had gotten this term from Jean-Marc
Piotte, who had learned it while writing his doctoral thesis on Gramsci.
We wanted to be clearly on the left, but not ultra-leftists like the
Maoist factions such as the CPC-ML or In Struggle! In fact, we were
attacked by one of them, which published an incendiary text against
us in the journal *Stratégie*. We were happy. We were not a voice in the
wilderness. Someone had read us. So we replied from the mouths of
our literary canons. I was asked to write the reply by the "production
collective" – we didn't want an editor or editorial committee. I did it,
a little reluctantly, but duty called. I wrote a long, convoluted text that
was no doubt tedious – except for the monks at *Stratégie* who had to
meticulously dissect it. I haven't reread that piece of prose, and it's
probably just as well.

We did not want to work on the right with the loonies of *Mainmise*
[Taking control] and the counterculture either. There too, some people
got carried away and disputes proliferated.

We celebrated the *Refus global* and identified with it. We revived some pieces, including a number by Paul-Marie Lapointe and the forgotten *The Sands of Dream*, by Thérèse Renaud. We owed this archival work to the poet Philippe Haeck. France Théoret and Léandre Bergeron later joined the team. That was toward the end. The journal died a natural death in 1976.

My column was called "Between Madness and Truth." Influenced by my readings in anti-psychiatry and written when I was preparing to become a psychoanalyst, inspired by Julien and Élisabeth Bigras and their "Red House seminars," the column talked about women and madness, criminalized or psychiatrized deviants, asylums, delirium, and liberating speech. Perhaps one day I'll reread those columns. To make a book of them? I don't know. For the time being, those pastel-coloured issues sleep in boxes at the back of a storage locker in Montreal.

I wrote my last column in the spring of 1976. That year, I had been chosen by my department at UQAM to represent our university in inter-university exchanges between Quebec and France, in a program funded by the Université du Québec network and the Canadian Department of External Affairs. I would go to teach Quebec literature – the novel, if memory serves – at Université Paris 13, in Villetaneuse, a suburb of Paris.

I arrived in Paris in March, ready and willing. I settled in and prepared my first class, which was supposed to take place in early April. However, on April 1, a general strike was declared in the universities, and it lasted for the entire three months I was scheduled to be in Paris. The first day of the strike, I went to the campus to see with my own eyes and understand what a strike was like in a French university. I was surprised to find that, unlike at home, there were no picket lines. Groups of young people were walking in all directions, some of them with signs, all circulating at will in the buildings where classes were normally given. I inquired as to where my department was and, above all, what to do as a professor from elsewhere, unfamiliar with the culture and customs of a French strike. I was advised to go to the room assigned for the course at the time of the class. And to discuss the "issues in the conflict" with the students present. I went twice, but since the classrooms were all empty, I didn't return again. The last afternoon I was there, the weather was so nice, a mild sunny May day, I did as all these strangers on the campus were doing, I sat down on the

grass, read, and took notes in my travel journal. I wrote a piece entitled "An Afternoon at Villetaneuse," which I sent to *Chroniques*. That was my final contribution to the journal, which was on its last legs on the other side of the Atlantic, as I learned when I got back home.

Since I found myself on vacation and I didn't want to be idle while being paid – with a cheque I went to pick up at the Department of External Affairs – I decided to educate myself. I wanted to get to know the women's movement in France up close – its writings, its struggles, its objectives. I made the rounds of what was happening, trying to explore what we called the dark continent. Every day, I would leave my charming little hotel on Rue du Cardinal-Lemoine and venture forth into the women's world of Paris with a notebook, which I filled in the cafés.

I met with women publishers, journal editors, booksellers, and writers. I went to meetings, sometimes large ones at places like the famous Maison de la Mutualité auditorium, sometimes more modest ones in the cubbyholes that served as offices of the activist groups. I attended lectures, panel discussions, and meetings where I was sometimes asked to talk about what was happening in Quebec. I greedily read mountains of books, articles, and pamphlets. I saw my old friends and made new ones. I was both studying and having fun, and that was the way I liked the life I lived in those heady months.

One day, invited by my friends from Christiane's I-Me-My group, I went to a big auditorium on the Jussieu campus where all kinds of groups and factions had come to try to organize a "unified women's demo," for the big May 1 demonstration. They wanted to go there together this time, "so as to avoid getting beat up by the guys from the unions." They wanted to be "women united," numerous and strong.

Every stripe and every tendency was represented in that gathering. Maoists marching in step, wearing Chinese khaki military garb; anarchists dressed in mauve, their breasts unconfined, flowers in their hands or their hair, belting out songs to the chagrin of the women warriors; lesbians, trans women, and cross-dressers wearing pretty pink, some graceful, some dancing locked mouth-to-mouth. Suddenly, a tall, severe-looking woman went to the blackboard and tried to write an agenda. Agenda? Blackboard? Are you kidding? They let her know in

no uncertain terms that they didn't want any "leaders" among women, or directives, or even microphones.

(Back home in Quebec, at a similar meeting organized as part of two weeks of women's activities, there had been a spectacle like that. I remember Marie Savard chanting one of her poems, sitting on the floor at the back of the stage. Without warning, right in the middle of her presentation, she tossed the mike away, saying, "This thing is phallic, we don't want it anymore." When you think about it, it's normal that after being in the shadows and silence for centuries, women were crazy and chaotic in their initial public expressions.)

So the tall woman at the blackboard went and sat down again and kept her mouth shut. In the uproar, with no one daring to open that meeting, a little group charged forward carrying placards – my friends told me they were "Trotskyists from the women's reconstruction of the fourth international." One of them wanted to propose a list of slogans to be chanted at the unified demo. She had barely finished reading the first slogan (which I forget) when a small voice spoke from the back of the hall – I recognized it as Christiane's voice, which carried well despite the fact that she was tiny – saying, "You can take your slogan and shove it."

There was a commotion. Shouts. Chants. People leaving. I tried to speak. I was sitting on a windowsill in the back of the auditorium in the full late-afternoon sun. People listened to me because of my accent. I told them it was ridiculous to argue this way when they were trying to organize a unified demonstration. A voice replied: "You're very nice, Quebec, but what you're saying is too good to be true." My friends and I left as well and went to a bistro to talk.

On May 1, at the big demonstration, hundreds of women were pushed to the end of the procession by the marshals. That evening, we saw on TV that many of them had been beaten.

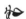

After those weeks of exploration and wandering, I was eager to go home. To see my friends and family again. Especially my children. The Internet didn't exist yet. Nor did webcams. Nor anything that would have allowed

us to make absence visible. We didn't miss it because we didn't know about it. Every week, I talked on the phone with Charles and Christophe. Every day, I sent each of them a postcard: to Charles, something with the planets and the celestial sphere; to Christophe, a cat story. I had made arrangements for babysitting by family, friends, and loved ones who would surround them with intelligence and affection. But nothing could replace me. I knew it, and I was beginning to have an intense desire to hold them in my arms. Like any normal mother, I felt a bit guilty for being away so long. And I arrived home laden with gifts.

Seeing everyone again on my return, I discovered that this long absence would cost me dearly. I was made to pay for it in many ways, most often unconsciously. Unfortunately, the road to hell is paved with good intentions, as we all know.

Our I-Me-My group was falling apart, as I said. My Parisian "holiday" was not without consequences for the weeping and gnashing of teeth of the brutal breakup of the last meeting. It's hard being a liberated woman.

I still accepted a few public invitations. I recall a discussion meeting at the women's bookstore on Rachel Street. In that pleasant and uncompromising place, where men were not admitted – as in many places in France, the United States, English Canada, and everywhere else – women, who often had been assaulted, oppressed, or subjugated, felt more at ease, more able to talk freely I was supposed to speak and answer questions from the audience. Marie Cardinal had also been invited. She was there by my side, warm as always. We were sitting on high stools. Some young videographers were filming us. One of them asked about the fact that we were living with women's "main enemy," men. We took that remark rather lightly and continued talking. Someone asked me if I had children. I answered yes, two boys. With those words, lightning struck. There were shouts and insults. I had brought two males into the world, had carried them in my womb? I was nothing but a traitor. Marie and I listened, incredulous. "You

have introjected phallic desire! How dare you call yourself a feminist?"
Things became confused. The room was awash with protests and
shouts of rage, insults, and lamentations. I launched into a tirade about
the men I would always love: grandfathers, uncles, father, brothers,
sons, friends, lovers. I could hardly make myself heard. Nothing and
no one could restore peace and calm in that room.

Marie and I were not gurus, nor did we want to be. We had no
sermons of salvation. We watched the spectacle of discord in disbelief.
When the gags that have been on mouths for centuries are torn away,
the mouths open and pour torrents. Thunderbolts that voices try as best
they can to channel into new words. Voice exercises for unheard voices.
The meeting ended in cacophony.

As usual, we left in small groups. Marie and I and a few friends
headed to the Charade, in Old Montreal, for something to eat and drink.
And to get our fill of talk. We said that the problem with feminists was
not quite the same in France and in Quebec. For those in France, the
biggest pitfall was the proliferation of groups and political factions. For
us in Quebec, it was the insurmountable split, the impassable boundary
that now divided heteros and radical lesbians. Only one woman dared
to think about bisexuality in the very body of her writing, and that was
Hélène Cixous.

ELSEWHERE IF I'M THERE

You don't have to look far for beauty and goodness, since they are here.

– Annie Leclerc

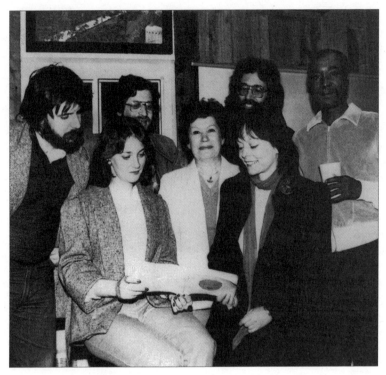

Gathering of Acadian writers, Edmundston, 1983.
Back row (from left): Herménégilde Chiasson, Gérald Leblanc, Melvin Gallant, and
Gérard Étienne
Front row: Dyane Léger, Lina Belzile-Madore, and Madeleine Gagnon

High Noon, or The Train Will Whistle Three Times

Before I ever saw the movie *High Noon*, I loved the French title. In my teenage girl's mind, "the train will whistle three times" was an invitation to a journey, to all journeys. To me, it meant "the train will whistle for you." From my childhood home by the river, we would hear the whistle several times a day. And at night, its sound lulled us to sleep. Before the mammoth trucks and buses took over our roads and ruined them, everything or almost everything, people and freight, was transported by train. From the Ocean Limited to the local train that made a few return trips a day, the arrivals and departures of the trains punctuated the time. And the trains always whistled three times entering or leaving the station.

My life as a child and an adolescent was steeped in that music, and it gave rise to my first dreams of travel, my first desire to go away. The train, more than any other means of locomotion, came regularly to tell me, with one joyful whistle, that it was possible to leave and go elsewhere and it was possible to come back from far away. I had gone short distances by horse or car or snowmobile, to Rimouski, Matane, or Matapédia, a maximum of seventy kilometres. In my child's mind, those distances were negligible when I heard the stories of people who had taken the train, either to come back from horizons so distant that just their names required the help of a geography book, or to go away to places equally strange – like the sea, which I'd never been to, and which you could see with your own eyes in Halifax, where the route of one of the trains ended, or in Gaspé, where it had to turn around and come back because the rails stopped at the water.

As for ships, I didn't dream about them yet. In my village, I had only seen light rowboats, canoes, or longboats gliding on the Matapédia

from one house to another or one neighbourhood to another. It was beautiful, I loved to watch them, but they didn't make long journeys, so they didn't stir my imagination. Until the day an adult (I forget who) told me that the river flowed into another river, the Restigouche, and the Restigouche emptied into Chaleur Bay, which itself merged, farther on, into the Atlantic Ocean along with Gaspé Bay and its three large rivers.

And then I could begin to dream. Of going there, of crossing lands unknown, not recognizing anyone because everything would be strange to me. Of following the road, becoming a passerby for others, carefully choosing just one travelling companion, or maybe two. Of beginning, in other climes, to no longer recognize myself, becoming strange to myself, and finally finding myself again. Of understanding myself better through the unfamiliar. Through the unknown that passed through me when I thought I was passing through its landscapes and its faces.

I was able to realize that dream of going away beginning in the early 1980s. For two reasons. The first concerned the children. In 1980, Charles and Christophe were sixteen and eleven years old respectively. One was in the middle of the torments of adolescence and the other was starting puberty, cocky and rebellious. They were intelligent and handsome, but difficult to raise. I was working hard at the university and going through a second painful separation, and I didn't have much authority over the young adventurers my sons had become. Besides, I had never been very strict – the boys had always called me Maman Bonbon [Sugar Mama]. Their father seemed to have a peaceful, happy life. He had remarried and was living in a luxurious house in Outremont. After fighting so hard for custody of the children ten years earlier, I was beginning to wonder if they wouldn't be better off with him now.

In addition, I was thinking that the time had perhaps come for me to leave my position as a university professor, since the job had become too demanding for what I wanted most to do: to write. I was aware that it would mean a loss of economic status, but not to the extent that I would later experience – but that's another story.

I knew deep down that the time had come for me to give my sons back to their father. We would be switching roles in a sense. They would regain that person they loved as much as they loved me, who was in their

eyes an inaccessible hero and a distant God, whom they only saw for one month in the summer, a week during the Christmas holidays, and every second weekend, the one they met for fun outings, who gave them toys and treats – they would regain him in the reality of everyday life. The legendary Ulysses would become just a normal father, supervising homework and exercising authority. The sons would be subject to the law of the father while I, freed from that order, would become myself again: the one who has her boys over for holidays and celebrations and who can spoil them.

I took some time – a few months – to mull over the plan. I consulted the people I loved. I discussed it quietly with my sons. Told them a hundred times that it was because I really loved them that I had thought of this. It was the purest and strongest love that made me think of reuniting them with their father. (Moreover, had I not been certain of the love the three of them had for each other, I would never have considered that exchange.)

I thought of the play *The Exchange*, by Paul Claudel. I thought, too, of the words of Blanchot: "In every giving up, there is a giving." And I thought of the chapter by Annie Leclerc in *Parole de femme* in which she says something like this: if we women really want fathers to take care of children, we have to stop whining and give the children to them.

Those months were both tumultuous and happy. The day I shared my decision with Patrick, he cried and said, "This is the most beautiful day of my life."

This new situation, along with my departure from UQAM, gave me more time, huge swaths of time to do what I loved most in the world – besides loving – to write. To write and to go away. To see "elsewhere if I'm there." And to write it.

I consider that the 1980s marked the real beginning of a literary work that is still in progress, and that will be completed with my last breath – if my brain holds out, of course. And that what I am writing now is just as young as, younger even than anything I wrote in the 1960s and 1970s. What I was writing then was old; what young people write is often old, for the simple reason that the first attempts contain the dross and the dust of the old stories you've been carrying with you before they have gone through the filter of analysis and lucidity. So I find it deplorable

that many literary histories, anthologies, and textbooks have not gone beyond my first publications, which they describe as "protest" texts, and which, very often, I have disavowed and have not reprinted in my own collections of past work.

My leaving the literature department at UQAM created more of a stir than my returning my sons to their father. I will immediately digress here to say that when they came of age, both of my boys came back to me. But differently. They were adults and had won their own freedom after hard struggle, each in his own way grappling with the law of the father.

The announcement of my decision to leave UQAM must have come rather suddenly for my colleagues in the department, some of whom were dear friends. They were stunned. They didn't understand. I must say that I myself didn't completely understand what I was doing. Some whispered that I had perhaps "gone crazy," and I got wind of this. Others were sad – they thought I was courageous, and confessed that they would have liked to do the same, but the high cost of living, the insecurity . . . and cried on my shoulder. And others were plainly angry. During the department meeting where I was asked to explain, I gave two answers. The first was that I wanted to take "preventive sick leave," and the second was – I remember my exact words – "When you see someone leap into the void, you keep quiet and hold your breath, you don't ask them to make a speech."

So I left UQAM. With no severance pay. With nothing. I was innocent and naive, of course. I didn't anticipate that there would be so many financial problems at times. The desire to leave a fixed place was stronger than anything. I was not leaving because I didn't like that place or those people, far from it. I was not leaving to get away from something or from myself. I was not leaving to die a little, as the saying goes. Just like when, at the age of four, I wanted to go far away from my house, it wasn't that I didn't like my house. I loved my family home, I cherished it. I loved its rooms, its bedrooms, its attic, its dormers, and its cellar; I loved its windows, its backyard, its front garden, and its river. And I loved my childhood. I had what's called a happy childhood, with good parents and happy siblings and a huge extended family that, with all its ups and downs, was a delight. No one among our parents or grandparents abused us. None

of our eleven aunts mistreated us. None of our nine uncles molested us, which you must admit is rare. That may not make for a bestseller, but it can still be written about. It doesn't get you on the TV talk shows, but so what? And despite all this beauty, in my home and in my department, I wanted to leave. Go figure!

In leaving UQAM, I was leaving a university, but I was not leaving teaching. It was the many administrative tasks and functions – the meetings, representation on various bodies, running of programs, departments, or graduate studies – to which we all had to contribute time, that I was giving up, not the encounters with students in classes or supervision of theses. The profession of teaching is to me one of the noblest there is. Sharing knowledge and discussing the questions of a discipline have always been an exciting adventure for me. This love of passing on knowledge is no doubt in my genes: one of my brothers and two of my sisters taught in college or university. Our mother was a teacher in the old system – she was said to be an excellent educator – and so were one of her brothers and two of her older sisters – three, actually, since the eldest, Marie-Anna, a nun named Sister Ange-de-Gethsémani, spent her life teaching deaf-mutes at a Montreal institution run by the Sisters of Providence (two things that really intrigued me about her when I was little were her name, Angel of Gethsemane, and the fact that she knew sign language, which she would sometimes demonstrate for us). In addition, our great-grandfather, Louis Desrosiers, the father of our grandmother Ernestine, was also a teacher.

Starting in 1982, I taught in many universities as a visiting professor or as writer in residence, a brand-new role and term that Quebec inherited from the English-speaking world, to the chagrin of academic literary purists, especially those from France. How many times did I hear the words, "Literary writing and creativity cannot be taught! It is literary theory, history, and analysis that should be taught in university!" I always answered pretty much the same thing: I spend an entire semester teaching my students that creativity or talent, or indeed genius, cannot be taught. But that you can talk about it, make speeches about it, and write about it for weeks, months, and years. That you can also read those who conceive and create works, and try to understand what the best of them thought,

said, and wrote about the writers who inspired them: for example, Valéry on Mallarmé; Blanchot on those two; Barthes on Stendhal; Victor Hugo or Joyce on Shakespeare; Dylan Thomas on John Donne; Victor-Lévy Beaulieu on Shakespeare or Melville or Joyce or Foucault. And go back and read those writers. That library is huge. Inexhaustible. I cannot list here all the inspiring writers and all the reader-writers we talked about in my seminars. I would have to write a thousand pages, and that would go far beyond the scope of this book. Perhaps I'll do that when I'm really old.

What I immediately recall are the delights of my courses once I was freed of the tasks that made the wheels of the institution turn, and that were tedious for me. I am thinking of Edmond Jabès and Writing with a capital *W*, because for him, writing was biblical. I am thinking of Deleuze and the instantaneous quality of poetic effect. Of Derrida, who decompartmentalized and opened up our conceptual territories to the ultimate outcome of a truth of writing, which is poem and dance, as in Nietzsche. Derrida, whose writings my students and I read from the earliest ones in the 1960s to *The Post Card*, creation in action, and his later writings.

In 1984, I was invited by Joseph Bonenfant at the Université de Sherbrooke to replace Richard Giguère, one of our great readers of poetry, who was on sabbatical. I taught two courses a week there, one on women's writing and the other on poetry. Joseph had concentrated my workload on two consecutive days so that the university would only have to pay for one night in a hotel. The hotel was called L'Ermitage, and the name suited it very well. It was in a little wood, and it was so silent under the canopy of green. I prepared my classes there, I dreamed, and I wrote. It was improvised country in the middle of the city, and as a result it was too beautiful to survive in our era of economic fundamentalism. In 2011, they levelled everything: motel cottages, trees, trails. When I was passing through Sherbrooke and saw the place, I was heartbroken; it was as if it had been devastated by sudden bombing. The clear-cutting had done its work. In Quebec, we don't need wars to destroy the landscape. The implacable machinery at the service of the powerful is enough.

From 1990 to 1995, when I was a visiting professor at the Université du Québec à Rimouski, I was lucky enough to meet students who

had not yet jettisoned the past. Who had not yet consigned history – general and literary – to oblivion. Had not turned their backs on their ancestors, their predecessors, their elders. Who were not convinced that their generation had invented everything, that youth automatically meant renewal, that renewal meant change, radical transformation, and, ultimately, revolution. I had the good fortune to meet students who still knew where they came from.

This poor knowledge of history is not the fault of the young people. It was the adults, their teachers, who miseducated them: teachers, professors, writers of programs whose main virtue was that they were new, as if novelty were any guarantee of excellence. Many civilizations have been devastated by war, but perhaps more have been damaged because a generation has become blind to its heritage. Most of the time, no one talks about these lost generations. They are like black holes in the firmament of knowledge. Perhaps we are in one of these lost times? Perhaps this means the coming era will be a period of enlightenment? We have to hope so.

So, in 1984, I arrived at the Université de Sherbrooke. I met students who were hungry for knowledge, curious and studious. I was haunted by a dead young woman, my friend Mireille, who lived within me. I was reading dozens of her texts, letters, and manuscripts. Her mother and friend Maryse was doing the same at her home. With Father Benoît Lacroix and Professor Joseph Bonenfant, Maryse was working in the pain of loss to put together her daughter's writings for a book, which was published in 1985 with her original calligraphy and drawings, under the title *Pomme de pin* [Pine cone]. Then in 1994, Maryse Trottier-Lanctôt's own book, *Terre d'origine* [Land of origin], was published. In it, she paid tribute to the daughter she had loved so much, who, through her death, had given life to these signs we call writing that had always been buried within her. She quoted Frédéric Mistral at the beginning of the book: "What though youth's halo only decked her brow! – / What though she wore / No diadem of gold or damask cloak! / I'll have her raised to glory like a Queen and honoured . . ."

Maryse died in 2006, surrounded by her four other daughters, Martine, Diane, Dominique, and Sophie. I was in Espalion, in Aveyron

in southern France. As the nurse had asked me to do – "She can't talk anymore, but she'll hear you" – I spoke to her on the telephone. The nurse held the phone to her ear. Maryse was on her deathbed. I was in a little room of the Vieux-Palais that was used as an office. I could see the Lot River and I could hear its waves lapping against the stone wall of the building. The stars had a transparent brightness that night. The air was clear. I didn't want to talk too long so as not to tire Maryse. I heard her breathing, and her silence, which seemed even deeper for having crossed the Atlantic and being carried by the Lot. I stopped talking for a moment. I listened to that silence and Maryse's breathing. The nurse took the phone again and said, "Keep talking, she's listening to you, she's smiling."

I talked to her about Mireille, about the water of the Lot, which I could hear. I talked to her of the Atlantic Ocean and the stars. I described to her the star where Mireille was. And told her that she would soon meet her. There. That she would take her in her arms, "like a queen, and honoured." I talked softly for a long time. Two days later, on February 19, at dawn, Maryse died.

From 1986 to 1988, I was a visiting professor in the department of comparative literature at the Université de Montréal, leading seminars on women's writing (we didn't yet speak of gender studies) and creative writing. I had known the department in its first incarnation, in the 1960s, and its founders, major intellectuals from American universities – Eugenio Donato, Eugene Vance, and others. It was thanks to them that, as a very young teacher writing my thesis, I came into contact with the French thinkers who have marked cultural studies in American universities: Roland Barthes, Jacques Derrida, Jacques Lacan, Michel Foucault, and Paul de Man. Thanks to Donato and Vance, I read their books and attended lectures by a few of them, including Roman Jakobson, Jacques Derrida, and Michel Foucault.

The current incarnation of the department did not disappoint me. It was made up of young scholars, and I became friends with a few of

them. Wladimir Krysinski, an extraordinary polyglot, was the heart of the department. I loved talking with him. He would sometimes attend my seminar, and I attended his with great interest. One day, he asked me to prepare a lecture on Quebec poetry for the university's literary scholars. Then he wanted to publish it. It came out under the title *La poésie québécoise actuelle* [Current Quebec poetry], with a foreword written by him. A few poets talked to me about that book – Gaston Miron, Paul Bélanger, Paul Chanel Malenfant. I don't think it's a great text, rather a modest essay. By a poet with her own interpretations, which were sometimes a bit off the mark. But, as often happens in Quebec, it was lost in the desert of oblivion among dunes of misunderstandings and buried paths. Being an intellectual in Quebec often carries a stigma. And if you're a woman, it's a shameful disease.

At a weekly seminar that brought together all the professors and graduate students, where each class was given by a professor and a student on a subject established in advance, it was decided by the students that the whole semester would be devoted to the study of one book. A big, difficult book, they said. They had drawn up a list of titles, from which they would choose one. There were *Écrits*, by Lacan, *Madness and Civilization*, by Foucault, *Of Grammatology*, by Derrida, and even Marx's *Capital*, suggested by a solitary voice. The title that was finally chosen by the students was *A Thousand Plateaus*, by Gilles Deleuze and Félix Guattari. The professors agreed. So every week, there were two presentations on this book prepared in collaboration by a professor and a student. What an ingenious way of exploring a major text!

As writer-in-residence that year (I had been a visiting professor the year before), I had the idea of writing short poems on what I considered the sixty basic concepts of *A Thousand Plateaus*. I read the poems at the last meeting of the course. They liked them. They wanted copies. Some even thought they should be published. The resulting book, entitled *L'instance orpheline* – based on Deleuze's ideas on poetry – was published by the late Anne-Marie Alonzo at Éditions Trois. The poems were accompanied by my "Lettres illisibles" [Unreadable letters], invented letters in the form of brush drawings in India ink. It was published in 1991, at a time when most of the critics were attacking me for the unreadability

of my writing. Since *Lueur*, in 1980, they had all been saying the same thing. The "Lettres illisibles" illustrating *L'instance orpheline* were an original way of protesting. It didn't have any more readers than the preceding books. I was criticized for the obscurity of my writing. It was even thought – and I was told this, sometimes angrily – that I deliberately wrote for a small readership, that I was an elitist. That I was destined to fail. These criticisms were hurtful, it's true. But they never discouraged me. Nor did they prevent me from following my path. How could anyone intentionally lose their readers by being obscure? You'd have to have a warped mind to think that.

I have always written. As in my journeys to faraway places where I don't understand the languages, where I'm lost in enchantment just crossing the land – I couldn't say why – I have written losing myself in the strangeness, attempting to bring to meaning, however obtuse, what comes from the very night of meaning, what has not yet encountered "the words to say it" because no common word has yet touched that part of the enigma of the world.

I don't believe that artists and intellectuals are on one side and the people on the other. Artists and intellectuals belong fully to the people. I am a daughter of the people, who writes of her travels in foreign lands, far away on the map of the world, deep in the depths of myself. Like Nicolas de Staël, like Tàpies, like Soulages, like Fernand Leduc, like Angelopoulos, like Rothko, and like Michel Brault, I am a child of the people, who draws *A Thousand Plateaus* in poems and India ink, at once unreadable and curiously clear.

Vancouver

In 1988, Dorothy Livesay, who lived in Vancouver, organized a tour for me of three universities in British Columbia: Simon Fraser, UBC, and the University of Victoria. Since I had written a preface to her poetry anthology *The Phases of Love,* we had become friends. Dorothy wished ardently that my books would become known in English Canada. The Canadian "two solitudes" outraged her. She found it unjust that works from Quebec, including mine, were so little known. Born in 1909 in Quebec, in the Eastern Townships, a region for which she had a deep affection, she was a fervent federalist. She had been an enthusiastic socialist, a friend of socialist and Communist intellectuals in Ontario. It was when her dear comrade-in-arms Stanley Ryerson came to UQAM as a professor that she reconnected with her Quebec origins. It was through Ryerson, whom I knew from the professors' union, that she met me and read my books. Dorothy, a committed feminist since her sixties, had gone through the century living as a free woman, and she spoke of her love affairs now from the vantage point of her late seventies with sometimes biting lucidity, but always with a keen sense of humour. She had fought epic struggles, and she could tell long, impassioned, sometimes comical stories about them.

Her life was one of social commitment, but her crowning achievement was her poetry. She was a great poet and was recognized as such from sea to sea. In Quebec, we got to know her in the 1970s. First there was the journal *ellipse,* which presented her alongside a little-known woman poet from Quebec, Medjé Vézina (1896–1981), who, like Livesay, wrote love poetry, but whose writing was more lyrical, filled with passion, voluptuous, as her contemporaries said. And just as lucid. Deliberately detached from the patriarchal powers, which in French Canada were clerical. This cost her fame.

Dorothy Livesay, who was known mainly to academics and bilingual poets in Quebec, did not understand the gulf between the two cultures and would not accept the ignorance of her anglophone compatriots about Quebec writers, including myself. So she organized that tour of the three British Columbia universities and notified everyone she knew to come and hear me.

I was extremely well received: luxurious hotels or university residences for visiting professors or writers, friendly dinners, meetings of small groups of people chosen by the organizers with Dorothy, official receptions in private homes, cocktail parties. I was welcomed warmly and at great cost. It was a time when a bilingual Canada was a dream, a utopia even, for Canadian intellectuals and artists. It was not what is understood today by bilingualism, that "desperanto" of a globalization dedicated to the Babel of stock-market speculation and the levelling of distinct cultures, in which Canadian franglais is jabbered and is even taught by people who are not English scholars and have never read Shakespeare.

As always during my public meetings abroad, I read from my work, and Dorothy read the translations. But above all, I talked about Quebec. And about the French Canada I had known during the four years of my studies in Moncton. I talked to them about our history and our literature. About the Conquest, in the case of Quebec, and the deportation, in the case of Acadia. By the British army, the army of the conquerors, in both cases. I situated the emergence of the two literatures, that of Quebec and that of Acadia. Told them, in French, translating as I went along, of the isolation of these literatures within the English-speaking world these people all belonged to, immersed as they were in the huge ocean of the USA, which has arrogated to itself the name *America*. I talked to them also about our isolation from France, which had never wanted, and still does not want, to acknowledge our French-language literatures of North America and their value. With the exception of some poets, since poets everywhere are always more aware. More open to foreign voices. And poets often translate.

And I read some of my work. I have always loved to read. It seems to come naturally to me. For a long time, I did theatre and gave public readings. I also read other poets. I remember reading a poem by Émile

Nelligan. One by Medjé Vézina. One by Claude Gauvreau. Two by Anne Hébert. And a few contemporaries.

I was on a little cloud during that whole trip, in the country next door that they said was "my" country.

On the eve of my last talk, I had this dream. I was with Patrick Straram, Janou Saint-Denis, and Denise Boucher. The three of them were laughing, drinking beer, and smoking a joint. I was sad. Patrick handed me a beer and a joint and said, "Come on, la Lionne" – Lioness, that's the nickname he'd given me – "have a beer with us. Smoke, too!" Suddenly, I looked at him intently and he became pallid, he looked like a corpse, but a standing corpse. I said, "Patrick, I can't drink or smoke with you. You're already dead." In the morning, I wrote down that dream in my travel journal. I was upset.

When I landed at the airport two days later, my friend Marie-Claire, who had come to pick me up, looked very solemn. She said, "I have some bad news to tell you. Patrick died two days ago." I took out my notebook and read her my dream, standing amid the suitcases. I checked the time. At the time of my dream, Patrick was dying of a heart attack in the ambulance taking him to the hospital. His last companion, Jacqueline, at his side. He asked for the ambulance to stop at a convenience store. He wanted a beer. The last thing he said was that he needed a slug of beer.

I hadn't seen him in recent months. Because he was drinking too much. And because he was mad at me for joining the Académie des lettres du Québec [Quebec Academy of Letters]. He said I had chosen power. That I had betrayed people. That I had become a corrupt petit-bourgeois academic. At the beginning, he used to call me the Gentle Lioness. Then he started calling me Lioness-Glow (from the title of my poetry book *Lueur*) in a preachy tone of voice. When he begged for a last swallow of beer, he must have been thinking about me and must have seen an image of me in a bright glow, and I received his appeal in my dream in Vancouver. I didn't respond to his request any more than Jacqueline and the ambulance technicians did. Because he was dead. I saw him. And told him so.

The day before I left Vancouver, Dorothy took me by boat to Galiano Island, which was her earthly paradise, and where one of her old lovers, now a friend, lived. He was her age and was called Anthony. He lived alone

in a camp he'd set up so he could sleep there cosily all year round, eat, read, and dream in the middle of a forest of centuries-old trees – I remember an enormous pine tree that Anthony said dated "from before the arrival of Christopher Columbus" – with birds of all colours and all songs, for which he had hung houses in the trees, and which he fed. He heated with wood in an old cast-iron stove, on which a tea kettle from another era was constantly whistling. He spent most of his days chopping wood and feeding the birds, which he called by names he had given them. Anthony was very handsome. Those two old people were an inseparable pair, who barely needed to speak to each other, they knew each other so well "sous toutes les coutures" [in every aspect], as Dorothy had told me in French.

We arrived there before noon, bringing flowers, chocolates, and wine. We would go shopping on the island – Dorothy still drove her car – if need be. I had offered to cook lunch. Anthony would not allow it. He would make the meal, he was the one who knew his kitchen and his stove. He was the one who would decide the menu. I remember a delicious omelette with bacon and potatoes, just like the old French Canadians used to make. We ate it with a red wine Dorothy had brought.

We talked. About their lives, mostly. And about mine when they asked me questions. They talked about the "two Canadas," English and French. Both of them said they deplored the Conquest. Anthony had been a union activist and a Communist in his youth. He looked back on all that now from the vantage point of his eighty years. And from the distance provided by the poetry he had begun to write a decade ago. He read us a poem that was like a manifesto, but loving. And the two of them sang me protest songs from their activist years. They wanted to take a nap after lunch. I did the dishes, cleaned the counter, tidied up, and swept.

I went walking in the thick ancient forest, which had many cleared trails. I listened to a symphony of birds, stroked the trees, breathed in the smell of the leaves and the humus, and ambled along on the soft carpet of moss. I sat down on an old bench and wrote.

When I returned, the two of them were snoring in their rocking chairs, the wine having no doubt deepened their slumber. I felt like a newly adopted daughter in the house. I was the newcomer from a distant province, and in just a day, my roots made of poems had intertwined with theirs.

London–
Edinburgh–
Dublin

A storm is raging outside, pounding my frosty windows. We are in the depths of winter, in that shortest month that nevertheless seems the longest. Endless February that blinds us on every side: last summer is no longer to be seen and next summer is not yet in sight. We are in the boreal darkness of the infinite whiteness of that snow whose squalls block all horizons. February 2012 in Montreal. Time freezes and I write the times past of my own life. Why?

Time freezes, but the time of dreams is in constant motion. The time of dreams shifts and moves around, the time of dreams is without borders, it knows neither years nor weeks, its day may be dark and its night may be bright. The time of dreams dances and snorts as in fairy tales.

Last night in this stormy February, in a dream that dissolved at waking when I started to think about it, I was taken back to that time of unsettling new freedom and a horizon so open that I could no longer see the lines of the roads ahead. With the threatening wind striking my windows, I was projected exactly thirty years back.

I had just left UQAM, I was free as a bird, and I was beginning to know what it was like to be poor. I was in my early forties and I wasn't overly concerned about it. Toward mid-November, the secretary of the Union des écrivains du Québec [UNEQ, the Quebec writers' union] called and asked if I would be interested in a European tour. I would leave in February. I would give readings and talks on Quebec literature in England, Scotland, and the Republic of Ireland, then Spain, and finally, France. The trip would last three months. UNEQ was organizing the whole thing:

purchasing airplane and train tickets, choosing hotels, drawing up the itinerary, selecting the places where I would talk and the people who would host me and act as my guides in each city. In addition, I would receive a payment for each presentation. Everything was generously subsidized by the Canadian Department of Foreign Affairs. How could I refuse such an invitation? I said yes right away, and with delight. But why had this offer been made to me? I asked. "We discussed it," answered Jean-Yves Collette, "and your name came to mind. We think you're an excellent candidate." I couldn't get over it. In retrospect, I still think it was truly miraculous. Those were the days.

(I sometimes think that the generation of young writers is right to be angry about how little support they receive from funding organizations for their creative work. Except that they sometimes go after the wrong targets. It is not the artists and intellectuals who benefited from the generosity of yesteryear that they should be angry with. We couldn't have predicted the current disaster. And had we been able to predict it, should we have deprived ourselves and bemoaned what would happen to young people a few decades later? Our collective sacrifice would have been in vain. Besides, we fought valiantly to obtain the small amount of funding then allocated to culture. We can only show solidarity with the youth today who feel they are being unfairly treated by a caste whose greed is gargantuan and which is accumulating indescribable riches and assets beyond all comprehension. The disparities between the few rich and the many poor have created such a gulf that the future promises to be a vast field of desolation. An era of suffering and ruin, unless something is done before it's too late. That is, soon. Those frustrated young people, many of whom are dear to me, must at all costs, with solid social and historical analysis, convert their outrage into revolt. And revolt into revolution. Into non-violent action. Without war. Without rape. And without bloodshed.)

And so I left on a cultural mission in early February 1983. I arrived in London. Colin Hicks, from the Quebec delegation in London, welcomed me. An affable man, open to Quebec, its culture, and its literature, he ensured that my stay was pleasant.

I was put up in a huge hotel in Piccadilly Circus, a little city within the immense city of London, distributed over several storeys, where the

hallways were filled with the aromas of Indian and Pakistani cooking. Some of the guests had converted their rooms into private residences. They lived there and ate there. I encountered some of them around the elevators, with their dark complexions and hurried air; they seemed to be constantly running to get to the bustling city where they worked. From my room, I would also hear babies crying and children whining. I was downtown, within walking distance of what I wanted to visit – essentially, streets and people, the Thames, and a single museum, the National Gallery. I would go back to my room after eating, to write, read, and sleep, dreaming to the sounds of the teeming city. Sometimes the chambermaids, who were all Black, would knock discreetly on my door to tidy up or bring me a tray with tea and cookies. We would talk a little, not wanting to bother each other.

At the Alliance française in London, I gave a lecture on Quebec literature and a reading of a few contemporary poets: Saint-Denys Garneau, Claude Gauvreau, Anne Hébert, Gaston Miron, Jacques Brault, Josée Yvon, and Geneviève Amyot. They wanted me to read some of my own texts, which I did with pleasure. There were other lectures and readings the following week at the University of Reading, where I went by train and was welcomed by a few professors, who took me for a beer at a pub. I was housed on campus in a beautiful residence reserved for visiting professors, a newly restored old building, where the muses of history accompanied my pages of writing and my sleep.

In Reading, a professor from France asked to meet me, and she came to my room after sending me a note. She had heard me the evening before at a reading and discussion, and she brought me a gift. She was the sister of Serge Doubrovsky, whom I had not yet read. Her name was Janine and she taught French literature at Reading. She was holding in her hands, like a treasure, the book *Fils* by her brother Serge, whom she loved, and she gave it to me affectionately, signed by her to me (that book has disappeared from my library, no doubt snitched, like a few others, or loaned and never returned). She had an admiration and an affection for her brother such as I have rarely seen – and when you read Doubrovsky, you understand why. I read *Fils* during that trip and I loved it. After that, I read practically all his books. I'm sure he is

the writer who sowed in me the first seeds of my autobiography. Serge Doubrovsky and Michel Leiris and Roger Laporte and Gabrielle Roy will remain my most cherished autobiographical models.

Doubrovsky called his books *autofictions*, a term he was the first to use, and which was later misused and applied to anything and everything. It was gutted of its original true and accurate meaning, which was that all autobiography is permeated with fiction. And all writing of fiction, especially the novel, is dependent on the life that feeds it. Recently, the term *autofiction* has shifted to refer to writing by women that talks about their bodies, their sex lives, and the emotional experiences that have given rise to their first literary travails.

I can never thank Janine Doubrovsky enough for leading me to the clearing where I found the long path that led me to this book I am now writing. We even corresponded after my visit to Reading. And then, as happens so often in life, our encounter faded with time.

After Reading, I took the train to Scotland, to Edinburgh, where I was welcomed by the great professor Ian Lockerbie and his no less wonderful wife, Rowena. I remember green grasslands in the shadow-dappled light in the countryside of England and Scotland. I remember chestnut-brown fields, cream-coloured cows, and endless sheep. Glued to the train window, I described everything I saw and wrote down the names of the towns and villages as we passed through the stations. From Reading to Edinburgh, to the rhythm of the train on the rails, I never stopped writing. I was in a foreign land in the train of my childhood, propelled by the conversations with the sister and the writing of the brother, the two Doubrovskys. I was inspired, happy.

In Edinburgh, I was housed in the Lockerbies' big beautiful house. Typical of the red-brick houses of the eighteenth century, in a luxurious residential neighbourhood that reminded me of upper Westmount. I was in a home away from home. There were many rooms, all large – even the bathroom was bigger than the living room in my house. Every room, including the bathroom, had a big fireplace. We had hot water bottles,

ELSEWHERE IF I'M THERE

as I discovered the first night when I pulled back the comforter and linen sheets of the compact bed. My bedroom was huge, with a solid wood desk, inviting for work. And I did spend all my spare time there, writing. The house was often chilly and damp, you could feel that it hadn't gotten any sun in centuries, but had been washed in rain and drizzle and often cloaked in the mist and fog from the North Sea. So we wore woollens, lit fires, and put draft stoppers in front of the cracks under the doors to hold the warmth in the rooms.

I don't remember my lecture anymore. I must have talked about Quebec literature, as usual. About poetry mainly, which was the mission assigned to me. And I must have read. Just now, I recall that Ian had done translations of a few of my texts. We read the two versions together for the audience. Ian taught French literature at the University of Edinburgh. He had long been interested in the French-language literatures of Canada. I saw him and Rowena once again after that. He had been invited to teach at McGill University for a session and I had them over to my place.

I also remember a big dinner party they gave in my honour. Around the long rectangular table that evening were scholars, professors of French-language literature, including Quebec literature, which seemed to fascinate everyone. And Acadian literature, because of Antonine Maillet and her *Pélagie-la-Charrette* being awarded the Prix Goncourt – they had hosted her the year before. The meal was delicious. Rowena was an excellent cook, and Ian, a good sommelier. After the meal, we moved to the living room, around the majestic brick fireplace sooty with time. Ian had prepared a tasting of fine Scotch whiskies, accompanied by a veritable lesson on the drink. He could tell what river the water used in making it had come from, the bedrock, and the depth of the water. We talked until late into the night over four different Scotches, with Ian expounding knowledgably on each one even before it touched his lips, just breathing it in. Everyone was smoking, cigars or cigarettes and even a pipe for one member of the group – it was a time when the clean air, with no disastrous holes in the ozone layer, still allowed us these long evenings that were filled with pure smoke, if I may say so, and were so festive.

When our work was finished, Ian, who had arranged for a free day, took me to visit the northern region of the Grampian Mountains, with

its rivers – where the water for the Scotch came from – and its mountain lakes, so mysterious that you couldn't help thinking you saw the Loch Ness monster through the mist and clouds. We saw ruined castles, their broken walls dating from long-ago wars. Ian was an excellent teacher of history and geography, so good that he effortlessly made fabulous stories of his explanations. He could pick up a brick, a pebble, or a shard of glass, hold it carefully in his hand, study it as if it were an ancient manuscript, tell you if it was Celtic or Roman, and dream the century and the historical event that had brought it to this remote trail in the northern mountains not far from the Caledonian Canal with its two mouths: in the north, the bay of the Moray Firth in the North Sea, and in the south, the bay of the Firth of Lorn in the Atlantic. Ian could talk about the legends and literature of Scotland, about King Artus and Macbeth, William the Conqueror and William I. And about the memories of the Gaelic language in his literary Scottish English, which also had roots in Latin, Saxon, and Norman.

We talked about Scotland and Quebec. About their relationship with the British Empire. About the infinite variations of each of our cultures and where they met, often, through the twists and turns of our respective histories. I hope I was able to give the Scots I met, professors, writers, and students, if not as much as they gave me, at least some of what I had come to communicate to them: the desire to know a little more about my people's history and literature from their beginning in New France in the seventeenth century.

From Edinburgh, I took the plane to Dublin. I had never physically been in Ireland, but I knew that country much better than those of the United Kingdom. I had become familiar with it through its writers, especially, and through its history, mythology, and music. From reading Yeats, Joyce, and Beckett, I had gained a complex and engaging image of the people and the land. My inner Ireland extended as far as my own French-Canadian land, dominated by the same British Empire, with its war-making and its pomp and ceremony, and by the same Roman

Catholic Church, an alienating institution with respect to the private and sexual lives of its flocks, but also a site of centuries-long resistance to the dominant royal and Anglican empire.

I also had a private knowledge of Ireland because of the Irish ancestry of my sons, through their father. Charles Patrick and Sean Christophe were educated in French in Quebec but carry within them a dual culture. They are bilingual, and have had the good fortune of never being shipwrecked on the shoals of franglais, in the land of "desperanto." When Charles, in his early twenties, wrote a book of poetry, *Profils*, self-published with the help of his friends, Plateau-Mont-Royal poets, I of course read it with great interest, and I observed with joy – which I expressed to him – that it showed a rich imagination that seemed to draw naturally on two linguistic worlds. It had poetic resonances that, without there being any question of plagiarism, brought into a single metaphorical field the heritage of a Nelligan and that of his mother. I was fascinated. It is true that my mother, a Beaulieu dit Hudon, was descended from Émile Nelligan's mother. I thus had a strong emotional investment in Ireland.

All the more so because through my sons' father, I had made many Irish friends, in Paris, Provence, New York, or Montreal. They called themselves second-generation Irish Americans. Those I knew were highly educated and seemed to have a gift for languages and literature. There was eloquence and lyricism in their speech. It was as if they had learned language at an early age with two playmates: rhetoric and poetics. As for French, which some of them spoke elegantly, they had learned it in university or in their travels, with real experts on French literature. No one in the United States had forced these young people to learn a second or third language in primary school. It was in college or university that this linguistic education was given. So none of them had learned to jabber in franglais.

I also had had the good fortune of having parents-in-law who were both born in Ireland and had come to the United States during the Great Depression, which, like that of today, affected the entire West. I mention them again to describe the state of mind I was in before I landed in Dublin. On the plane, I remembered and wrote down some

of the Shakespearean sonnets my mother-in-law, poor and with little education, would recite at fourteen years of age while tending the cows in County Cork, where she was born. I never tired of hearing them in her lilting voice and Gaelic accent and would often ask for an encore. Her English was beautiful. It came out of great poetry. That's the only real way to learn any language, by reciting poems, great poems, because poetry is the soul and breath of a language. My expectations were high as I approached Ireland.

The man sent by the University of Dublin French department to meet me at the airport and take me to my hotel spoke with an accent unlike any English I knew, and he spoke fast. I had trouble understanding what he said. He didn't pay much attention to me and kept his eyes fixed on the road. And he smelled of alcohol. I was looking at everything, wanting to devour all of Dublin with my eyes on the drive from the airport to my hotel downtown.

My driver left me, bag and baggage, in the lobby of the little hotel, which seemed pleasant. I had finally understood that there were no activities planned for me, since the University of Dublin was on strike, as were all the affiliated colleges where I was to have read and spoken. Everything was closed, paralyzed by a labour conflict, the issues of which I knew nothing about. There would surely be a message at the reception desk, my taciturn escort had said. There goes my much-awaited encounter with Ireland, I said to myself as I entered my room, which was clean, silent, and gloomy, with a big writing table at the window. I felt like I was in a convent.

During the four days of my stay in Dublin, no message was left for me at the reception desk and I saw no one. I stayed out all day and explored Dublin, going wherever my imagination, my feet, and my eyes led me. On the first morning, I went to the university campus. Everything was closed. No picket lines, no placards or banners. No human beings in the vicinity. It was dead as could be. Where were the strikers? I never found out. No doubt in their houses or, better yet, in the many pubs all around, no way to know. I bought a newspaper or two. Nothing on the strike. No demonstrations in the streets either. I went back to the hotel. Not a word there either.

I understood then that I would be alone in Dublin and that I would discover a part of my Ireland on my own. Every morning, I got up early, and every day, I walked, criss-crossing the city in every direction. I saw only one church and didn't go to any museums. Nor a tourist bureau. I saw the streets, the neighbourhoods, and the people. There were always crowds of people walking in groups, talking loudly, laughing and singing, and men who were often drunk, alone, walking fast, chuckling, looking me in the eye, telling me bits of stories I didn't understand. I went to the open-air market in the lower town, where fat wives in aprons and ruddy-faced husbands, cigarettes dangling from their mouths, shouted their wares of meat and fish, fruits and vegetables. I listened to the symphony, surprised to find that the general atmosphere under that morning's sun took me back to Provence. From that moment on, I considered Ireland a branch of the Mediterranean that had become detached from the European continent millennia ago. And its inhabitants, so many refugees who no longer remembered where they came from – hence their ease in moving between languages, from Gaelic to English in the modern era as once they had done between Celtic and Latin; hence also their affinity for poetry, the perfect vehicle for absence and lost paradise, but also for epiphanies, as their genius Joyce said.

At noon, I would eat in a pub. How can you know Ireland if you don't get to know its pubs? I witnessed in daytime abuses and excesses of alcohol that we see at home only in the small hours of the night. I listened to their music and their songs. Sometimes someone would stand up and read out loud a passage from a book he loved. Then, returning to his beer, he would drink to anyone and everyone and sit down and absorb himself in his book again. And from the back of the room, another would stand up and recite a poem.

One day, wanting to see the Irish Sea, I ordered a taxi at the hotel, which took me to Baile Átha Cliath, a part of town where I could see it and, in a stream the driver knew, I touched the water. The cabbie and I barely spoke. He sang. I listened and I looked. I was sitting in front to see better. In the mist that afternoon, the place was soft and silent, like us. The driver took me back to the hotel. I asked the price of the journey. It was almost nothing. I left a generous tip. I saw his eyes laughing for the

first time. I said thank you in my language, and he, in his. I didn't know if it was English or Gaelic or a mixture of the two.

Every evening, I would return early – in strange cities, I never go out alone in the evening, men are lucky – and would have supper in my room, as the hotel had proposed, which I liked. My tray would arrive at about seven, always with the same menu: little sandwiches of cold meat and cheese on white bread, cut in triangles, like the ones my mother would make for the picnics of my childhood when we went to swim in Lake Matapédia in the afternoon. There would be a huge teapot on the tray along with a plate of cookies. The second morning, I asked for some fruit and vegetables. The next day, there was an apple on my tray, and the day after that, a carrot. I would eat with the television on for company. After that, I would write. I would get ready for bed. And I would read until I fell asleep.

On my fourth day in Dublin, I received a call from the professor in charge of my visit to Cork, Michel Martiny, who would pick me up at the airport of that city in the south. I was to read and speak at the university, where he taught French literature. I was to stay with him and his wife, Lisbeth. Accustomed to my solitude, I was a little disappointed to learn that we would be in close proximity in a single modest house. I generally don't like to stay in other people's homes. I made the best of it, and even convinced myself of the advantages of experiencing this country from the inside and seeing the habits and customs of a foreign household. And everything went well. Lisbeth and Michel were a charming couple. Everything in their house was calm and tidy. They had a little garden with a few shrubs where I could hear the birds singing in the morning. Birds know no borders, their songs are the same from one country to the next. They have one great mission on earth, that of uniting human migrants.

Michel introduced me to professors, students, and a few writers he knew, whose names I don't recall now. I fulfilled my task as ambassador of Quebec literature. They talked to me about theirs. We told each other stories of our remarkable peoples, both subjugated by the same colonial empire but having taken different paths, with them recently freed from the trusteeship of London and now independent, to their great good

fortune, and us still subject to the Dominion of the English Crown. My new friends in Cork couldn't get over it – and neither could I.

In addition to small seminars, which were informal and full of human warmth, a lecture had been planned for me in the big auditorium of the university on the last evening of my stay. In fact, it was supposed to be the highlight of my visit. Michel and I went there an hour before to see the professors' offices and get the feel of the place. At the appointed time, we went to the auditorium, where, to our astonishment, there wasn't a soul in sight. Michel, incredulous, walked all around the hall and then through the corridors. He came back and said nervously, "Not a soul! But that's impossible!"

We waited a good hour, I would say. He was beside himself. At first bitter and angry (at his students and his colleagues, and at himself, no doubt), he then became dejected. He didn't say anything more to me. I think he was ashamed. Ashamed for himself, whose preparatory work had not been recognized, and for me, his guest from far away, whose presence had not been honoured. I felt it in his silence and his defeated air, and the way he averted his eyes and no longer dared look at me. I suggested that we leave the university and go to a pub, I didn't really know where, but somewhere we could get our minds off things. He didn't want to go to a pub, and even less to go home. He just said, "If you like, I'll take you for a walk."

We set out for the hills of Cork. On little rocky paths, we walked, climbed, and walked some more. He scarcely spoke. At one point, I saw he was on the verge of tears. His heart was filled with anger and shame. It wasn't for me to open it up even a little to let out the bottled-up feelings. In the opaque darkness with the sparkle of the stars and the lights of the city, I walked beside him in my own silence. I was sure he would have preferred to be alone. But he did his duty to the bitter end and accompanied me on that sombre trek.

I was cold after those hours of wandering. At home, Lisbeth was waiting for us, worried. She didn't understand what had happened any more than we did. I remember mulled wine with cinnamon and sweet buns hot from the oven. I remember that everything melted in my mouth. And that the three of us talked by the fireplace far into the night.

In the airplane that took me back to Dublin, and then to Madrid, I sang to myself, but in the negative, a song by Gilles Vigneault. After so many dreams in which I had magnified Ireland, I was hearing in my head, "Tell me you didn't see Ireland." It seemed to me that Ireland went hand-in-hand with madness. (Recently when reading the very moving autobiography by the Irish author Nuala O'Faolain, *Are You Somebody? The Accidental Memoir of a Dublin Woman*, I gained a more intimate understanding of that general madness made up of alcoholism, violence, sexual frustration, political and economic misery, and genius. Reconciled, I would be ready to return there.)

Two weeks after leaving Cork, I received a letter from Michel Martiny, sent through a Canadian diplomatic pouch. He said that on the posters put up all around the university, my lecture had been announced for the following week, same time, same place. Dozens of people had waited in vain in the auditorium and had been extremely disappointed.

Madrid–
Barcelona

I didn't know Spain. I had crossed it in 1976, from France to Portugal, going through the Basque country and the arid plains in the north. My memory of it was of extreme dry heat, where there wasn't a living soul for kilometres, or even a cheap café where you could quench your thirst. In my mind, Spain was a desert. I couldn't imagine it otherwise. Countries are like people, or like books. Each one has its time. Its time to be known. Otherwise, they often show us only images or attitudes that make us want to flee them and be on our way.

In the spring of 1983, I discovered a Spain that I loved. Landing in Madrid, it felt good to go from the northern mists to the southern sun! At the airport, I saw a man about my age, elegantly dressed, holding one soft leather glove while wearing the other – which seemed to me the height of style – hurrying to embrace me, all smiles. It was Émile Martel, the cultural attaché at the Canadian embassy in Madrid. A person dressed for a special occasion who favours you with such a welcome reconciles you with the entire world in an instant. Waiting for my baggage at the carousel, we chatted as if we'd known each other forever. It's often that way when you meet a compatriot abroad, especially when they have a job or profession related to something dear to you, in this case literature and writing. I basked in the double warmth: of the welcome and of the sun.

I stayed with Émile and his wife, Nicole Perron. In the big official residence they occupied in Madrid, there was a suite with a bedroom and a sitting room where I could easily be alone to write, listen to music, or watch television. I was in their home, but at the same time I had a place of my own. They received me like a queen: great meals cooked by Nicole, fine wines too, animated conversations and fascinating outings to bookstores, art galleries, museums, and flea markets. An ornamental ceramic dating from the sixteenth century and a huge piece of pottery

with a handle and spout and covered with an immaculate white glaze have followed me through journeys and moves to this day. They are two pieces of Spain, both in my kitchen, that remind me of a magnificent visit.

There was also an embassy car with a driver available to me. I didn't abuse the privilege. I only gave one talk in Madrid, at the faculty of literature of the University of Madrid. Nicole and Émile went with me. We were greeted by the dean, accompanied by a few professors, and he conducted us to a packed auditorium, where hundreds of students, all in Romance languages and French literature, were already waiting for us.

I spoke at length: about the literary history of New France and the general history of the Canadiens, as the inhabitants of North America of French origin were called at the time. Not yet French Canadians, as we were called when the descendants of the English conquerors appropriated the term *Canadian* for themselves, and even less Québécois, which would come later with the Quiet Revolution, which I also spoke about. I remember talking about the first accounts of the French explorers and missionaries. About the first stories, written in the nineteenth century. About the first great historical novel, *Les anciens Canadiens*. About the first epic poetry, still in the nineteenth century. About the effects of the Conquest, which were evident in our literature of that time. About the traces of our first history of Canada, written by François-Xavier Garneau in the mid-nineteenth century, in the novels and stories that followed. About our entry into modernity. I quoted Nelligan. About the novels of the soil. About the first urban novels. I went back to the *Refus global* of the Automatistes. I distinguished them from the Surrealists, although they were related. I spoke of Claude Gauvreau and Anne Hébert, those two contemporaries who essentially gave birth to our modern literature. I read excerpts from those two pioneers. Then I talked about my close contemporaries, novelists, poets, and non-fiction writers. I didn't want to list them all, I would have lost my audience.

Finally, I talked about my own books, about my conception of literature and writing. And I read from a few of my works. I wanted to show them that Quebec literature was rich and plentiful and that there was a publishing infrastructure and funding bodies to keep

it alive. There were a lot of questions. Serious, friendly exchanges. The dean came on stage at the end and made closing remarks and gave me a gift, another thing that has followed me in all my bookshelves: *Don Quixote*, by Cervantes, in a leather-bound edition with gilt edges and 356 engravings by Gustave Doré.

Shortly after that, Émile and Nicole took me to Cuenca, a small city in the Serranía de Cuenca mountain range not far from Madrid, which reminded me of Les Baux-de-Provence because of the way it was built into the rock, where we saw the most beautiful little museum in the world – the Museo de Arte Abstracto Español. Entirely dedicated to contemporary Spanish abstract painting, built high on the rocks, with windows like so many paintings setting off the works of Tàpies, Sempere, Viladecans, and others in a marvellous ceremony for the eye in the imposing silence of the place. I've always wanted to go back to that museum, which I think of daily when I look quietly at the Viladecans engraving, with its blues, its blacks, and its green, of which I saw the original oil painting. I have gone back to it often in writing. Many of my poems from the 1980s include memory traces of it.

After Madrid, there was Barcelona, where Jean Fredette, an art lover, who was also from the Canadian embassy, and who became a friend, was waiting for me. He was my guide throughout my stay in Catalonia. Together we visited the many beauties of Barcelona. I fell in love with that city – a passion that will never be diminished by separation. I will always love Barcelona.

We stayed in a pleasant inn in the centre of the city. From my window, I could see Gaudí's strange, majestic church, the Sagrada Família; I say strange, because it is as if Gaudí had been able to conceive of our terrestrial links with the God of the Holy Family only through crazy sculptural curves and architectural labyrinths made up of endless enigmas. In fact, this sacred work is still being finished. The Sagrada Família is a startling, all-too-human analysis of an interminable discourse of the deity.

Jean Fredette took me everywhere in Barcelona – literary cafés, where I read and met artists, including Joàn Pujold, a friend since that day; galleries and museums; an opera, which we attended with representatives of the Catalan government in the box of the mayor of Barcelona; the

Museu d'Art Contemporani, where we feasted on works by Picasso and Miró, and more by Tàpies. Tàpies, who died not long before I wrote these lines. I love his paintings so much; they have a place in my inner heaven beside those of Rothko, Soulages, and Borduas. We walked the famous La Rambla as far as the old port on the Mediterranean, where I was able to touch those waters again. We went to the country, to Tarrasa if memory serves, with friends of Jean's, to a garden where we tasted *calçots*, giant braised shallots, which were served on equally giant terra cotta tiles, and which we swallowed after dripping them in a sauce, with bibs around our necks and our heads bent back like herons sliding smelts or sardines down their throats.

The day after I gave my lecture at the University of Barcelona, the front page of all the daily papers talked about Quebec, its literature, and its representative. In the warmth of that journalistic reception, I understood how important our country-in-becoming was for the Catalans and for their Catalonia, a province with a desire for independence from the Castilian majority. They spoke of our province of Quebec as a model to be followed in language and culture. And yet, we had just lost our first referendum, in 1980. And yet, the Catalans had so much to teach us. I felt ignorant next to them. That people inspired me, and as little as I know about them, the Catalans give me a better understanding of what it means to be a minority that for centuries has been developing under the domination of a majority.

Toulouse

After Spain, France was a very different story. In theory, according to the itinerary, I was expected in two cities, Toulouse and Bordeaux. In Toulouse, no one met me when I arrived by train. At the reception desk of the hotel, there was a terse note with an illegible signature that said more or less this: Get settled, I will come by to meet you tomorrow. No one came the next day, nor the day after.

I spent three days wandering around Toulouse, a city I didn't know, and that I discovered under a sun that made its pink more pink. I saw its Canal du Midi – which I saw again on subsequent visits, tinged with the dark green of the surrounding vegetation – silver in daytime, then golden at dusk, that first time, when all I had to do was stroll around under the sun. I would walk all day, stopping at bistros to eat and write.

I saw a wonder that took my breath away and lifted my soul, the Jacobin convent. I kept studying the details, stepping back a bit, then moving closer again, walking around the cloister and its little gardens, then going inside again into the round, empty nave where the pink and beige and ochre tones of the bricks in the purity of their Romanesque lines are both austerity and exuberance, a lively orchestra of colours and solitude in total silence. I was alone in the Jacobin that afternoon.

I know, I could have gone to the Basilica of Saint-Sernin, another masterpiece close by. But too much beauty can kill – that's a metaphor, I know very well – and I didn't go. In those fragile moments, I relived the great aesthetic shock I had experienced on seeing the Corinth Canal, the Parthenon in Athens, or the Sainte-Chapelle in Paris. I had promised myself I would go browse in bookstores, but that would have spoiled the pleasure of my day. So I walked back to my hotel. I slept, daydreamed, and wrote until it was time for dinner, when I went to an excellent restaurant. I remember a veal chop with chanterelles and a lemon cream sauce, accompanied by a Cahors that was just as nice.

I spent my days like this, wandering through that unexpected vacation. But I did go to one bookstore, which was beautiful and well stocked – it was Ombres Blanches, I believe. As I expected – it's always like that in France – there were no books from Quebec. Not one. *Nada. Nichts.* If I had been a blowhard from back home, a man given to violent or pompous tirades, I would have alerted the customers and staff. I didn't even introduce myself. I just went out for a breath of air.

All Quebec writers, publishers, and book distributors have observed this absence and this lack of respect. Contemporary Quebec literature is just as rich and valuable as its French counterpart. It's just that the French literary world doesn't know it. Doesn't want to know. This phenomenon has been analyzed from every angle. But perhaps not analyzed enough; otherwise, in the half century that we've been knocking ourselves out making this observation, things would have started to change.

(It is with poets and poetry that exchanges take place and there's mutual recognition. The *marchés de la poésie* [poetry markets] in Paris and Montreal and the few poetry festivals, including the biggest one in Trois-Rivières, are proof of this. Other than that, in France and the francophone literary world that drinks from that source, our literature does not exist. Fortunately, there is the Quebec bookstore on Rue Gay-Lussac in Paris.)

After Toulouse, I took the train to Bordeaux. I love the train, and I loved crossing the countryside of the Garonne region by train. We headed toward Arcachon Bay on the Gironde coast and the Atlantic, and I swear I could smell it.

As for my literary mission, I felt it would be just as roving as that of Toulouse – and it was, with one exception. The same treatment when I arrived at the hotel: a message from an unknown person saying, "Welcome, I'll come by again." Of course, I never saw this person, just as I didn't meet any writers, professors, or critics, and I won't even mention readers. But there were instructions at the end of the message: I was to report the next day to the "Seniors' University" at the University of Bordeaux. Yes, "seniors," I had read it correctly.

I went there at the time indicated and found myself in a classroom packed with old people, men and women, all attentive, smiling, and

impeccably dressed, who must have been from the upper crust of Bordeaux society, no doubt ultra-Catholics – I had read Mauriac in college. I introduced myself, and, as I generally do when I teach, I took a little survey. Sure enough, I had before me a group of retired high-ranking officers from the French army and their wives. They had done Indochina and Algeria and a few skirmishes in the colonies in the Pacific or the West Indies. They knew Canada, and they knew that Frenchmen had settled there before the conquest by the British Empire and that they had often married "Indian women converted by the missionaries." I found my old generals and their wives charming. They wanted to know everything, to understand everything about what had become of the descendants of those French settlers of New France, a "young" representative of whom was there now in front of them in the flesh.

I had a wonderful time! Finally, I could talk about this subject that has always fascinated me, I mean since primary school, where our classes on the history of Canada and French Canada were important and many. I could talk to them about the beginnings of the history of my people in New France and the beginnings of their literature. For these people, whose old eyes were still shining, I went back to the source, or the sources, of my people's history. I talked about the Grande Noirceur and the dominant role of the Roman Catholic Church; about the *Refus global* and the Quiet Revolution. I named writers of each generation and read excerpts from a few of them. Then, since I was already in unfamiliar territory, I read some more challenging pieces: one by Claude Gauvreau, which I had practised out loud many times for its music, and one of mine, one of my first poems in *joual* – explaining to them what *joual* was, and about Frère Untel (Brother Anonymous), who had originated the term in his *Impertinences*, and how the term had come into use. The poem was a long lament. After I read it, one of the old generals stood up. With tears in his voice and in his eyes, he said, "You know, I understood it very well. My grandfather in rural Burgundy spoke just like that."

We spent three hours together. We talked. They invited me for a drink in their reception hall at the university, and I went. They served

me a Saint-Émilion and petits fours. They had everything prepared, "in case things went well," one of the wives with the petits fours told me.

I enjoyed myself the rest of my time in Bordeaux. I remember writing a little and walking a lot. I remember an elegant café by the river where I drew in my notebook. My work was done. I was going to take the train to Paris, stay with friends for a few days, and then return to Montreal. Perhaps that was why words abandoned me. And why I drew in my notebook until the end of the trip.

The End
of Love

 I hesitated for a long time before writing what follows. On my return to Montreal, as always, I came back to my loved ones with affection and contentment. I had been away for three months, and once again, I was made to pay dearly for it. By the man I loved, who had shared my life for three years. He had asked me to write him every day (don't forget that the Internet didn't exist then and that letters were the preferred means of communication with loved ones, as email is today). He had asked me to recount my trip to him in writing: the public activities, the friends and new acquaintances, the cities and villages, the landscapes, and my immediate impressions. Which I did with pleasure every day. What writer would refuse such an invitation? I wrote long letters that were actually more detailed than my travel journal. Going to the post office wherever I was became both a task and a pleasure.

 A few days after my return, I experienced a terrible scene that I will never forget. I remember we were both in the living room–dining room and we were talking. There was no argument or even acrimonious discussion. Suddenly, he stood up like an automaton, went to another room, and came back with the pile of my letters – a veritable book. He pulled off the elastic around them and started to tear them up one by one, systematically. He was standing, absorbed in his task. His gaze was vacant. I watched the dozens of tiny bits of paper fall to the floor and I watched that human shredder zealously destroying my writings. I was in a state of shock, not wanting to believe what I was seeing, and I was struck dumb, as if catatonic. Then I heard myself shouting "No!" and I rushed out of the house and ran madly down Chabot Street without knowing where I was going, ending up in De Lorimier Park, crying my eyes out. I said to myself, "There are shelters for battered women, but no place of refuge for those whose writings have

been torn to pieces." I had a flash of realization that I would leave that man one day, though it might take a long time – which it did.

Alone, I shouldered my emotional burden and entered the phase of the end of love. You don't learn that in any school, you have to experience it in a painful conscious inner solitude. The end of love means retracing your steps on a path that was once filled with delights and reliving them one by one in the light of lucidity, seeing the bucolic field changed into an arid trail through thorn bushes in a huge "vale of tears," as the Bible said of the entire earth.

You have to take the time. To move forward courageously, especially if you have loved madly.

RETURN TO THE SOURCE

The wind is rising! . . . We must try to live!

– Paul Valéry

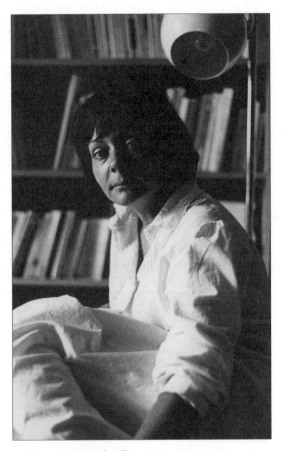

Madeleine in the study of her apartment on
Rue du Parc-Lafontaine, 1976.
Photo Claire Lejeune

Vertigo

At the ceiling of a huge empty hall that might be a gymnasium or a columbarium, there is a metal beam running the entire length of the room. I am lying on the beam and I have to go all the way along it to the end, or else I will die there. The beam is no wider than my body. I have to creep forward like a snake. I can't look down at the floor far below or I'll fall. I have vertigo. I always get vertigo, but the risk of losing my balance is increased because of that empty space, because of the height and the narrowness of the beam. I advance laboriously. One false move and I'll fall to the ground. And because the ground is infinitely far away, I'll be dead as soon as I touch it. In any case, I cannot risk even a glance at the floor. Anyone who suffers from absolute vertigo knows what I'm talking about. You can't play with the void in such a position.

My eyes must be totally focused on a single point on the wall ahead of me. The end of the beam and of this impossible journey, which is torture. I cannot even tell myself what I've just written. If I think, I'll fall. I just have to go on. To continue my reptilian advance, using my right arm in front of me as a long antenna, giving a first push without any sudden movements, with a barely perceptible motion like a fish gliding silently, while the hand at the end of my antenna feels the beam, guiding the rest of me, with my consciousness inside. All the courage I need is in that hand. The hand knows it will be first to touch the wall ahead. The hand knows it will close its fingers around the hook the stealthy eye thought it glimpsed there. The journey seems endless. I must go on, I tell myself softly. Trust the hand that will grab hold, and the whole body will follow.

Between the fear of a deadly fall and practically blind trust in the hand moving ahead of my body, I woke up with aching muscles. My whole right side, the side that was guiding my movement, hurt, from my neck

and shoulder to my hand and down my whole body to my heel. The right side, my more fragile side since my car accident – whiplash – in 1971.

It's 2012 and I've had this dream. About to start a chapter that's scaring me stiff, so I had this dream. I got out of bed still feeling the effects of the vertigo and my fight for survival. I made myself a cup of warm milk with honey – my favourite remedy for restless nights – and I knew I was going to go back to the book (and back to bed too) and finally begin this frightening chapter. That was a month ago. Which shows that I put off the terrifying thing as long as I could.

So here I am at the beginning of this "return to the source," a slice of life that takes me back to the land of my origin, to Rimouski, where I was invited to teach in the literature department of the Université du Québec à Rimouski, UQAR, in extraordinary material conditions – thank you, Renald Bérubé, thank you, Hélène Tremblay, thank you, Marc-André Dionne. Rimouski, where I was supposed to stay for one year as a visiting professor, and where I finally lived for five full years that were both wonderful and challenging – I will tell why. Rimouski, the gateway to the Matapédia Valley, my valley, at the centre of which is Amqui, my town, my village for always.

Rimouski, very close to Amqui and to my parents, Jeanne and Jean-Baptiste, who were still alive and still living in their big house by the river, alone, and as always, generously hosting a thousand visitors: children, grandchildren, extended family, and friends. Amqui, where Jeanne and Jean-Baptiste would soon be saying goodbye to the big house, and then the seniors' residence Les Pignons, then the long-term care centre in the hospital. Then, the final days of each of them. Then, their deaths, exactly one year apart, December 30, 1996, for Maman, and December 30, 1997, for Papa, at the same time of day, in the early evening.

They were still alive when I arrived in Rimouski in 1990, both with their difficulties of the end of life, which was normal if I may say so, in their natural living environment, surrounded by family and friends, loved ones they had known from the cradle, those who were not yet "gone," as they would say about their dead, whose memory they cherished and whom they might greet when passing the houses where those absent ones had lived, or in the cemetery when a burial brought them

RETURN TO THE SOURCE

there. They would then make "the pilgrimage of the deceased," as my mother would say, to all the gravestones. And in their big house, familiar workers would come by to do repairs or their attentive neighbours would drop in, and Cécile would come every day. Cécile, whom they adored, who did everything for them, cooking, shopping, and a little cleaning, and especially, who devoted herself body and soul to them, who loved them. Cécile was paid for those everyday tasks. "I would have done it for nothing," she told me one day. "I loved them like my own parents, may they rest in peace!"

The worst came after that old age that my mother, quoting de Gaulle, described as a shipwreck. The worst came after her death, which left the way open for two Furies to pursue a shrunken Oedipus, to kidnap our father, who was in a state of "senile dementia," as the diagnosis described this ninety-year-old man, to snatch him from his hospital bed where he had been confined because he constantly wanted to escape and return to his house or his seigneury trail and because he tried to strike anyone who dared approach him with an avenging fist – except Cécile, the one he loved so much he wanted to take her with him to heaven, where Jeanne, the love of his life, was.

The worst was tearing the father away from his living environment, like uprooting an oak tree from its original soil to transplant it very far away in the asphalt of Montreal, where the two furious daughters lived. Torn away from his loved ones, from his fields and woods, which he could see from his hospital window, and thrown into an anonymous room where nothing was familiar, on Fleury Street in Montreal, where his only scenery was a brick wall, the wall of a bank, he sank into the hell of loneliness, strangeness, and loss of references, and there he truly became demented. It was a vertiginous slide down the icy wall of life, a life that did not, in fact, last much longer.

Uprooted, Jean-Baptiste experienced hell on earth during the last sad part of his life. He had lost even his Cécile, his final love, who served only to accompany him in the so-called assisted transport for the long journey of six hundred kilometres from Amqui to Montreal in a raging snowstorm, with him sitting in a little seat behind the driver, not knowing where he was being taken, his legs purple, Cécile said. She didn't know

that she would be unceremoniously fired as soon as they reached the fatal long-term care facility.

The vertigo at the beginning of this chapter came from there. It came from a fear that could not be named at the time, the fear of having to write this, this terrible end of my father's life. It took me years to understand a lot of things surrounding that tragedy, such as the dismissal of Cécile, who, unknown to her, must have been, after my mother, a barrier on the Oedipal path of the two Furies.

(I know that some people, even many, would prefer to turn the page, so to speak, not to analyze, not to think any more about these horrors strewn in this vale of tears. I know. I am not one of them. I need to understand. To analyze. To stir the blood-soaked soil until other seeds can be cast there. Until these seeds can sprout and yield their grains, bushes, and thickets, their trees and their flowers once again. I know. That I need not only to understand, but also to write about this. I would even say that understanding can only come through writing. That's how I am. Otherwise, I die and I burn. Otherwise, I crash to the ground, as from the beam in my nightmare.)

One might wonder, what was the reason for that fury on the part of the two eldest sisters of my family? Why that fit of rage, that madness that, according to Cicero, can even "befall a wise man"? And why none of the many siblings stopped them. Beware of perfect families, which ours was in everyone's eyes and our own. Under the cloak of perfection, invisible powers based on imperceptible kingdoms are established. These powers may be money or intellectual or physical superiority or any other attribute that is without too much thought judged irrefutable. With us, the original cloak of perfection was based on primogeniture, the legal foundation of which was the Bible and the law of the father, which was reiterated throughout childhood and for generations by the fathers and grandfathers of the paternal line. The ground is not necessarily prepared for such an appropriation and such a display of power in all families. In mine, it was. This produced amazing effects. Combined with the Oedipal burden of the two Furies, it had explosive results.

A long time before the kidnapping of Jean-Baptiste, they had come and taken possession of the bodies and the property of Jeanne and

Jean-Baptiste and dragged the two declining old people to the notary's office. They made them sign what they loudly called powers of attorney and mandates of property. By legal means, they took absolute power in every respect, medical and financial, over the persons of our two parents.

(People who believe they are immune to such abuses because they supposedly come from perfect families can close this book now. I am not writing for those who take pride in never having wanted to walk the subterranean corridors of the earth they were born from. The world is full of people who are not conscious.)

The kidnapping of Jean-Baptiste had begun with the notarial abduction three or four years earlier. Since I was in Rimouski, I had a front-row seat for the ghastly spectacle. As I was faithfully applying myself, as any loving daughter would have done, to the duties related to my parents' failing health, I was on the lookout for information and was trying to understand the complex workings of a health-care system that was in its infancy with respect to old people. Our parents, we mustn't forget, belonged to the first generation that would not grow old in their own homes with the help of daughters, or more rarely, sons, whose mission was to take care of them until their last breath. I had seen this with my maternal and paternal grandparents. Everyone my age is familiar with that way of ending one's days.

Things had changed. In the early 1990s, the system that would follow was not yet fully functional. There were no long-term care hospitals. People got by as best they could: staff in hospitals or local community service centres, children and friends of old people, volunteers on the margins of what has become a real (unpaid) occupation. We were all looking for solutions together. We tinkered. We invented. There, as everywhere, there were intelligent, resourceful individuals. And, as everywhere, some who were thoughtless and misguided. A complex system, the one we are familiar with today, was for better or for worse being put in place. With the joys and sorrows of the previously unheard-of end of life outside the family home.

The UQAR literature department had had the brilliant idea of assigning me a weekly course for what they called the Amqui cohort. (The university had established two cohorts on its huge territory, one for

Carleton and one for Amqui, to provide additional training for teachers, social workers, and nurses from these regions, who continued to work while studying. The university administration was absolutely correct in deciding it was more logical to have three or four professors move rather than dozens of students.) Consequently, I could stay over with my parents as long as they remained in the big house, crossing the valley once a week, rain or shine. I stayed in a hotel after they had to give up the house – which caused incredible dramas among the siblings. I could write a book on that alone. But before my parents' exodus to the hospital, how happy they were to see me arrive once a week, eat with them (and dear Cécile, who was a good cook), sleep in their house, and review my class preparation at the dining-room table! How often they told me that and showed it! I will never forget what a joy it was for them. And I sometimes would have liked to be from another century, to have no other ties and to become "the daughter at home" or "the staff of old age" for my parents. But I was of this century, and so many activities awaited me in Rimouski and elsewhere. I was travelling a lot in those years. Every time I left them, there was a drama. My mother would cry and my father would watch me from the window until I (well, my car and I) were a little speck on the horizon.

After a while, the health-care system held no more secrets for me. I knew the doctors and nurses and the operation of the hospital and the local community service centre, as well as the hospital in Rimouski, where you had to go when you needed to see a specialist or have surgery. Every time, I was there. And I would keep the rest of the family informed. I remember two notebooks filled with information – I still have them – one for Maman and the other for Papa.

I remember the day the two Furies came down to Amqui from Montreal, without telling me and without stopping in Rimouski, for the notarized powers of attorney whereby they took possession of the bodies of our parents. My world crumbled when I learned of that. I looked at my two health notebooks and wanted to destroy them. To burn them in the backyard of the little building where I lived on Rue Trépanier, in a magic ceremony to avert the evil spells. My good friend Hélène, who knew just about everything about the family history – and who loved

my parents like her own – saw my notebooks in my hands ready for the macabre ceremony and said, "Don't burn your notebooks. Keep them. You don't know what they could give you one day." They are here in a box that I never open. They are here beside Maman's little honeymoon bag containing a few of her personal writings. And her many letters, which I never reread either. They are tied in a white silk ribbon, like those of Annie Leclerc and Lucie Laporte, which I don't open either.

After the notary and through the period of quarrelling with the whole health-care system, from which I had been banished, and where I had cultivated many friendships, I thought I must have wept all the tears in my body. I believe that, since I have no more. The fountain is dried up. The crater is empty.

"I have no more tears, the fountain is dried up." The expression comes from my lovely aunt, Jeanne-Alice, the wife of Jean-Baptiste's brother Ferdinand. It was at the funeral parlour, after the death of Jean-Baptiste, that Jeanne-Alice spoke those words. She had already lost her husband and three of their children, Gilles, Roselyne, and Louis. "It was too much," she told me. Each of the two families, Jean-Baptiste and Jeanne, and Ferdinand and Jeanne-Alice, had had ten children. Our two houses were separated by the river and the footbridge. We kids were the same ages. We were friends. And paired by age and grade at school. Rodrigue and Paul-André, Carmen and Madeleine, Monique and Françoise were the best friends in the world during childhood and adolescence. Some have remained so. Life, following its course, has separated others.

I will soon stop talking about the two Furies and leave them to their silent (for me) destiny. I prefer loving to the opposite. In Greek mythology, there were three Furies, evil goddesses, guardians of the Underworld: Alecto, Megaera, and Tisiphone. We only had the two, and that was quite enough. I leave Tisiphone and Megaera far behind me.

All the mythologies and dramaturgies of humanity, from the most ancient to the most recent, have had the gift of expressing the subterranean impulses and unconscious affects that have eluded philosophy and the

humanities. Since I wrote that difficult passage, I have been thinking of Shakespeare, Hugo, Beckett, and our Quebec playwrights of here and now. On waking, I thought of Claude Gauvreau's *The Charge of the Expormidable Moose*. We are far from all of them. I see the day coming when we will move closer to them.

There are people, including some of the dearest ones in my own family, who will say I am exaggerating, and that I should forget all that. Artists, of whom I am one, are known to exaggerate. To embellish. It's their mission to go overboard. There are important fragments that often are not visible to the naked eye. That's why there are magnifying glasses and microscopes, and spyglasses and other instruments of celestial mechanics such as telescopes. Seeing far, paradoxically, helps us to better perceive what is closest. For the family turmoil around the final days and the deaths of our parents, one cannot blame those who have seen less or have seen nothing at all for being blind. Nor can one blame the witness who saw for telling what he or she observed. It is for him, and in this case for her, a condition of survival.

On this morning of April 16, 2012, through my window, I hear the songs and shouts of students on Sherbrooke Street marching against the government's unjust plan to raise tuition. Their footsteps and their chanting voices are a symphonic overture to my ears, accompanying my private goodbye ceremony: Goodbye, deities of the Underworld! Goodbye, Tisiphone and Megaera!

Post-mortem

A few months after the turmoil in the family, a good friend who was close to my parents and their offspring asked me, "Don't you think everything they've put you through originated in the Furies' terrible jealousy of you?" Jealousy? That was a shock and a revelation to me. I went back over the horrid events and I felt I understood. Something my mother once said in a solemn tone – "There has never been any jealousy among my children" – suddenly revealed its true meaning. The flat, emphatic way she stated this suggested a subtext that was the opposite of the explicit meaning. Her children, whom she and my father had always wanted to be perfect, should not, could not, show what to her was one of the worst faults – a cardinal sin, let us not forget. Born in 1910 in the Catholic darkness of the sacred diocese of Rimouski, she found it inconceivable that her children could show any of the cardinal sins, especially not petty jealousy.

If we strip off the veneer of religion (as thick as it is), all these despicable and shameful sins again become what they have always been: normal impulses that one has to acknowledge in order to free oneself from their most harmful effects on family members and close friends. And on oneself, to begin with. Because it's oneself that jealousy hurts. In those disturbing subterranean lands deep within us, it is painful and very strange to desire harm to another person. Especially if you love that other person. Because these impulses and feelings have been systematically repressed within families, and not extracted from the religious, moral, and punitive overlay, because they have been kept hidden for years, sometimes for a whole lifetime, this is what happens: there is an earthquake, the earth cracks open, and the fire that has been smouldering underneath the surface explodes in all directions, discharging its debris and lava blindly, ferociously. Those who still believe in perfect families and who take such impulses for flaws or imperfections live, sadly, in the limbo of life.

So it was jealousy! That was what Maman, like so many others, did not want to see. And that was what that sweet, perfect woman was playing with, very much in spite of herself. Like an innocent little girl, I would say. There was intelligence in her play, because she was very intelligent. As was her husband, Jean-Baptiste, incidentally, who, like almost all men, pretended not to see anything. A big fat cat with his religion, who would take everything in, purring in his corner, feigning sleep and letting the women deal with those complex, exposed, teeming feelings while he moved on the stage of the world.

Jealousy? I was told this after my parents' deaths, and I remembered. Since my arrival in Rimouski, I was the only daughter who had come back to the region and who was close to my parents. I had come back to work at UQAR, never suspecting that I would be responsible for taking care of my declining parents. To which was added the responsibility of looking after Maman's brother and sister, Uncle Léopold, the priest, and Aunt Adèle, the priest's servant in the second part of her life. Uncle Léopold was Megaera's godfather, which didn't help matters. Those two old people, Léopold and Adèle, loved me, appreciated my visits, and showered me with presents: beautiful books, jewellery, and even a statue of St. Joseph in a coat edged in gold (pure gold, they said) that I still have in a cupboard and that I don't really know what to do with, so it remains there, sleeping.

Jeanne, our mother, had a favourite pastime – until she was on her deathbed – the telephone. Every day, she called her children in Montreal, Quebec City, and Moncton, and she talked. When Jeanne saw death coming, she had an irrepressible need to talk. It was a continuous stream that got on the nerves of quite a few people, including her husband, who managed to become completely deaf to it. Without my knowing it, she talked about me. She talked a lot about me. Said how my presence so close to them added years to their lives. Beautiful years (she told me that too, when I arrived, hugging me while Jean-Baptiste blushed with embarrassment).

And she talked about my achievements at every opportunity. She sang my praises. And as fate would have it, I had a lot of achievements when I arrived in Rimouski. First of all, Jeanne saw my being invited to

teach at the university as a great honour. "Can you imagine? My daughter Madeleine, a visiting professor?" The fact that the honour was nearby seemed to increase its positive impact. I arrived in Rimouski in January 1990, and in 1991, I received the Governor General's Literary Award for *Chant pour un Québec lointain* [*Song for a Far Quebec*]. Then the Rimouski Book Fair awarded me the Arthur-Buies Prize for my body of work. Maman came to Rimouski, with Cécile driving, and they attended the ceremony. Jeanne was overjoyed. And Amqui, my hometown, gave me the Artquimédia Prize. My friends Jean, Paul Chanel, and Hélène came down from Rimouski. During the ceremony, there were speeches, by the mayor, the writer Paul Chanel Malenfant, and me. Medals were awarded. Maman, in a beautiful dress bought especially for the occasion, went up to the stage to accept her medal. There were some four hundred people in the hall. Jeanne was walking on air.

I like celebrations, and people who know me are aware of that. I like prizes and awards. I like being celebrated. But – how can I put this? – I am not vain or pretentious, and I don't run after honours. I have a natural modesty. I don't get up in the morning and say to myself, "I'm a writer, what glory!" Without pretending to the humility of a saint (religion again), I feel joy and a certain pride when my profession, which I work at all the time, is recognized and celebrated. If I think about my writer contemporaries, I would place myself halfway between those who hide (for example, Ducharme and Poulin), and those who want to be at centre stage, who display themselves and sometimes show off (I won't name any of them for fear of incurring their wrath – in any case, everyone knows who they are). Halfway, then. *In medio stat virtus.*

When I think about everything Maman must have said on the telephone during those years, I know she must have wearied some people's ears and kindled intense jealousies. This being said, the nastiness surrounding the end of my parents' lives and their deaths can be understood, but nothing can excuse it. Forgiveness can only be granted if it is asked for, if the harm done is understood and analyzed, and if reparation is made.

Rimouski

To me, Rimouski represented the first time I left home and the major journey when I left my family for boarding school in 1948. I was then in grade five of primary school. I had pleaded with my mother to let me go away. I had seen my older sisters and my brother Paul-André, already studying elementary Latin – just that word rang in my ears like an incredible odyssey to far-off lands – go away in September with nice clean suitcases that smelled good, setting out on fabulous adventures. This time, in 1990, it was also a great adventure, but in the opposite direction, since it was Montreal – and a whole life – that I had to leave to move to Rimouski.

When I arrived, I wanted to visit the places of my dreamy, isolated childhood and the university where I was going to work, which since its founding had been located in the Ursuline monastery. As is well known, the Quiet Revolution, in emptying the religious communities of many of their members, made a built heritage available to public educational institutions, both colleges and universities. I made a kind of secular pilgrimage to the site of my old convent. I even had a guide, my friend Simonne Plourde, a professor of literature and ethics, and still an Ursuline. Who better to be my guide than a nun who had lived for years within those walls and had kept alive the memory of the time before the changes? Simonne decided the itinerary. She drove me everywhere where I might recognize a sign or trace of the transformed past. Without her talent as an observer and her sense of humour, I would have been sad, because I didn't recognize much at first glance.

She would say, "You see, there, that was such and such a room." Almost everything had been obliterated by the good citizens who had been the initiators or engineers of the changes. The dormitories and refectories were no longer there. Even the chapel, the beautiful chapel, had been subjected to the assaults of the demolishers and had become

a library. The railings, the pulpit, the stained-glass windows, and the columns were gone. Simonne, her eyes fixed on the floor, walking and counting her steps in those imagined rooms of old and relying on the permanence of the wood or mosaic under her feet, would say, "You see? The hall started here and ended there." Or she would spot a piece of railing, a part of a colonnade, a section of a banister, or, even better, the complete staircase that led "to your dormitory," and we would go up and back down the stairs of the monastery she had reconstructed room by room, a masterpiece of imagination defying the historical ruptures and restoring a superb past reconciled with the present. Thanks to her, when I went to classrooms or meeting rooms or the cafeteria in those years, I was walking with a history in my head. A history and its architecture, which human beings destroy with or without wars – but which memory keeps alive wherever we go.

I taught classes there that were similar to those I had given in Montreal and elsewhere, and I met students in Rimouski who were different from those I had known but in many respects the same: eager for knowledge and wanting to understand, except for the few who, like students everywhere, were there just to accumulate credits and finish as quickly as possible. You teach for them as you do for the others, and sometimes, as if by chance, a light comes on in them in the course of a thought, a sentence, or even a daydream. He has understood something, it's not clear yet what it is. Or she has grasped what she didn't know how to look for and it's no longer uncertain and doubtful, something has woken her up and she will never be the same. That goes for him, too. They will come to the class now to reconnect to that current they had been unaware of in themselves until then. They will want to continue to learn. To read, to write on sheets of paper or in notebooks or even on the computers they take out of their bags, with a flame already in their eyes. In class or at the end of the term, they will produce an assignment on a text they had previously felt was for others, the scholars they had feared yesterday and embrace today.

I saw those flashes of awakening in both Rimouski and Montreal. And I never understood those urbane academics with all their degrees who did not believe in university education "in the regions," as we say.

I've even heard some of them declare from the height of their scholarly certainty that we should "abolish the universities in the regions" and make those "hordes of poor students from the underdeveloped rural areas" come to the big universities in the cities. How ignorant you have to be to come out with such inanities! You have to not know your own country, its diversity and its beauties and its human beings hungry for knowledge, drawn by all there is to know in the world, from the stars to the dust, from the soil to its harvests, from the written word in books to the words tattooed on your heart and reproduced – oh, the magic! – on a sheet of paper or a screen, from the waters to their fish and their boats, from the forests with their animals to the compasses to walk their trails or the tundra, from algebraic formulas to all the structured thoughts and all the poems of the earth. To know the entire world, you have to start with your own garden. With the regions of your own country, be they near or far. Long live the network of Quebec universities with its public French-language universities in every region. It is one of the beautiful fruits of the Quiet Revolution.

I loved Rimouski, a pretty provincial town, and its memories of a time when it was the queen of the region, with its beautiful religious architecture, where not everything had been destroyed despite the simplification of the cathedral's interior. Rimouski, the seat of an arch-diocese where the built heritage of a prosperous time, which survived the big fire of 1952, still bears witness to the talents of the architects and builders: a beautiful bishopric and presbytery as well as a Grand Séminaire that has been turned into a guest house for still-active old priests or visiting professors. The seminary was where I lived for my first weeks in Rimouski, surrounded by religious knick-knacks, which didn't bother me, living in the suite Vicar General Gabriel gave up for me, eating at what they called the literary table, where the cuisine was excellent, always. At that big round table, Abbés Pineau and Michaud, researchers and theologians who were professors at the Petit Séminaire (now a CEGEP, or public college), were good company, masters of the art of conversation and discussion, which is being lost today, when lengthy subjects bore people; they died recently at the ages of ninety-one and ninety-two respectively.

I loved Rimouski, its people, its walks, and the St. Lawrence River. I made many friends there. In the summer of 1990, I stayed in the pretty house of Jean-Claude Bréthes and Élisabeth Haghebaert, which they had loaned me. Maman came to visit for a few days and was delighted with her room and the cupboards filled with fine laces and delicate cottons, as well as the fat cat called Chat, who would curl up beside her and purr – Maman adored cats. One splendid day of that sweet summer, I invited all my friends and acquaintances to a wonderful dinner party. There were about forty of us. They didn't all belong to the same circles, but the evening came together like a mayonnaise. I had made a meal of fish and seafood, with the main dish steamed salmon – four beautiful salmon. The wine flowed deliciously. I can still see the people in the garden with little tables set up facing the river that we could see beyond Canuel Island just below, under a sky that was giving us the gift of its brilliance and the dance of its aurora borealis. I'll always remember René Simon singing Alsatian songs in the wee hours, raising his glass and toasting life, "glorious life," he said, from which he too has now departed, a few years ago, in his nineties, leaving in deep mourning his friend Simonne, who was with him at that party.

I loved Rimouski: walking, partying with friends, writing and painting and taking pictures there. I painted, mostly in a studio I rented starting in autumn 1990, in the Grande Place, facing the St. Lawrence, which I could see between the town and Saint-Barnabé Island, and then beyond the island to infinity, or as far as the North Shore. When the weather was clear, you caught a glimpse of little lights in Forestville, but you couldn't really make out the shore. You had to imagine it. To dream it.

My favourite daily walk was the bee trail – there was a hive there – which ran silently through the century-old trees and buildings of a magnificent farm and a rose garden. You could take it from behind the grey stone convent of the Sisters of the Holy Rosary, fortunately still in good condition, as far as the UQAR parking lot, formerly a park and garden. In winter you'd see just a few anonymous footprints in the snow from the rare passersby. In any season, my strides on the silent trail and the calm beauties of the place consoled me for the miseries and horrors of those months: the family nastiness and the suffering of the four old

people I was watching over: Jeanne, Jean-Baptiste, Adèle, and Léopold. Consoled me, too, for the deaths, because there were several, one after the other, as if death came in series so that you'd dwell on it a little more. First, my cousin Irène Beaulieu, to whom I had recently become close. Irène, gentle Irène, who expressed her affection by placing dishes of candies on all the furniture and tables in that modest little apartment where she received visitors, although, with severe diabetes – like our grandmother Ernestine – she was not allowed to eat any, but having visitors permitted her to cheat, as she said. To make her happy, I would eat two or three.

It was at Irène's funeral that I saw Papa drive his car for the last time. I was following him and my mother in my car from the Mont-Joli Cemetery to the hotel-motel of the same name, and I couldn't believe my eyes. He was zigzagging at the wheel as if he were dancing a two-step waltz. I thought for a moment he was going to go into the ditch or the field and that would be the end of my parents, and I held my breath. But no, he got back on the road, Route 132, got the car back on its four wheels as if it were nothing. I spoke to the two of them in the following days. I couldn't imagine how he had managed to get back across the valley to Amqui after the funeral service. He said he had no idea what I was afraid of. Irène's last journey was the end of his days at the wheel. He never drove again.

And Dyne Mousso died during that time, at the age of sixty-two. Before her death, Dyne had disappeared for many people, including me, behind the impassable wall of alcohol she had erected over the years. I talked about Dyne in my book *Le deuil du soleil*, which I wrote in Rimouski around 1994. Dyne's voice remains alive; it has survived her. She was a reader of many of my texts for the cultural network of Radio-Canada in its golden days. Her voice was to poetry what Callas's was to opera. After her death, my texts were orphans. Until the arrival of Nathalie Gascon, whose voice sang my words in a different register but with as much grace. Happily, she is still alive.

In 1994, Lucie Laporte was murdered by her lover in Auvers-sur-Oise, in France, where she lived in an artist's studio. Lucie was forty-eight years old. Her work was starting to become known beyond the borders of Quebec, which is what she wanted. I have a large painting of hers,

which I bought one year when she was the poorest of the poor whereas I had just received a grant from the Canada Council for the Arts. I kept the many letters she wrote me over the years, in which she recounted her day-to-day life. Her life and her dead loves. I did a book with her, *Femmeros* [Womaneros]. Made up of her very black drawings and my prose poems on the sorrows of women in love, which were inspired by her drawings.

In 1989, when I was living in Montreal, Rolande Ross, a literature professor at the CEGEP in Rimouski, had invited me to read some work for a big evening she was organizing at the regional museum there. It was in December and I thought it would be prudent to go by train. When Rolande came to pick me up at the train station at the end of the day, she was shaken and white with horror. She told me of the deaths that morning of fourteen young women students at the École Polytechnique in Montreal. It was December 6. Killed by "a guy who targeted feminists." All of us, men and women, were upset. The poetry evening was rather macabre. At the last minute, I changed my choice of texts and decided to read excerpts from *Femmeros*. I spoke of the sombre drawings by Lucie Laporte. And I read texts about dead loves, from Teresa of Avila to Héloïse, to Ophelia, to Marguerite Duras. It was five years after the massacre and that reading in Rimouski that Lucie Laporte was killed by the lover she had adored. My reveries on the Holy Rosary trail, as I called it, soothed me. The beauty of nature is the best healer in the world.

I went back to the university, glad to be reunited with my colleagues in literature, in that "big little department," as our amiable rector, Marc-André Dionne, called it. And I went back to my students, undergraduate and master's level, who were zealously working to solve the enigmas of the literary works they were studying. They were sometimes discouraged but most often dazzled, like those in Montreal, New York, Vancouver, or Paris, and the questions they asked me were similar to my own, whether we were reading Valéry or Anne Hébert or studying Barthes, Blanchot, Lacan, or Derrida.

New Freedom

Although I went back to Montreal often, the distance over the passing months allowed me to finally break up with the man who had torn up my writing. Some will say I'm slow, and I am in these matters where passion blinds, but once I've decided, the break is radical and there's no going back. Everything seems instantaneous, like a bolt of lightning that strikes without warning on the horizon. Yet it happens without shouting or tears, or even words, which often have been repeated over and over to no effect. One day, more precisely one morning, when I was getting ready to leave for the university, the man who tore up my writing was there. In a stunning moment of cold lucidity, I told him not to be there anymore. To leave. And never to come back. I don't want to report everything I said, but it was so clear, so obvious, that the lightning bolt hit him too. He left, and it was over.

The scene with the torn-up letters had taken place in March 1983. It was now February 1991. A wild creature that had been asleep and dreaming all that time was waking up. I was that wild creature that was tasting its new sovereignty. Free at last, I slowly paced my territory. I stirred the earth, breathed in the smell of humus, rubbed my nose on young shoots, looked up to see the tops of the trees and the slivers of sky between the branches and leaves. I could have shouted out my newly regained freedom, but I kept my voice low, it was so new, I needed to get used to it. I pressed my ear to the drumbeats of the earth and prepared to meet living beings, all my loving ones, on the other side of the clearing I glimpsed in the distance. (That day, I believe I gave the best class of my life.)

I had just left my "third man," as my friend Élisabeth said. I knew with certainty that a woman who writes, with rare exceptions, is intolerable for any lover. It would attract at the beginning, but little by little, stealthily, the malevolent serpent would crawl between the two of them and get them expelled from the paradise of innocent delights. Over the centuries,

there have been thousands of plausible interpretations of that episode in Genesis in which the diabolical serpent offered Eve an apple and she in turn, caught in the net of seduction, drawn by the juiciness and sweetness of the forbidden fruit, gave it to Adam, who could not resist. We know what happened next. The two of them, punished by God in person, were driven from the earthly paradise. This paradise lost would become the basis for the morality and aesthetics of the three monotheisms that have until now governed human destiny – that morality and that aesthetics with their aura of the original longing and guilt, and also their condemnation of Eve, the first seductress, beguiled by the serpent, and the corrupter of her poor dear Adam. Eve and all her female descendants, all women, until the end of time.

Except. Except that the interpreters, almost all of them male, have not seen the essential truth in the biblical fable: what was forbidden was not primarily the fruit of the tree, but the tree itself through its fruits, and that tree that mustn't be touched was the tree "of the knowledge of good and evil," as Genesis says. The tree of knowledge, therefore. Knowledge reserved for God alone. Forbidden to humans. And to women especially. The emblematic woman of the defining text of human thought in the area of thought itself has no right to knowledge, and the man who touches and tastes the fruit of knowledge that she was the first to pick will be punished and banished with her. With knowledge, he will now have to manage alone. And alone he will become a weeping Sisyphus exhausted by an absurd task or a melancholy searcher or a sorry pervert. Or a pope. With her, sent away from the tree of knowledge, he will make children. Which she will give birth to "in sorrow."

Or Adam will tear up the little pieces of paper Eve has written in her moments of inspiration. Do you know any male writers who have not been served, worshipped, and supported by the women who loved them? I don't. Do you know any women who have been able to write, and even build a body of work, with a man at their side? I don't.

Of course, in the twentieth century, things changed. Women are freer, at least in our countries, but those who write or paint or build houses, bridges, or buildings, or who simply think, are alone. They have the right to climb all the trees of knowledge, but most often, they are

alone. I admit that those who are not creating a body of work, and never will, may suffer less. They can cultivate empathy. And all those men and women who think I am exaggerating, be on your way. As Francis Ponge wrote, "Reader, if you have followed me this far, I kiss your lips."

I know one thing, however: as long as women of all religions who want to understand do not question one of the founding myths of their origins, the subjugation of women as alleged seductresses and corrupters will continue, and knowledge will be forbidden to them. And there will continue to be women who are beaten, raped, excised, and burkanized. Forbidden by law to drive cars, boats, airplanes, or spacecraft. Or bicycles. And those women in our so-called free countries who believe that feminism is dead are sadly mistaken.

Back to the subject at hand. My third Adam. After the breakup, I was so happy with my new freedom that I remember saying to myself, and sometimes confiding to close friends, close women friends: my body is a territory where no one will tread anymore, and after everything I've experienced, and come out still very much alive, I deserve a Military Cross.

I felt free. Alone and free. I believed I had left the arena of desire forever, with its passions, its pleasures, and its transports. And the troubling and tiresome side effects. I walked alone. I wrote alone. I slept alone. And I breathed. I even went to a jewellery store one day to buy myself a ring to celebrate what I called my engagement to myself. I still have that ring, which I don't wear often, and which I find touching. It's of old carved silver set with a small lapis stone. I walked alone wearing my ring, and the thought that no one knew what was happening to me delighted me. That is solitude.

I was fifty-two years old. Since the age of seventeen, since my first French kiss on a beach in Percé, there had always been lovers in my life. I was an impassioned lover. And now I found myself alone and happy for it. I had become another, and yet the same.

Sometimes I wonder how I ever managed to find time to write. It's as if that time didn't count in my life as other time did. Do we remember the

time we spend breathing, or do we count the steps when we walk? This makes me think that writing must have been both breathing and walking for me. Short of abolishing all memory and being totally in one's actions, like an animal following its impulses, I don't see how writing, that is, one's reveries, one's thoughts, and their actualization in writing, can be conceived otherwise than in the breath and its cadence.

If I think back to the books I wrote during my stay in Rimouski and to all the events, happy or sad, that took up my time, I have to conclude that writing is indeed the art of stealing time from ordinary time. Stealing time is not something you learn. It's a form of asceticism. It clings to the skin of the soul.

Song for a Far Quebec, whose music I heard in Paris at my friend Annie's home in my room upstairs, was written the first Rimouski winter in an office at UQAR whose window looked out on the rolling hills to the south as far as the mountains of the Matapédia region, whiteness to infinity. That book was warmly received by readers. It was loved. It has now been set to music by the composer Rachel Laurin, thanks to patron and friend Daniel Turp. The first long poems were presented recently in a recital at the Chapelle historique du Bon-Pasteur in Montreal, with pianist Olivier Godin and baritone Marc Boucher. What resonance for a text that was written in the silent solitude of the winter landscapes of my country!

After that, I wrote *La terre est remplie de langage* [The land is filled with language] I don't recall exactly in what places, except that it has in it all the seasons and many vacations. As if I had instinctively placed Quebec at the centre, but Quebec expanded to the entire earth, fragmented and scattered over its cliffs, propelled across the celestial vault, and brought back among its dead under their tombstones, with their stories running among imaginary epitaphs, traces of writing etched along the walls, strewn gently as far as the sprouting plants, the first bushes facing the circular waters, the first groves of trees, and then the tall forests from which we all come. Things speak for themselves and by themselves in that book. I didn't know it then, but it was really an ecological, environmentalist book. An environment with the stones and all the minerals thinking and mingling in the waters.

Les cathédrales sauvages is a strange book. In some respects, it reminds me of *La lettre infinie* from the 1980s. It was not very well received and it disturbed quite a few people. It would today be called an autofiction. One of my sons said, "A person has to know you, Madeleine, to understand this book." And the other one agreed. Perhaps I should have been more explicit? You can't remake the world. That's the way it was written. I like it because it brings back such sweet memories. It was written in large part in Élisabeth and Jean-Claude's house, the one they loaned me in the summer of 1990. I had decided to apply Patrick Modiano's recipe, which I'd read, I'm not sure where, and which consisted of writing at least two pages every morning and then cheerfully going on with your normal life. The recipe suited me well that summer. The house was often filled with visitors and I took advantage of that to steal some time from the hours that stretched out around the table after breakfast, with cups of coffee and lots of stories. In my writing room – Élisabeth's office – I would hear the murmur of the voices around the cheerful morning table and I would look out at the garden, the island, and the river. I immersed myself in inventions and recollections, which, one after the other, led me to bits of true stories enmeshed with the invented ones (which were equally true, depending on how you conceive truth). In the end, this produced a funny kind of novel in which the dead are as alive as the living, and the multifaceted story of a life pulses as much in the supposedly real facts as in the inventions. Chat was at my feet, dreaming and warming himself in his mistress's slippers.

My Town of Amqui asked me to write some poetry about the places cherished by people there, and I responded to their request with a little book made up of four prose poems entitled *Là où les eaux s'amusent* [Where the waters play], a literal translation of the Micmac name *Amqui*, accompanied by drawings by my Rimouski friend Colette Rousseau. The book goes to the geographic heart of my land of origin, where two rivers meet, a big one and a little one, the Matapédia and the Humqui, creating eddies and celebrations, fishings and drownings, lives and deaths. Disappearance and then rebirth under another name, in another river, the Restigouche, which in turn disappears and reappears in Chaleur Bay, and soon the sea, and farther, the Atlantic Ocean. There where words were born. Where they played, and then left for elsewhere.

I love my books. If I didn't, I would not be here writing. Writing about myself and about my books. I am able to see the strengths and the weaknesses of each one. I can also understand their trajectory, from the very first publications to the most recent. I can even glimpse what will follow after this book, while knowing full well that the act of writing will lead me to discover paths other than those glimpsed. While writing dreams the world, it also, like me, knows that in the beginning, it was dreamed by that world, by the wholly Other, including the other-in-the-self that came, unknown to its initial plan and to my own consciousness, to etch its tattoos, impulses, or letters on the monument-body, which writing captures and tries to translate as best it can.

I love to write and I love my books. I look at them neither from above nor from afar. Facing them, it is as if I were at my side, beside myself. This is Rimbaud's "I is another." When I write, I am the tool and the worker. I do not watch myself writing. I is there in her work. Wholly one. I is there in her body of work. On the job twenty times, I works on the phrases, the verses, the paragraphs that line up on the page, busy little ants running toward what will follow, laden with meaning.

I will not pretend not to know what I have accomplished, nor will I put on a facade of humility, which, as everyone knows or should know, is the worst form of pride.

The last book I wrote in Rimouski, in 1994, was the novel *Against the Wind*. I cherish that book, one of a few that were given to me like gifts from the muses, from another world, brought back to life. The story came to me whole, and the entire first chapter came into my mind complete. I was crossing an empty field in Rimouski, returning from the grocery store, a shortcut I always took because it was so much like the country in the city, or like a piece of the nineteenth century left behind. A huge rectangle covered with wild grasses and anarchic trails traced here and there by idle wanderers. I had my path, always the same one, and I never met anyone there. It seemed that the few scattered walkers on that fallow land had chosen their own paths. From afar, we would recognize each other without knowing each other, and if a stranger had come, one could have seen a slight movement of alertness on the part of the regulars. (That

empty field no longer exists. As is the case everywhere, nature abhors a vacuum, or any unlucrative space, and condominiums have popped up there like mushrooms.)

On my solitary path one morning after doing my grocery shopping, I received the gift of the first chapter of the novel, as well as my character, Joseph, who was born the same year as I was, and in the same region – which allowed me to know him better. When I got home, I didn't wait, and with a steaming cup of coffee, I wrote that first chapter in one sitting. It was a very difficult scene, in which Joseph, at the age of ten, sees his mother raped in her bed by a fat stranger, a monster, an ogre. Joseph, in the kitchen, had heard muffled noises from the bedroom, then a scream from his mother, a moan, a breath, then nothing more. He had tiptoed upstairs and had seen the hairy monster on top of his mother. Had seen his beloved mother's tear-filled eyes and had gone back downstairs like lightning, grabbed a big knife, flown back upstairs like a frightened bird, and plunged the knife into the rapist's body until blood spurted. Had pushed the man off with the help of his mother, the body tumbling to the floor, and Joseph in his mother's arms, bodies entwined in blood and tears, bodies dizzy with a pain they would carry within them till the end of time, like the bodies of the mother and the son in *Mamma Roma* by Pasolini.

By having Joseph grow up to be an artist, I was able, at the deepest level of my writing, to link an initial wound and sublimation in artistic expression, death and creation, original suffering and ultimate pleasure in the act of painting (and writing) as well as in the act of love. Because Joseph is an intelligent artist, an incurable lover who will attempt through-out his life to grasp the idea of the painting and that of the loved body.

It took me years to see the clear connection between Joseph and myself, apart from the chronological coincidences and the affinities with respect to our chosen professions. For a long time, I didn't see it; basically, I had reversed the roles. Having as a mother experienced in my flesh the rape of one of my sons, I had felt at the time, without really admitting it to myself, a terrifying urge to murder the rapist, the one who had attacked the flesh of my flesh. That tragedy was given back to me in the saving form of a novel on that wasteland of another time.

Grand Forks

I travelled a lot during those years in Rimouski. By car, by bus, by plane, to conferences, lectures, book fairs, or just to see friends, I took to the road as I have always loved to do. Watching the landscape stream by or flying over clouds, invisible cities, waterways, or villages, and, with my finger on a map, imagining them, is for me a source of inexhaustible pleasure. I know people who can spend their whole lives going around the world just looking out their window or strolling between the rows in their garden. Great books have been born of those contemplative souls who travel without moving. And who write about it. I have just as much need to read these stationary writers as I have to follow the explorers on their long routes.

I love authors like Philippe Jaccottet and Robert Lalonde. I also love those like Victor Segalen and Ryszard Kapuściński. I need Jacques Cartier's accounts of his travels as much as Marie de l'Incarnation's quiet meditations. Explorers meditate and pray by travelling, while mystics explore the world as introspection has reconstituted it within them. I travel with all of them. I go away with their books, but especially with fragments of memories of the books, and I'm all eyes and ears for encounters with other human beings who are on this planet at the same time as I am – oh, happy coincidence! – most of whom I will never see again. Other people will remain clinging to the memories of their landscapes, and I will see them again.

So it was that one day I answered an invitation from the University of North Dakota, at Grand Forks, to be precise – I said I was going to "Grandes Fourchettes" – to take part in a conference on Canadian literatures, English and French, which is how they were referred to in the early 1990s; the terms *francophone* and *anglophone*, to describe literature, had not yet emerged.

From Rimouski to Grand Forks, the distance as the crow flies is not so great. Airplanes are not birds: it took me four flights to get there:

first, a Mont-Joli–Montreal flight; a second one, Montreal–Toronto; a third, Toronto–St. Louis, Missouri; and the last one, St. Louis–Grand Forks, North Dakota. Grand Forks is right next to Manitoba. Four flights and a crazy distance, and you're back very close to what they tell you is your country, Canada. But you feel so far from home, and that country they've been saying is yours since you were little seems so foreign to you, that you no longer recognize yourself. And you think again of Kapuściński, who, thanks to Herodotus's accounts of his travels across Persia and the Peloponnese in the sixth century BCE, moves through space and time in the twentieth century and meditates on his own space, his own time, the Poland of our era.

In Grand Forks, North Dakota, far from home and yet close to Manitoba, which they say is mine, it seemed to me I travelled an entire lifetime in my head. I was not the same when I left three days later. And nor was my country. On the return flights, I said to myself that any Québécois who was conscious of this bipolarity must either go mad or create masterpieces. No need to come from a great country to create great works, contrary to what some short-sighted intellectuals have said. It is enough to grasp deeply, through its twists and turns and its rhizomes, the bipolarity that is our collective lot. That was expressed by artists such as Borduas and Riopelle, and even, despite all appearances, in the *Microchromies* of Fernand Leduc. And also in literature, by writers such as Gabrielle Roy, Saint-Denys Garneau, and Anne Hébert. I will refrain from mentioning the living. We are most often mistaken when we single out one of them. The reasons for the choice are rarely pure. History will judge.

When the plane set down on the tarmac in Grand Forks, I saw the guide and driver mentioned in the invitation coming toward me. An athlete in a cowboy hat, jeans, and boots, who greeted me with a wide, white-toothed smile, the kind you see in westerns or Chiclet commercials. With one quick hand, he took my bag as if he were lifting a straw and led me to his huge, gleaming Jeep. We crossed an area of bush and industrial scrap metal to the university campus, where I was to stay. He talked to me in his loud, cheerful voice and whistled a country and western tune. His presence was reassuring. I liked him right away.

This Hercules I had taken for a handyman at the university turned out to be a gentleman and a serious student, as I learned in the hours that followed: he was a doctoral student in literature, president of the student association and editor of the student newspaper. After my talk, he did an interview with me and devoted the whole front page of his newspaper to it. He had just discovered the existence of Quebec literature – like all of them, who had until then believed that Canada had a single literature, which was "English" like theirs.

It was Dorothy Livesay once again who had got me invited to that conference. She was there, along with two very Canadian writers, Michael Ondaatje and Roch Carrier.

It was not me personally who was being applauded by my cowboy and his fellow students; it was the spokesperson for a country and a literature that they were discovering with delight. I talked to them about French-Canadian, Acadian, and Québécois literature and the others, from St. John's, Newfoundland, to Vancouver. I cited dates and events from New France to the present. I gave names of politicians and historians and writers, including women, who entered literature through the front door starting in the 1960s. I talked to them about the need to know the history of a people through its poetry and fiction as much as through its science, its discoveries, its conquests and wars. I also told them of the desire for independence and the will to achieve it expressed by that neighbouring people in many ways since the Conquest.

Before the bilingual reading of poems by Dorothy Livesay and myself, we both spoke about the need to know and recognize minority literatures, or otherwise world literature would level those distinctive voices and swallow them up without a second thought. Our colleagues Carrier and Ondaatje were angry and stopped looking at us. Dorothy had the wind in her sails and she kissed me, whispering in my ear, "Bravo, darling, you really got them." And yet Dorothy Livesay was an ardent federalist. She had been born in the "Eastern Townships," as she called the region, and the bones of her ancestors "rested in that good earth." She was a very beautiful old lady with blue eyes and a rosy complexion, who was "proud of all these young women from Quebec talking about

poetry." She was radiant – and also, I had at her invitation done her hair and makeup that morning. Beyond the squabbles between the two peoples of Canada, beyond that "once insurmountable wall between the two cultures," she heard the echoes of "the new women's voices" singing, each in her own language.

On my last day in Grand Forks, my cowboy escort asked me what I would like to see in the city. "I'll take you wherever you like," he said. I hesitated and said finally that it would be fun to see the best western bar, which he gladly took me to. The bar was huge and the little band was excellent. We drank some good beer while listening to our favourite songs. And telling each other stories. About literature, writing, and loves. We both acknowledged that you can't rely on first impressions. He was no more a hulking, uncultured cowboy than I was a snobbish, distant intellectual.

Because It
Was She

Annie needed me to be there when she woke up, and I was. From Quebec City, I took the plane to Charles de Gaulle Airport, took the RER train to Saint-Michel, and went to the Curie hospital, on Rue Lhomond in the fifth arrondissement, walking behind the Sorbonne. I absolutely wanted to be there before she woke up. It was the early 1990s – I forget the exact date. My good friend, my dear little greatly beloved Annie, was having her first operation for breast cancer. She got better that time, then got sick again a few years later. She got better again, fought, believed in healing, and was finally assailed violently, her whole body racked with cancers, the metastases growing everywhere until there was nothing left of her organs, her hair, her eyes, her skin burned away, even her voice, which would speak no more. All of her, which would pass away, as they say. Annie Leclerc, who would die in a hospice on October 13, 2006, at the age of sixty-six. And I wasn't there.

But that first time in the early 1990s, I was there. Standing by her bed, I watched her sleep. She didn't appear to be in pain. She had a peaceful look on her face, which I would describe as a young angel's face, with blonde hair ashen with age and a little smile no doubt expressing the pleasant path she would take to waking and the land of the living. She opened her eyes and said, "You're here, that's good, how did you do it?" I hadn't finished answering, "I'm here. I came to Paris from Rimouski for you. I'll stay for a few days," when she fell asleep again.

During a brief conversation in the hours that followed, I remember that she talked to me about her Limousin and the ponds in which she had learned to swim. I remember going swimming with her in her favourite pond. I'm not a very good swimmer, but I slid easily over that water as if ancient memories of fish had awakened deep in my body. Beside her

hospital bed, I talked with her again about the countries of our respective childhoods. "Your Limousin is beautiful," I said. "You'll have to come and see my Matapédia when you're better." She said, chuckling, that her trees, her deciduous trees, were among the most wonderful species on earth, while my poor trees were just evergreens that grew wild there. I answered, "No, no, you'll see," and called her a true Frenchwoman who was always sure she was right, which she was – like all the French.

Annie never came to the country of my childhood, nor did she come to see my mother, who had liked her from their first meeting, liked her books and wanted so much to have her visit her home. Like many others, it was an unfulfilled dream. Unfulfilled dreams cause small sorrows, killing us slowly. Without them scattered through our lives, we would be eternal.

Annie and I met in 1975, at the Rencontre québécoise internationale des écrivains that I described above. That precious moment of friendship at first sight held us together, sharing our lives – our children, our houses, our books – until 1995. What happened in 1995? What happened is that I fell in love with a woman, and that love was shared and is still at the time I am writing these lines. Today is May 9, 2012. It is morning. It is drizzling and misty and I'm still filled with happiness.

I don't want to betray Annie's memory. To recount our conversations and ups and downs when she has gone to the non-place of eternal silence. I can't talk about her anymore if she's not there for the conversation. Together, until the final break, we practised the art of conversation more than that of discussion – and certainly more than that of argument. With humour, the unfathomable humour that propelled us upstream from our adult lives to where everything gave way to the cascades of laughter of young girls with an unquenched love of life, the young girls we were becoming.

I was happy for Annie that Nancy Huston took up the torch for her during the last years of her life and the last assaults of her illness. Annie had an enduring need for a strong, loving female friendship with someone whose love of writing was as strong as hers. I read *Passions d'Annie Leclerc*, which my friend Nancy Huston published after Annie's death. The coincidences between the two friendships are surprising.

I confess to having to skip certain passages because they brought back so much pain still unexpressed around our separation after twenty years of a friendship that for me endures beyond death.

It was a cloudless day. Through the airplane window, I clearly saw the ice, the icebergs, and the water of Labrador, Newfoundland, and the Lower North Shore. The line of black-and-white blocks looked like a painting by Paul-Émile Borduas. Kilometre after kilometre, with nothing seeming to move below, we advanced as if weightless, slipping through dozens of Borduas's paintings. As if that genius knew the pattern of our northern coast without ever actually seeing it, having crossed the Atlantic by boat, and reproduced it to infinity on canvas. I was at an open-air posthumous vernissage of my much-loved painter. I was going home. The plane had just begun its descent. We would land in Montreal. I was returning from Paris.

I had just taken part in the radio series *Conversations parisiennes* [Paris conversations] for the Radio-Canada cultural network. Doris Dumais, from Rimouski, was the producer, and Monique Durand, a journalist from Toronto, played the triple role of researcher, host, and interviewer. It was the golden age of the cultural network, when everyone who was active in Montreal, Quebec City, Moncton, Toronto, Rimouski, and elsewhere contributed to the wonderful odyssey of that network, before blind policy-makers killed and buried it, telling us the ersatz replacement would be better and would be more profitable, which turned out, predictably, to be false. You can't kill with impunity. I've already talked about this; I'm repeating myself. In writing, as in music, repetition is often necessary.

They had nicknamed me the Interlocutor. I took part in all the conversations, with Anne Hébert, Benoîte Groult, and Nancy Huston. The questions asked concerned our lives, our writing, and the place of women's voices on the contemporary literary scene.

It was now February 1995. I was going back to my Rimouski home. Doris Dumais and I would take the night train from Montreal to

Rimouski, each in her roomette, a way of travelling that Doris discovered with delight, each of us with her reveries to the swaying of the train and the thrumming of the rails.

The next evening, I had a class to teach at UQAR, and the day after, I would cross the snow-covered valley to Amqui, where I was giving a writing workshop, and see my parents. Our time together was still peaceful. It was before the thunderous arrival of Tisiphone and Megaera on the scene. It was a time when Jeanne, Jean-Baptiste, and I could still chat. "Aren't you tired?" my mother asked me after a long conversation during which she and my father had me tell them about my trip over our pre-dinner drinks, which consisted of a glass of wine for me, a gin and tonic for Jean-Baptiste, and a little glass of port for Jeanne, which she would sip while imagining that she had been on the trip. "Tired?" I answered. "How can I be tired when the two older women, Anne and Benoîte, sparkled with intelligence, and the younger one, Nancy, glowed with good-humoured beauty. And when there were Borduas paintings all along the coasts." I saw my mother's eyes fill with mysteries and questions. And I heard myself say, "And besides, you know, how can you be tired when love ...?"

I didn't finish my sentence. I wasn't ready to speak my love for a woman. I learned afterward that it caused quite a stir. At my age, after I had always been catalogued as hetero, it turned out to be intolerable for many people, including some of the most open, most progressive, and least homophobic of my friends. Some great heterosexual seducers stopped speaking to me, and some even became nasty. From what I sensed at first from putting together snatches of talk or behaviour, and later understood, these former Casanovas, under their seductive ways, had a deeply repressed homosexuality, which came back to haunt them like a ghost on contact with what I had become. Of course, they didn't see it. Besides, I had not become other. I was the same. That is, like all of us, men and women, I had always been other.

There were women who were amazed, and wept and loved me even more, they said. And I believe them.

There were lifelong lesbians who welcomed me, brimming with affection.

There were radical lesbians who refused my company because I was not a real one, hadn't been one of them forever.

There were gay male friends who took me in their arms and would love me forever.

There were writer friends who took more interest in who was in my bed than what was in my books.

And there was one friend – it was Thierry, who died too early – who said, quoting Montaigne, who had uttered these simple words to his detractors, justifying his tender friendship with La Boétie: "Because it was he. Because it was I."

Because it was she. Because it was I.

I lost men friends and women friends who didn't understand those simple words. And when I went out among people with Her, I never in my life saw so many attempts to divide us. Never so many "triangulations," as psychologists and psychiatrists quite aptly say. Difficult to understand and analyze all those distortions, all those subterranean mysteries. For the precious time that remains for me to live, I am leaving the enigmas to themselves. I am ridding my life of hatreds and rejections. And all the forces of death.

I love. I am neither hetero, nor homo, nor trans. And, like all men and women, I am all those.

I'm not "coming out" (I hate that expression). I'm not coming out of a closet after having, my whole life, buried a sexuality that I am now allowing myself to live. I do not breathe easier since I've loved a person of the same sex. I am not someone who was born a homosexual and failed to realize it for an entire lifetime. I do not define myself, or define anyone, by sexual orientation. Or gender.

Nor am I interested in explaining the world by gender theory, which I see as a huge wall, more solid even than the Berlin Wall, to stop people from going to the other side. The other side, where things are vague and multiple. Complex and multifaceted. Solar and lunar. Terrestrial and marine. Elusive and indefinable. Suspended like the elementary particles. Filled with illuminated stars and planets. Dotted with black holes that will never be reducible to the flashes of understanding we have of full spaces.

Because it was She. Because it was I.

Here, precisely, when I have the time and the soul for paper weddings, I make a poem.

February 1995. I had only a few months left in Rimouski. I would leave my little apartment on Rue Trépanier and return to Montreal in July. I had left Montreal the summer of the song "Tu m'aimes-tu?" [Do you love me?], and I would return the summer of "Écoute pas ça" [Don't listen to that].

I had to find myself a new home in Montreal. It was hot, very hot, that summer of 1995. I scoured three neighbourhoods: Côte-des-Neiges, the Plateau, and downtown. In my car with no AC, I was sweating buckets and searching frantically. I have always hated apartment hunting. To console myself, I listened to cassettes. I drove around with Mozart's *Exsultate, Jubilate*, mostly, and Jean-Pierre Ferland, as well as country and folk music. I finally found an apartment in a downtown building. High up in the sky, on the twenty-second floor. From it, I can see the St. Lawrence, the Jacques-Cartier Bridge, and three mountains, Saint-Bruno, Saint-Hilaire, and Saint-Grégoire, which look like floating islands when it's foggy. I rented it for one year, enough time to look for something better and bigger. I'm still there. It's been eighteen years.

NOW

My instrument was no longer black,
but this secret light born of black.

– Pierre Soulages

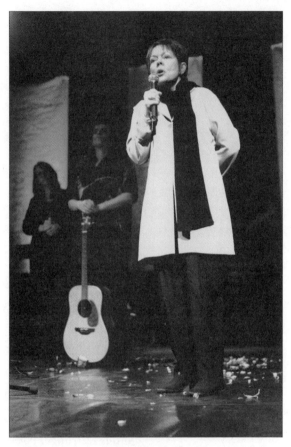

Madeleine on the stage of Montreal's Lion d'Or, August 1997

Women
and War

Since 1998, the year I turned sixty, I've been in the time of now, an extended time that circles the horizon under the vault of the heavens, wherever I am on the planet. There are two times in life: youth, when you age a little each day without even realizing it, and old age, when you've reached the point of no return. When aging is no longer that long journey toward your end. When you're within it, completely. At the end of the process of aging. Consciously in that absolute present that you can write or paint or interpret in music. Because you know you will not be able to reach the other side of that circle around the horizon. Because there is no other side of the horizon, ever. And because trying to plunge into it anyway is unthinkable, unrepresentable, and unperformable, that other side of the circle of the horizon being death. And because death cannot be thought. Or represented. Or performed. Just to conceive of it involves a single choice: to decide to live in the present.

In this present that is both gift and modality of time, there is a past, also full, and laden with remembrances, teeming and unruly, which will come in a jumble or one by one according to the whims of memory. They will be a delight for the painter, the musician, or the writer, who, needless to say, lives the life of an ordinary person. Paradoxically, this full present is not opaque. It allows a multitude of dreams, and even plans, to filter in, because the reason of the time before death is neither logical nor reasonable. Imagination is there keeping an eye on the days. Even though you know from mathematical science that you have fewer days to live than days you have lived, you're caught in the wheel of plans, programs, and utopias, a wheel that sometimes races out of control with its load and must repeatedly be held back, as when you were ten years old, when the time in front of you was so huge with its promises of a thousand possible lives that you didn't even stop to think about it and

revel in it, until the whole cart overturned with you in it, you who until then had been in the pure pleasure of things, moving forward, farther, elsewhere. Toward a life in movement and recreated by movement.

In this final age, you also notice that time goes faster. Like Frida Kahlo at the very end of her diary, you can only say to yourself, "I hope the exit is joyful."

To decide to live in the present. Which is not alone, but laden with stories past and dreams of an imaginary future. *Alea jacta est.*

It was quite soon after I made these observations about the end of this beloved life that I had one of my most extraordinary adventures ever, consigning to oblivion the sadness of the observations and their inseparable companion, the awareness, as keen as a burn, of the absurdity of a life born to die. That experience gave rise to two books, *Women in a World at War*, a series of essays, and its fictional counterpart, *My Name Is Bosnia*. The first was written in 1999, and the original French version published in 2000. This book was written quickly, in the speed and strangeness of trips across the Balkans, the Middle East, and the Far East, with frequent returns to Paris, where my colleague and friend, the journalist Monique Durand, and I had our home base in the twentieth arrondissement, which we rediscovered with joy each time we went back there. The countries travelled, the landscapes and the ruins, as well as the people I see again in the depths of my memory, are all characters in my writing.

The novel, *My Name Is Bosnia,* took a lot longer to write; it was published in 2005 in French. The quality of writing does not depend on the speed of its execution. As in music or painting, each composition determines its own space and time. The sentences on the page, the notes on the staff, or the brushstrokes on the canvas may come like a bolt of lightning or an arrow shot from a bow. The opposite is also possible; they may emerge with the infinite slowness of gestation. A raw, keen consciousness that long ago shattered in an instant can take years to be revealed in multiple shards in paintings, musical scores, or books, like gold-bearing sand running underground through the artist's work.

The response to *Women in a World at War* by the press, radio, and television in France and Switzerland was exceptional, and I thought for a moment that financial ease had finally come. That was reckoning without the cliquish games I have always refused to play, or the candour, an often negative quality, that made me confess in an interview that, yes, some characters were invented. What an affront to the documentary genre, which is supposed to be objective! The term *docufiction* was not yet current. And it was not yet acknowledged or understood that greater truth can in some cases be achieved through fiction. Will people ever understand that in writing, things are always filtered through the imagination?

In Quebec, both books were given a great reception. Especially *Women in a World at War*. Everyone my colleague and I met was impressed by what they saw as the courage and boldness it took to travel through countries where the blood of war was still warm and the ruins still smouldering. While I made a book out of those adventures, my journalist colleague and friend, a true artisan of those journeys and the agenda of the meetings – with victims, witnesses, and experts on violence against women in armed conflicts – had, on our return, produced a series of ten radio programs that were broadcast on the now-defunct cultural network of Radio-Canada and a little later by the association of French-language public radio broadcasters in Europe.

People found these travels by two women in more or less dangerous lands surprising and fascinating. We were both astonished by the enthusiastic reception. And we knew, too, that what they took for courage – and sometimes for audacity – was for us, from the moment the idea for the project arose, only a simple desire to understand the thoughts and feelings and the role of women in that eternal human drama called war. We wanted to grasp what the women we met had to say about the human tragedy they had experienced. We wanted to understand, but with them, their comprehension of the phenomenon of war. Their complex and varied views. Were they solely victims? Or were they sometimes accomplices in that expression of a death instinct in action, inextricably attached to the wall of flesh and memories of vengeance, age-old wounds they dared to glimpse through the flashes of

lucidity crushing them? And shattering the awareness of both of us. From our very first intuitions, around 1997, that we slowly formulated in many conversations and discussions and in studying the documentation available, and according to the understanding we each had of the place of women in war, we constantly asked questions. And often, our only answers were enigmas. We worked with them.

I am one of the rare writers who read reviews and learn from them. I even consider them natural extensions of my books. They have always permitted me to look back and rediscover my writing path. To take up the pen or the keyboard again. And to write again. Better. And further. Reviews that were true readings have helped me. Would I write without them? Probably. Because nothing, even the silence of echoes, will ever be able to separate me from the words that make books and allow me to understand the world differently. As for bad reviews, you just have to sweep them from your path like so many stones that your foot idly dislodges. And the nasty reviews, since there are always some of those, and even more when you've known success? What to do then? In that case, the stones have become boulders, and you simply have to change your route.

Today is June 3, 2012. It's Sunday. Last night before going to sleep, I read this sentence from a very beautiful little book by Laurent Gaudé, *Les Oliviers du Négus*: "There would be no place in that world of torments and struggle for the dying old." I woke up to the tolling of the little bell of Bon-Pasteur, muffled under the blanket of dense grey clouds – you can hear it better on Sundays, when the noise of commerce and the din of the trucks are quiet.

During the night, I had dreamed of my mother, whom I was taking care of, so old and trembling with fever and cold, asking me how it was that she was not dead yet. Not far from her was Jean-Jacques Brochier. In the haze between two dreams, I wondered how it was that they were together, she having died in December 1996 and he in October 2004, and, moreover, not having known each other when they were alive. They were together through the love they each had for me, and through the love I had given each of them. Through the incalculable affection free of fiery passion that characterized those loves. And through the kind

of blind belief each of them had, without saying much, in the value of my own writing.

On waking, I remembered my last meeting with Jean-Jacques. It was in the spring of 2004. He knew he had an illness he would not recover from, and he had told me nothing about it. We were at his table in a little restaurant in Saint-Germain-des-Prés. He had invited me to lunch, as he did each time I was in Paris. I haven't forgotten a single sentence we exchanged on that occasion. I've forgotten the name of the restaurant, but nothing of what we said. You hold onto the memories you can. Hypermnesia is just as bad as amnesia. Both keep memories from breathing.

Laying his hand on my forearm toward the end of the meal, he asked if my health was good. The words may seem banal, but the intensity of his gaze and his voice were not. You always hear the last words of the living better after their death, when you actually know they were the last. I answered yes, without thinking, not knowing my yes was falling on the ears of a condemned man.

We were very close to Grasset, which had always been his publisher. They had sacked him, he said, and so had the *Magazine littéraire*, where he had been editor-in-chief. Power-hungry Young Turks had pushed him out unceremoniously. He was alone. Alone like a finished old man who was of no use anymore to the builders of glory and fame. Alone, irremediably alone, like all the finished old men who are no longer of use to anyone. And yet he was no older than I. We were the same age, but Jean-Jacques had already been made ancient by lurking death, all human deaths, and his own.

The faces old people show to death are frightening. So we hide them. While they are banished behind the curtain of the big stage of life, the old enjoy themselves like crazy in the company of the stars. At that lunch, I talked with Jean-Jacques about my novel, for which I had been frantically looking for a title for months. After I told him the story, he unhesitatingly gave me the title I used.

(I've just been for a walk. Memory is truly a filter that operates through luminous holes pierced in an opaque background. The name of the restaurant Jean-Jacques took me to for lunch that Tuesday, March 30, 2004, has suddenly come back to me. It was Le Perron, on Rue

Perronet near Boulevard Saint-Germain. I went back there after learning of his death, but I couldn't go in. Something kept me outside, just as I hadn't been able to go into the bistro Le verre à pied on Rue Mouffetard, where I used to go for lunch with my friend Thierry in 2004, the year before his death that came so quickly, when as fate would have it, we lived on the same street, Rue du Fer à Moulin, a few houses apart, and we would meet at one of our homes or else in places in the neighbourhood that inspired us: markets, churches for concerts of religious music, and sometimes, at noon, when our respective writing had begun well in the morning, at Le Verre à pied, his favourite bistro.)

Because I wanted to talk about the two books on women and war together, I have skipped a few years. I would like to go back to them now. Back upstream.

After the deaths of my parents, the goodbye to the big house, which was sold, the difficult dividing up of their things, the execution of the will, and the return of a certain degree of calm to our wounded family, I see now that I would no doubt have been unable to survive without that love filled with happiness and joys, as are all burgeoning great loves. When such a love blossoms on the still-smouldering ashes of a dead past, either it quickly goes up in smoke or it becomes the spark for a new chapter of the story. The rest of the story would depend on both of us. In my case, it depended on writing.

I see now that the faraway foreign wars were, without my knowing it at first, a way to understand and cope with the little wars very nearby that occurred within the family – and in the most intimate places within ourselves. It took the last years, the final decline, and then the deaths of our mother and father, to ignite the flames of the fatal passions. Wars always arise from the anticipation of a death. I see now that between *Le deuil du soleil*, a requiem book tied to the passing of dear ones, and *Women in a World at War* (with its fictional counterpart, *My Name Is Bosnia*), I had, without knowing it consciously, asked the earth for a truce, a pause, and I had rested in a conversation with the elements in

Stone Dream, written from 1997 to 1999, the year of its publication. That writing was a reverie rather than a reflection. In Bachelard's sense, reverie does not exclude thought; it is its very foundation. Written mostly on the north coast of the Gaspé Peninsula, a country dug deep between the rocks of the mountains and the rocks of the sea, with inscriptions carved millennia ago by the flint of years, dark furrows and light of mica dust, galleries of shale piled with strange drawings of fossilized animals and crumbling forgotten ancient legends. I recall hours of walking and climbing, breathing deeply of the iodine and salt of the waves, attempting to decode those remembrances of centuries determined to survive, sometimes seeing in them murderous warriors, wolves prowling amid the bones of men, women, and children. From the open sea, I heard the music of the wind piercing the curtain of mist or disappearing muffled into the fog. I stopped often, taking my notebook out of my oilskins. And I wrote notes as I discovered things.

One day, I had nothing more to write, while knowing that the book was not finished. I let it, too, rest. I waited. I said to myself that this book was the last of a series in which matter and things were dreamed. It had all begun with *Pensées du poème* (1983), had continued with *La terre est remplie de langage* (1993), and it would end with this one, *Rêve de pierre* [*Stone Dream*], which, for the time being, had nothing more to say.

Then, another day, coming back from a walk on the shore, I heard the music of the book. The rhythm, the scansion, and the timbre of the fourth and last part, "Lecture des pierres" [Reading the stones], were given to me complete. I hurried into the little house, to my writing table looking out on the shore and the sea, and I opened my notebook. The music was there. I needed to find the words that fit with it. The words came, all by themselves, it seemed. That's the way it is with poetry. I thought of the magnificent poem by Aragon, "Tu n'en reviendras pas" [You won't come back], which ends with these words: "Already the stone thinks where your name is inscribed / Already you are no more than a golden word on our squares / . . . Already you only exist for having perished." The golden words shone in the setting sun. My "square" was as vast as the whole Gaspé Peninsula. There among the names on the stones, I had inscribed the fictional names of Jeanne and Jean-Baptiste.

I had gone beyond the torments of familial excess and suffering. I had created. Sublimated. That was my last book of poetry.

If I had written every time I stopped writing this book, doubting the need for it, I would have made another book. *The Book of Questions*, like so many negatives that were never developed. *The Book of Doubt*, more precisely, in which the beautiful assurance of the beginning that dared to believe it was following in the footsteps of an imagination Montaigne vanished. The book of the loss of beliefs, in which an invented God, the father of autobiography, disappeared forever.

Then, in the morning, it was obvious. Just like that, a ray of sunshine cut through the fog bank. You had to continue, to stop asking questions, not too many in any case. To continue to dip your pen into the ink of memories. No new evidence struck you. It was a "salvo from the future," as René Char said of poetry. You had to stick with what you'd started until the end, that autobiography without which you would disappear from this life. You had no choice. It was a matter of survival. So you took to the road again with your baggage, from which you once in a while took out a story, another event that could not be lived otherwise than by aging in the soil of writing, narrative, myth, dream, or poem. You were rich with that material; indeed, it was your only wealth. Otherwise, you knew, you were as poor as Job, always in the lean years. You would never have the house, the garden, or the piano of your dreams. Apart from the people you loved, your only wealth had gone into the words of your writing – and sometimes speaking.

This morning, with the sunbeam coming into your house after days of rain and wind, you were brought back to a similar sunbeam falling from one wall to the other across the Provençal cottage you lived in one year, in Cucuron in the Lubéron, which was nestled against the little chain of mountains that ran to Manosque and to Sisteron, and from which you could on clear days make out Montagne Sainte-Victoire, all blue, while you were in the mauve of the Grand Morne, feet on the crunching herbs that had been growing there forever. That time, you had been in the same

sunbeam as the one this morning in Montreal, the same caressing beam of light, because it's the same sun from one country to another.

It was 2001, the year of intense promotion of *Women in a World at War*. I spent months travelling back and forth, taking the TGV to Avignon and then to Lyon to go to Paris, Geneva, and Brussels, or Toulouse and Bordeaux, or to return to Lebanon by plane. There was also Oslo, where there was no wine flowing, but rather beer with its sensible meals; Oslo and its Frogner Park with the majestic, sad sculptures of Gustav Vigeland; its Viking ships that I would have liked to take to Lapland, starting from the southeast, from the end of Oslo Fjord, crossing the Skagerrak Strait. Where in the evening in the street you'd see drunk pink-cheeked men who beat their wives; where we went to a concert at the National Gallery and the whole audience stood up as one, religiously, when the queen came in dressed like a well-brought-up young lady – Sonja Haraldsen, First Lady of Norway.

The year when each journey in the surrounding area became a pilgrimage. Aix-en-Provence, an hour's drive to the south, where every little crossroads took me back to 1962–1963, when I would walk there, pregnant, protective hands on my brooding belly, and after childbirth, with baby Charles in the stroller when we did our shopping on Rue des Italiens and we would go down by the fountain of the Four Dolphins and back up again by the Cours Mirabeau and our street, Boulevard du Roi-René. Our house had remained the same, as had all of old Aix, and each time, I could have kissed the two blocks of grey stone that served as steps to the entrance, from which I would climb up to the "converted attic," but now without my baby, and, as I did at the fountain where we would rest, weep hot tears. But I was not sad – I was happy in these places, and so in love – I was just moved by the past, which had also been happy. That's how it is with nostalgia.

The year I saw Manosque again and was caught up in the same sweet melancholy, the same happiness as before, because today when I return there, I'm still carried away with happiness. (I wrote about that rediscovered Manosque in Part Two of *My Name Is Bosnia* a few years later.) As for Sisteron, we passed through there on our way to Croix-Haute Pass and Grenoble, where I was going to pay homage to my indirect

ancestor, Stendhal. But Sisteron also for a phrase in a poem by my friend Paul Chanel Malenfant: "We will come back to Sisteron."

The year I wrote *Mémoires d'enfance* [Memories of childhood], at the request of Victor-Lévy Beaulieu, the author and publisher at Éditions Trois-Pistoles. He had created a collection called *Écrire*, in which writers described, in a maximum of a hundred pages, as he had specified to me in a letter, "the why and how" of their writing. I loved that request from this writer, who wanted other writers in this way to honour his little publishing house that had grown big. In those fragments of childhood memories, I continued, but in a more elaborate form, what I had started with *Là où les eaux s'amusent*. In both cases, it was a matter of telling about the key moments (the *kairos*) of childhood onto which the first sprigs of the imagination of writing would be grafted, like fragments of autofiction that would be the basis of the books that punctuated my whole life, including this one.

High
Mountains

When I was young, I dreamed of the high mountains, and climbing and camping in the wilderness, where we would eat bread dipped in bowls of steaming goat's milk. It was the period when I was reading books by Father Hublet, a Jesuit who enchanted a generation of Catholics in the days before social media. At thirteen or fourteen years old, I had such a love of nature that I clung to it, immersed myself in it, even melted into it, not thinking about anything when I was in it. My friends and I would sometimes get up in the middle of the night and go to the top of the hills surrounding the village to see the stars shining and then disappearing and the sun rising above the treetops. We had left our houses without our mothers knowing, and there, in silence, totally absorbed in the beauty of things, we rejoiced while crunching our apples, the sounds of which mingled with the first notes of the birds waking to the day, as exhilarated as we were.

Each of those moments stolen from the time of the normal life of beds and houses would bring back my crazy desire to go away. To go elsewhere in the world, everywhere where beauty was beautiful and grandeur, grand. Everywhere where nature woke up fresh from the great silence of the nights. Everywhere where waking remembered the dream of the stars. Everywhere where the murmurs of dawn made themselves heard to the perfect pitch of those who took the trouble to listen for them.

I was there today, in the high mountains. In memory. In Savoie. In a village built on ancient ruins of medieval stones, perched at 1,200 metres altitude above the Maurienne Valley, from which we saw the snow-covered peaks, including Mont Blanc. I was there in the flesh, in that place a thousand times imagined at thirteen or fourteen, and as always, the reality was greater than fiction. Except that the reality was all the more impressive for having passed through the layers of invention of fiction.

We were living in one of those medieval ruins, which friends were restoring, patiently, intelligently, so that a house emerged – there were only three in the village – a witness to two eras. If its walls could have spoken, we would have heard the sounds of herds of humans and beasts rushing down the slopes and escarpments, tattered soldiers returning from lost wars or stubborn Resistance fighters, shaggy haired, hiding from the bloodthirsty conquerors. Or the screams of mothers in the throes of labour, followed by the wails of their slippery newborns. We would have heard the cawing of giant black buzzards come to feast on the placental remains and then flying off with a mournful whistle between the walls of the unmoving foothills that we could make out some nights.

On a few occasions, a friend of the family of rebuilders lent us that house with the walls that spoke. We would walk on the steep path traced by centuries of footsteps. Surrounded by the circular wall of mountains whose southern and northern slopes told the time of day under the sun, alert to the slightest noise from the valley below or from other villages, invisible, which made their presence known by the ringing of bells, villages far away or very close according to the intensity and the echoing of the bells. Permeated also by the sounds around us: the snorting of an unknown animal, the humming of imperceptible insects, the rustling of leaves and wings, the lapping of some hidden spring, and the cacophony of echoes coming from all the mountains together. Sometimes we heard the bells of cows or sheep being driven down from one village to another by a herder with a reedy voice accompanied by the happy yelping of a dog.

In that populated solitude, we were alone without really being alone. Against the background of silence that seemed immutable and tinged with eternity, the mountains gave us muted music and words to write. In the infinite spaces that writing strives to explore, the great silence of the mountains met the polyphony of the ocean. Two limits of the earth that might seem superhuman, but that humans have dedicated their lives to conquering: mountain climbers prepared to sacrifice themselves and seafarers determined to cross the seas from horizon to horizon, from waters to waters and from port to port, so that one day it might be said, "You have explored the waters of the entire

planet, mariner, discoverer, geographer, and explorer of new continents, we justly honour and value you."

Accustomed as I was to the music of the seas I had known and to the ordinary sounds of a gentle valley, its hills, its leafy trees, its fields of grain, its little herds and flocks clearly visible, lowing, cackling, or bleating near the stables and henhouses, and the homes filled with the humans to whom those familiar animals belonged, I was stunned by the first night I spent in the high mountains. The silence kept me awake until dawn, until things outside and inside regained their usual dimensions, at least usual in those places of ultimate strangeness.

I had fallen asleep immediately when I went to bed, but soon after, the all-powerful darkness woke me up. I got out of bed and walked a few steps to the window. Before me, I could make out an immobile mass that blocked the horizon like a great wall so high that it was impossible to see any part of the sky. Not even a glimmer from moon or stars. I searched, but I saw nothing but that barrier surrounding us. It took me a while to understand that it was the mountains, that massif of which we were prisoners, and which the dark night revealed in its true immensity. I was in the darkness of fear, as when we were children and we'd scare ourselves by sneaking into the attic, where there was no electricity and the windows were blocked by all kinds of unrecognizable objects and hardly let in a ray of light from an opaque sky.

It took me some time to get used to the mountains. I gradually understood that I shouldn't try to approach them head-on. There were thousands of trails that had been created between the stones over as many centuries. From time to time, you'd have to take one and then another, and go up or down by as many walks as there were human beings to clear paths, and follow the traces that (almost) always led to familiar places – a chapel, a watering trough, or just a rest stop where you could sit and think on a natural bench, a big flat rock smoothed by time, where you could see what others before you had seen in wordlessly designating it a rest area: the mountains spreading 360 degrees around, to the highest ones in the distance, even more solemn than ours, or, looking down, some emerald lake you'd gaze at fascinated, whose water you'd have liked to go down to and touch or swim in, but it was so far.

It could be dangerous, you'd think, right when a monumental golden eagle followed an imaginary line between two peaks and dove into your peaceful lake with a splashing of wings and water.

One day, I understood why monks and nuns built their abbeys, monasteries, and hermitages high in the mountains. First because they believed themselves closer to God, to heaven and its inhabitants, since the celestial vault was always seen as the ground floor of the true divine heaven. Also because the great silence of the high country enabled the mystic silence from which prayers and songs could soar toward the sky, freed from human cacophony, and there await the great day of the passage to eternal life. The monks and nuns left the siren song of the sea to the mariners.

Women
Alive

One day in July 2002, I received a call in the Gaspé Peninsula, where I was spending the summer, from the person in charge of the Prix du Québec. I had been awarded the Prix Athanase-David. It was one of the happiest days of my life. I felt three emotions: joy for this honour I was graciously being given; gratitude to the members of the jury, the colleagues who had submitted the nomination, and all those who had believed in the merits of that gift; pride too, in my ancestors all resting in this soil, in Quebec City, Île d'Orléans, the Beaupré coast, and the villages of the Lower St. Lawrence and the Gaspé Peninsula.

I found the last feeling surprising, as if I had carried in me, and in the very heart of my writing, the ancestors who had come from France so long ago, pioneers who had toiled, who had broken their backs clearing the land, cutting down trees, building houses, laying out roads, and later, when they had the means and the time, had studied in the little country schools or boarding schools. I was proud, too, for those women, often in poverty and always in pain, who had brought so many children into the world, all the way down to me. I thought very hard about the women I had known, my grandmothers and my mother, my aunts and all my female cousins, the richer ones and the more modest, the educated and the ignorant, all of them wise and generous, I thought about them and I thanked them for this gift. Then I took a walk along the water. I saw them all again, the ancestors and the living, and paid them a silent, emotional tribute of gratitude and recognition, which I entrusted to the open sea like a secret gift carried off by the waves.

I had experienced the same feeling of closeness to my ancestors when my town of Amqui named its municipal library after me in 1998. When I go back there and see that name in wrought-iron letters on the

facade, I feel intimidated and moved, and I have only one desire: to return to that land of my origin when I die.

And later, when I received another prize, from Romania this time, the Ronald Gasparic Prize, named for a young writer murdered at the age of twenty-one by the dictatorship. Not knowing anyone on that jury, from there or from here, of course, I greeted it with joy, with a feeling of distant fraternity, of strange closeness to the poetry of a young poet who had been sacrificed. This time, I had the feeling of belonging concretely to the "unavowable community" Blanchot spoke of, avowed here through a gift come from the elsewhere that poetry – his, mine – had brought near. (Going for a walk after that news, but in the streets of Montreal, where I was at the time, I dreamed that I could also be buried in Romania, and thought how lucky believers are: in my place, they would say to themselves that their ancestors under the ground and in heaven might perhaps be conversing with that young unknown poet who had been introduced to them through the magic of a Romanian jury that had read the poetry of their still-living relative.)

I have always been delighted to receive honours and tributes for my writing. I do not belong to the brotherhood of the humble. I say *brotherhood* because the self-proclaimed humble are men, writers who are respected, celebrated, even glorified, who with each laurel wreath, medal, or prize never fail to remind everyone of their modesty. Who quote each other and congratulate each other. It is a brotherhood, I tell you, a band of brothers who are self-effacing in their fame – a nice paradox that dazzles, or should I say, blinds, many. This renown of the humble, with a few well-known exceptions, eludes women. With women's historical (and time-honoured) erasure from the great works of the whole of humanity, how could they be expected to cultivate humility? Having been present on the great stage of the world for barely a century, they are striving, slowly and sometimes clumsily, to cultivate self-esteem and pride, and have little time or desire to join the brotherhood of the humble. Besides, would those male peers of ours want to have in their inner sanctum rebels like us who would quietly slip away at the first expressions of the false modesty and true arrogance that drive them?

The opposite of that brotherhood is those who love the limelight. Soloists infatuated with their success, blazing a trail to glory, they are on every public stage, shamelessly parading their arrogance and vanity. You hear them everywhere. They constantly cultivate the gardens of fame. They too are writers, but in the end, having seen too much of them, we no longer read them. Women writers are in no danger of taking part in that conceited chatter. With exceptions, once again. I have a few friends among the writers of the brotherhood of the humble. It would be more difficult for me to find friends among the lovers of the limelight, who generally cannot stand me.

It is difficult for us women, and for myself, to find the right balance on this question of the social legitimation of a profession that is dear to us. Like all women, I belong to the lineage of human beings of the shadows. That lineage absent from power – the power to rule, to govern, to navigate, to conquer and discover, to be a warrior, a philosopher, a writer. I was not part of the representation of power and wisdom. Still today, when one thinks of the wise or of leaders of government, it is deep voices and grey temples that come to mind. One never thinks of national funerals for women who have written. Or sung. Or painted. We're not in the habit. Males can afford to think themselves humble. Women don't have that luxury. Not yet. I am in that lineage of the shadows. The danger that threatens us women writers – like all women in the public eye – is envy. In the historical sisterhood of the obscure, we have learned mistrust and rivalry. Having barely achieved self-recognition, we have difficulty building alliances, even silent ones.

During the 1970s, we attempted those new solidarities. Incapable of reading each one of our voices, the critics confined us in a category labelled *feminists*, which didn't last long. Chapters on "feminist writing" or "women's writing" (and their variant "writing in the feminine") in anthologies and textbooks on Quebec literature were published for about a decade. Not only did the generic category deny the individuality and originality of each of the voices of my generation of women writers, but it quickly disappeared from the textbooks, to be replaced by "migrant writing." I have nothing against reading writers, men or women, who have come from elsewhere – only, as with women, putting them in a

fixed, stable category can prevent readers from getting to know each unique voice and individual imagination.

The multiplicity that is revealed in fiction and poetry makes it possible through reading to reconstruct the polyphony of writing, be it from here or elsewhere, whose ultimate purpose – whether or not the writer is conscious of it – is to give back to the world a truth (or truths) that it is impossible to define without that writing. In order to grasp that multiplicity, we have to spend time with books in their singularity. Not smother them in educational categories and criticism that deny the originality of each one. Or reduce reading to gender or geographic identity. As an institution, literature is national: it is dependent on a nation, a people, and a geographic space. Whereas writing always transcends borders: it is universal and is disseminated in many unique voices. One of the most insightful readings of *Women in a World at War* was by Philippe Trétiack, in *Elle France*. He compared the writerly quest in the book to that of V. S. Naipaul. A Western woman from the north and an Eastern man from the south: on the surface, everything about these two writers seems opposite. Except for the writing, which, like algebra, transcends the primary identities of gender and geography.

May the young generation of students, who recently provided a brilliant demonstration of a new social consciousness – today is June 16, 2012 – regain their relationship with history (the history of humanity, of their country of Quebec and its literature)! June 16, Bloomsday, the day of Joyce's *Ulysses*. All young people who want to know where they come from should take a trip through the labyrinth of their people's imagination: its fiction and poetry.

As for women from here and elsewhere who have lent their writing to the just cause of relations between men and women, and their own emergence from the shadows, let us not be too quick to sign their death warrant or declare their movement dead. Feminism is not dead. It lives on today, differently. I was part of the feminist movement of the 1970s and 1980's. I am still part of it. The proof is that I am writing this. I am still writing. We are still writing. Don't pronounce us dead just yet. Before the death knell has truly sounded. As long as we are not dead, we are still alive.

Informed readers, young and old, please let us distinguish feminist discourse and speech from writing as such – which, generally speaking, criticism failed to do in the early days of the movement. Often, the writing itself was ignored in favour of the political discourse. Unfortunately, certain major writers have not been able to read the women of their time because of this confusion. As if the message of Zola's *J'accuse* had prevented the critics of his time from reading the writing in his novels. Closer to us, I am thinking of Kundera who was sadly wrong on the question of women, their discourse and their speech. His great book *Testaments Betrayed* would have gained in philosophical and educational import if he had recognized the blindness of his novels to relations between men and women. And the abysmal absence of an intelligent female voice at the very heart of amorous desire. That master of the novel would have done us a favour had he recognized this deficiency that has always defined us in the order of discourse.

Despite everything, we are uncompromising. Like the non-fissile nucleus of the atom. Here in the shadows, precisely, where we have endured for centuries. Passion, desire, and love have kept us awake from century to century. Penelopes of the day, Penelopes of the night, we have been patiently weaving. We have prepared our words. Sharpened the words of our writing, which emerged into the light of day fully and voluminously in the middle of the twentieth century. We have created works of life from language to language. Stop telling us we're dead. As long as we live. As long as we write. As long as we breathe. We are alive.

EPILOGUE
IN THE
FORM OF
A FABLE

So much happens on the periphery that it is hard
sometimes to come back to yourself.

– Jacques Rancourt

We were all together, the living and the dead, all of us, women writers of what was called the women's movement. There were even some who had come from before, before us, some of them dead, others not. I saw each one of us. We were walking in groups or two by two, and even a few alone. We were in a big garden in front of a huge house with many floors – which looked like the house of my childhood. We saw lights on in the windows. We saw shapes moving from window to window. Caught notes of music, heard snatches of conversation, disconnected words fluttering between mouths and ears. There was a party going on inside. A party for male writers, all masked, they too both dead and living, celebrating each other.

Among the women from before, walking more slowly than the others because they had been gone a long time, I recognized George Sand and Colette, both of them surprised at being in the same garden at the same time. Then the two Marguerites, Yourcenar and Duras, who were having a lively discussion and laughing. Virginia Woolf, though, was all alone. I saw her leave the garden, cross the park along the riverbank, pass Anaïs Nin – they smiled at each other – and bend down to pick up some stones, which she would put in her pockets in order to sink when she went into the water, remembering her book *The Waves* – which was translated into French by Yourcenar, but she would never know it – reciting certain passages of that long prose poem, and her body would sink straight down toward the dark, eternal abyss.

In the park by the river, I saw Louise Labé and Hélène Cixous, the former dead, the latter alive, take each other by the hand and decide to go into the little woods to the west, where they would disappear from our view and would walk for a long time, a longer time than our human measurements can calculate, through underbrush and dense forest as far as the tundra, would go away to the other side of the horizon line, singing.

In the garden, a group formed around a table under a weeping ash to study and conduct a "home writing workshop" – they had indicated it

with a rough wooden sign. It had been Claire Lejeune's idea. There were about a dozen of them, studious and cheerful, including Flora Tristan, Olympe de Gouges, Annie Leclerc, Nancy Huston, Louky Bersianik, and Marie Savard, who was laughing heartily and said, "We don't think the moon is made of green cheese. We don't think mikes are phalluses." In a corner sitting on a rock, Denise Boucher and Christiane Rochefort were almost shouting: "We want to change groups. We've had it up the vajayjay!" I offered them a cigarette, told them, "It's good for your lungs," and disappeared. Don't really know where I disappeared to, since it was me.

So where was I? A dream doesn't make an ending for a book, what was I thinking? I had wanted to look at "why autobiography" and whether it's different from autofiction. Is the question of truth the same, the truth of memories of events or people, the truth of the evocation of flayed flesh burning with being cut out of a body, mine, which has preserved it like so many sheets of paper stuck to its carapace, torn sometimes until they bled with words and other times like fine papyrus from which phrases would flow and poems that would arrange the story of a life, mine, knowing that it deserves no more than all the others to be written, to look back at itself, but as much as all lives, to be exposed in a singular truth to which each man or woman has a right, but which they all subsequently avail themselves of since they all have bodies that have saved it, some seem hardly to care. What do they do to get away?

From what? you will reply.

There I was, asking myself these questions, knowing very well that fiction is everywhere when you tell your own story, that it is even there when you tell another's (but which other's?) story, so that you would also have to invent a word for biography: *biofiction*. And to know that there are as many truths in biofiction as there are in autofiction, since truth does not involve *logos* alone, but mythography also turns it to advantage. I hear a little (inner) voice saying, "What's gotten into you, Madeleine? Why are you losing us, when until now you held us by the hand?" "Because I'm lost myself," I answer. Because autobiography (or autofiction) is precisely the story of one's own loss, because nothing would be written if nothing had been lost,

vanished, gone away. If nothing had disappeared, perished, broken off. If nothing had dissipated, evaporated, fled, dissolved, drowned. Finally, autobiography – or autofiction – is the multifarious story of averting fate and keeping death at bay.

While I was musing about these questions, I told myself what I mustn't forget in this last chapter, this epilogue invented only to avoid leaving the book. I asked myself "how to manage afterwards?" The way you ask yourself in your heart how you'll manage when the children are gone, really gone, when the boys have become men, when they're travelling distant roads, each with his own stories, his own autofictions, and when you, mother, have without knowing it become one of those pages torn from their own stories until they bled with their words, when you, mother, could do nothing if, for example, they were swallowed up by the muddy ground at the limits of a land of war, from which they would return only when this body that carried and loved them had turned to dust, sand, and ashes.

Or that "how to manage afterwards?" of the youth behind you when, all around, old age is scorned, looked down on, and its speech (or writing) has lost all authority – unless you are male and a wise old man, of course – when it is no longer a friend, or hardly, when it is replaced because its body is no longer an object of desire, never again an object of desire, but constantly reminds everyone of its closeness to death, and death frightens, so they turn away, they pass it whistling in their heads, and they start hating it – death as well as the person who carries it – finding all the faults of the world in it, scorning it, repudiating it, simply because life has imposed another lover on it, who kisses the body, covers it, no one wants to see it, they free themselves from it, everywhere they hate death, regardless of what the pious say, or the human ostriches, of whom there are millions in the world, your blinded friends among them.

Who is She who does not make us laugh?

In the extreme heat weighing down on Montreal in late June of 2012, after a bright season when youth by the thousands took to the streets to defend universities that were not businesses but rather places of creation and invention, where one would be able to rest while working on the

Gay Science in every domain, where the life of the mind was restored to its happy place, where the sciences, arts, and philosophies would quietly win out over the *moneychangers of the temple,* where there were also the middle-aged and the old who had dreamed of coming back to that temple, and I was one of them. From my window in the centre of the city, my front-row seat on the twenty-second floor, I saw them march by each evening, I saw them confront the police sent by the merchants of knowledge, equipped with an unjust law, the shameful Bill 78, which drastically curtailed the right to demonstrate. I was with them, but from my window, when the armed battalions and the police came on foot, on motorcycles, on horses, or in cars, and when the brutality squads handcuffed them and took them in after throwing them to the ground face down, arms twisted, and legs crushed. I was both shocked by that coercive power that had returned with its malevolent deeds and rituals, and happy to have contributed in my way to bringing into the world this generation of youth that was finally rebelling.

I said to myself, I have experienced this, I have had the time to witness this awakening, I have had the time to hear this clamour, to see the joy of those resisting the steamroller of big capital, the eloquent happiness of the young despite the blows they took, and even though I can no longer run with them through the jammed streets with the sirens screaming, even though I can no longer flee down little roads and alleys or climb hills and rocks, as I did so often on the beach at low tide on the Lower St. Lawrence or the Gaspé Peninsula, even though I can no longer clamber up and down crests at high speed with the animal body that was mine, and my balance, coordination, and agility are lost forever, I am with them, resisting with my whole being, and my keen heart and spirit have become a huge red square covering this body-continent from horizon to horizon, blood-red, life-red, beating to the rhythm of the oceans and all the continents.

I saw the demos going through the streets of my city and I danced in my heart, not that frenetic disco dance of people who have nothing to think or say, no, but that dance that thinks, like Nietzsche's dance at the end of thought, at the limits of *logos* when the poem takes its place, fills the stage, fills the space stage left and stage right. I saw girls and boys

marching, because with these enraptured young people, the revolution was no longer just the business of the big male bullhorns, the loudmouths who screamed and shouted and swore all alone above stunned crowds, no, there were as many girls as boys, and the voices of the boys were neither loud nor swearing, they were even soft, but with the softness of the truly strong. What we were asking for in our feminist youth was not in vain, then, it had borne its fruits in a generation that, while it had long seemed asleep, was not sleeping, it was preparing.

When I saw, through the window of television, that the demonstrators in Egypt, religious to the hilt and the rifle butt, were raping women by the thousands when they tried to join them, and that those war crimes, crimes against humanity, were not yet being condemned by anyone, by no international judicial body, I said to myself that feminism, which is far from dead here, should turn its gaze and its consciousness toward all those places in the world where women are detained, tied up, and raped by perverted jailers, and I told myself as I fell asleep last night that the women there will have to work for a long time to free themselves from their shackles, just as it took a long time for the slaves to gain their freedom.

The women from my dream came back again in the sleep of a heat wave and the mugginess of a coming storm. First I saw, on the edge of a field of oats to the northeast, Flannery O'Connor, who was going toward Susan Sontag to have her sign a copy of her book *Illness as Metaphor*, which Susan Sontag gladly did. Speaking in a low voice, she said – I read her lips, the way you can in dreams – "I'm going to leave soon for the beyond, *this* cancer is mine." Then I looked farther, where there was once a little point where my friend Orietta drowned at ten years old, and I saw Rosa Luxemburg hand in hand with Sigrid Undset, and I remembered as a teenager reading *Kristin Lavransdatter*, a novel that opened the door to Scandinavia, and then to the whole world, for me, just as, a few years later, the novels of Dostoevsky and the poems of Marina Tsvetaeva opened the Iron Curtain and Russia all the way to the distant Orient. I would never have imagined that Rosa Luxemburg and Sigrid Undset could have known each other, and even less been together on the little point. Then I saw Doris Lessing and Dorothy Livesay, Suzanne Jacob and

Marie-Claire Blais, walking toward them two by two. The four of them entered the commemorative park created by the town and they became little black marks, like the black keys of the piano against the bright white ones, or like branches against the leaded glass of the sky – which was pure azure that day.

I went back near the party house, where the humble male writers were having a drink, quoting and congratulating each other. A few of them stole out the back door and, almost shyly, came over to us. There was Saint-Denys Garneau, who joined his cousin, the great Anne Hébert, on a flat rock on the riverbank, and suddenly the Matapédia had become the Matane, and then the Rivière du Moulin, and Anne was resting her bare feet in the fast-moving water, she had tossed her shoes into the underbrush beside the steep trail, she was watching the water flow, she seemed so far from us all and she was crying. In the backyard of my childhood house, the nice guys who had escaped from the celebration of the humble were conversing among themselves, hands in their pockets, looking off into the distance, but I couldn't hear the words from where I was. They saw me and came toward me, I recognized about a dozen of them, including Yvon Rivard, Robert Lalonde, Paul Bélanger, Pierre-Yves Soucy, and Paul Chanel Malenfant, who stood behind the others, he was afraid, he was trembling, I didn't know why. We ate sandwiches and drank rosé by the footbridge. Georges Leroux arrived with Claude Lévesque, and I said to myself, "It can't be, Claude is dead," but "Yes, it can," Georges replied, "with writing, anything is possible, with autobiography, even more so." There we all were, leaning on the railing of the footbridge watching amused as Louis Hamelin and Jean-François Beauchemin paddled by toward the Restigouche in a canoe, fishing rods at their sides; before disappearing from view at the bend by the church, they tipped their old young fishermen's hats to us.

An instant later – but in nights like these, instants are eternal – the guys and I at the same time saw a group of young women sitting in a circle on the grass, they seemed to be playing cards or dice or taking turns reading texts they were proud of. I recognized Denise Desautels, Diane Régimbald, Nicole Brossard, Louise Dupré, Hélène Dorion, Martine Audet, and Louise Warren; others had their backs to me,

so I couldn't see who they were. Nancy Huston was walking along the sidewalk on Rue Sainte-Ursule, calling to them, "Girls, I want to be with you." "Come on then," said one of them, while another, I don't know who, shouted, "I'm all in favour, but what's in store for you is ignorance and oblivion. Time will quickly erase you, as it will us. The humble guys will see to it. You know, with us, glory lasts as long as a rose." It was then that we all heard an epic argument going on: Rosa Luxemburg was bawling out Sigrid Undset, calling her "a petit bourgeois who's written some excellent novels, that's all very nice, but you've never stood up for the cause of women, much less the proletariat." Sigrid Undset defended herself as best she could, but things were getting nasty, until my grandmother Rose, in the window of her house, banged a wooden spoon on a pot and yelled, "Girls, stop arguing! Go to bed! We want to get some rest!"

Coming toward us on the footbridge, accompanied by my friend Daniel Turp and some other brave gentlemen, were Normand Baillargeon and Laurier Lacroix. With them, I recognized Thierry Hentsch and Gilles Dostaler, who were chatting, and, running after them, Régis, who was pleading in German, "I want to be with you, I want to be with you." They welcomed him with open arms and took him with them although he was coming back from such a long time beyond life. These good-hearted men, worthy sons of Don Quixote, reached the circle of women sitting on the grass, which now included Monique LaRue and Madeleine Monette, as well as my two sisters Raymonde and Françoise and our dead little sister Pauline. Slowly, as if in a procession, my two sons came forward, and then my four brothers, their uncles, and then my uncles and my male cousins and the grandfathers, including Jean-Baptiste, wearing his straw hat and looking kindly but skeptical, who asked me, "Are you for the independence of Quebec?" To which I answered, "I'm for the independence of Quebec, but I'm not a nationalist." He had *Le Monde diplomatique* under his arm, he opened it and said simply, "You'll explain it to me when you have time." It was just at that moment that I turned back toward the house. I saw that the brotherhood of the humble had left, the lights were no longer on, it was morning, and in the kitchen window were my mother and my two grandmothers, Ernestine and Rose. The

house seemed to be teeming with aunts and children, they looked happy, and Jeanne's smile, as broad as a half moon, lit up the earth.

A young man carrying a bundle like a hobo from the old days, who seemed to have come out of nowhere, went straight to the house under the window of the three women, raised his beautiful curly head, and said to them innocently, "I'm hungry, and I'm looking for a wise man." Grand-mère Rose, or perhaps the three of them together but in a single voice said, "You can come in. We have mountains of food, we're all good cooks, but as for the rest, you see, young man, young angel, the house, the yard, and the garden are filled with wise women, from the one who brought you into the world down to them. But first, come and eat."

I write this as I mourn an old and very close writer friend, the unparalleled Assia Djebar, who died February 6, 2015, a mere few days ago. All women and many men should be grieving today the departure of this author, occasional translator, and filmmaker, of Algerian origin. In her work, she used French, the language of the colonizer, to help dissipate the male colonizer's view of Algeria and show a truer one, that emphasizes the life (and suffering) of women before and after nationhood was achieved. We have lost someone whose voice and values were truly necessary to our current and future well-being.

This so-tragic event multiplies, however, the pleasure I take in reading the autobiography of Madeleine Gagnon, an equally shining feminist star in the Quebec firmament. Like Assia, she was accustomed to using her own existence as subject matter for her fiction and non-fiction. Like Assia, she increasingly portrayed the hidden and public lives of women. Here she offers a fascinating analytic overview, weaving her own life into that of her native Québec.

Although opinions may diverge on this issue, Madeleine, certainly an avowed pacifist, has always perceived herself as living in a colonized country, Quebec; she is therefore in favour of Quebec independence. Unlike Assia, she always writes, not in the language of the colonizer but in the language of the colonized: French. Much of her energy has traditionally been devoted, in English Canada (The Rest of Canada) and across the Western world in particular, to making known and supporting the language, the literature, and other cultural phenomena of her native land. She believes that the only way to know a country is to bathe in its writings, its paintings, its music, and so on, and she has encouraged the world to wrap itself in the productions of her country. She may well be the best ambassador ever born for Quebec.

To read this book by Madeleine Gagnon is to read Quebec and its evolution. It is not necessarily a paradise on earth that she offers us. Indeed, from her earliest years, she was aware of the injustice and oppression that flourished in her environment. Her own childhood was in fact very happy, in the midst of the traditionally large, rural Quebec family; parents, aunts, uncles, cousins, all kind and friendly to her. One must assume, naturally, that she did not always see the physical and psychological violence that took place behind closed doors or that might be waiting to explode in her later years.

She certainly came to understand that women were almost totally oppressed by the Catholic Church and frequently by the males in their own families. Wife beating seems to have been a common and acceptable occurrence, although Madeleine quotes one suitor who promises his future father-in-law never to beat his future wife! Men were not always free either to live as they chose, even if the Church did not weigh on them quite so heavily as it did on women.

And so, wherever Madeleine turns, the religious boarding school, the birthing hospital, various artistic communities, the world of publishing, with a few exceptions, she is subjected to unreasonable authority, to contempt as a "would-be" female writer, to silence and oblivion in critical circles; the list is endless. Gradually her lifelong struggle against injustice, which began because of the general oppression that characterized the country she was born into, becomes more focused and turns into a rejection of patriarchy, which is alive and well in various countries, cultures, religions, or beliefs. Not all men were hostile to her ambitions and her achievements; indeed her father exceptionally encouraged all his daughters to pursue their education. It remains true, however, that women who broke the pattern were generally despised as deviants. Fortunately she did find much, if not total, support among women; more enlightened men also encouraged her ambitions and promoted her writing.

Madeleine's literary production evolved over the years as her consciousness of injustice grew and Quebec society started breaking its chains and engaging in its Quiet Revolution. Many of her early writings, inspired it would seem by her recent readings of Karl Marx and Friedrich Engels, certainly did much to disturb her Church-bound compatriots,

brought up to fear the Communist threat. Then, gradually, she came to realize the horrors of the Shoah; beyond that, after absorbing tales of colonization in Ireland from her first husband's family, she lived her first experience of the persistent maltreatment of Black people in the United States. And so it went on. The more she travelled and the more she read, the more oppression she found. And she learned that the oppressed can also oppress; a male victim can very easily express his discomfiture, his rage, on a woman, for instance. Madeleine's refusal of injustice will focus on the abjection of women, as she reveals in particular in her famous book *Les femmes et la guerre* (*Women in a World at War*), later made into a radio series.

Feminism naturally takes many forms. It also functions with bursts of energy. One can quote here the women of ancient Rome who, even in such early times, were given to demonstrating against perceived injustice. The difficulties of daily survival already prevent a continuous regular stream of action, as do changing circumstances which require regular regrouping. As Madeleine was writing this autobiography, popular opinion suggested that feminism was a thing of the past, a belief she did not share. And how right she was. In our Quebec, Canadian, North American society, we are now living through a resurgence of active feminism, as we see on all our social media the famous men who either allegedly or provenly batter and/or rape, even kill women, for their own pleasure or to reaffirm their power.

Madeleine's feminism is very specific, and that to some extent increases her partial solitude. Her hostility is not directed against a series of individuals nor does she target men, who for her must be part of the solution. She rebels against and wishes to overcome social and political systems that are founded on the idea of separation and hierarchy. The world she envisaged, and envisages still, is, to offer a few examples, a world in which colonies would not exist; nor would slavery or exploitation of one person by another. Co-operation and kindness would replace hostility and cruelty.

The path to this new world must be cleared, and, like a few other feminists, she has identified how this might be achieved. Like Jeanne Hyvrard in France, for example, Giuseppina Moneta in Italy, and, to a

much lesser extent, myself, she knows we must un-think the world around us. Un-think it from the beginning. Re-imagine the world which should have been and make it happen. It is not a question of erasing. We must take a clean sheet on which nothing was ever written and build on that.

Rethinking the world is not an easy task. How does one rethink something of which one has no experience? It's quite a frightening thought, but Madeleine is not easily frightened. As long as she is still with us, she will still be fighting. Her memoirs make that very clear. And, after that, her writings will continue to inspire her readers.

— MAÏR VERTHUY

C.M., Distinguished Professor Emerita
Concordia University, Montreal

ACKNOWLEDGEMENTS

I am grateful to the following organizations and individuals:

The Canada Council for the Arts, for awarding me a grant under the Grants for Professional Writers: Creative Writing program.

The Amis de l'Association pour la Renaissance du Vieux-Palais d'Espalion and its president, Philippe Meyer, and his colleagues Isabelle Cadars and Magalie Lacoste, thanks to whom I was able to experience a happy writing residency for six months in 2009.

Friends Jeanne-Marie Rugira and Serge Lapointe of the Réseau québécois pour la pratique des histoires de vie (RQPHV), for their vision.

The writers of the Coupole des Femmes in Paris, Lise Gauvin and Madeleine Monette, Annie Richard, and Georgiana Colville, for their openness to autobiographical writing.

I am deeply grateful to Claudette Beaudoin, Isabel Ménard, Jarryd Desmeules, and Jocelyne Aubertin for their patience with technical assistance.

And for their insightful reading, Jacques Allard, Monique Durand, Danielle Fournier, and Simone Sauren.

Behind the scenes of this book, there were people who in various ways encouraged my journey of writing. All my gratitude goes to those people who did studies or organized conferences on my work or interpreted it in images, music, or theatre: Michèle Côté, Jacques Fournier, and Irene Whittome, Stéphane Hirschi, Rachel Laurin, Marcel Pomerlo and his actors, Françoise Faucher, Markita Boies, Catherine Dracjman, and Jean Marchand.

Also, my readings at public tributes to the poets Denise Desautels, Anthony Phelps, and Michel van Schendel quietly enabled me to improve certain passages of this book. I wish to thank these poets.

For the English edition, I thank Phyllis Aronoff and Howard Scott and everyone at Talonbooks.

INDEX TO LITERARY AND CULTURAL REFERENCES

TRANSLATORS

PHYLLIS ARONOFF lives in Montreal. She holds a master's degree in English literature. *The Wanderer*, her translation of *La Québécoite* by Régine Robin, won the 1998 Jewish Book Award for fiction. She and Howard Scott were awarded the 2001 Quebec Writers' Federation Translation Award for *The Great Peace of Montreal of 1701*. She is a past president of the Literary Translators' Association of Canada.

HOWARD SCOTT is a Montreal literary translator who specializes in the genres of fiction and non-fiction. He is a past president of the Literary Translators' Association of Canada. His literary translations include works by Madeleine Gagnon and Quebec science-fiction writer Élisabeth Vonarburg. In 1997, Scott received the prestigious Governor General's Translation Award for his work on Louky Bersianik's *The Euguelion*. In 1999, his translation of "The Eighth Register," a science-fiction story by Alain Bergeron, won the Sidewise Award for Alternate History for best short-form.

MAÏR VERTHUY

MAÏR VERTHUY is a long-time Montreal feminist. Born in Wales, she graduated from London University (Middle Temple) and worked at Oxford University Press before immigrating to Canada in 1959. In 1965, she joined the French department of Sir George Williams University, now part of Concordia University.

In 1978, she was appointed principal of the university's new Simone de Beauvoir Institute, a bilingual Bishop Street college that was the first in North America dedicated to women's studies; she kept the job until 1983. Verthuy retired in 2003 as a distinguished professor emerita and now volunteers as secretary of the Montreal Council of Women.

In 2008, she won the Governor General's Award for her outstanding work on behalf of feminist causes in Canada.

A widow and the mother of two children, Verthuy lives in Outremont, Quebec.

MADELEINE GAGNON

MADELEINE GAGNON has made a mark on Quebec literature as a poet, novelist, and non-fiction writer. Born in Amqui, a little village in the Matapédia Valley, she decided at the age of twelve to be a writer and, after her early education with the Ursuline nuns, went on to study literature, philosophy, and psychoanalysis at the Université de Montréal, the Sorbonne, and the Université d'Aix-en-Provence, where she received her doctorate. Since 1969, she has published more than thirty books while at the same time teaching literature at several Quebec universities. Her work in all genres combines passion, lucidity, erudition, poetic vision, and political commitment, boldly transgressing the boundaries between poetry and prose. Among her many awards are the prestigious Athanase-David Prize (2002) for her lifetime body of work, the Governor General's Award for Poetry (1991) for *Chant pour un Québec lointain* (translated by Howard Scott as *Song for a Far Quebec*), and the Journal de Montréal Prize (1986) for *Les fleurs du Catalpa*. Her work has also won international recognition, with many publications in France and some fifteen translations into English, Spanish, and Italian. Nancy Huston has described Madeleine Gagnon as someone in whom the boundary between inner and outer life is porous; her words are poetry and her ear for the words of others is poetry too. Everything she takes in from the world is filtered, processed, transformed by the insistent rhythms of the songs within her.

AWARDS AND DISTINCTIONS

2013 Member of the Order of Canada

2007–2009 Career Award of the Council of Arts and
 Letters of Quebec

2008 Ronald Gasparic International Poetry Prize,
 Romania

2002 Athanase David Prize for a lifetime of work

2001 Marcel Couture Prize at Salon du livre
 (Montréal) for *Les femmes et la guerre*

1991 Governor General's Literary Award for Poetry
 for *Chant pour un Québec lointain*

1991 Artquimédia Prize

1990 Arthur Buies Prize at Salon du livre
 (Rimouski) for a lifetime of work

1986 Journal de Montréal literary prize for
 Les fleurs du Catalpa